THE ARTS OF BRITAIN

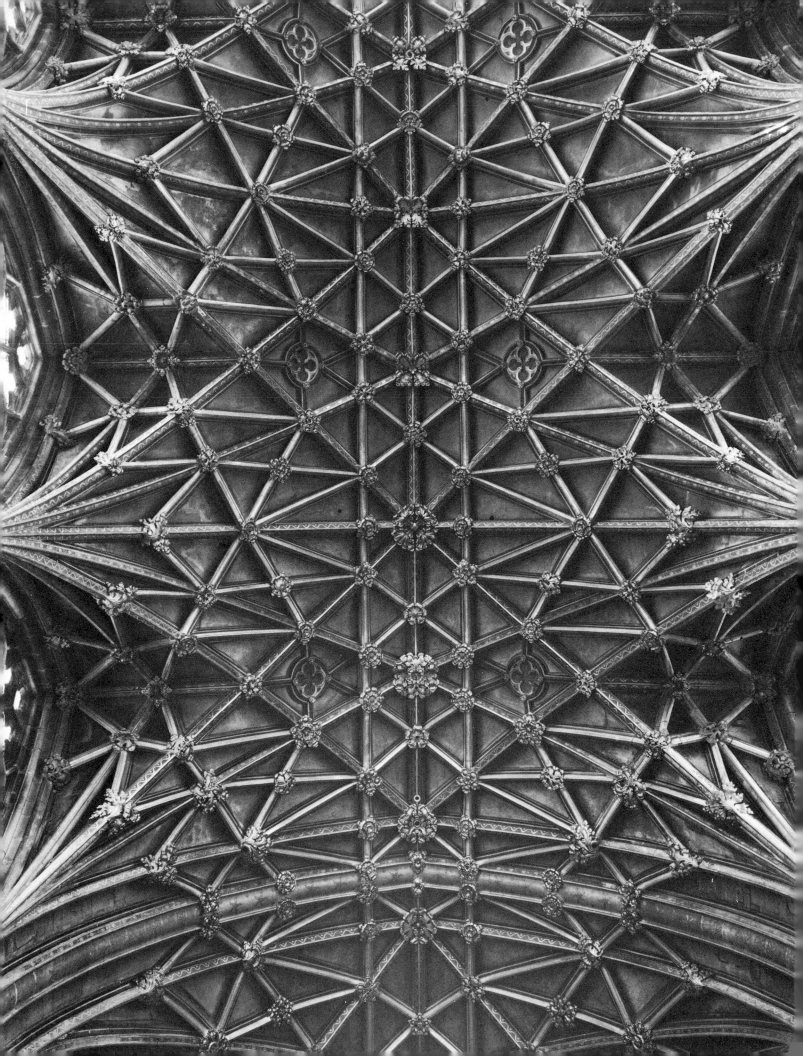

THE ARTS OF BRITAIN

EDITED BY

Edwin Mullins

PHAIDON · OXFORD

Phaidon Press Limited, Littlegate House, St Ebbe's Street, Oxford
First published 1983

© 1983 Phaidon Press Limited

British Library Cataloguing in Publication Data

The Arts of Britain.
 1. Arts—Great Britain.
 I. Mullins, Edwin
 700'941 NX543.A1

ISBN 0-7148-2285-X

Phototypeset in 10/12pt Sabon by Tradespools Limited, Frome, Somerset
Printed in Spain by H. Fournier, S. A. - Vitoria

FRONTISPIECE
Choir vault, Gloucester Cathedral. 1337

Contents

Preface

The theme of this book is the visual arts of Britain in the widest possible sense, embracing whatever the people of these islands have built and shaped, coloured and decorated with a more than utilitarian purpose, from pre-history to the present day.

It is a book that examines the enormous question of 'Britishness'. What have generations of artists and craftsmen, architects and designers, produced that has shaped our environment and therefore our lives? What are the events and circumstances that have conditioned the things they have produced? What are the qualities for which the arts of Britain have been celebrated? What is it that we have excelled at, or done differently from other nations — and why?

In such a broad field painting and sculpture take their place alongside architecture and ceramics, silver and jewellery, gardens and glass, textiles and furniture, archaeology and folk art, industrial design and modern studio crafts, photography and book illustration, clocks, weapons, musical instruments. A final section leads us to the New World and the British impact there.

Each contributor has taken a personal line quite independent of any other, in no case attempting a definitive account. The result is a sequence of selective appreciations by a team of experts. In some areas there is an inevitable overlap and interweaving, for example between sculpture and building, and between crafts and design. My own section, on painting and drawing, begins with the period of the Reformation, not because these arts did not exist until then but because medieval and earlier painting by and large seemed more suitably discussed elsewhere as illustration.

The range of topics covered is wide, but in the end it may be worth asking oneself if such a thing as a 'national character' emerges — or, rather, a multi-national character, since the book embraces Ireland, Scotland and Wales, besides England. So many tides have washed over our islands, wrecking, reshaping, irrigating: as a result are we in any real sense the same nation as when the Gothic cathedrals were being built, or before puritanism took hold, or before the Industrial Revolution, or before the British Empire painted the maps of the world red? Is the British climate perhaps the only constant factor — though even this has changed since the days when vineyards flourished as far north as Scotland?

Whether or not there is a persistent national character, there is at least such a thing as the art of a nation, and that is part of our inheritance and part of our lives. It is an aspect of what we are, because it is what we have created by a multitude of diverse skills answering a host of diverse needs. This book is a celebration of the Arts of Britain.

EDWIN MULLINS

OVERLEAF I. Richard Wilson, *Dover* (detail). *c.* 1747. Oil. Paul Mellon Collection, Upperville, Virginia

1

Painting and Drawing

EDWIN MULLINS

What is British about British Painting?

GENERAL THOUGHTS about British painting are guided by a number of historical and geographical landmarks. Such landmarks are as crucial to a discussion of other arts as they are to painting, so that this introductory section may also serve as an introduction to the book as a whole.

To begin with, anyone in Great Britain who ever put brush to canvas has been aware that he is doing so on an island. Some have been proud of it, like Hogarth and Constable, to the point of arrogance. Some, like Reynolds and Turner, have treated the English Channel as no barrier at all, more a channel of communication. Most often, though, British artists have regarded their geographical insularity with an uncomfortable sense of inferiority and an eye trained a little anxiously on the latest events in Antwerp and Amsterdam, Rome and Paris or, more recently, New York. Generally speaking, from Tudor times to the present day, British art has been conceived either in self-conscious relation to modernism or in stalwart rejection of it, but always in the knowledge that whatever modernism might be it belonged elsewhere. The art of these islands has very rarely found itself within what is generally considered to be the mainstream of European painting or of international painting: its story is one of continual irrigations from the continent of Europe or the New World, and occasionally of a decisive contribution.

Not surprisingly, British painting lacks the continuous grand sweep of Italian or French art. Its progress has been jerky. As with British architects, our painters have fallen under one foreign influence after another depending on the direction of cultural trade-winds – German under the impact of Holbein; Dutch and Flemish under that of Mytens, Rubens, Van Dyck, Van Ruysdael, and Van de Velde; Italian (the Riccis, Rosa, Pellegrini, Canaletto); French (Clouet, Claude, Watteau, Delacroix, Ingres, the Impressionists, Cubists, Surrealists); and consistently in recent years American, since the dominance of the New York School in the 1950s and 1960s.

Art historians are inclined to play the game of source-hunting. Accordingly British art has sometimes been made to look a feebly second-hand affair when seen in the light of ancestry. There has been a temptation to treat as properly British only those lone talents who can be credited with no clear ancestry at all – artists such as William Blake, Samuel Palmer, Richard Dadd, the Pre-Raphaelites, Stanley Spencer, and, in our own day, a seemingly inexhaustible supply of lady 'primitives' who paint their fantasies brightly. In this way Britishness has grown synonymous with the slightly odd. In fact, any visitor to our national collection at the Tate Gallery will recognize a far greater diversity of British qualities than this. He may also perceive that ancestry, however clearly defined, invariably tells less about a painter than what he brings to his art himself.

Professor Nikolaus Pevsner has had a stab at defining these national qualities. 'On the one hand', he writes, 'there are moderation, reasonableness, rationalism, observation, and conservatism; on the other there are imagination, fantasy, irrationalism.' But, again, the visitor to the Tate Gallery may find these abstract qualities less noticeable than physical ones, the most obvious being the British climate, without which we should never have had the glorious mists of Turner or the mellow fruitfulness of Constable. And what about those personal qualities so often associated with the British, love of compromise, respect for free speech and personal liberty, belief in fair play? How, if at all, are these reflected in our art?

It may be wise to begin with history. In 1533 King Henry VIII had his marriage to Catherine of Aragon annulled. The following year he broke with the Vatican and appointed himself supreme head of the Church of England. Henry's secession from the Roman Church had a profound effect on art, for it brought to an abrupt end the British medieval tradition of religious image-making, along with much

of the fine craftsmanship that was associated with church ritual. Images (along with the monasteries) were smashed or burnt, jewellery looted, silver melted down: it was the eclipse of an era. But artistically it was also the dawn of a new and different era. British art took a direction it would never otherwise have taken and which in Roman Catholic Europe was not to be taken for another two centuries. It became predominantly secular. Since holy images were banned, artists switched to secular ones. From the arrival of the German Hans Holbein, and his entry into the royal service in the 1530s, the principal activity of painters in this country became portraiture, and was to remain so for the next two and a half centuries.

If the Reformation was one historical event to exert a crucial influence on the nature of British painting, then the Civil War one hundred years later was another. The Protectorate of Cromwell, and the subsequent Restoration of Charles II, did not in themselves change the face of British painting all that much. But, more important, they changed the spirit of it. The fact that England had its republican revolution so much earlier than continental nations helped shape British art as much as it shaped British life. For one thing it meant that, quite early on, painting ceased to be primarily a court art: there was no British Versailles. Its chief patrons were neither church nor monarch: they were the gentry and the rising middle classes. It was for the most part a private art for private houses – a family art. Hogarth, in the eighteenth century, was proud to write at the head of the supplement he planned to his treatise *The Analysis of Beauty* that it was 'Not dedicated to any prince in Christendom for fear it might be thought an idle piece of Arrogance'. What Protestant and very British sentiments! Just as British is the fact that the academy of which Reynolds became first president in 1768 should have been founded in emulation of the French Académie, yet at the same time the monarch was and has remained merely its patron; the Royal Academy is at heart a self-regulating body of professional individuals who are in the pocket of no authority, even if in the past they have not been reluctant to line their own pockets by ensuring that the most remunerative commissions came their way.

Because British artists were tied to no central authority of church or monarch, they tended to share the outlook of their private patrons. This meant that from as early as the Restoration of Charles II British art was able to reflect the free intellectual climate which in the eighteenth century was to be the envy of Europe: hence the flourishing of the art of moral and social satire and of political caricature – which of course still continues. It also led painters to reflect the lifestyle of those patrons, and to depict them not as courtiers or as church donors but simply as townsmen and countrymen, as gentry proud of their mansions and their estates, their animals, their sporting pleasures, their life at ease. If British artists did not exactly invent the open-air portrait, they certainly explored it and developed it in such a way that they have left us a unique historical account of the British ruling class in the context of the property it has owned.

One further historical event has been important in shaping British painting – the Industrial Revolution. Had British art remained tied to a royal court, that extraordinary burst of scientific and technological inventiveness in late eighteenth- and nineteenth-century Britain might well have passed it by. Or, had artists continued to serve the Church (as in Italy and Spain), recording didactic fantasies and sombre martyrdoms of long ago, then the excitement of an iron-foundry or a steam-hammer might never have been felt. As it was, events shaped British art into one of observation rather than of allegory; and the heirs to the tradition of straight portraiture, of fox-hunting scenes and views of stately parks and mansions, found no difficulty in broadening their gaze to include the new phenomena of industry that were springing up often on the verges of those very estates. Industry was just another of those wonders of man's world which it was perfectly natural for British artists to record. Turner, for instance, found it no problem to switch from the voyages of Ulysses to a snowstorm in the Alps to the passage of a steam-train in the urban murk. The physical world could be the setting for whatever scene his imagination chose to enact there.

These various historical events, together with native conditions such as geography, climate and economics, helped breed certain characteristics into our national art. One very noticeable characteristic of British painting is its small scale. James Thornhill at Greenwich is one of the very few British artists to have covered areas of wall or canvas to match in size, say, Florentine fresco cycles or those vast compositions with which Delacroix and Courbet tried to hog attention at the Paris Salons. Think of the finest British artists and in the mind's eye one sees work that is domestic in scale. The most sumptuous Gainsborough is no larger than a life-size double portrait can be. The most enthusiastic British artists of the 1960s, liberated from the restrictions of easel painting by the example of New York painters, could never quite manage the same confident acreage that

Americans seemed to tackle without breaking sweat. Historians have suggested that this natural smallness of scale is the legacy of medieval missals and psalters, of Tudor and Stuart miniature painting, and of that very English and small-scale art – the watercolour. Maybe so. More to the point, perhaps, has been sheer lack of opportunity to paint anything larger. Since the Reformation there have been few churches to decorate; since Charles I there have been no majestic state commissions; allegory, which lends itself to expanses of figures, the British have never understood; history painting was loftily talked about in the eighteenth century but practised with little success; while Baroque flights of nudity have offended the Protestant ethic.

The consistently hybrid nature of British painting has already been mentioned. From the miniaturists of Elizabeth I's era to the various breeds of abstract painters in Elizabeth II's, debts to artists from abroad have rarely ceased. And on those occasions when the import of ideas *has* ceased, such as in the late sixteenth century and again during the High Victorian period, British art has been at its least inspired.

Maybe it has been the constant awareness of debts owed abroad that has so often inflamed British painters with a kind of xenophobic conservatism. Hogarth possessed this. He signed himself 'Britophil', and was proudly conscious of being the first native painter ever to achieve international standing. Reynolds possessed it, too, though more in dignity than in bigotry. Stubbs made the prescribed visit to Italy largely to be able to boast on his return that it had been quite unnecessary. Constable, too, turned his back on the Continent, pleased to proclaim that he was 'born to paint a happier land, my dear old England'. Such attitudes were echoed throughout the nineteenth and early twentieth centuries, and not only in the corridors of the Royal Academy: in 1920 the Seven & Five Society, shortly to become a forum of British abstraction, offered a lordly reprimand to the Continent for heating such a dangerous cauldron of avant-garde ideas – they were 'grateful', they said, 'to the pioneers, but feel that there has been of late too much pioneering along too many lines in altogether too much of a hurry...'

But twenty-two miles of English Channel cannot be entirely to blame for this xenophobic conservatism. All the Latin countries were steeped in a classical tradition which the British Isles have never truly shared. Even Germany, through its Roman Catholic south, was on easier terms with classical art than we were; the Netherlands, too, partly through years of Spanish rule and partly because artistic links between Holland and Italy remained secure even after the rise of Calvinism. In England those links were at best fitful and uneasy. Reynolds and Thornhill are exceptions who prove the rule. What British artists did have was their own tradition, which was to a great extent a literary one. Poetry and the theatre were in their veins. Hogarth could write, 'my picture is my stage, and men and women my players' who 'exhibit a *dumb show*'. Evidence of the fruitfulness of this literary tradition is the remarkable number of British artists who have been writers as well. Hogarth, Fuseli, Palmer, Blake, and Turner all wrote as well as painted. The tradition continued through the later nineteenth century with Rossetti and into the twentieth with Wyndham Lewis, Jack Yeats, David Jones, Michael Ayrton, and Mervyn Peake; while a fascination with words is fundamental in the paintings of one of the most imaginative of the younger artists today, Tom Phillips (Fig. 34). The story of British art can sometimes look like the story of the painted word.

Lacking a classical tradition, and hence an intimacy with Greek mythology, British painters have rarely felt comfortable with the nude. This is not principally a moral taboo – how could it be when our literary tradition is steeped in erotic love? It is much more the absence of any perception that paint and colour may possess sensuous properties evocative of the forms they describe, the human form above all, which Italian artists (particularly the Venetians) felt as if by instinct. A notable exception is Gainsborough, rare among British artists in clearly enjoying the actual material of paint rather as a master chef might enjoy making fine pastry; and even Gainsborough painted but one nude all his life and that a wispy one. In no sense is ours a climate for nudes, and those artists who have treated the theme have often fallen either into respectable pornography (like Leighton and Alma-Tadema) or into voluptuousness (Etty and Matthew Smith).

Mistrust of sensuousness has sometimes spilt over into a mistrust of the senses generally. Blake got himself into a great muddle here because as a committed sensualist he was nonetheless vigorously opposed to the kind of sumptuous portraiture practised by his hated contemporary, Reynolds – the 'man hired to depress art', as he called him. Blake attempted to resolve this confusion by separating mind and body: 'Mental things are alone real, what is called corporeal ... is ... an Imposture.' He frequently reduced human forms to insubstantial wraith-like creatures (Fig. 2). In effect Blake was rationalizing a natural talent for the linear rather than the rounded,

Caricature

EDWIN MULLINS

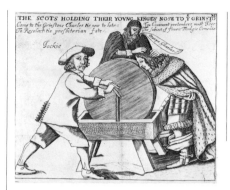

CARICATURE debunks power: it is the most therapeutic of all the arts because it is the raspberry of Everyman blown at those who wield authority over him. Britain has a long tradition of (especially) political caricature because the right to answer back was fixed unusually early – in the seventeenth century. Following the Civil War and the Commonwealth no British ruler could consider himself immune from attack. The institutions of power were now secure, but their occupants were not.

At first the attacks were cautious enough to avoid personal malice; they were more in the nature of pointed political comment, as in Fig. 1 depicting the future King Charles II in 1651 having his nose ground by the Scottish Calvinist Church in return for political support in his bid to regain the throne. Already freedom of expression has moved a long way from Charles I's insistence on the inviolate and Divine Right of Kings.

Early political broadsides were generally anonymous, and they made no claims to be works of art. The first British artist of distinction to embrace caricature was William Hogarth (1697–1764), and he did so as a moral force. Caricature was a means of making society more just, and his victim in Fig. 3 is the Lord Chief Justice of the day, Sir John Willes, who was a man infamously corrupt. Willes's obesity and ugliness are exaggerated in the classic pattern of caricature, which attaches itself to physical traits to make a moral point.

Within fifty years caricature grew bolder and more vicious. James Gillray (1756–1815), perhaps our greatest caricaturist, often employed schoolboy lavatorial humour to debunk his victims, as in Fig. 2, entitled *New Discoveries in Pneumaticks, or an Experimental Lecture on the Powers*

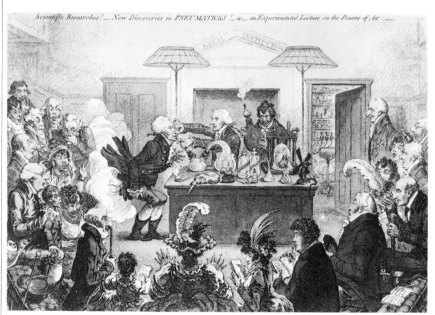

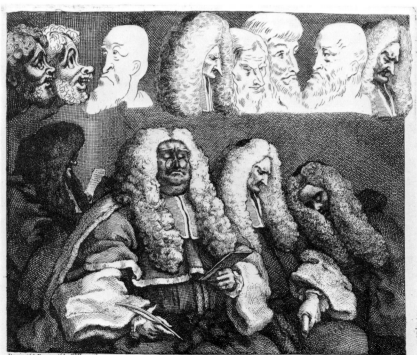

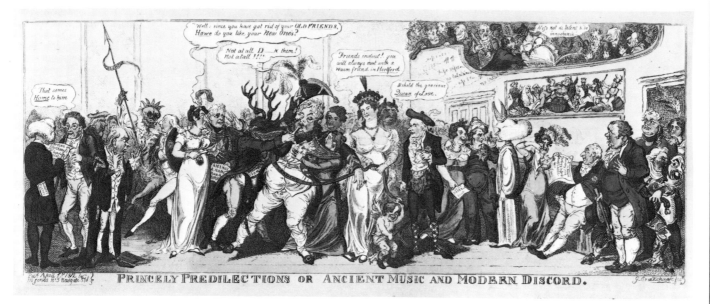

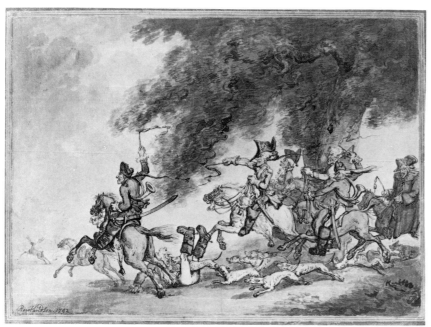

ABOVE 4. George Cruikshank, *Princely Predilections* (Prince Regent with his Mistress, Lady Hertford). 1812. London, British Museum

LEFT 5. Thomas Rowlandson, *The French Hunt*. 1792. Pen, watercolour and pencil. London, British Museum

BELOW 6. Max Beerbohm, *Dante Gabriel Rossetti in his Back Garden*. 1904. Private Collection

BOTTOM 7. Vicky (Victor Weisz), 'Supermac' (*Evening Standard*, 2 January 1959). University of Kent

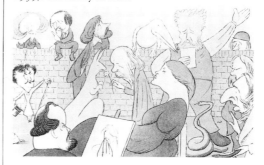

of Air: a pompous scientific occasion culminates in an explosive fart. Who could respect boffins after that?

Thomas Rowlandson (1756–1827) was adept at rollicking social caricature: in Fig. 5 his theme is *The French Hunt*, a shamelessly chauvinist view of the ludicrous 'frogs' just three years after the French Revolution. The extreme liberties that could now be taken with royalty is reflected in Fig. 4 by George Cruikshank (1792–1878), showing a debauched Prince Regent led like a drunken bull by present and past mistresses and their cuckolded husbands.

The outstanding caricaturist of the late Victorian era, Max Beerbohm (1872–1956), turns his mocking eye in Fig. 6 on his fellow-artists, with a portly Rossetti sketching an absurd Pre-Raphaelite model surrounded by a garden menagerie of posturing animals and artists who include Swinburne, Morris, Whistler and Ruskin.

Arguably the outstanding political caricaturist of recent years was Vicky: his Supermac figure of Harold Macmillan continued a tradition of pictorial debunking that has remained unbroken since Stuart times (Fig. 7).

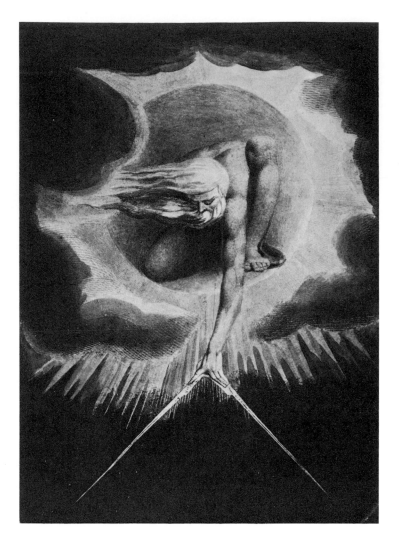

2. William Blake, *The Ancient of Days.*
Etching, with watercolour. 1794.
London, British Museum

There may be a link between this mistrust of sensuous paint qualities and the British tendency to see painting as a medium for narrative; just as, more obviously, there is a link here with the importance of the literary tradition. Some of the earliest life-size portraits, like George Gower's *Armada Portrait of Elizabeth I* (Fig. 3), tells a story in a simple iconographic way by setting the figure against a recognizable scene of action. Reynolds adopted a similar method when he surrounded his subjects with attributes of their profession or reminders of some military triumph. In this way Reynolds cleverly adapted the procedures of history painting to the demands of portraiture.

But British narrative painting has sometimes been much more explicit than this. Hogarth made paintings in series so that they could be followed like a picture-book (*Marriage à la Mode* and *A Rake's Progress* are the best known of them). There was nothing new in this – medieval art had consistently been narrative: what was new was the choice of themes from contemporary society. The influence of Hogarth was profound, particularly through the popular engravings he made of his series, and the fashion for pictorial moral narratives enjoyed an enormous revival in Victorian England largely under the impact of Methodism. Britain may have little church art, but a great deal of it is darkened by the shadow of the pulpit.

Hogarth believed, as indeed the medieval church painters and carvers had believed, that art was a moral force: he called his series 'modern moral subjects' whose purpose was to 'entertain and improve the mind'. His view was widely shared throughout the eighteenth and nineteenth centuries, not least by Blake: 'For Blake art was only justified if it was didactic,' Martin Butlin of the Tate Gallery has written. All the Pre-Raphaelites were concerned – some more profoundly concerned than others – to improve the spectator through their art; their spokesman John Ruskin went so far as to state that 'the art of any country is an exact exponent of its ethical life', and that painters 'cannot be great unless they are ... good'. (I wonder what he would have made of Caravaggio, a murderer!) The Pre-Raphaelite Holman Hunt went even further, all the way to the Holy Land to paint *The Scapegoat* in miserable discomfort by the shores of the Dead Sea so that his biblically-inspired document should look, and be, authentic. William Morris even echoed Abraham Lincoln when he proclaimed that art must be 'by the people for the people'. These were stirring times to be a British painter.

and he was far from alone among British artists in this preference for form defined by line rather than by bulk or colour. It was shared by Hilliard and the other early miniaturists, by almost all the native portrait painters both before and after Van Dyck (Reynolds and again Gainsborough excepted); by the early watercolourists, too; by Burne-Jones, Beardsley, and the American-born Whistler; and in our own century pre-eminently by Wyndham Lewis, John Minton, Ben Nicholson, Lucien Freud, Victor Pasmore and David Hockney. In fact British art has been to a remarkable extent linear, whether or not this is – as Pevsner has suggested – the legacy of medieval manuscript illumination and Gothic 'Decorated' architecture.

Another consequence of Britain's remoteness from the classical tradition, and of its rupture from the Church of Rome, seems to have been a lingering of medievalism. It is not altogether clear why a nation which had broken with its religious past should have clung so tenaciously to the medieval spirit: nonetheless in Britain (as in another great Protestant region of Europe, Northern Germany) a pre-Renaissance mood of mysticism and other-worldliness did persist. The Elizabethan court was fascinated by medieval chivalry. The Gothic style of architecture flourished here well into the seventeenth century, scarcely subsiding before it was revived again amid the cult of ruins, the delirium of Walpole's Strawberry Hill, and the outpourings of Romanticism, right down to the exuberance of nineteenth-century railway stations and Victorian parish churches decorated by Burne-Jones. The visions of Blake and Palmer were medieval; so were those of Martin and Dadd. Rossetti loved medieval illustrated manuscripts and steeped his imagination in Malory's *Morte d'Arthur*. William Morris revived the floral dream-world of medieval tapestry along with the ideal of the medieval crafts workshop; and in the present century a trance of nostalgia for the Middle Ages hangs over the work of Stanley Spencer, David Jones, and Cecil Collins, and the landscapes of John Piper and Graham Sutherland (Fig. 4).

3. George Gower, *'The Armada Portrait' of Elizabeth I. c. 1588*. Oil. The Duke of Bedford

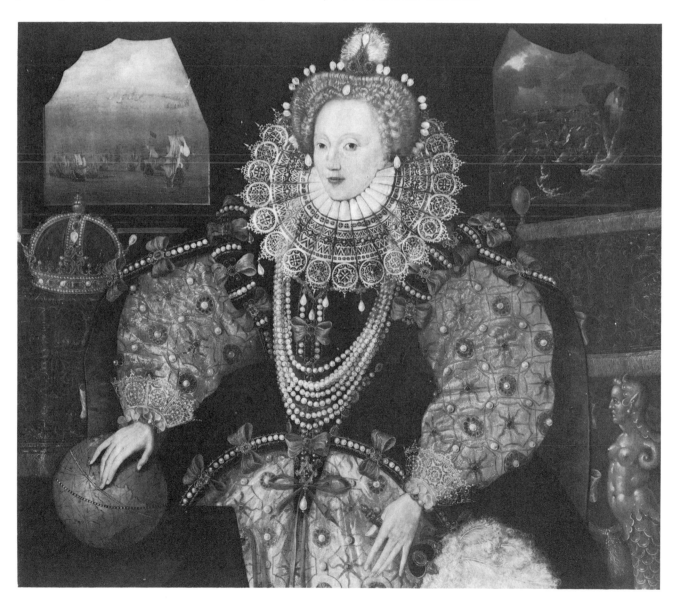

Hand in hand with this lingering medievalism has gone a respect for the artist as dreamer, as visionary, as solitary witness to the underlying truths in the world he walks. Protestantism is a lonely religion. The Protestant alone with his God, with his faith, easily becomes the artist alone with his vision of the truth, brought to him by his own privately conducted meditations. Britain has contributed more outsiders to the pantheon of art than any other nation, from Stubbs and Blake to Stanley Spencer and Alfred Wallis, L. S. Lowry and Francis Bacon – solitaries quite different one from another but sharing within their solitariness a reliance on the unique self as provider of all that the creative spirit needs, without the community of other spirits. Constable expressed it well, in his usual forthright manner, when he replied to a visitor who enquired if a picture had been painted for someone in particular: 'Yes sir,' he said, 'it is painted for a very particular person – the person for whom I have all my life painted,' – meaning, of course, himself.

Constable also maintained that his art was 'to be found under every hedge, and in every lane'. This apparently ingenuous remark assumes the status of a defiant *credo* if one appreciates that the highest form of art was still reckoned to be history painting on a grand scale: it was like proclaiming brass to be as valuable as gold. Gainsborough had been able to sell very few of his landscapes; Richard Wilson had experienced almost equal difficulty as he got older; and Turner succeeded largely because his reputation as a landscape painter had been built on his skill at imitating the prestigious Claude Lorraine, who in any case was a painter of classical and therefore ideal landscapes and paid no vulgar attention to lanes and hedgerows, which were for rabbits and peasants and not for exhibitors at the Royal Academy.

It is an irony that by the time the status of landscape came to be fully recognized, landscape as an art was already moribund in Britain; and yet landscape painting is certainly the most widely recognized achievement of British artists. Wilson and Gainsborough effectively began it during the middle decades of the eighteenth century, and though neither enjoyed much success they left a body of work to be admired and a standard to be emulated. Gainsborough's sentiments about the countryside stand for the way the whole nation has come to feel about the country: 'I'm sick of portraits and wish very much to take my Viol da Gamba and walk off to some sweet village where I can paint landskips and enjoy the tag end of life in quietness and ease.' No French artist could have said that until Corot nearly a century

later. The artist alone with himself is alone in the company of nature, and 'nature' to British artists has a special and comforting meaning, as true of the St Ives painters of the mid-twentieth century as of Madox Brown in the 1850s and Constable and Turner a generation earlier. Constable's modest lanes and hedgerows are where a painter's eyes and imagination feed: 'We exist but in a landscape and we are the creatures of a landscape.' The poetry of Wordsworth and the novels of Thomas Hardy and D. H. Lawrence express just the same spiritual bond between man and landscape: it is where man belongs, in a fundamental, almost religious, sense – indeed overtly religious in the case of painters like Holman Hunt and Samuel Palmer (Fig. 5). Landscape painting is perhaps the closest thing to a religious art that Britain has produced since the Middle Ages.

This special relationship with nature may have a more prosaic origin. Because there was no call for holy images after the Reformation, painters turned from the metaphysical world to the physical. In Protestant England painting became centred on portraiture, in which there was little room for frills except the frills of dress. Invention was not much called for. Observation was the requirement, and this bred an attitude crustily summed up by Dr Johnson: 'I had rather see the portrait of a dog I know than all the allegories you can show me.' Observation led to a search for Truth – not spiritual Truth in the sense that *Paradise Lost* and *A Pilgrim's Progress* are quests for spiritual Truth, but tangible Truth. Truth about life as it is seen to be. And here lies the strength of Hogarth. He is a social observer, and a fearless social commentator. With Hogarth the search for Truth became by extension a search for Moral Truth. Social art needed to have a moral bite. And in this respect his achievement echoes across the centuries, in the caricatures of Rowlandson and Gillray, in the moralizing canvases of the High Victorians, and in our own day in the burlesques of Ruskin Spear and Peggy Cook and even in some of the 'Pop' social satires of Richard Hamilton. It is the recurring voice of British rectitude which in Hogarth was first heard loud and clear.

The notion of art as the expression of facts rather than of ideas – as a pragmatic exercise rather than an idealistic one – brought within the range of British artists a remarkable gamut of data. No other country's art mirrors so broadly the life of its people or the appearance of its cities and its countryside over such a span of time and such a span of social classes. Quite apart from portraiture and social satire, the British eye for facts took in – pre-eminently – the land;

where people lived; the great churches and ruined abbeys; the mansions and estates of those who owned and ruled England. The very British art of watercolour is rooted in humble topographical records of such places. England's most imaginative painter of the countryside, Turner, enjoyed early success doing canvases of those stately homes in which he was a welcome house-guest: only later, above all at Petworth (Fig. 6), did he feel free to transform a humdrum topographical art into lyrical accounts of colour and atmosphere in which landscape and people dissolve into a radiance of light. And even when Turner's painstaking years as a recorder of hard topographical facts were long past, he never lost that urgency to root his invention in pure observation. The famous statement of his reaction to a storm at sea in 1842 perfectly illustrates this urgency. 'I got the sailors to lash me to the mast to observe it. I was lashed for four hours and I did not expect to escape, but I felt bound to record it if I did.' He was sixty-seven!

So painting came to be regarded as a cryptoscience. Constable advocated that it was indeed 'a science, and should be pursued as an enquiry into the laws of nature. Why then may not landscape painting be considered as a branch of natural philosophy of which pictures are but the experiments?' Stubbs buried himself in a remote country farmhouse in order to study and record the anatomy of the horse. The Victorian traveller-artists documented the wonders of foreign places and alien civilizations with much the same conscientious and dispassionate excitement. 'The peculiarity of my work', wrote Edward Lear, 'lies, I believe, in its accuracy...' It may not be the 'accuracy' of Lear's watercolours that impresses us today so much as their strange visionary exuberance; nonetheless it was facts – bare journalistic facts – which he believed he was assembling in his sketch-books, like a botanist loading collecting-boxes with unheard-of specimens to bring home.

Small wonder, then, that painters were on hand to respond to the cataclysm of the Industrial Revolution. Just as Hogarth, Stubbs, Gainsborough, and Zoffany left us a record of pre-industrial Britain, so in their quite different modes of response Wright of Derby, de Loutherbourg, Turner, Cotman, Ibbetson, Martin, Bourne, Grimshaw, Eyre Crowe, Lowry, Herman and Sutherland have recorded the impact on Britain of the machine. The wonder of science is there, the spectacle of industry, the visionary horror of it, the enslavement and nobility of those trapped by it, the humour of it.

All British art is a kind of anatomy lesson – no, not

4. Graham Sutherland,
Road at Porthclais with Setting Sun. 1979. Gouache.
Haverfordwest, Picton Castle Gallery

quite all because there have been the dreamers and the mystics as well, but by far the greater part of it: an anatomy lesson whose subject may be the monarch or a shrimp-girl, the weather or the foxhunt, the pit-shaft or the pulpit. It is not the art of invention, nor the art of love, nor the art of ecstasy; it may well lack, as Professor Pevsner has suggested, 'that fanaticism or at least that intensity which alone can bring forth the very greatest in art'. And yet ... and straightaway the mind gropes for the contradiction. The statement made is followed by a qualification to that statement. How very British! And how like British painting: offer a generalization and up pops the exception. Try to sum up the landscape tradition, then consider how Turner put a spoke in it. Look at the Age of Reason, then wonder how Blake could have emerged from it. Try to wrap up the mid-twentieth century and fumble for a way of forcing Bacon within those wrappers – or Spencer, or Pasmore, or Tom Phillips. Such definitions are useful to hold in the hand and look at, then before they crystallize into a theory let slip through one's fingers.

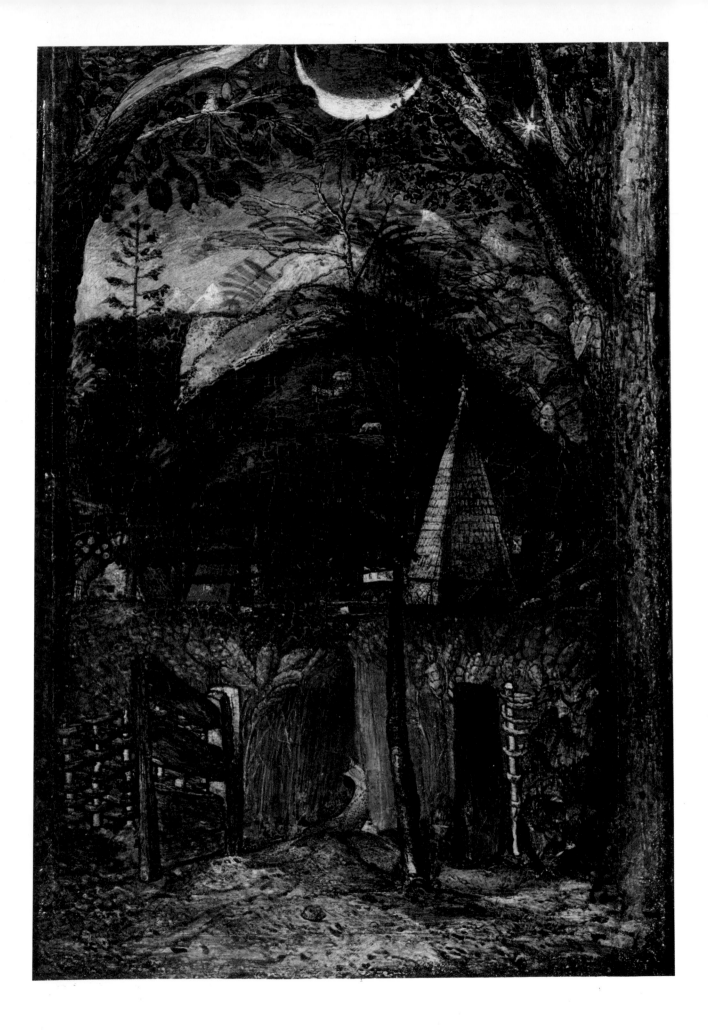

6. J. M. W. Turner, *Petworth Park: Tillington Church in the Distance. c.* 1828. Oil. London, Tate Gallery

The Changing Nature of British Art

Strictly speaking an account of British painting ought to begin with the earliest coloured scratchings on medieval walls and to conclude with something still wet on the canvas. But the confusion of the here-and-now is such that a chapter at least would be required to make sense of it, so I intend to stop at a point where the paint is already dry.

At the other end of the time-scale the outstanding early achievements of British painters are unquestionably the illuminated gospels and psalters of the Dark and Middle Ages, and these are discussed more appropriately in the essays on Early Britain (pp. 246–60) and Prints and Book Illustration (pp. 53–60). As for church murals and altarpieces, the story of British art would be very different had the wrath of the Reformation spared us enough to judge by; as it is, those that survive attract attention as unlikely survivors more than as works of high artistry. The celebrated *Wilton Diptych*, incorporating a portrait of King Richard II, was not painted in England at all but in France; while other medieval portraits of English kings, the finest of which hang in the National Portrait Gallery in London, demonstrate that as far as painting is concerned these islands

LEFT
5. Samuel Palmer, *Hilly Scene. c.* 1826–8. Tempera. London, Tate Gallery

occupied a very provincial backwater indeed until well into the sixteenth century.

If one looks for a first prominent landmark, then it has to be Holbein's portrait of Henry VIII's Chancellor, Sir Thomas More, painted in 1527 (Fig. 7). Hans Holbein himself was not British but German. He was the outstanding painter of North European humanism, that literary and intellectual movement which fuelled the Reformation. He had already illustrated Luther's Bible, and had done three portraits of the most celebrated humanist of the day, Erasmus of Rotterdam. It was Erasmus who furnished Holbein with a letter of introduction to More. His first visit to this country lasted eighteen months. Five years later he returned and spent the remainder of his life here, for most of that time as official painter to King Henry VIII. It is Holbein's intense and needle-sharp portraits of the king, his family and his courtiers which belatedly pulled this country's art out of the Middle Ages. They were the first paintings done in this country to reflect the intelligence and naturalism of the North European Renaissance, and they set a technical standard for British painters to emulate for the next hundred years. Not until the arrival of Van Dyck in 1632 was an artist of comparable international stature to settle in these islands.

Holbein is a giant among sixteenth-century artists working in Britain. Had the murals he painted for the Palace of Whitehall not been destroyed, his supremacy would now seem even greater, comparable to

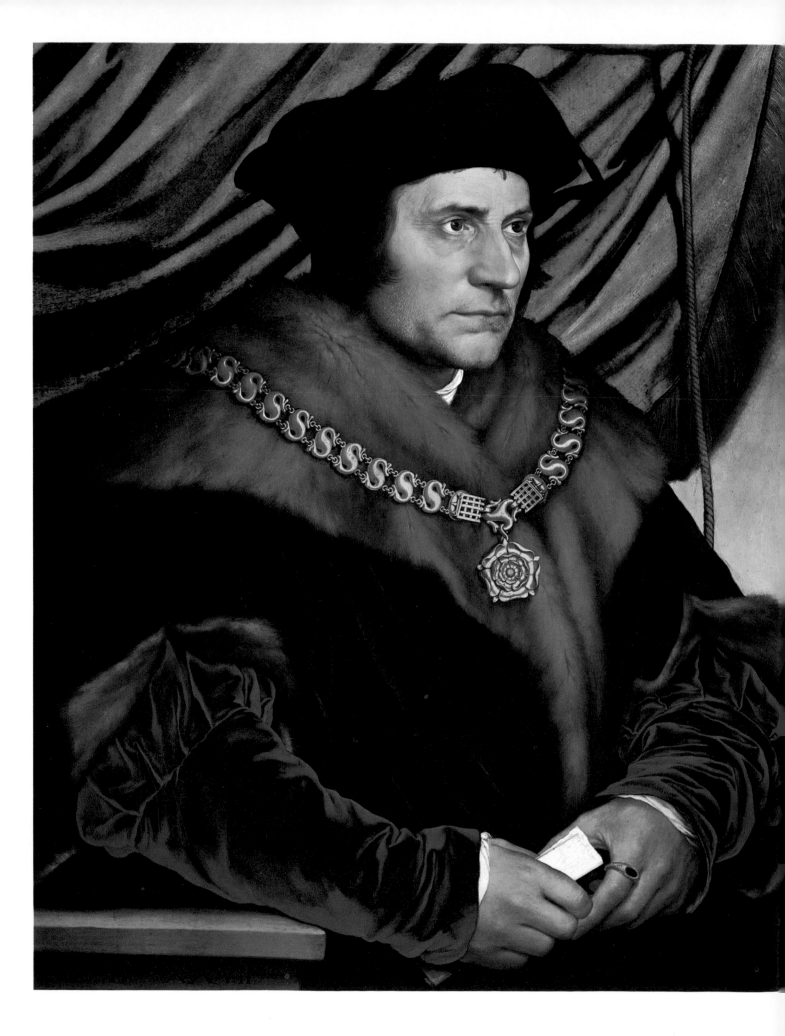

that of Mantegna in Mantua sixty years earlier. As it is, Holbein's achievement in this country rests upon his individual portraits and upon that remarkable pictorial 'biography' of two visiting Frenchmen known as *The Ambassadors*, in which the two figures stand nonchalantly surrounded by the attributes of their learning and success. But Henry did not use Holbein as imaginatively as the Gonzagas used Mantegna – too much of the painter's time seems to have been spent travelling about taking likenesses of potential wives. There was not much call for imaginative painting in Henry's England.

Holbein's lasting influence on British painting was as a portrait miniaturist, and it is this exquisite skill at which British artists, thanks to Holbein, excelled in Europe. In Elizabeth I's reign Nicholas Hilliard was to his monarch what Holbein had been to Henry VIII, except that Hilliard possessed little of his predecessor's sophisticated worldliness. The Renaissance now seems further away than sixty years before. Hilliard disliked the artifice of naturalism, particularly shadows, which he claimed produced 'a grosser line' – an observation which any continental court painter of the time would have imagined had tumbled out of the ark. What Hilliard did possess was a poetic touch and a feeling for subtleties of mood and character, 'those lovely graces, witty smilings, and those stolen glances which suddenly, like lightening, pass and another countenance taketh place'. He was especially good at depicting languid beautiful people, of whom his famous *Unknown Man among Roses* is the finest example (Fig. 8). Professor Ellis Waterhouse has commented that Hilliard is the only English painter whose work echoes the world of Shakespeare's early plays.

The leading miniaturist of the following reign, that of James I, was Isaac Oliver, a pupil of Hilliard and in many respects the more accomplished artist. Unlike his predecessor, Oliver travelled and studied on the Continent, and a breath of the Renaissance fills out his portraits with a physical vitality which Hilliard's portraits lack. His study of *Lord Herbert of Cherbury*, elegantly reclining by a stream, has an air of romantic melancholy new in British painting. If Hilliard reflects the world of early Shakespeare, then Oliver's art echoes the Jacobean love-poetry of Jonson, Drayton, Daniel, and Donne.

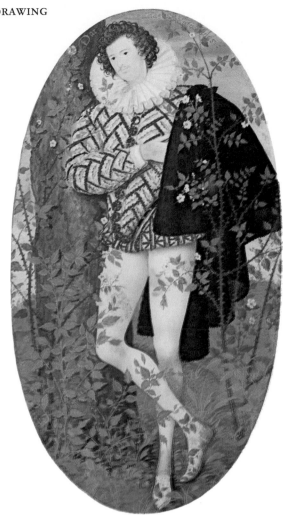

8. Nicholas Hilliard, *Unknown Man among Roses*. *c*.1588. Miniature. London, Victoria and Albert Museum

In the century between Holbein and Van Dyck most of the leading practitioners of life-size portrait painting were likewise foreigners; and they were not of the first rank. Guillim Scrots came from the Netherlands, and Hans Eworth from Flanders. The only notable British-born portraitist on this scale was George Gower, who painted the celebrated *Armada Portrait of Elizabeth I* (Fig. 3). Late in the reign of Elizabeth the court did obtain the services of one unusually gifted foreign artist, Marcus Gheeraerts, another Fleming; and the naturalism he introduced was carried on by the somewhat duller Daniel Mytens, whom Charles I made his Court Painter for life. Charles, though, was too fine a judge of paintings to settle for the second-rate, and in 1632, having failed to 'sign' Rubens, he acquired the services of Rubens' most brilliant follower, Anthony van Dyck.

LEFT
7. Hans Holbein, *Sir Thomas More*. 1527. Oil. New York, The Frick Collection

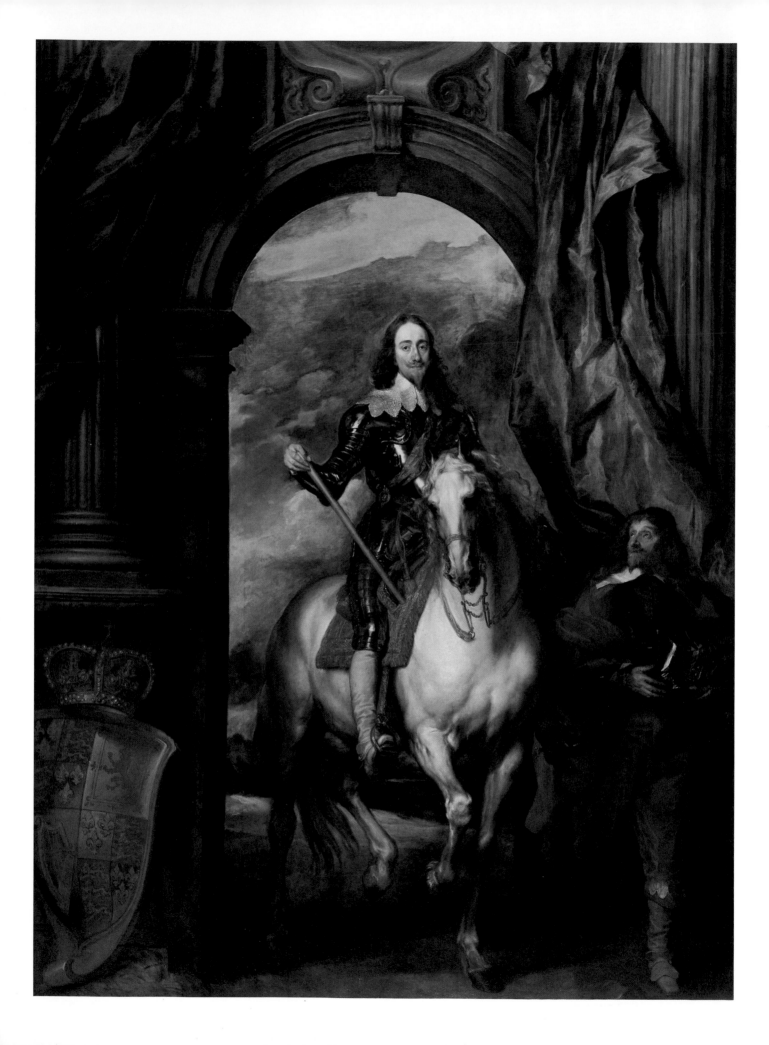

By any criterion the reign of Charles I, however disastrous politically, was one of the great eras of art patronage. Britain at last had its Medici. Rubens called Charles 'the greatest amateur of painting among the princes in the world'. Charles repaid the compliment by knighting him when he came over on a diplomatic mission in 1629–30, and probably seized the opportunity to make arrangements for Rubens to paint the ceiling of Inigo Jones's Banqueting Hall in Whitehall – the one full-blooded Baroque decoration in this country. Had Charles I got his way Rubens would have stayed, in the formidable company of Velázquez, Rembrandt and the sculptor Bernini, all three of whom Charles would have liked to employ. The effect on British painting, and on our national collections, had the royal dream come true is an intriguing speculation; however, Charles was more successful at collecting pictures than artists – with the notable exception of Van Dyck.

Van Dyck was to British seventeenth-century painting what Holbein had been to that of the sixteenth. He too dictated the style of painting in Britain for generations to come. A natural courtier, Van Dyck was treated by Charles with a respect never before accorded to an artist in this country; he was honoured in much the same way as Leonardo had been honoured in Milan, Titian in Venice and Michelangelo in Rome. Van Dyck repaid his monarch with some of the finest royal portraits ever painted. His equestrian portrait, still in the Royal Collection, was designed to be hung on the far wall of the Gallery at St James's Palace, flanked by seven of Titian's Roman emperors that Charles had just acquired from the collection of the Duke of Mantua. Charles saw himself in the context of imperial grandeur, and Van Dyck rose effortlessly to the challenge (Fig. 9). He was a painter who, unlike the workaday Mytens, could invest his sitters with glamour and grandeur; yet this grandeur was always human, never grandiose. Van Dyck liked Charles as a man, and the man is never smothered by the paraphernalia of kingship. He remains a small and sensitive human who rises naturally to fill a divine role. Van Dyck could flatter people without lapsing into pomposity, and find dignity in them without causing them to strut. The poet Cowley wrote of the painter after his death in 1641, 'Most other men set next to him in view, / Appear'd more shadows than th' Men he drew.'

LEFT
9. Sir Anthony van Dyck, *Charles I on Horseback with Seigneur de St Antoine*. 1633. Oil. Buckingham Palace, Royal Collection

British art returned to its backwater after the death of Van Dyck. Charles I did not long outlive his protégé; Cromwell's Puritans got more pleasure out of destroying images than sponsoring them; and Charles II possessed neither the revenues nor the taste for lavish patronage. But the passing of Van Dyck's comet left enough brightness in the sky to keep portraiture flourishing. William Dobson, who succeeded Van Dyck as Court Painter, would rate higher in our estimation had he outlived his predecessor by more than five years: his muscular, half-length portraits of court notables carry no hint of the Civil War, and are heavy with references to classical learning soon to be the hallmark of Reynolds.

Among foreign artists who came over to fill the gap created by Van Dyck's death, the busiest was the German-born Peter Lely, who was remarkably successful in exploiting the voluptuous mood that settled on the English court after the Restoration of Charles II, and particularly adept at painting pretty girls in studied postures which he would catalogue and number like knitting-patterns. Another German, Godfrey Kneller, was a generation younger, also a painter of lovely ladies, and best known today for his Hampton Court Beauties of 1690–1 and for his forty-two portraits of members of the Kit-Cat Club – all identical in size. But the most talented of the later Stuart portrait painters was Samuel Cooper (Fig. 10), the last outstanding miniaturist this country produced, whose career spanned the Commonwealth and the Restoration apparently without falter. The diarist Samuel Pepys paid Cooper thirty pounds – a huge sum – for a miniature of his wife in 1668, and recorded in his diary that 'the painting is so extraordinary, as I do never expect to see the like again'.

10. Samuel Cooper, *James II as Duke of York*. 1661. Miniature. London, Victoria and Albert Museum

Professor Ellis Waterhouse has bluntly stated that 'all the great movements in European painting during the seventeenth century passed Britain by'. Some late migrants, though, did find employment here. If Baroque painting was something the British never cared for, it was still a necessary embellishment of Baroque architecture, which was more acceptable. Louis Laguerre came from France and worked at Blenheim, Antonio Verrio from Italy to be kept busy at Windsor, Chatsworth and Burghley. The two Riccis (Marco and Sebastiano), Jacopo Amigoni and Giovanni Pellegrini arrived from Venice; and out of this late burgeoning of Baroque decoration for town and country houses emerged the one native painter to achieve fame in this Baroque manner, James Thornhill, who rose to fame through his Painted Hall at Greenwich and his ceiling at Hampton Court. Thornhill was showered with honours and titles by a nation relieved that here at last was a native-born

11. William Hogarth, *Self-portrait with his Dog Trump*. 1745. Oil. London, Tate Gallery

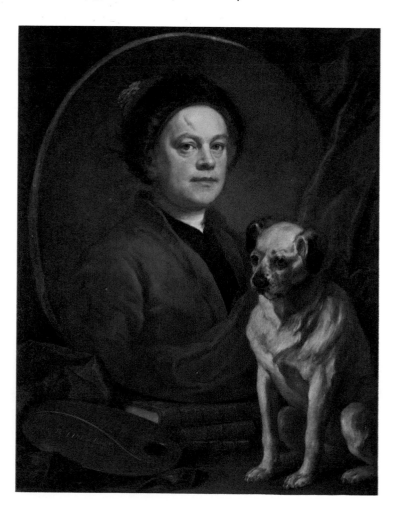

artist to match all those visiting Italians; history, though, has awarded him the more accidental fame of being father-in-law to the most trenchantly English painter of the eighteenth century, William Hogarth.

Hogarth's bristling Englishness has to be seen against the background of all this Italianate Baroque fluff. He even advised his students not to go to Italy: it might lead them astray. The English experience he felt was closer to Nature, which in Hogarth's mind meant closer to Truth – to social truth and moral truth, to the essential man stripped of pretension and vanity. Hogarth's self-portrait of 1745 tells us quite a lot about him (Fig. 11). Here is his pet pug, Trump, solidly in the foreground – enough to make any elegant Italian wince. His own image is actually a portrait within a portrait, and it rests on volumes of Shakespeare, Milton, and his older contemporary, Swift. His art, in other words, finds its source of inspiration in literature, and what is more in English literature. Against these books lies the artist's palette on which is drawn a curved line with the accompanying words 'the line of beauty', a reference to the theoretical treatise he was writing, to be called *The Analysis of Beauty*. The painting is frank, and frankly instructional.

Hogarth held career portrait painters in some contempt. Conventional portraiture he called 'phiz-mongering'. He did just enough of it himself to prove he could do it. His portraits of Captain Coram, creator of the Foundling Hospital, and of the Graham children are masterpieces of observation, without airs and graces, as are the pictures he did of his servants and of *The Shrimp Girl*.

It is not so easy today to perceive just what a break Hogarth made with tradition. First of all, he held out for the artist's independence from aristocratic patrons and connoisseurs. Trained humbly as a craftsman, he found his market and his living in engraving popular editions of what he called his 'modern moral subjects'. Secondly, he insisted that art should be about contemporary society: ordinary people of his own day, not gods or kings or historical figures. Finally, art should have a moral function: it should comment on the modern world, and if possible improve that world. He preferred to work in series because in this way a tale could be clearly seen to unfold. His first excursion into this kind of popular genre was, characteristically, a contemporary social satire – six versions between 1729 and 1731 of John Gay's recently-performed *The Beggar's Opera*, itself a burlesque of Italian high opera and therefore a target particularly to Hogarth's taste.

But real success came to him in 1732 with six

engravings entitled *A Harlot's Progress*, the tale of a country rector's daughter who enters domestic service in London, becomes a rich man's mistress, then a whore, and ultimately comes to a wretched end in prison. Hogarth was now famous, and three years later he brought out a sequel, *A Rake's Progress*, eight paintings which he also engraved, this time on the downfall of a young man who inherits a fortune, turns to drink and bad company, is sent to a debtor's prison (as Hogarth's own father had been), and finally to a madhouse. Ten years later Hogarth completed a trio of 'modern moral subjects' with six celebrated paintings called *Marriage à la Mode*, in which depravity overtakes both a young man and a young woman as a result of a disastrous arranged marriage.

Hogarth democratized British art. He took it down from the rather narrow pedestal where it had been serving the rich and recording their well-satisfied faces. But he was not alone in broadening the scope of painting in this country. There was a new vogue for topographical art: the gentry wanted their houses recorded as well as themselves. The Dutchman Jan Siberechts had started the fashion, and among the mansions he painted were Longleat and the original Chatsworth. Another continental artist, Wenceslaus Hollar, was appointed by Charles II to the post of His Majesty's Stenographer and Designer of Prospects; and his views of London before the Great Fire, including old St Paul's, supply us with some of the most accurate accounts we have of the medieval city.

Along with topography and country house painting emerged animal painting. Barlow, mentioned in Evelyn's Diary for 1656 as 'a famous painter of fowl, beasts and birds', is the first notable artist in this genre. The manner of painting was Dutch in origin – an open-air zoo of heterogeneous wildlife – but soon it became anglicized into a theme more in keeping with country gentlemen's pursuits, the sporting picture. A host of sporting painters followed Barlow in the eighteenth century, most notably John Wootton and James Seymour, both of whom worked, appropriately, at Newmarket. Marine painting also came into vogue through the influence of Dutch artists. Willem van de Velde the Elder settled in this country in 1673 (having changed sides in mid-war) and founded a whole school of sea-and-ships painters, the most successful of whom were his prolific son Willem the Younger, Charles Brooking, Peter Monamy, and Samuel Scott. Scott was also a topographical artist, with a feeling for light (largely under the influence of Canaletto who visited England in 1746) that suggests he might have become a gifted landscape

painter had there been employment for such a person in the mid-eighteenth century. As it was, the distinction of being the first gifted artist in Britain to grasp the imaginative possibilities of pure landscape – as distinct from topographical accounts of specific places – was George Lambert, a painter who is much underrated.

By the mid-eighteenth century, British art suddenly looks complex and varied. With the wisdom of hindsight one sees it building up to a period of greatness, for within the hundred years 1750–1850 lived most of the painters upon whose reputation the fame of British art in general rests – in particular Reynolds and Gainsborough, Stubbs and Blake, Constable and Turner.

Some lesser figures herald this high period. Francis Hayman personifies the sheer diversity of British art at this time. Like Hogarth he was trained as an engraver and concerned himself with low-life scenes and conversation pieces. But he also tackled historical subjects, fancy pictures, sporting scenes, and painted theatrical backdrops, while his small portraits sometimes have naturalistic landscape backgrounds that anticipate the early work of Gainsborough, as do those of Arthur Devis. A more important portrait painter than either of these was the Scotsman Allan Ramsay, whose Italianate paintings in the Grand Manner anticipate Reynolds in much the way that Hayman and Devis anticipate Gainsborough.

The respective merits of the two great contemporaries, Joshua Reynolds and Thomas Gainsborough, tend to divide people. Homan Potterton has put it well: 'What is sensitivity in Gainsborough for one person may well smack of simpering when seen by another; and what is grandeur in Reynolds for that person could equally be interpreted as pretentiousness by the former.' One neat example of the difference between the two is their comments on the actress Mrs Siddons, whom they both painted. 'Here is my name,' pronounced Reynolds, 'for I have resolved to go down to posterity upon the hem of your garment.' Gainsborough, incapable of such pomposity, grumbled, 'Confound the nose, there's no end to it.' Reynolds saw her greatness and his glory in painting her, Gainsborough her features and the professional problems these set.

Reynolds was the first British portrait painter of stature to have lived and studied in Italy. He returned uplifted by Michelangelo and Titian, and with a high-minded determination to elevate British portraiture by investing his subjects with a sense of history. Reynolds was not particularly sensitive to dramatic

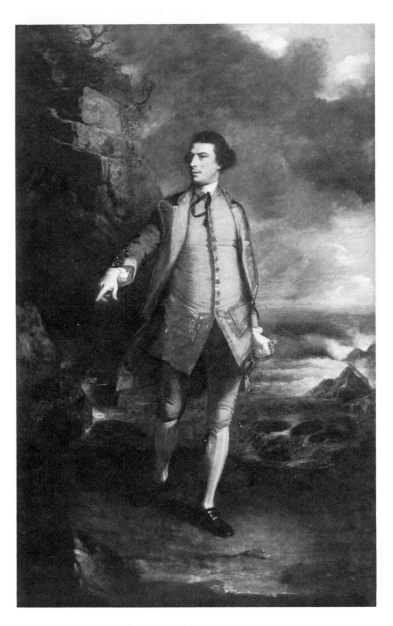

12. Sir Joshua Reynolds, *The Hon. Augustus (later Viscount) Keppel.* 1753–4. Oil. Greenwich, National Maritime Museum

and his right hand extended in some grand gesture of command. Reynolds has employed all his knowledge of Italian portraiture and of Dutch landscape and marine painting to put together something fresh in British art.

Reynolds became the most prestigious and the highest-paid portrait painter of his day. He worked indefatigably, painted everybody who was anybody, and employed a small army of assistants. If today his achievement looks less than is promised in the Keppel portrait, it is perhaps because this habit of delegating to workaday craftsmen seems symptomatic of a sacrifice of 'touch' to overall effect, of an insensitivity to the actual business of putting paint on canvas which today we have come to admire more than it was admired in the eighteenth century. Accordingly Reynolds' portraits look immensely impressive and often a bit dull – physically inert in a way that the most ludicrously frothy Gainsborough portrait never does. Reynolds' stature is more obvious than his genius. He was acknowledged by everyone in his day (except Blake) as the supreme master of his craft. In 1768, he became the first President of the Royal Academy he had worked so hard to establish as the showcase of British art. And his fifteen *Discourses* remain the most eloquent display of thinking by any British painter about his own profession.

Gainsborough was quite different. Where Reynolds set portraiture in the context of history, Gainsborough saw it in the context of landscape. He was not interested in history. Neither was he prepared to delegate to a team of assistants. For him painting was not the mechanical execution of a preconceived design; the actual painting of it was the thing – what Reynolds, not quite comprehending, called 'odd scratches and marks'. Gainsborough is that rarity in British art, a 'touch' painter: from the earthy stillness of the first portraits and landscapes to the feather-lightness of his later work, Gainsborough's handling of colour is always sensuous, and the elegance of his figures owes much to the portraits of Van Dyck and the *fêtes galantes* of Watteau. It seems fitting that Gainsborough was privately a musician, and Reynolds privately a scholar; fitting also – since both were generous spirits – that each should have admired the other.

There are surprising anomalies in Gainsborough. He repeatedly wrote and spoke of his dislike of portraits and his scorn for the rich who commissioned them: 'Well do serious people love froth,' he said. But he proceeded to gild the aristocracy with a glamour which none of his successors could match for naturalness, because among Gainsborough's

effect, but his somewhat prosaic natural gifts (compared to Gainsborough's) became formidable instruments in the service of some grand design. No more powerful portrait has been painted in this country than *Viscount Keppel* (Fig. 12), with which Reynolds forged his immense reputation in 1753. Keppel was the ship's commander who had taken Reynolds to Italy, and the artist painted him in personal gratitude. Against a stormy sea and sky and a wall of rock the admiral stands like a monument on the shore, his tunic matching the steely blue-green of the waves,

bountiful talents was the sharpest eye for a likeness in British painting. He professed to prefer landscape painting and yet increasingly as he grew more successful the landscape backgrounds to his portraits become an artificial Arcadia quite as unreal as those of his French contemporary Boucher who professed no interest in landscape whatever.

Gainsborough's earliest portraits, such as *Mr and Mrs Andrews*, painted in his native Suffolk, are solid and homespun accounts of minor gentry at ease among their acres. They have a fresh, honest look matching the freshness of the landscape around them, which is lovingly painted with a Dutch attention to natural detail and a moist northern light. In 1760 Gainsborough moved to Bath, and in 1774 to London. It was a journey up the social scale and further and further from his roots as a countryman. In the Andrews portrait the small prim figures pose self-consciously like dolls in a natural landscape. The contrast between this and 'high' Gainsborough portraits like *Countess Howe* (Fig. 13) or *The Hon. Mrs Graham* is enormous. Now Gainsborough is painter to the beautiful people. They are preposterously gorgeous in their froth of satins and jewellery, and no more belong to the landscape around them than a pekinese to a fox-hunt. These were the people who owned England and adorned England, and Gainsborough – with wit and affection and the sharpest of eyes – adorned them for posterity.

Of the portrait painters who followed Reynolds and Gainsborough most focused their sights on Reynolds, the more prestigious of the two. George Romney, like Reynolds, spent some time in Italy and affected a Grand Manner of history painting less suited to his talents than the fetching studies he made in plenty of Emma Hamilton. The Scots painter Henry Raeburn likewise went to Italy and became deeply influenced by Reynolds. So was John Hoppner; so was John Opie, a pedestrian artist whom Reynolds described as 'like Caravaggio, but finer'. And so was Thomas Lawrence, who succeeded Reynolds as Painter to the King. In terms of virtuosity and theatrical panache Lawrence outstripped all his predecessors, even Van Dyck, and this virtuosity earned him a European reputation unequalled by any British artist hitherto. His was a fame largely denied to another Reynolds follower, Benjamin Haydon, whose thwarted ambition to be a history painter steered him tragically to suicide. But then history painting was a genre more esteemed than liked in this country, and Haydon's predecessors, Gavin Hamilton and the American Benjamin West, had only succeeded in it through a coolness of approach that

evoked in British eyes the perfection of Raphael and Poussin. Indeed, the fashionable success of West, who succeeded Reynolds as President of the Royal Academy, is one of the more depressing chapters in the story of British art, and the first evidence we have of that peculiarly English fondness for story-telling in art, no matter how prosaic the telling. Fuseli dismissed West with the comment, 'He scarcely ever thought, and he hasn't any soul.'

The mid-eighteenth century also saw the emergence of British landscape painting. The gentry who were hanging portraits by Reynolds and Gainsborough in their country mansions were also commissioning Capability Brown to transform their gardens and parks into versions of the landscapes of Claude Lorraine. Accordingly there grew a demand, albeit a modest one, for landscape painting of a classical, Arcadian kind. At the same time the taste for Dutch painting was creating an equally modest vogue for the kind of bucolic and more natural landscapes which Gainsborough loved to paint. The master of the classical landscape style was Richard Wilson, who had worked in Italy and returned home

13. Thomas Gainsborough, *Mary, Countess Howe* Oil. *c.* 1763–4. London, Iveagh Bequest, Kenwood

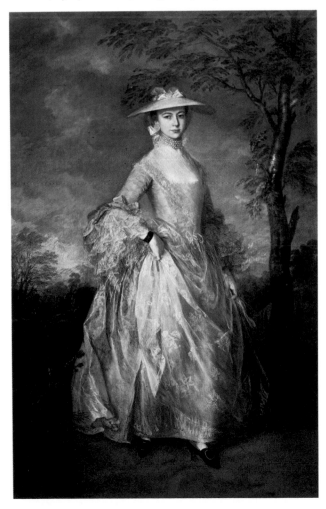

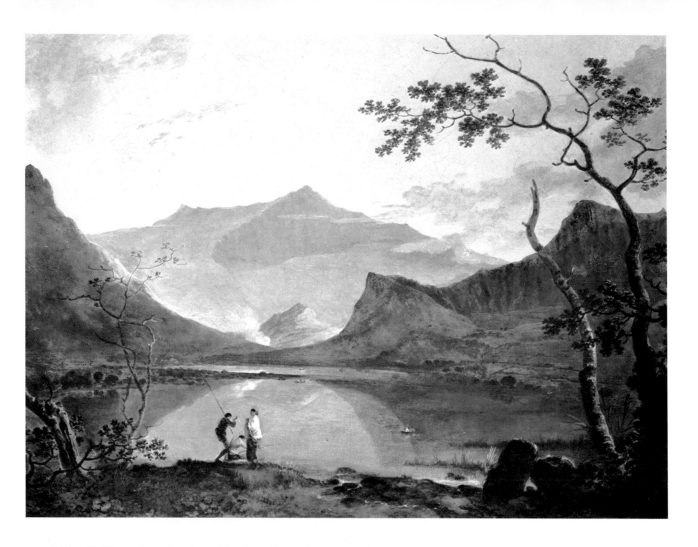

14. Richard Wilson, *Snowdon from Llyn Nantlle*. Early 1760s. Oil. Liverpool, Walker Art Gallery

with an idyllic vision of countryside which he proceeded to apply to the local scene, combining it with a freshness of response to the real countryside around him. In his Italianate views of England and Wales, Wilson gave his clients a version of their native landscape, embalmed in a golden stillness, which their classical tastes preferred to the more weatherbeaten reality. Even Mount Snowdon glows magnificently in an Italian light (Fig. 14).

Other Italianate visions of landscape had their impact, too. Salvator Rosa's melodramatic accounts of mountains and storms fired the emergent spirit of Romanticism in Britain as powerfully as Claude and Poussin inspired the Age of Reason. Sentiment replaced serenity. Philip de Loutherbourg, Julius Caesar Ibbetson, George Morland and James Ward were leading practitioners of this cult of wildness. The supreme examples, though, are the Alpine landscapes of a painter who was nearly a generation younger, J. M. W. Turner. Among Turner's remark-

able gifts was an ability to infuse landscape with so many different sentiments. He could respond to the awesome grandeur of nature in the 'sublime' manner of the Italian, Rosa; equally he could see it as classically beautiful through the eyes of the Frenchman, Claude Lorraine; and he could emphasize its pleasing 'picturesque' qualities as if he were the Dutchman, Jakob van Ruysdael. Ultimately Turner's personal vision grew from a fusion of all three.

But before coming to Turner, two major artists of the eighteenth century must be considered: George Stubbs, and Joseph Wright of Derby. They are two of the most unusual, and un-European, of British artists. Stubbs was Gainsborough's generation, and he did for horses what his contemporary did for their owners: he painted them as no one had ever painted them before. They were portraits of horses; but, more than that, they were studies based on a more familiar anatomical acquaintance with a living form than any artist had commanded since Leonardo. Stubbs dissec-

ted horses as Leonardo had dissected human beings, and with the same passionate scientific curiosity. Stubbs published his *Anatomy of the Horse* in 1766. Furthermore, he painted his subjects – often with their owners, like the wonderful *Melbourne and Milbanke Families* (Fig. 15) – not in the manner of a sporting artist, in which action is the thing, but as components of a sublime classical composition.

Wright of Derby also caught the prevailing passion for scientific inquiry. If he had had his way Wright would have become a fashionable portrait painter, but he possessed no remarkable talent for it nor the required panache; instead he spent most of his life in the unfashionable North Midlands, where he became familiar with a new breed of middle-class pragmatists who were beginning to push back the boundaries of applied science and give impetus to what became known as the Industrial Revolution. They were men like Newton, Arkwright, Wedgwood. Wright's employment of artificial lighting owes a lot to the example of Caravaggio and Honthorst, but the use to which he put these effects was new. Light here is no theatrical device, nor is it mystical revelation; it reveals the new wonders of science, whether it is

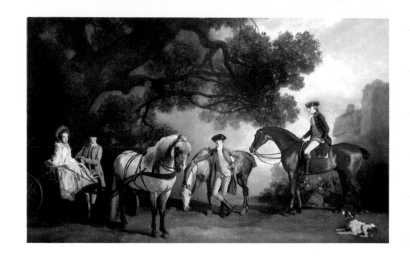

15. George Stubbs, *Lord and Lady Melbourne, Sir Ralph Milbanke and John Milbanke*. 1769–70. London, National Gallery

Arkwright's Cotton-Mill glowing in the moonlit darkness, *An Experiment with an Air-Pump*, or *A Philosopher Giving a Lecture on the Orrery* (Fig. 16). Light reveals and dramatizes the discoveries of new technology as well as the astonishment of those who witness them.

16. Joseph Wright of Derby, *A Philosopher Giving a Lecture on the Orrery*. 1766. Derby Art Gallery

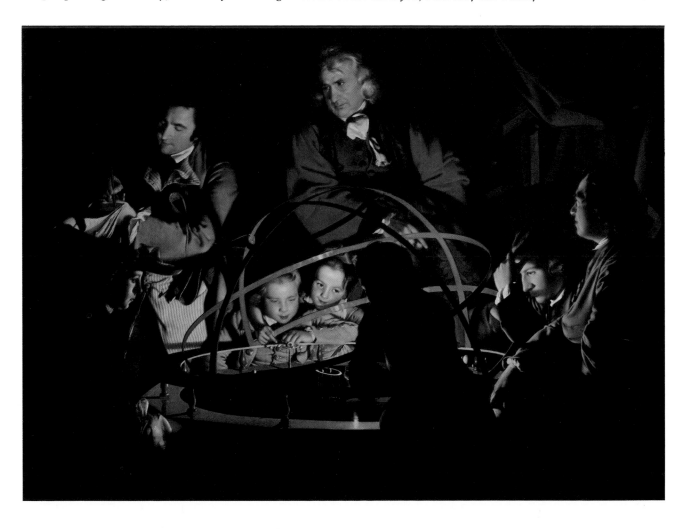

Painting and the Industrial Revolution

EDWIN MULLINS

BELOW 1. Joseph Wright of Derby, *Arkwright's Cotton Mill. c.* 1783. Oil. Private Collection

BOTTOM 2. Philippe Jacques de Loutherbourg, *Coalbrookdale by Night.* 1801. Oil. London, Science Museum

RIGHT 3. John Martin, *The Hollow Deep of Hell* (illustration to *Paradise Lost*). 1827. Mezzotint. London, British Museum

FAR RIGHT 4. J. M. W. Turner, *Rain, Steam and Speed – The Great Western Railway.* Exhibited 1844. Oil. London, National Gallery

THE Industrial Revolution occurred in Britain at the moment when artists were developing a taste for things awesome. In the last quarter of the eighteenth century British artists were opening their eyes to the theatrical wonders of nature: the Alps became more exciting than the landscape of the Roman Campagna, and cataracts more attractive than streams where milkmaids watered their herds. The wonderful manifestations of science and industry might have been created for this new species of imagination.

Industry, then, was seen at first as a fresh marvel of nature. Joseph Wright of Derby (1734–97) lived and worked in the midst of it. He was friends with several of the new men of science, among them Richard Arkwright, creator of the Spinning Jenny. Arkwright set up a water-powered cotton mill near Wright's home town, and in 1783 the artist painted it (Fig. 1) as a dramatic phenomenon picked out by the moon among picturesque crags.

The heart of this new industrial wonderland was Coalbrookdale. Here Abraham Darby had constructed a miracle of science, a single-span iron bridge (still standing) thrown across the romantic wooded valley of the Severn. Numerous painters travelled to Coalbrookdale, among them Wright's contemporary Philip de Loutherbourg (1740–1812); and being an artist who liked rearranging nature for powerful effect he too painted the scene by night (Fig. 2).

J. M. W. Turner (1775–1851) also travelled to Coalbrookdale and painted it, but then Turner travelled everywhere that was new. The energy of industry excited him. *Rain, Steam and Speed* (Fig. 4), one of his most celebrated accounts of light and atmosphere, is also the record of a

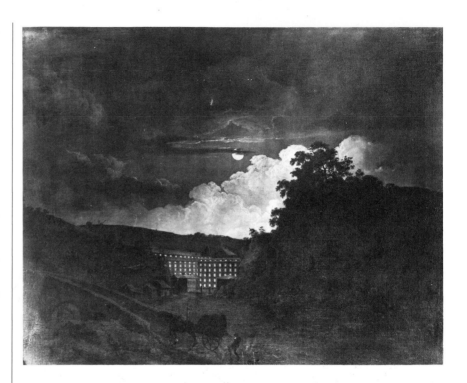

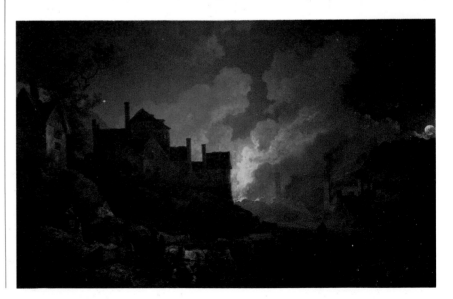

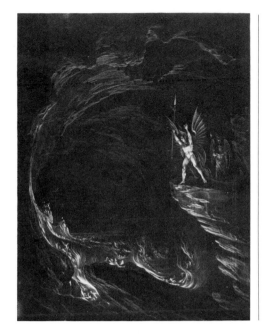

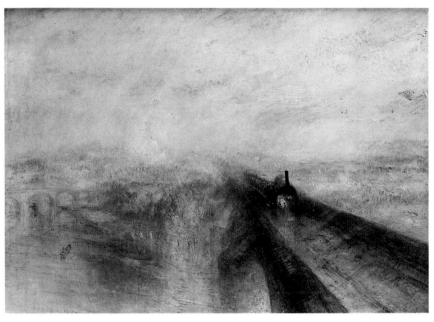

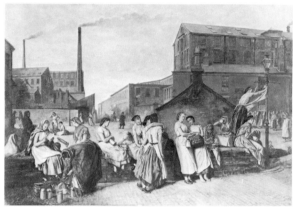

RIGHT 5. Eyre Crowe, *The Dinner Hour, Wigan.* 1874. Oil. Manchester, City Art Gallery

BELOW 6. L. S. Lowry, *Coming from the Mill.* 1930. Oil. Salford Art Gallery and Museum

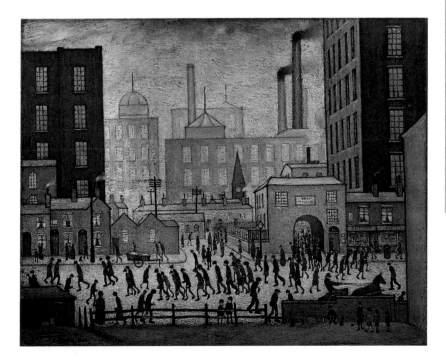

brand-new 'Firefly Class' train crossing Brunel's splendid bridge at Maidenhead, just opened for the Great Western Railway in the year Turner painted it, 1844.

There was a darker side to all this wonder. Mary Shelley's *Frankenstein* (1818) expressed the dread that science might destroy man, and this sense of foreboding was apocalyptically expressed by John Martin (1789–1854) in his illustration for Milton's *Paradise Lost* (Fig. 3), inspired by the tunnel Brunel was at that moment driving under the Thames.

Not until the late nineteenth century did the emphasis in painting begin to switch from the architecture of the Industrial Revolution to its effect on the proletariat enslaved by it. Victorian social artists could be masters of double-think, happy to expose gross poverty while glossing it with a pious work ethic. In this respect *The Dinner Hour* (Fig. 5) by Eyre Crowe (1824–1910) is a refreshingly unsentimental account of factory girls off-duty, as well as a surprising ancestor of the bleak industrial cityscapes of L. S. Lowry (1887–1976) in our own century (Fig. 6).

Turner also responded to the new technology, but in his case, it is *things* rather than people that excited him, things that were given an awesome life of their own by the invention of steam-power. The train in *Rain, Steam and Speed*, or the steamship in *Snow Storm*, are seen as part of the cauldron of natural forces in which they are set. As in all Turner's important work, people are either absent altogether or belittled by the forces they have unleashed; significantly the few pictures in which man does dominate are records of a pre-industrial world that seems peaceful and nostalgic by comparison – paintings of a blacksmith's shop or fishermen hauling in their nets. Turner in a tranquil mood is invariably responding to an old world, not the new: either it is the timeless classical vision of Claude or the deer-parks of feudal England – Petworth above all – untouchably permanent under golden skies.

The greatness of Turner lies in his power to reach out and touch so many worlds; generally they are the worlds man inhabits and encounters, rather than man himself. Few British artists have more fruitfully ignored Pope's dictum that 'the proper study of mankind is man'. Turner began as a recorder of scenes and places in the topographical watercolour tradition. His engraved series such as the *Picturesque Views of England and Wales*, and the *Great Rivers of France*, which secured his fame and livelihood, are part of an enormous corpus of documentation that Turner built up on his travels through Britain and the Continent. Watercolour was a medium he regarded as highly as oil, and it was his primary medium for experiment. His earliest studies are built up in careful brush-strokes; later he came to favour applying layer upon layer of colour washes, ultimately exploring the subtleties of watercolour to capture the most limpid effects of sunlight on clouds and on water. And it is these lyrical jottings, sometimes no more than smudges of colour in a sketch-book, that seem to have shown Turner how to achieve similar effects in the more robust medium of oil-paint, principally in those extraordinary late canvases on fire with light.

Light, natural forces, and myth – these are Turner's preoccupations. Light embalms or dramatizes the world he sees. Natural forces supply the primitive energy to create or destroy that world. Myth provides forms of human action upon which these forces bear. Gathering such preoccupations together and expressing them in paint was often a performance achieved only at the last possible minute. Turner's 'assaults' on the annual Varnishing Day at the Royal Academy are legendary: he would sometimes transform a canvas in a matter of hours, squeezing colour direct from the tube, stroking it across the surface with a palette knife, smudging it away with an oily rag, or moulding and cutting into it with his fingers and his thumbnail, shaped like an eagle's claw for the purpose.

Technically so 'modern', Turner nonetheless held the already old-fashioned view that art should express themes that were sublime and heroic – the epic quality in life. A large body of his work is devoted to the themes of history and myth which best displayed that epic quality and which were rated most highly by prevailing canons of taste. What Turner added of his own was the discovery of an epic quality in nature itself. Storms, raging seas, mountain scenery, above all the sun – these natural elements could in themselves be sublime and heroic. Turner removed epic painting from the private possession of those with a classical education, and gave it to everyone.

Compared to Turner, John Constable saw the world narrowly. He had no interest in locating the epic quality in nature; he loved nature for itself, in its infinite variety of smallness. His range of motifs looks limited compared to that of his great contemporary because he preferred to explore the multiplicity of subtle change in the natural world about him. 'Nature is simple, plain and true in all her works,' he wrote. Constable travelled, but he had none of Turner's burning need to travel; he could have completed the most substantial part of his life's work without making more than a day's ride from his native Suffolk village of East Bergholt. Turner was a townsman, and he responded to the English countryside as he responded to everything he witnessed – with an inner fire of the imagination. Constable on the other hand, like Gainsborough, *was* a countryman, and his response to landscape was one of love born of long acquaintance and a profound sense of belonging. If Constable is the favourite painter of the British it is because he has expressed better than anyone that warm intimacy with a known patch of land which the British seem to feel so deeply, and which still finds daily expression in the cult of the back-garden. The quality of feeling in an oil-sketch like *Barges on the Stour* (Fig. 17) is not simply that of a view perceived and recorded on an artist's travels; the vigour of Constable's brush-work is an expression of sheer joy at painting a scene he has known all his thirty-five years – barges carrying corn from Flatford Mill (which his father owned) to the wharf nearby where they would pick up coal and make the return journey through the lock-gates, while across the River Stour and the water-meadows rises the church-tower of the neighbouring village of Dedham, to which the artist had walked daily to school as a

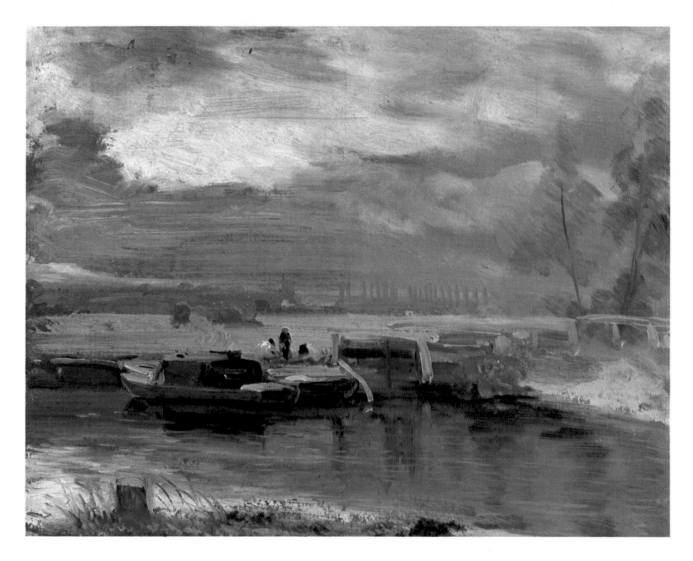

17. John Constable, *Barges on the Stour at Flatford Lock. c.* 1810–12. Oil. London, Victoria and Albert Museum

boy. Constable's paintings are enriched by such local sentiments and youthful memories just as are the *Lyrical Ballads* of his contemporary, Wordsworth.

Some of this freshness became lost in the carefully finished paintings he prepared for public exhibition during his struggle for recognition by the Royal Academy, which still regarded landscape painting as a lowly form of art compared to history painting and portraiture. Constable's quiet rivers sound none of the heroic overtones of Turner's raging seas, and it is impossible to imagine Turner writing, as Constable did (to his friend and patron the Reverend John Fisher), 'Old rotten banks, slimy posts, and brickwork. I love such things.' To Constable, art was about ordinary things deeply felt.

It is his technique which makes Constable look so modern; his love of the paint-surface, those rapid flecks and spots of surprising colour, that pie-crust of floury white giving off the sparkle of the sun on tiny plants and blades of water. His British contemporaries found this technique crude and sketchy, and it was left to the French, Delacroix in particular, to perceive the genius in him when *The Hay Wain* was exhibited at the Paris Salon of 1824 and won a Gold Medal. Constable's direct influence on French nineteenth-century painting has been exaggerated, as indeed has Turner's; nonetheless, it was the French painters Boudin, Daubigny, Courbet, Manet and the Impressionists who explored the vistas of open-air painting which Constable had opened up. In this country he had no worthy heirs, and neither for that matter did Turner.

The most important shift of all in the nature of British art was this change from portraiture to landscape. In the early eighteenth century Jonathan Richardson could state that landscape could 'excite no Noble Sentiments' with little fear of being contradicted. Less than a hundred and fifty years later the most influential critic of his day, John Ruskin, could write of the innate spiritual content of the natural world and be contradicted only by those who refused to move with the times.

Popular credit for this change tends to go to the great landscape painters, Constable and Turner. Nonetheless, a crowd of lesser artists was just as responsible – the professional watercolourists. The medium of watercolour was the ideal vehicle for expressing a response to English countryside in all its fickle subtleties of light. A liquid medium, it conveyed the natural moistness of landscape better than oilpaint. Watercolour looks moist even when it is dry, just as our landscape does. It is also a medium that lends itself to technical virtuosity. The earliest watercolourists, such as Paul Sandby and Francis Towne, employed watercolour to apply washes to topographical drawing. But under the influence of the drawing master Alexander Cozens, who evolved a 'blot' system and set out a 'New Method of Assisting the Invention in Drawing Original Compositions of Landscape', younger artists like his son J. R. Cozens, Thomas Girtin, and John 'Warwick' Smith began to use the medium more freely for its own sake,

18. Henry Fuseli, *The Nightmare*. 1781. Oil. Frankfurt, Goethe Museum

employing coloured and textured paper to add poetic effect. The East Anglian painters were especially prolific in watercolour, and the geographical similarity of East Anglia to Holland may have contributed to the empathy they all felt towards Dutch landscape artists of the seventeenth century, particularly Van Ruysdael and Hobbema. The key figure here is John Crome, who founded the Norwich Society in his house in 1803 and whose followers included one of the finest masters of British watercolour painting – J. S. Cotman. Other watercolourists who flourished at this period, the first half of the nineteenth century, included Peter de Wint (who worked in the Lincolnshire fen-country), David Cox (in Wales), James Holland, William Callow, and two artists who worked mainly on the Continent, Thomas Shotter Boys and the more talented Richard Bonington, a friend of the French painter Delacroix.

Much British art of the years 1750 to 1850 is a child of the Age of Reason – confident, objective, concerned with observable facts about man and his environment. But there is also a powerful undercurrent of a quite different temper, little concerned with reason and lodged deeply in the subconscious. This is not so much Romantic art (of which Turner – or one part of him – is a more obvious progenitor) as a new kind of visionary history painting. And the three chief painters of this genre are Fuseli, Blake and Palmer.

Henry Fuseli, the eldest of the three (born in 1741), was a Swiss. He became an ordained priest, then assumed the profession of artist under the influence of Reynolds whom he met in 1768. Fuseli's subject-matter was largely literary – Homer, Dante, Shakespeare, Milton, German myths, and the Bible. His style owed a cumbersome debt to Michelangelo whose work he knew well as a result of eight years spent in Rome. But it is the treatment of his subjects that marks him out as a remarkable forerunner of twentieth-century psychological painting. 'The most unexplored region of art is dreams,' Fuseli wrote. 'The engines in Fuseli's Mind are Blasphemy, lechery and blood,' said his follower Haydon. *The Nightmare*, which Fuseli exhibited at the Royal Academy in 1781, is a disturbing sexual fantasy in which we, the spectators, become voyeurs of the sleeping girl's terrors (Fig. 18).

Six years later Fuseli met and soon befriended William Blake, sixteen years his junior and an artist who shared Fuseli's love of literature and his fascination for the power of dreams, as well as his deep respect for Michelangelo. But where the older artist could claim direct acquaintance with Michelangelo's work in Rome, Blake's authority was the Archangel

Gabriel, who revealed Michelangelo to him in a vision. In fact the neo-classicism of Blake's own figures is rooted not in High Renaissance Italy so much as in the bloodless drawings of his own contemporary, the sculptor John Flaxman. With Blake muscular anatomy is invariably subservient to flowing line: his people writhe, dance and gesticulate as if in a trance. The world they inhabit is an intense and private one. They mime Blake's ideas, thoughts and visions of man and the universe, seen always as a complex mythology of allegorical figures. This mythology is exclusive to himself and not at all easy to comprehend, and it found its purest expression in a sequence of fifteen illuminated books hand-written, hand-engraved and hand-coloured in the medieval tradition. Some of these illustrate the Bible, some the poetry of Virgil, Dante, Milton, Young, and Gray, while the most ambitious illustrate his own poetry, lyrical and epic. If a great deal of Blake's writings reads like an elaborate essay in mystification, pictorially these illuminated books are among the most glorious imaginative achievements in British art.

Nineteen-year-old Samuel Palmer visited the elderly Blake in 1824, and wrote of the scene as 'a kind of vision' and of Blake's spartan house as 'the chariot of fire'. The prophet and painter sat there, he said, in 'primitive grandeur'. The encounter fired Palmer with an exultant confirmation of his own visionary powers as an artist, and for a few youthful years in the village of Shoreham in Kent he produced small, glowing landscapes evocative of a pastoral paradise. Nature is ripe and fecund. Trees, houses, churches, plants, animals, and man share the beneficence of a kindly God under an apocalyptic sun.

But the bright vision dimmed. Palmer's decline into Victorian sentimentality symbolizes a decline of British art generally. While modernism was stirring in Europe, the second half of the nineteenth century remained a time of prosaic conservatism in England. Artists gained fortunes and knighthoods, but they were never more insular. It is puzzling that at the very moment when the English novel was rising to a peak, painting should be sinking into such ordinariness. This was the half-century when that bravest of French art-dealers, Durand-Ruel, gave up trying to interest the British in Impressionism, and the National Gallery refused the gift of a Degas!

The bright stars of the second half of the nineteenth century are the painters on the fringe. There was 'Mad' Martin, whose operatic imagination romanticized Turner rather as Palmer romanticized Blake. There was Francis Danby, whose sexy pastorals at sunset titillated the fantasies of the new

19. J. F. Lewis, *The Hhareem*. 1850. Watercolour. London, Victoria and Albert Museum

industrial barons. There was Richard Dadd, who murdered his father and passed the rest of his life in Bedlam and Broadmoor creating 'fairy' pictures in watercolour that resemble Bosch reincarnated into Victorian children's book illustrations. And there were those amazing artist-travellers who satisfied the empire-building taste for remote places with careful records of exotic scenery, architecture and social customs – David Wilkie in Palestine, Edward Lear throughout the Middle East and India, David Roberts, William Müller and J. F. Lewis in Egypt. Lewis even lived the life of a pasha in Cairo for ten years (Fig. 19), and Roberts plodded through Sinai and Nubia in full Arab dress accompanied by twenty-one camels, sketching ancient sites. They were the artist-forerunners of Burton and Speke, Lawrence and Thesiger.

Then there were the stay-at-home Victorians: William Etty, that addict of the Royal Academy life-class, whose Titianesque nudes stroked the Victorians' private fondness for the prurient while ruffling their public sense of propriety; G. F. Watts, who laboured to revive the Italian High Renaissance in the Home Counties; William Frith, whose panoramas of daily life contented Queen Victoria almost as warmly as the 'doggy' portraits of Edwin Landseer; and, besides these, a parade of whiskered academicians – Frederick Leighton, Edward Poynter, William Orchardson, Lawrence Alma-Tadema, and the rest of them – who grew locally famous and beribboned with titles, satisfying the wealthiest society in the world that true art lay here in Britain and that all

those foreigners playing with new ideas like Impressionism had got it quite wrong.

These were the wilderness years – with the exception of a handful of young men who found an unexpected oasis in which nature flourished with a new and wonderful brightness. They were the Pre-Raphaelites. Three young painters – William Holman Hunt, D.G. Rossetti and John Millais – came together in 1848 to form a society which they called the Pre-Raphaelite Brotherhood. The choice of title reflected a shared belief that the fountain of European art had become muddied since Raphael, and that painting must now reacquaint itself with the spirituality and jewel-like naturalism of art as it existed in medieval times and in the hands of early Renaissance artists such as Van Eyck, Botticelli, and the painters of the great Italian fresco cycles. In practice this meant an emphasis on sharply-drawn outlines, on naturalistic details, and on historical and religious themes weighty with moral significance. It also meant compositions taken straight from life as observed and hence an equal emphasis on contemporary subjects that were natural and unposed. Their historical and literary themes tend to look as fresh as those from life: Millais' *Ophelia* (Fig. 21), for

20. William Holman Hunt, *Our English Coasts*. 1852. Oil. London, Tate Gallery

instance, floating to her death, occupies as natural-looking a world as Holman Hunt's sheep in *Our English Coasts* (Fig. 20). If anything, Hunt's sheep looks more staged.

Of the Pre-Raphaelites, Millais was the most naturally talented, as well as the most naturally lightweight. His historical and mythological subjects

21. John Everett Millais, *Ophelia*. 1851–2. Oil. London, Tate Gallery

22. Ford Madox Brown, *Walton-on-the-Naze*. 1859–60. Oil. Birmingham Museums and Art Gallery

are wonderfully executed, but peeping through his figures, particularly his young women, is a wide-eyed sweetness that already announces his intention to pursue a fashionable Victorian career. Hunt, by contrast, looks workaday and uncomfortably humourless; nonetheless it was Hunt who stuck with Pre-Raphaelitism to the end, his Protestant conscience pinned brightly to his painter's smock. As the painter of *The Awakening Conscience*, *The Light of the World* and *The Hireling Shepherd*, it is Hunt who now seems the most redoubtably Victorian of the Brotherhood. The most mercurial was Rossetti. Like Blake, he was also a poet and a devotee of medieval manuscripts. And like Blake he was concerned with inner realities, not with the objective world. Rossetti was primarily a love painter, one of the few this country has produced, and in his best work there is an intensity which none of his fellow Pre-Raphaelites could match.

The slightly older Ford Madox Brown never joined the Brotherhood but was strongly influenced by

them. His most successful paintings are not the ones most readily associated with him (heavily moralizing pictures like *Work*, or the intensely meaningful *Last of England*), but bright idyllic landscapes such as *Walton-on-the-Naze* (Fig. 22) and *An English Autumn Afternoon*, where the spirit of Gainsborough and Constable has been given a garden-party freshness, and the figures who relax in the sunshine in intimate groups take their place in the landscape as naturally and elegantly as the figures of Watteau.

Among other artists on the fringe of the Brotherhood the most prolific was Edward Burne-Jones. He was a friend of Rossetti, a designer of tapestries and quantities of stained glass for Victorian Gothic churches; as a painter he was a devotee of Botticelli whose mythological compositions inspired a host of finely-drawn allegorical paintings permeated with an air of rather limp sexuality. The American painter James Whistler was another friend of Rossetti. Like Burne-Jones, he forms a link between the Brother-

37

hood of the mid-nineteenth century and the Symbolist and Aesthetic movements of the seventies and eighties. The tonal compositions of Whistler, in particular his *Nocturnes*, brought the faintest echoes of French Impressionism into painting in this country; while his passion for recently-discovered Japanese art introduced a new exoticism into British art, a quality soon to be exploited by the much younger Aubrey Beardsley. Beardsley was primarily a draughtsman, and a brilliant one. His fame spread throughout Europe with the publication of *The Yellow Book* and his illustrations to Oscar Wilde's *Salome*. Beardsley's importance as a progenitor of Art Nouveau makes him one of the very few British artists of the last hundred years to have occupied a position in the vanguard of an international movement.

Artistically the weakness of the Victorian era in general was its self-confident insularity. Britain turned her back on Europe and cultivated her impe-

23. Walter Sickert, *Ennui. c.* 1914. Oil. London, Tate Gallery

rial back-garden. Yet this insularity was also a certain strength: British art may have seemed archaic looked at from Paris, but at least it was massively self-assured. With the early twentieth century and the death of Queen Victoria, this self-assurance began to crumble. A new era began in which British artists engaged in a series of uneasy scrambles to catch up with events on the Continent.

Because they had so much catching up to do, the scrambles came thick and fast. The Impressionists had made no impact to speak of when Durand-Ruel showed them in Bond Street back in 1870 (even though Monet and Pissarro were working in London at the time), and little more when they were shown intermittently during the eighties. It was 1905 before modern French landscape painting began to make a lasting impact over here, when Durand-Ruel again showed Impressionism in London at the Grafton Galleries. By this time Pissarro's son Lucien, now resident in England, had become a torch-bearer for modernism, along with Sickert who had just returned after seven years in France, and a handful of painters who formed what became known as the Fitzroy Street Group. By this time Impressionism in France had long come and gone, Post- and Neo-Impressionism had likewise run their course, Fauvism was already emerging and in a very few years Cubism would launch itself upon the international art world. In less than a decade between 1905 and the outbreak of the First World War British taste, lulled by decades of Victorianism, was battered by wave after wave of continental 'outrages'. Durand-Ruel's Impressionist exhibition of 1905 was followed five years later by Roger Fry's famous 'Manet and the Post-Impressionists' exhibition. In 1912 came Fry's second show, which centred on Cézanne, and by this time the young Wyndham Lewis had begun to paint the first pictures that announced the impact of Cubism in Britain. The even more violent impact of Italian Futurism followed shortly, and with an enthusiastic amalgamation of the two Lewis marched the British avant-garde into the spirit of the first mechanized war in history. Lewis's Vorticism made its rude assault on British eyes under the banner of the magazine 'Blast'.

A few reputations survive from this period. Walter Sickert, with his sombre-toned Impressionism applied to racy nudes, dingy interiors, and London scenes of taverns and music-halls, remains the most talented British artist of his time (Fig. 23). His contemporary, Philip Wilson Steer, managed a small number of truly fresh open-air studies painted on the Suffolk coast. The American-born John Sargent, a friend of Monet, took time off from society portrait

painting to leave us some colourful Impressionist landscapes. Brangwyn covered acres of wall-space with muddy figures that won him surprising fame for a short time. The impact (almost simultaneous) of Seurat, Gauguin, Van Gogh and Matisse threw up a collection of lesser artists calling themselves the Camden Town Group, the most imaginative of whom was Harold Gilman and the most eye-catching Augustus John. Gwen John, Augustus's sister, as retiring as he was flamboyant, went to live rather gloomily in Paris where she produced small interiors and figure-studies as sensitive as anything painted in England apart from by Sickert. Another isolated painter more or less permanently resident in France until the Second World War was Matthew Smith, heavily under the influence of Matisse and among the richest colourists this country has produced (Fig. 25). A third lonely figure who emerged during this period was the Irish painter Jack Yeats, brother of W.B. Yeats the poet, whose lively romantic scenes often based on literature and Irish legend caught the wind of Expressionism in a manner no other artist from these islands achieved this century. Finally, among the painters in the circle of Wyndham Lewis during the First World War, William Roberts, Edward Wadsworth, and David Bomberg (Fig. 24) each contributed to the collective dynamic style of Vorticism, only to go their separate ways during the postwar years.

Often in this century British art has seemed to be striving either to find its independence or to lose it: alternately throwing a lifeline to America and Europe and gratefully casting adrift. Is British art British or is it international? Increasingly this becomes the question as the century advances. For the first decade and a half young painters strove to be continentals – French in particular. That urge to make up time lost its momentum in the mud of the First World War, and was followed by a return to contented insularity in the twenties. Admittedly, the pace of Europe slowed too. The twenties generally was a time of artistic retrenchment – until the rise of Surrealism. In Britain the interval lasted rather longer because Surrealism made no early impact here.

Insularity returned in the twenties, but individuality returned too. Several of the most inimitable British painters of this century took their first confident steps during this supposedly fallow period, drawing strength from the absence of pressure to 'be like the French'. They were painters like Ben Nicholson, Paul Nash, Stanley Spencer, Ivon Hitchens, Edward Burra, David Jones, Christopher Wood, Alfred Wallis – a remarkable octet for any single

24. David Bomberg, *In the Hold*. 1913–14. Oil. London, Tate Gallery

25. Matthew Smith, *Nude, Fitzroy Street, No. 1*. 1916. Oil. London, Tate Gallery

26. Ben Nicholson, *November 11 1947 (Mousehole)*. 1947. Oil and pencil. London, British Council

a bit of a maverick, veering between post-Cubist still lifes, Mondrian-like abstraction, and artless-looking landscapes displaying a love and respect for 'le Douanier' Rousseau and the fisherman-painter Wallis. Nicholson flits like a shadow in and out among the major innovatory artists of our century, never perhaps quite one himself yet always probing and revaluing their works, and in that minor key of his applying a wonderful sensibility to their vision, always with that subtlest response to light and an absolute assurance of line (Fig. 26). Something of the same is true of Paul Nash, who died much younger but achieved a comparable blend of a very English and mystical love of landscape with a consciousness of contemporary art currents abroad, in his case Surrealism. Burra, too, attaches himself to Surrealism, though again in an idiosyncratic way, always his own man, with an acid view of low life as well as a grand vision of landscape for which he is still insufficiently credited. The most idiosyncratic of the eight painters just mentioned was Stanley Spencer: another dreamer, with an earthbound Christian vision of his native Cookham, where hefty villagers enact a masque of Christ's Passion and Resurrection in a landscape of eternal summer (Fig. 27). Palmer's Shoreham was Spencer's Cookham.

decade (and the more remarkable considering that this was also the moment when British sculpture under Epstein, Moore and Hepworth was being reborn). Nicholson's achievement of course spans much of the century since he died in 1982, at the age of eighty-eight. In international terms he has seemed

27. Stanley Spencer, *Resurrection, Cookham*. 1923–6. Oil. London, Tate Gallery

The thirties seems like a decade of more intense activity than the twenties partly because it was more perceptively written about at the time (by Herbert Read above all), but more particularly because painters endlessly got together in groups, issuing manifestos, exhibiting together and thereby achieving a sharper group identity. The 7 and 5, Unit One, Art Now, Axis, Circle, the Euston Road School: one group followed hard on the heels of another, each representing a renewed response to events on the Continent, to abstraction on the one hand and Surrealism on the other. Then towards the end of the decade an influx of (mainly) Jewish artists fleeing Hitler cemented those bonds with European art for a brief ecstatic period before most of them crossed over to America, leaving Britain – suddenly – as isolated as it had ever been. Only this time it was not twenty-two miles of English Channel separating us from the heart of things but three thousand miles of the Atlantic Ocean. In the eighteenth century any young painter who wanted to drink at the spring journeyed to Rome; in the nineteenth and early twentieth centuries it was Paris; from now onwards it would be New York.

Meanwhile yet another period of isolation set in. The Second World War closed Britain off. As with the twenties, it is customary to play down artistic achievements made at this time of insularity, internationalism having acquired cult status. The forties, though, were not lean years. Sutherland had tapped a rich vein of landscape in Pembrokeshire, and the War Artists' scheme produced at least two major achievements – the shelter drawings of Moore and the daydream panoramas of Paul Nash, of which his vision of wrecked German aircraft, *Totes Meer*, is justly the most famous (Fig. 28).

The wartime flight from London and the bombing did lead to one important post-war centre of activity far from the capital, and that was St Ives, in Cornwall. The fisherman-painter Alfred Wallis lived on there until 1942. Nicholson, who respected Wallis deeply, became the central figure of the St Ives School during the forties and fifties, and around him flourished a younger generation of abstract and semi-abstract painters who likewise drew their inspiration from local landscape – in particular Peter Lanyon, Roger Hilton, Bryan Wynter, Terry Frost and Patrick Heron. In London, on the other hand, the most interesting work was still being done by painters more or less isolated from each other. Francis Bacon was beginning his claustrophobic studies of human pain, direct assaults on the spectator's nervous system, which he sometimes weighted with savage

28. Paul Nash, *Totes Meer*. 1940–1. Oil. London, Tate Gallery

29. Francis Bacon, *Study after Velázquez' Portrait of Pope Innocent X*. 1953. Oil. New York, Collection of Mr and Mrs William A. M. Burden

30. Victor Pasmore, *Yellow Abstract*. 1959. Oil.
London, Tate Gallery

references to Grünewald, to the Russian film director Eisenstein, to the pioneer photographer Muybridge, and most sensationally to Velázquez in his celebrated *Study after Velázquez' Pope Innocent X* (Fig. 29). Lucien Freud was another lone eye; his intense, baleful portraits and figure studies gave flesh a reptilian coldness and the human spirit a neurotic bleakness. A different bleakness – a mocking cynicism – suffused the human anthills of the Manchester

painter L. S. Lowry, another in the long line of British 'loners'.

Of the artists whose work reflected currents of art beyond these shores, William Scott was the one British painter of this immediate post-war era to apply a vision of his own to the French Cubist tradition of still life; and Victor Pasmore, who swung from Post-Impressionist landscapes towards pure abstraction in the late forties, began an exploration of how the experience of our surroundings can be distilled into shapes and colours and textures. Never cerebral or formula-bound, Pasmore's art has a knack of making abstraction a perfectly natural and satisfying way of pin-pointing sensations of being and seeing in a modern world (Fig. 30).

By the end of the fifties this cell-like quality of British painting had once again changed, and another era of frenzied group activity took over, just as it had in the thirties. The impact of post-war American painting – huge, splashy, confident, uncompromisingly abstract – was dynamic, and a new generation of British painters hurled itself into the vortex. In 1960 John Hoyland, Robyn Denny, Richard Smith and Bernard Cohen came together under the banner of 'Situation': pictures had to be large – aggressively so by English standards – and without the slightest allusion to nature. If there were few walls large enough to hang them on, then there were always museums, and the sixties saw a rebirth of the idea of 'public' pictures that was as fervent and overblown as the eighteenth-century promotion of history paintings had been. Smith remains the most lyrical and inventive of this original group, stretching the conventional boundaries of painting to include curved and three-dimensional surfaces and even suspended forms evocative of enormous kites (Fig. 31).

31. Richard Smith, *Diary*. 1975. Acrylic on canvas. Private Collection

32. David Hockney, *Rocky Mountains and Tired Indians*. 1965. Acrylic. Amsterdam, Peter Stuyvesant Foundation

Smith was also the link with another splashy movement of the sixties, likewise linked to the American scene, Pop Art. Some of Smith's three-dimensional paintings suggested commercial packages: his was little more than a flirtation with the world of advertisements, comic-strips, mass-media images and urban artefacts, but now the best part of an entire generation of British artists embraced that world. Pop Art was bright, brash, sexy, and an altogether refreshing antidote to the angst-ridden solemnity that had hung over so much British post-war art. It was also ingenuously boyish in its adulation of some of the more surface aspects of American life, the world of the freeway, the amusement arcade and hard-sell commercialism. British Pop artists, however, contributed a sophisticated touch which gave their work an edge over many of their transatlantic counterparts: they were witty. And the wittiest of them was David Hockney (Fig. 32). He, along with Peter Blake, Derek Boshier, Allen Jones, Peter Phillips, Patrick Caulfield – and the rather older Richard Hamilton, Eduardo Paolozzi and the American-born R. B. Kitaj – found themselves carrying this country into the vanguard of an international art movement for the first time this century.

One other major international painting movement swept through Britain during the later sixties – 'Op' Art. At its crudest this is geometrical pattern-making designed to produce the illusion of shimmer or movement, about as imaginative as an optician's test-card. But among the battalions of 'Op' artists who flourished briefly during this period one painter emerged with a perception of how such optical tricks could be used to explore and codify our psychic perception of colour and movement in the world about us – Bridget Riley (Fig. 33). Her paintings, invariably serene and graceful rather than painful on the eye, extend intelligent roots back to the pointillism of Seurat and beyond that to the mathematically-ordered figure compositions of Piero della Francesca.

The direction of British art since the late 1960s is harder to chart, and to a great extent this is because definitions of what constitutes a picture are no longer clear. In the late sixties painters were still recognizably painters: they made pictures which went on walls, even if those pictures sometimes bulged and the walls needed to be inordinately large. But by the seventies and eighties the very term 'painter' had begun to sound old-fashioned. Several of the more interesting painters of the present day even adopt quite intentionally an old-fashioned stance – Peter

33. Bridget Riley, *Crest*. 1964. Emulsion.
London, British Council

Blake, Bill Jacklin, Tom Phillips. Even New Realism does not look so very new, only newly assertive. Some of the best 'paintings' being done in the eighties are being produced not by the avant-garde at all but by the old guard: Pasmore, Heron, Bacon, Frank Auerbach, Caulfield, Riley, Richard Smith, Michael Andrews.

To many others the term 'painter' no longer strictly applies. When Conceptual Art arrived to intrigue, or bore, the art world in the late sixties, the emphasis shifted from art as an activity to art as an idea. Art became the record of a thought-process, and that record might be written, or photographic, or it might be an object selected for special significance, but it was rarely a painting. The personal relationship to landscape, which recurs in British painting from Gainsborough and Wilson to Constable and Turner, Palmer, Madox Brown, Paul Nash, Spencer, Burra and Sutherland, is most deeply felt today either in the photographic records assembled by artists such as Richard Long, or in the work of painters who have turned their back on modernism, like the Ruralists.

It is the age of mixed-media art, in which painting spills over into sculpture, into crafts, into advertising and consumer goods, on to billboards and buildings, postcards, nature itself – life itself. Two of the most talked-about British artists of our time, Gilbert and George, have made their daily life their daily art. Their dedication to this end sounds a curious echo of the great Victorian artist-critic John Ruskin, who also believed life should be a work of art; even an echo of Oscar Wilde, of Whistler and the nineteenth-century Aesthetic Movement. Had this chapter been written in the 1880s, not the 1980s, it is quite likely that then, too, painting as we have known it might have seemed to be nearing an end. And yet the painting of the century following was to dazzle our eyes and stir our brains more challengingly than that of any century preceding it. Maybe a lesson of hope lies here.

34. Tom Phillips, *Oh Miss South Africa '75*. 1975. Acrylic gouache. Private Collection

2

Photography

JOHN TAYLOR

PHOTOGRAPHY was invented simultaneously in the two most industrialized and powerful nations in the world. In France in 1839 L. J. M. Daguerre (1787–1851) succeeded in making direct positives upon polished silver which afforded a view of minute detail and startling definition. Science seemed again to have enhanced everyone's capacity for gathering facts. In Britain, these facts could be duplicated after 1839, when W. H. Fox Talbot (1800–77) invented the calotype, a two-stage process of photography involving both negative and positive images.

From the outset the success of photography was assured: it promised to gather up all the objects of the world, and so served an insatiable appetite for both fact and novelty. Gathering facts and artefacts was a matter of national prestige which could not be left to the libraries and the museums. The international exhibitions in London (1851) and Paris (1855) brought to light quantities of objects and art works that had never been seen by so many people. The railways enabled people to travel long distances and to see a large number of sites and monuments. Steamships made it easier to appropriate the world beyond Europe. The photograph met the demand for facts that could be listed in a huge inventory of the world's treasures. It was a scientific analogue to the belief that the world could be understood in terms of its appearance. The world was made for mankind, and photographs indicated the fruits of Positivism, enterprise and an expanding Empire.

Art suddenly became photography. From the 1850s, paintings, engravings, and sculptures were copied extensively. In the 1870s, this activity was given a new impetus with the introduction of the Woodburytype, invented by Walter B. Woodbury (1834–85). This was a cheap process, and offered exceptionally sharp reproduction. It brought Fine Art to a large audience in such publications as *The Picture Gallery of British Art* (1872).

But some photographers were themselves ambitious to be artists. The daguerrotype was unsuitable for artistic interpretation: there was too much detail, and no room for selection. The image of the calotype, however, was softer and allowed for interpretative possibilities. It immediately attracted photographers as artists. There still remained the need to identify the realm and role of Art, and to instil these qualities into photographic realism.

In spite of technical deficiencies, photographs were nevertheless regarded as truer to life than any painting style; but in Art, truth to life was less significant than truth to Beauty. In French painting, Realism was an aberrant style and attitude of mind which avoided Beauty and sought to promote ignoble subject matter and bad drawing as High Art. In Britain, photographic realism, which dealt easily with mundane facts, had somehow to be allied to the Beautiful and noble Art of Reynolds. By the 1850s, the wild Romantic imagination of the turn of the century had been tempered by the older eighteenth-century virtues of decorum. It was the Pre-Raphaelites who showed how a zeal for materiality could be combined with moralizing and didactics on themes of love and death. These developments were important for photographic artists, who wished to use photographic realism to serve the ideals of Art. They were not attracted by the seeming neutrality and harsh reality of photographs, since these qualities were undesirable in Art. Record work, and stereoscopes, lacked beautiful sentiment. Photography could only become Art if its images came close to the appearance and preoccupation of established genres in painting. Hence, in 1857, Oscar Reijlander (1813–75) achieved a *succès de scandale* with his *Two Ways of Life* (Fig. 35). He used over thirty negatives to illustrate Virtue and Temptation. This elevated moral purpose was both enlivened and endangered by the use of naked women.

Decorum was always observed by the most influential art photographer of the period, H. P. Robinson (1830–1901). He specialized in constructing scenes

46

35. Oscar Reijlander, *The Two Ways of Life*. 1857. Carbon print. London, Royal Photographic Society Collection

36. H. P. Robinson, *When the Day's Work is Done*. 1877. Albumen print. London, Royal Photographic Society Collection

Photography
in the
First World War

JOHN TAYLOR

A T the start of the First World War there was a perfect match between pictorial photography and attitudes towards patriotism and the British Empire. The pictorial photographer had an elevated purpose: he used rules of composition and good taste in order to mirror and confirm the 'common abundant life'. In 1914 the Empire seemed glorious: it was a focus for intense patriotism and for trade. The photographer could 'do his bit' in two complementary ways: he could continue to take pictures, and so help to further trade; he could also make pictorial photographs that encapsulated the fervour of the times.

The editor of *The Amateur Photographer*, F. J. Mortimer (1874–1944), believed that 'Art keeps the patriotic sentiment acute, swells the roll of volunteers, and makes more bearable the incredible inhumanities of war'. He felt that artistic pictorial photography should express the 'patriotic idea'. Many such photographs were published in this influential magazine; photographs of enlisted men, or men dejected because they were refused admission to the army. In addition, there were attempts to create symbolic images (Fig. 1).

Pictorialism was a recognized style of Art photography, but other than in general symbols it was difficult to conceive how photography could be used to picture this war in Europe, which few people had seen. There were snapshots in the illustrated papers, but these were too particular or realistic to be Art. Some photographers succeeded in proposing a modern subject in a pictorial style, which worked through 'the avoidance of any human anguish in association with the kindly presence of ministering nurses' (Fig. 4).

F. J. Mortimer himself was the most successful pictorial photographer of war scenes. He understood the photo-journalistic need for realism as well as the pictorial need for propriety (Fig. 2). He avoided both mawkish sentiment and awkward generalizations. Before the war he had built up an enormous stock of negatives of naval activities, and during the war, when there were strict prohibitions upon photography near any possible military target, he was able to continue his preferred method of combination printing (Figs. 2, 3 and 5). However, as the war progressed, the idealized reality of

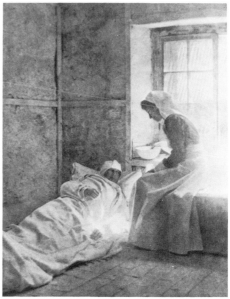

pictorialism no longer seemed to meet the harshness of experience. Art photography, jingoism, colonization, and expansive trade were all characteristics of British cultural life in the nineteenth century. After 1918, they were all finished.

FAR LEFT 1. Mrs G. A. Barton, *In Time of War*. 1914. Reproduced from *The Amateur Photographer*

LEFT 2. F. J. Mortimer, *From the Trenches*. 1917. London, Permanent Collection of The Camera Club

ABOVE LEFT 3. F. J. Mortimer, *The End of the Trail*. 1919. Bromoil print. London, Permanent Collection of The Camera Club

ABOVE RIGHT 4. F. Powell Ayles, *The Work of the Huns*. 1917. Reproduced from *The Amateur Photographer*

BELOW 5. F. J. Mortimer, *The Minesweeper and the Destroyer – All's Well*. 1917. Bromoil print. London, Royal Photographic Society Collection

37. George Davison, *The Onion Field*. 1890.
Photogravure. London, Kodak Museum

from contemporary domestic life (Fig. 36). He pursued the Ideal with ferocity, and was prepared to fell trees in order to complete a picturesque view, though his surgical tendencies were probably confined to the darkroom and combining negatives. He wrote eleven books on photography, which were revised and reprinted, and some of them translated into French and German. The first and most popular book was *Pictorial Effect in Photography* (1869). This is a collection of prescriptions for combining negatives into the most picturesque compositions. It is a typical Victorian handbook, like C. R. Leslie's *Handbook for Young Painters* (1854), full of literary reference, and imbued with the governance of Art by Rule. He used these perennial Rules to combine the photographic imprints of imperfect Nature to reveal Beauty and Truth.

Whereas Reijlander had engaged in generalized melodrama, Robinson showed that the simple folk of rural England could become the substance of improving art in the fashion of David Wilkie and S. R. Percy.

Julia Margaret Cameron (1815–79) was interested neither in recording facts nor in telling stories: her concern was to evoke a spiritual world. She photographed some of the most eminent Victorians, such as Herschel, Carlyle and Tennyson, with the camera lens deliberately turned out of focus, in order, as she said, to 'heal the little frets of life' and 'to merge one's individual self in the thoughts of the mighty whole'.

In contradiction to the elaborate composition of

Robinson, Dr Peter Emerson (1856–1936) believed that artistic selection should take place on site, and remain truer to Nature than to Art. He advocated straight photography. But his photographs were not pin-sharp. Indeed, Emerson admired the soft-focus work of Cameron, although he held that the basis for 'impressionism' was not a correlation with spiritualism, but a close approximation to the physical characteristics of the eye in differential focusing. Precision lenses could be made to reproduce images as the eye naturally created them if they were adjusted so that one plane of the picture was in focus, and the other planes were slightly out of focus. His ideas were published in *Naturalistic Photography* (1889), and though in 1890 he declared photography to be a science after all, his work enabled photographers to move with the times, away from stage productions towards evocative impressions. The earlier passion of the 1870s for regenerative Art, Ruskin and Positivism, was altered in the 1890s by the gradual acceptance of Whistlerian Nocturnes, and the withdrawal into Aestheticism, which emphasized the private responses of the refined sensibility, and Art for Art's sake.

People began to concentrate upon the impressionistic and effective possibilities of soft focusing. The most notorious example is one of the earliest: George Davison's *The Onion Field* (Fig. 37) of 1890 was taken with a pinhole camera and printed on rough paper. Art photographers still talked about Nature, Beauty and Truth, but their personal temperament now assumed more importance. Romantic individualism again emerged as vital in making art, but it was deeply infected by Victorian precepts, so that dangerous genius was rejected in favour of wilful fancy.

In 1891 Davison submitted a late entry to the annual Salon of the Royal Photographic Society. The rules of 'the Royal' were broken and his prints were hung in pride of place. Most photographic work at 'the Royal' was scientific, and there was little sympathy for the artists, so the sudden appearance of Davison's advanced art photographs began a wrangle which resulted in the secession of the art photographers. They formed their own group, known as the Linked Ring Brotherhood, and held internationally respected Photographic Salons every year from 1893 to 1909.

During this period there was an unusual coincidence of technology and artistic style. A photographic print could be made to look like a drawing, or a lithograph either in black and white, or in colour by the use of one of the various oil pigment processes,

such as gum bichromate. The purists, who were opposed to such manipulation, gave their straight photographs a luminous sheen by using the platinum process. Both straight photographers and manipulators were united for a time in their notions of art photography, which they felt could accommodate the styles and ideals of Fine Art. These notions were based largely upon a mixture of Late Victorian propriety and Aestheticism, but there was also considerable interest in Japanese art which favoured and eventually made respectable in Britain certain decorative and asymetric compositional devices. Symbolism, however, was not so well favoured in Britain: it was too closely associated with the Bohemian lifestyles of Oscar Wilde and Aubrey Beardsley, and was clearly expressed in *The Yellow Book*. Symbolism amongst the photographers took the form of close-knit societies – such as the Linked Ring Brotherhood – with elaborate rituals and codes, and is much less evident in the photographs themselves than it is in the work of American contemporaries.

From 1908 there were serious disagreements within the Linked Ring about the nature of art photography, and these soon resulted in the break-up of the group. The dominant faction spurned innovation as merely fashionable, and preferred the more secure and optimistic ideas of pictorialism. Conservative attitudes towards art were embraced as positive attributes, in particular to ward off the 'temporary crazes' that had seized the Americans, and had begun to infect some British photographers.

In 1917 Alvin Coburn (1882–1966) exhibited his abstract photographs, called 'Vortographs', in London (Fig. 38). This triumph of the imagination signalled the end of nineteenth-century art photography. However, this signal was ignored by the establishment, who neglected Vortographs in particular and experiment in general, and continued to make idealized pictorial photographs.

But the pace and experience of life during the First World War gradually broke down all resistance to change except in the most Victorian and conservative circles of art photography. If conservative pictorialism continued, it no longer seemed appropriate to modern times. The monolithic Victorian endeavour was superseded by a pluralism of styles and attitudes to photography that could not be understood within the old compass of Art. Coburn had introduced abstract photography, and the experimentation was continued by other American photographers such as Curtis Moffat (1887–1949) and Francis Bruguière (1880–1945), who were in London during the 1920s. Unexpected ideas about

38. Alvin Langdon Coburn, *Vortograph*. 1917. Bromide print. London, Royal Photographic Society Collection

39. Bill Brandt, *Parlour-maid and Under-maid Ready to Serve Dinner*. 1933. Bromide print. London, Bill Brandt

art found their way into photography. Modernism in photography, in the form of Rayographs, negative prints, multiple exposures and solarizations, began to appear in such influential fashion magazines as *Vogue* and *Vanity Fair*. Cecil Beaton (1904–80) began to experiment with Rayographs in 1926, but he also created ingenious distortions in straight photography in such elaborate jokes as his portraits of artistic figures of the day.

There was also a general demand for straight photography which helped to bring to light the 'new' subjects of urban and industrial life. This work began with E. O. Hoppé's (1878–1972) picturesque 'Human Documents' of 1922, and culminated in the thirties, in the exemplary work of Bill Brandt (b. 1904). Brandt was thought to be an anthropologist (Fig. 39): he atomized the class structure of Britain in his books, such as *The English at Home* (1936) and *A Night in London* (1938), and in his work for magazines such as *Lilliput* and *Picture Post*. The sobriquet of social scientist was high praise indeed in the thirties, when social documentary work of all kinds was a typical and respectable obsession. More-over, Brandt became one of the most sophisticated Surrealists in Britain.

Influential photographers who emerged immediately after the Second World War include the photo-journalist Bert Hardy (b. 1913) and the fashion photographer Norman Parkinson (b. 1913), though the period was dominated by Beaton, Brandt and other pre-war photographers such as Angus McBean (b. 1904) and Kurt Hutton (1893–1960). In the mid-1960s, when London was 'swinging', a top fashion photographer like David Bailey (b. 1938) was as glamorous as any pop star. At the same time, the reputation of British photographers for documentary work continued, although in those optimistic times the emphasis had shifted from concern to acerbic wit. This is best seen in the work of Tony Ray-Jones (1941–72). In the mid-1970s, Ian Berry (b. 1934) returned to the mainstream tradition of Brandt in his acid vision of *The English* (1978).

Commercial photography, social documentary, and modernist experiment have all enlarged our own category of acceptable art photography, and this in turn has shaped our attitudes towards photography of the past. With our modern prejudices, we pay much less attention to the high-minded Art photographers of 1900 than we do to the snapshots of Paul

Martin (1864–1944) or the photo-journalism of Horace Nicholls (1867–1941).

And yet in our own times there is still a discrete art photography. A significant minority of landscape photographers such as Paul Hill (b. 1941) and Raymond Moore (b. 1920) are heirs to the romantic pictorialists in the search for the Ideal. Others, such as John Hilliard (b. 1945) and Victor Burgin (b. 1941), attend to more recent developments in the arts, such as Conceptual Art.

Modern documentary photography exists within High Art in the work of socialist radical feminists like Jo Spence (b. 1934), and in the work of the 'Exit Photography Group', for example, *Down Wapping* (1974) and *Survival Programmes: In Britain's Inner Cities* (1982).

Some important debates concerning the nature and role of photography now take place within the confines of art photography. There is a wide gulf between two opposing groups. Some hold the traditional view of the artist as genius, or specially creative individual who behaves in ways not open to other people; whereas a second group wants to shift the emphasis away from the refined sensibility of authorship towards the centrality of modern theories of social production in art. These specialist debates are thrown into relief when we recall that the exigencies of commerce have a tremendous influence. On the one hand fashion and advertising photography is exhibited in important galleries, such as the Hayward Gallery or the National Portrait Gallery, and collected by national bodies such as the Arts Council. And on the other hand 'hard news' photographs shot on assignment, and first seen in the glossy magazines and colour supplements, also quickly find their way into national archives. Hence Don McCullin's (b. 1935) photographs of atrocities in Africa and Vietnam are held in the National Photographic Collection at the Victoria and Albert Museum.

These developments are significant. Commercial enterprises continue to sustain photo-journalists such as Chris Steele-Perkins (b. 1947), and Mike Abrahams (b. 1952). There has been an impressive shift, which would have astonished earlier enthusiasts for Art photography, away from the precious iconic photograph that is all too easily used to illustrate supposedly inevitable or 'timeless' aspects of 'the human condition', and towards a documentary recording of the historically specific experience.

Prints and Book Illustration

JOYCE IRENE WHALLEY

BRITAIN has a long and vigorous tradition of book illustration and print-making which happily shows no sign of diminishing. We take for granted the wealth of imagery with which we are constantly surrounded, from our earliest infant readings to the mature choice of pictures for the walls of our homes. Moreover, much of the work produced in this country over the centuries has had a considerable influence on arts abroad, so that at times Britain has led the field in the work of its book illustrators and print-makers.

This supremacy started as early as the seventh century. At that period the northern tradition of decoration, more usually found on metalwork, blended with Celtic mysticism to produce such remarkable works as the Lindisfarne Gospels (Fig. 41), written and illuminated about 698, and the Book of Kells which was probably written on Iona about one hundred years later. This Insular (or Anglo-Celtic) style permeated the work of monastic scribes in places as far away as Switzerland, whither it was taken by missionary monks from the British Isles. The effect of this style on the human figure was to reduce it to mere ornament, as we can see in the pictures of the Evangelists which appear at the beginning of their respective Gospels in these manuscripts. But the Insular style at its convoluted best produced some of the most magnificently ornamented books of the early Middle Ages; the pages with their intricate all-over designs have very aptly been called 'carpet pages', and they remain unsurpassed.

By reason of its geographical position, Britain was always very susceptible to continental influence, and this tendency was strengthened by the Norman Conquest of the eleventh century. Most of the books produced during the Middle Ages were intended for religious purposes, but the universality of the Church did ensure a wide diffusion of artistic styles throughout the West. Many of the illuminated manuscripts destined for use in England were in fact produced in France or the Netherlands. Perhaps the most characteristic examples of later English medieval books were the large Psalters of the fourteenth century, whose margins were often alive with drolleries or genre scenes of great vitality and social awareness. Probably the best known of such volumes is the Luttrell Psalter, *c.* 1340 (Fig. 40). By the late Middle Ages book production was being carried on not in monastic scriptoria but in lay workshops, on something like a factory system. Inevitably this led to greater diversity of subject matter and an increasingly secular interest in it.

With the invention of printing from movable types in the middle of the fifteenth century, the era of the hand-produced book virtually came to an end. But even before William Caxton set up the first English printing press at Westminster in 1476, the print had

40. Kitchen scene from the Luttrell Psalter. *c.* 1340. London, British Library

Children's Books

JOYCE IRENE WHALLEY

GOOD book illustration is the perfect marriage of text and picture; this is especially true when the book comes under the censorious eye of the young. Many story-book characters are fixed for ever in the form given to them by their first illustrator and interpreter. British children have been fortunate in the wealth of literature and illustration provided for them ever since John Newbury became the first children's book seller and publisher when he set up shop in St Paul's Churchyard in 1744.

Most eighteenth-century books were illustrated by as yet unidentified artists, many of them hack workers. For reasons of economy most of the illustrations were woodcuts, and the quality varied between the crude simplicity of the chapbooks and the more sophisticated style of *Cobwebs to Catch Flies* (1783) with its large print, spacious layout, and relevant pictures (Fig. 1). But in the nineteenth century artists began to put their names to their children's book illustrations. As early as 1823 George Cruikshank (1792–1878) illustrated the first edition of what was to become known as *Grimm's Fairy Tales* (Fig. 5).

A special feature of English children's books was the 'toy book'. Essentially this was a broadsheet with text and illustrations, folded to form an eight-page booklet. The illustrations were usually hand-coloured and varied greatly in their style and execution. But with the introduction of colour printing in the mid-nineteenth century, the toy book not only continued to flower in even greater glory but was taken up by two of the great artists of the end of the century, Walter Crane (1845–1915) and Randolph Caldecott (1846–86), each of whom issued his own series of toy books.

Some illustrators still preferred to work in black-and-white, and the 1860s and 1870s show many established artists turning their attention to children's books. It was Sir John Tenniel (1820–1914) who fixed for ever in visual form the creatures of Lewis Carroll's imagination, in his illustrations to *Alice's Adventures in Wonderland* (1865), and *Through the Looking-Glass* (1871) (Fig. 2).

By the beginning of the twentieth century children's book illustration had become somewhat simpler. Gradually the whole concept of children's books was changing as they tended to become larger, with a greater insistence on colour – often garish colour. In the highly personal styles of artists like Arthur Rackham (1867–1939), Edmund Dulac (1882–1953), and Kay Nielson (1886–1957), we are reminded that children's books are usually bought by adults, and the sophisticated style of illustration might not in fact be the child's own choice.

One artist who has remained the children's choice ever since the publication of her first book *The Tale of Peter Rabbit* in 1902 is Beatrix Potter (1866–1943) (Fig. 4). Scientifically accurate and with few concessions to childish reading ability, she created a personal world of visual images to accompany her own texts. E. H. Shepard (1879–1976) did not write his own stories, yet when he illustrated the books of A. A. Milne there was such an identity of imagination between artist and writer that the world of Winnie-the-Pooh is now firmly established in the form created by Shepard (Fig. 6).

Contemporary children's book illustration offers as many styles and techniques as does the adult book, but the child's love of the grotesque, the mysterious, the factual and the colourful, a love so well understood by Mervyn Peake (1911–68) (Fig. 3), ensures that there will still be work for all who will take this love seriously.

OPPOSITE TOP 1. Lady Fenn, *Cobwebs to Catch Flies; or, Dialogues in Short Sentences Adapted to Children from the Age of Three to Eight Years.* 1783. Woodcut

OPPOSITE BELOW 2. Sir John Tenniel, Alice in the Railway Carriage from Lewis Carroll's *Through the Looking-Glass.* 1871. Wood engraving

BELOW 3. Mervyn Peake, Long John Silver from R. L. Stevenson's *Treasure Island.* 1949

ABOVE RIGHT 4. Beatrix Potter, Old Mrs Rabbit from *The Tale of Benjamin Bunny.* 1904. Watercolour

CENTRE RIGHT 5. George Cruikshank, Rumplestiltskin from one of Grimm's folk tales translated as *German Popular Stories.* 1823–6. Etching

BELOW RIGHT 6. E. H. Shepard, Pooh and Piglet from A.A. Milne's *Winnie-the-Pooh.* 1926

begun its own independent existence. The earliest prints were woodcuts, usually of religious subjects and no doubt often produced in association with special shrines and places of pilgrimage – the forerunners of the modern souvenir. The same method of relief-printed illustration was also used in the earliest printed books, since woodcuts and text could go through the press at the same time – a process that was both economical and convenient. Since both prints and printing were introduced from Europe into Britain, it is not surprising to find that much illustrative work of the early period was dominated by continental influences and artists. The general run of English work at this period was far below the standard of that produced in Italy or later in France. Only perhaps the elaborately designed title-pages of the sixteenth and seventeenth centuries had a certain Mannerist or Baroque panache about them.

Engraving on copper had begun almost as early as that on wood, and in the same way it was used for both prints and book illustration. Copper-plate engraving resulted in a much finer line, and consequently it permitted the use of far greater detail than was possible in woodcuts. It was especially suitable for maps and other topographical works, and of course for portraits, where again detail was important. A considerable amount of English work was done under the influence of the Bohemian artist Wenceslaus Hollar (1606–77), who dominated the scene in the second half of the seventeenth century. Apart from Francis Barlow (c. 1626-1704) few native-born artists could rank with those of the continental schools, but England did produce many competent engravers who admirably interpreted the artists' vision.

One technique developed in the second half of the seventeenth century was, however, taken up with such enthusiasm and skill that it became known in Europe as 'la manière anglaise'. This was the mezzotint, introduced by Prince Rupert in the 1660s. It was a medium particularly suited to the rendering of tone, since the mezzotinter started with a roughened plate (which would print black) and smoothed the parts that he wished to show lighter. Mezzotint was thus far better than copper-plate engraving for the reproduction of paintings, and was especially popular for portraits, in which it could subtly render the nuances of the original oil painting. After its first flowering in the late seventeenth century it was again favoured for the work of Reynolds and Gainsborough. The rich darkness and velvet tone of the mezzotint can be recognized in many familiar portrait reproductions of this period.

Although a wide range of prints was produced during the seventeenth and eighteenth centuries, no first-rank native artist appeared until William Hogarth (1697–1764). If Hogarth thought of himself primarily as a painter, it was the engravings of his paintings which brought him his greatest fame among his contemporaries. In particular he popularized the series of engravings, in which a whole story is told in a sequence of pictures. Among his best known examples are *A Rake's Progress*, (1735) and *Marriage à la Mode* (1745). The Hogarthian genre of social satire was continued later in the century by James Gillray (1757–1815) and Thomas Rowlandson (1756–1827), both of whom developed a highly personal and easily recognizable style.

The late eighteenth century also produced a number of fine topographical artists, whose works continue to be much sought after. Country seats, foreign tours, and, after the outbreak of the long continental wars, native scenes, all provided a source

42. Noel Humphreys, *The Miracles of Our Lord*. 1848 London, National Art Library

of inspiration for which there was (and is) a ready market. Many of the topographical artists chose aquatint as the best method of rendering in multiple form the characteristics of the original watercolour or sketch. Unlike the sharp line of an engraving, aquatint produces a much softer effect, since the picture is painted on a resin-covered plate before being immersed in acid, and so renders the effect of watercolour or drawing more accurately. Many aquatints were hand-coloured, and in this state they form one of the most attractive aspects of the graphic arts of the late eighteenth and early nineteenth centuries. It is interesting to recall that much of Turner's early work was in this field of topographical studies, and that he himself etched, or supervised the printing of, many of his own later works. Although there were few really outstanding names among the topographical print-makers, there were many very competent artists. The surviving examples show the high standard which existed, and also the peculiarly English quality of the genre, which was closely linked to the current school of watercolour painting.

43. William Blake, 'The Sick Rose' from *Songs of Innocence and Experience*. 1789–94. Etching and watercolour

One outstanding artist of the period who refused to fit comfortably into any category or school was William Blake (1757–1827). Blake himself described his work as 'illuminated printing' (Fig. 43). He drew his pictures and the accompanying text in acid-resisting medium on copper, whose background was then etched away. The resulting print was frequently hand-coloured. In addition to the remarkable artwork, Blake was usually responsible for the text as well, which consisted mainly of expositions of his own personal mythology. All this made his prints and illuminated books highly idiosyncratic, but Blake was by no means without followers or influence, and something of his style and vision can be seen in the work of Edward Calvert (1799–1883) and Samuel Palmer (1805–81).

The late eighteenth and early nineteenth centuries saw two important additions to the techniques available to the graphic artist: steel engraving and lithography, the latter invented by Aloys Senefelder (1771–1834). Steel engraving was merely a development of the older copper-plate engraving, but steel, being a harder metal, was more suitable for long runs of prints. It was therefore eminently suited for the production of prints intended for the popular market – often topical items such as portraits of heroes or famous beauties, or representation of contemporary events. However, in unskilled hands it could become cold and lifeless, and by the 1850s had largely dropped out of favour.

Lithography was particularly suitable for rendering the soft quality of drawings, but it was perhaps even more significant in the later nineteenth century when it played an important part in the development of colour printing (chromolithography). Its popularity was renewed in the present century when it was taken up with enthusiasm by artists working in the period between the two World Wars, and the soft effect thus given to their work was very characteristic of both this and the immediate post-war period.

In recent years original prints have enjoyed a new vogue, and it has become fashionable to choose them to replace the colour reproductions which had previously adorned so many homes. Various new techniques are now available to the modern print-maker, the silk screen and stencil processes having proved especially popular. The current popularity of such graphic works has now spilled over into areas which would have amazed the earlier artists, and objects as diverse as carrier bags and T-shirts can be seen as examples of the print-maker's art.

44. Thomas Bewick, Curlew, from *The History of British Birds* (two volumes). 1797–1804. Wood engraving

Turning now to book illustration, it will be recalled that the earliest printed books were illustrated with woodcuts, which could be printed at the same time as the letterpress. But the woodcut did not lend itself readily to fine or detailed work, and it gradually became relegated to cheaper or simpler publications such as chapbooks and broadsheets. Its place was taken by copper-plate engraving or etching, which allowed a more detailed impression. This was especially important in the scientific, topographical, and other learned books which came from the press in increasing numbers in the seventeenth century. During the eighteenth century book illustration, like the independent print, continued to be very much under foreign influence, although there was a flourishing school of native engravers. The century as a whole saw a vast output of illustrated books of all kinds. Inevitably to some extent the pictures to be found in these books were similar in subject to those found in prints: again topography, portraiture, and current events dominated the scene. But the publication of novels and books of verse also increased during this period, and many of these volumes contained fine engraved illustrations which show the high standard reached by the best book artists of the day.

It was Thomas Bewick (1753–1828) who radically transformed the scope of British book illustration and who lifted the art of wood engraving from the depths into which it had sunk (Fig. 44). He chose to engrave his work on the end grain of a hard wood

such as box, rather than on the softer plank side of the wood. His method of white-line engraving allowed greater subtlety of effect, and was swiftly adopted by other artists, especially those working on book illustration. Bewick was also a good naturalist and his major works were *The General History of Quadrupeds* (1790), and *The History of British Birds*, of which the first volume on land birds appeared in 1797, and the second volume on water birds in 1804. But it was not merely his pioneering work in the field of natural history illustration that made his books so famous, but the fact that all the volumes were adorned with a wealth of social comment in the form of vignettes appended to the various sections. So greatly was his work admired, and that of his brother John, that for many years the words 'after Bewick' appeared on the title-pages of books whose illustrations were in fact far from being after either brother. But the full significance of Bewick's work is to be found in the subsequent flowering of the wood-engraved illustrated book which reached its peak in the 1860s.

45. Christopher Kent, illustration for Shakespeare's *King Lear*. 1973. Etching. The Circle Press

In the 1850s and 1860s book illustration in Britain reached a very high standard indeed. Although colour printing had now become commercially viable, mainly through the development of the process initiated by George Baxter (1804–67), many artists still preferred to work in black-and-white, and it was probably in this field that British book artists and engravers excelled. Moreover their artistic standing was so high that artists and engravers alike could expect to see their names listed against each picture they contributed to the many gift books and keepsakes which were such a feature of the mid-Victorian publishing scene. A study of such publications reveals just how many black-and-white artists were at work in the period before the invention of photography, and its application to book illustration, changed methods of production so radically. In colour, perhaps the most characteristic British contribution was the illuminated book. This was encouraged by the interest in all things medieval which influenced so many contemporary art forms during the mid-century, and involved everything from railway stations to books. For the general public, interest in illuminated manuscripts was stimulated by the introduction of the printing technique of chromolithography, which enabled original manuscripts to be reproduced in all their glory for the first time, at least as far as the non-specialist reader was concerned.

The end of the nineteenth century saw a vast outpouring of popular illustrative material in a variety of books and journals, much of it of no lasting value. To some extent the important work was now being done in the field of children's books, which was dominated in the last quarter of the century by the work of Walter Crane (1845–1915), Randolph Caldecott (1845–86) and Kate Greenaway (1846–1901). But the same period also saw the influence of William Morris and his Kelmscott Press, which encouraged the rise of a number of private presses, many of whom produced very fine illustrated books (Fig. 42). This influence was to prove of great importance in the twentieth century, during which private presses have continued to provide patronage for the book artist (Fig. 45). The main source of contemporary book illustration is again, inevitably, to be found in the field of children's books, where the British child continues to enjoy the incomparable range of illustrative material which has been his heritage for more than a century. But the continued existence of an institution like the Folio Society, which commissions work from contemporary artists for sale to its wide membership, confirms the fact that the illustrator, like the print-maker, is still alive and flourishing in Britain today.

4

Folk Art

JAMES AYRES

IN a remarkable passage in *Moby Dick* (1851) Herman Melville was one of the first writers to acknowledge without prejudice the 'barbaric spirit' to be found in all art. Since he based his thesis on the contemporary seaman's craft of 'scrimshaw' (engraved whales' teeth), practised by both British and American whalers, his perception is the more conspicuous (Fig. 46). He, perhaps uniquely, could see the 'savage' qualities in classical Greek work, and the 'human perseverance' represented by an 'Hawaiian war-club or spear paddle' or a 'Latin lexicon'. Few are capable of such an inclusive view of cultural history. Possibly for this reason the exclusive tendencies of the aesthete have encouraged the emergence of a sub-division of the visual arts known variously as naïve, primitive or non-academic. In many ways the term 'vernacular art' would be more appropriate since it implies no pronouncement on the quality of the 'diction' found in this work, while acknowledging the presence of a distinctive dialect which, though sometimes drawing inspiration from the dominant but minority culture, remains distinct from it.

In England, one of the earliest students of dialect in language was John Collier (1708–86) who, under the pseudonym of Tim Bobbin, published a number of books in the Lancashire dialect. It is for this work that he is chiefly remembered in the *Dictionary of National Biography*. However, in his own time he was better known for his paintings and engravings as 'the Lancashire Hogarth', a sobriquet based upon his choice of subject matter rather than upon any conventional skill as a draughtsman. Collier and his near-contemporary John Kay of Edinburgh (1742–1826) are uncharacteristic of this facet of British painting in that they were self-taught professional artists who were each dependent upon a patron. Most painters at this time were trained in the 'craft' of paint if not the 'art' of painting. These tradesmen painters advertised themselves in the trade directories of various regional centres not under the élite cate-

46. Scrimshaw (engraved whale's tooth), signed Waite. 1838. Kingston upon Hull City Museums and Art Galleries

gory of 'Artists: Portrait, Landscape, Miniature', but in the ranks of 'Painters: House, Sign, etc.'. As such a category indicates, house and sign painting were two important sources of income for these individuals.

Before the time of mass-produced 'convenience paints' the preparation of colour was an important part of the craft of painting. Furthermore, poorer households could not afford the fashionable wallpaper which was in general use with the well-to-do by the eighteenth century, and the house painter was expected to use his artistry to provide stencilled wall decorations. The painting of murals and, by the late eighteenth century and probably earlier, the decoration with landscapes of transparent blinds for windows provided other important sources of income for the house painter. A recently discovered mural by one such painter in a house in Cheltenham is probably the work of Thomas Vick, who may have lived there or was certainly a near neighbour. This remarkable example may be dated reasonably accurately to 1826–30 since the composition illustrates J. B. Papworth's dome on the Montpellier Pump Room which was not completed until 1825–6. Very similar work was produced by the Walters family of Bristol. They are listed from 1819 to 1847 in Pigot's *Directory*,

47. Portrait of the ship 'Cosma' by a 19th-century English primitive artist. Oil. London, Rutland Gallery

48. Bay trotting horse with a mill in the background by a 19th-century English artist. Oil. London, Rutland Gallery

where they occur under the usual heading as house painters but variously described as 'Sign and Furniture Painters' or as 'Ornamental Painters'. A recently restored house at Butcombe, Avon, was found to be stencilled throughout except in two principal rooms, the walls of which bear remarkable scenic murals. One of these, the finest, is signed Walters, presumably Thomas, and dates from about 1840, at which time he was based at 26 Upper Maudlin Street, Bristol. It should be emphasized that very few murals of this type and period have so far been located in Britain, although they are well known in New England. The importance of sign painting as part of the stock-in-trade of the house painter is confirmed by Nathaniel Whittock in his *Painters' and Glaziers' Guide* (London, 1827), which includes a chapter on

sign painting as well as the other branches of the trade outlined above.

It should not be assumed that those who were listed as house and sign painters did not, at least occasionally, produce easel paintings. A shipping scene of 1827 by a member of the Walters family survives and so too does a still life of 1869 by John Booth Higginson, the 'painter and decorator' from Madeley, Staffordshire. The still life was a rather unusual subject for such painters. They more often supplied their patrons with more 'useful' pictures of prize farm animals or prized ships (Figs. 47 and 48). The agrarian revolution of the eighteenth century, coupled with the early lack of stud books, meant that a prize animal stood as testament to its own pedigree. Farmers therefore found it helpful to commission portraits of these animals. Some of these paintings were the work of 'respectable' if minor artists like Thomas Weaver, others were the products of hitherto unknown painters like William Bagshaw of Rugby. This craftsman is listed in the Rugby *Directories* under 'Plumbers and Glaziers' although his name is distinguished with an asterisk and the note 'and artist'.

Sporting subjects form a significant group by painters such as Richard Roper, whom Edward Edwards described as 'A painter of sporting pieces, race-horses, dogs, and dead game ... His powers as an artist were not considerable yet sufficient to satisfy the Gentlemen of the turf and stable.' Condescension of this sort was usual, but seldom was the victim of such conventional attitudes identified. Today most such artists are shrouded in anonymity. A surviving trade card for Bowen and Fuss, 'Painters and Glaziers in General' of '29 Artichoke Lane, near Sampson's Gardens, Wapping', includes the information 'NB Ships Likness's taken', but none by this firm has as yet come to light.

The connection between the painting of ships and ships' portraits was probably as close as between house painting and non-academic easel painting in that both services were, in each case, frequently provided by the same individual. Related to the ship portrait were the sailors' woolwork pictures of ships which were so popular in the second half of the nineteenth century. In general these seem to have been the work of Royal Naval personnel; certainly Royal Naval vessels are more often than not the subject. Soldiers also produced some woolwork pictures, perhaps on the long sea voyage to India, but these are less common. In idle hours at sea the whalers on both the Atlantic and the Pacific created scrimshaw such as Melville described. These ex-

amples of engraved whales' teeth, and household objects made out of whalebone and ivory, and of dark-brown 'baleen' from the Baleen whale, are mainly of nineteenth-century date.

One characteristic which many of these artists shared was a love of detail, a delight in recording, so far as they were able, the real world. No wonder the sailor, the farmer and the 'gentlemen of the turf' employed them. Reynolds, as one would expect, dismissed them in his *Discourses*. 'He [the academic painter] will permit the lower Painter, like the florist or collector of shells, to exhibit the minute discriminations which distinguish one object of the same species from another ... it is the mind which the Painter of genius desires to address.' The vernacular painter either attempted an objective view of the world or, at times, aspired to the greater truths of the mind's eye. Alfred Wallis, the Cornish fisherman-painter of the earlier part of this century, wrote that 'what i do mosley is what use To Bee out of my own memery what we may never see again ...' This reliance on memory created emblems that were of an

49. Portrait of Colour Sergeant Dollery of the 34th Cumberland Regiment and his family. 1826. Watercolour. Carlisle Castle, The Border Regiment and King's Own Royal Border Regiment Museum

heraldic character rather than an observed truth. A 'portrait' of a soldier or a sailor could be more important for the details of its uniform than for its facial 'likeness'. In the first half of the nineteenth century portraits of 'other ranks' in the army were made as family keepsakes. The limners who made these simple watercolours detail the uniforms, but the identification of the person is dependent upon an inscription, often in verse, which demonstrates the spirit in which they were made and given. This approach enabled portraits to be painted before the 'subject' was known to the painter or a recipient for the picture had been determined upon. The latter point is confirmed by the two versions of the Dollery portrait where the word 'Aunt' is inserted in the accompanying verse in one example and 'Parents' in another, both occurring as afterthoughts (Fig. 49). The tradition for these portraits was extinguished almost as soon as it was established by the development of photography. More conventional portraits in oil that were clearly painted in the presence of the sitter exist and a description of such an easel painter at work occurs in Goldsmith's *The Vicar of Wakefield* (1766) and in Dickens's *Nicholas Nickleby* (1830). In an age of high infant mortality children form a recurring theme, often shown in association with a favourite animal or toy.

Pre-packed watercolour paints were an innovation of the latter part of the eighteenth century and oil paint sold in flexible metal tubes was available by the 1840s. These developments opened up the possibility of painting to numerous amateurs. For some, and especially young ladies in finishing schools, painting became a sophisticated 'accomplishment' and in the early nineteenth century painting on velvet was a fashionable 'ladies' amusement'. For others, such as the farmer Joseph Sheppard of Worle (1834–1928) near Weston super Mare, or the Thames boatman Walter Greaves (1846–1930), it could be a means of representing their everyday world. In both instances these men were to receive some academic training, the Greaves brothers (Walter and Henry) from Whistler, and Sheppard by attending evening classes run by the now almost forgotten artist James A. Davis. The training they received gave them an insight into their weaknesses rather than an awareness of their strengths, and their work deteriorated to the fairly average level of the worthy amateur or, as in the case of Greaves, achieved a spurious sophistication by aping the *Nocturnes* of the American master. By 1928 when Alfred Wallis was discovered by Ben Nicholson and Christopher Wood, the position was reversed. Wallis was encouraged to persist with his

Signs

JAMES AYRES

TODAY, the identification of town premises by number is so universal that it is hard to imagine a time when this was not so. Street numbering, however, was not general in Britain until the late eighteenth century. Before that, and since classical antiquity, signs were the means of identifying a private home, a public house, a trade, or a shop.

Medieval signs often consisted of a pole painted in various colours, and set pointing upwards at an angle of 45° to the frontage of the building. The most visible and therefore the most effective were three-dimensional signs, or signboards, thrust out beyond the building line by means of a sign-iron. Since pendent signs occasionally fell on the street below these were something of a hazard to passers-by, and following the Great Fire of London of 1666 the authorities attempted to forbid their use, urging their replacement by signs carved in stone in high relief set flush into the façades of buildings (Fig. 1). Signs of this type were safer but they were also less easy to see, so it was not long before the signboard and sign-iron returned to the street scene, a feature confirmed by many eighteenth-century prints (Fig. 2). However, bye-laws designed to prohibit signs for reasons of public safety were introduced in many cities and towns, and from the late eighteenth century onwards the use of signs declined except for inns, public houses and for certain trades – pawnbrokers and barbers, for instance, continued to use their traditional emblems (Fig. 3).

The subject matter of signs was frequently quite unrelated to the trade that they advertised, or to the people whose houses they denoted (Fig. 5). The bunch of grapes of the inn, the striped pole of the barber, and the three brass (gilded) balls of the pawnbroker are exceptions in that these were not used in other contexts.

In 1762 Bonnell Thornton, with the help of William Hogarth, organized an exhibition of signboards. A decade later a similar collection was shown in London under the title 'The Drol-o-phusikon, a whimsical and original exhibition of sign painting'. These two shows may have been organized as a mockery of the fashionable art exhibitions of the late eighteenth century, but they also constitute an early acknowledgement of the sign as an art form.

In London, sign carving and painting was a trade generally carried on in workshops in and around Fleet Street where craftsmen such as Barlow, Craddock, Thomas Proctor (Fig. 4), Willi Steward, and others sold 'signes ready painted and Bushes for Taverns, Border Clothes for shops, Constables Staffs, Laurells for Clubs, Dyall Boards for Clocks, Sugar Loaves and Tobacco-roles'.

At the Black-a-Moor's Head, in Harp-Alley *near* Fleet-Ditch,

Liveth Thomas Procter, *Painter*, who Painteth and Selleth all sorts of *Signs*, *Bushes*, *Bacchus's*, *Bunches of Grapes*, and *Show-Boards*, at Reasonable Prices: The Oldest Shop.

FAR LEFT 1. Carved stone sign from Blackamoor Street, City of London. 1715. The Museum of London

FAR LEFT BELOW 2. Cheapside in the City of London. Detail of a mid-18th-century engraving by Bowles showing the profusion of shop signs. London, British Museum

BELOW LEFT 3. Chimney-sweep's sign formerly at 43 Sherbourne Street, Cheltenham. Cheltenham Art Gallery and Museum

LEFT 4. Trade card of Thomas Proctor. Early 18th century. London, British Museum

BELOW 5. Ship's figurehead used as a sign at the Red Lion, Martlesham, Suffolk. Early 18th century

native talents as a painter and it was Christopher Wood who attempted and failed to abandon, to unlearn, his training.

One of the refreshing features of much of the pictorial work in this class is that it is not confined to watercolour and oil paint. Many substances were used, separately or in combination with others, to create pictures – sand, shells, cut and rolled paper, mica, textiles, butterflies, seeds, feathers, straw, and many other materials. Of course the use of these various materials for picture-making provided a genteel 'amusement' for the leisured classes from the late seventeenth century. By the first half of the nineteenth century at least one working craftsman, a tailor by trade, was able to sell 'feltwork' pictures to tourists. George Smart of Frant near Tunbridge Wells could boast the patronage of no less a person than the Duke of Sussex. His early collages are stuck to background scenes painted in watercolour, but in later examples he used hand-coloured lithographs. It is just possible that in drawing these backgrounds Smart used his camera obscura, an illustration of which occurs in some of his works and is mentioned in the verse on his trade label. His favourite subjects, which he often repeated, were *The Earth Stopper* and two well-known local 'characters', *The Postman* (Old Bright) and *The Goose Woman* (Elizabeth Horne, aged 88 in 1830).

By the eighteenth century the academic sculptor worked in marble, terracotta and bronze. Wood, that most tactile of substances, was hardly conceived of as a sculptural material. In contrast the vernacular sculptor possessed no such prejudice but in effect continued a medieval tradition for wood carving, including the use of gilding and painting. This flamboyant surface decoration was nevertheless handled with great sensitivity. Unfortunately repainting has often destroyed the subtle use of powerful colour. Technically wood is a more difficult material to carve to its ultimate potential than either stone or marble. The decorative carvers of the eighteenth and nineteenth centuries were not amateurs. They may have been far removed from the academic sculptors of their day, but their work was the result of years of apprenticeship. The importance of this point lies in the fact that much vernacular art is different not so much in quality as in status. The one claims intellectual superiority, the other demonstrates technical

skill. In reality a particular person may have been endowed with both, but his work has been placed by historical circumstances in one category or the other.

The eighteenth-century decorative wood carvers of this kind found many openings for their work; these included ship-carving, three-dimensional trade signs, and also the carved frames that Hogarth illustrates surrounding two-dimensional signboards. By the nineteenth century the iron hulls of the steam-powered ships meant that carved decoration was no longer possible. One 'ornamental carver', A. E. Anderson of Hotwells, Bristol, is known to have turned from ship-carving to making roundabout animals for fairgrounds. This transition was probably widespread since the steam-power that destroyed one area of patronage made possible the development of another. With the roundabouts, those monuments to 'de-mountable baroque' that only steam could drive, may be seen the last appearance of vernacular sculpture in Britain.

Perhaps one of the best known and least understood aspects of vernacular art is the painted decoration traditionally applied to canal narrow-boats. It is well known that, in addition to the name of the boat's owner, roses and castles abound, but the source of these two emblems is not known. The castles usually have a foreign look and the roses a calligraphic treatment, similar to some painted ceramic decoration, which is otherwise not found elsewhere in Britain. None of this work blossomed until the canals were in decline in the face of competition with the railways. Only when it became necessary for these boats to be 'manned' by the unpaid labour of a family did these homely devices appear. Whatever their source they, together with that other late manifestation of a 'people's art', the Romany wagon, are proof that industrialization did not immediately destroy vernacular art, and did not prevent new forms from developing. In the twentieth century there are isolated examples of a surviving art in this general tradition, such as the straw thatch decorations by Alf Wright of Somerton, Somerset, but these are surely the exception. Is it the evening class that is the enemy within? Is it the possibility available to us all of becoming 'real' artists that has denied us the hope of ever doing so? Whatever the cause, we recognize in this work values that are now lost and which are therefore the more cherished.

5

Architecture

J. M. RICHARDS

Through much of Western architectural history Britain appears as no more than an outlying part of Europe, where the styles and techniques originating in the centres of European culture – located for the most part in France and Italy – were duly adopted with only minor variations resulting from different skills and resources. But there are certain periods in which history reveals Britain as having an architectural will of her own, periods that can be seen to reflect changes in her political and economic relations with Europe as well as the varying strength of her own creative impulses.

To say this, of course, is to over-simplify. Even during the long periods of total British subservience to European culture there were moments when Britain made her own contributions, not only adopting but improving on the European model, as for example when the masons building Durham Cathedral (Fig. 50), in the Romanesque style of Caen and Jumièges which permeated England after the Norman Conquest, introduced, in 1128, something quite new: ribbed vaulting, which had no precedent in France and was not to be employed there until a generation afterwards. But such innovations, then and for several centuries, were rare and untypical. Any essay on architecture in Britain must concentrate on the episodes that came later when Britain can be seen to have asserted her independence and created a mode of building markedly different from those current in the rest of Europe.

Four such episodes are oustanding. The first was in the fourteenth and fifteenth centuries, when Europe was beginning to turn irrevocably to the Renaissance. Britain on the other hand persisted with the process of devising new strains of what we now call Gothic, the style of the whole of European architecture throughout the Middle Ages. English Gothic had hitherto followed the same phases as continental, though with certain differences that make it impossible to confuse, say, an English cathedral with a

50. Durham Cathedral: nave with ribbed vaulting dating from 1128 (the first instance of its use in Britain)

51. York Minster: the typically Perpendicular western towers (1432–74)

ment of the preceding Gothic styles in that it owed its structure and proportions, especially the characteristic proportion of wide window to minimal supporting wall, to the ambition that had repeatedly fired the Gothic builders: to enclose greater spaces by ever more daring means. Window and wall were dissolved into one tall screen – a continuous arcade of openings – and wall surfaces were unified by the rectangular panelling that gave Perpendicular architecture its name and was echoed in the tracery that subdivided the windows.

The beginnings of this new direction in Gothic architecture can be traced much further back – as far as 1292, to St Stephen's Chapel in the Palace of Westminster (where Parliament met from 1547; the chapel was refurbished by Wren in 1707 and was destroyed in the fire of 1834). It next showed itself

52. Ilminster, Somerset: one of the Perpendicular church towers for which the county is noted

French. These are often a matter of aspiration rather than of style or constructional ability. The aim of the French cathedral, for example, was airy space and soaring height, the piling of daring vault on arch as though to court the disaster that actually happened at Beauvais in 1284; whereas nothing comparable was achieved in Britain, except to a lesser degree at Westminster Abbey and in the choir at Canterbury – the most French of the greater English churches.

The divergence came early in the fifteenth century, by which time the Renaissance was establishing itself in Italy and the Gothic buildings still being constructed elsewhere in all continental countries were increasingly elaborate and flamboyant. Only in Britain did Gothic turn in the opposite direction, towards a rectilinear austerity that relied more on geometry than on ornament. Britain created a Gothic architecture of her own which was afterwards christened Perpendicular. It was a further logical develop-

clearly in the choir of Gloucester Cathedral, rebuilt in 1330 as a setting for the tomb of the murdered King Edward II. Those were the pioneers. Many other splendid interiors followed their initiatives, such as the nave of Canterbury Cathedral (begun in 1380 and the work of Henry Yevele, King Richard II's master-mason) and the nave at Winchester (around 1400).

But the change was far from being only internal. Another characteristic Perpendicular contribution to many of England's greater churches was the addition of richly modelled towers of a type no other country possesses, which gave them the spectacular silhouettes that are so splendid a feature of the distant views of the cities most of them still dominate. Examples are the western towers of York Minster (Fig. 51), Beverley Minster, and Canterbury, Gloucester, and Worcester Cathedrals, all of which have gracefully pinnacled towers built between 1375 and 1500.

However, the most remarkable, and the most widespread, achievement of the Perpendicular age was the great number of large upstanding parish churches (Fig. 52). By the end of the fourteenth century, first the wool and then the cloth-weaving trades were making England wealthy, and political as well as economic power, previously concentrated in the crown and the baronage, was now to a much greater extent in the hands of the local gentry and the town burgesses and merchants, organized into influential trade guilds. The building of churches was one expression of regional prosperity and the pride taken in it, and this became the great age of English parish church building (Fig. 53).

In the wool-growing and cloth-making districts especially, extending across England from Somerset and the Cotswolds in the south-west to East Anglia, Lincolnshire and Yorkshire, new churches were built in great numbers, exploiting the happy circumstance that underlying nearly all these districts was a plentiful supply of limestone suitable for building. These ambitiously conceived churches are remarkable for their size and, in conformity with the new Perpendicular style, for their light airy interiors. The only comparable European interiors are those of some of the late fourteenth-century hall-churches of Bavaria and Westphalia which do not really rival them in either quality or quantity (a hall-church is one with the aisles the same height as the nave, as in Bristol Cathedral). Another characteristically English feature of the Perpendicular parish churches is their square-topped towers, a phenomenon almost unknown on the Continent. Such towers are a familiar

ingredient of the rural landscape of nearly every part of England, except in a few localities such as Northamptonshire and Lincolnshire which, especially during the fourteenth century, made a speciality of spires. This was a period that saw new towers added to many earlier churches.

Instead of the stone vaulting that was being developed in increasing complexity in the cathedrals and abbeys but required a degree of technical skill and invention not available everywhere, the parish churches of the Perpendicular period made a speciality of elaborate timber roofs, which are once more a peculiarly English achievement and a tribute to England's traditional skill in carpentry. This was shown also in numerous carved rood-screens and other furnishings. Timber roofs are seen at their finest

53. Cirencester, Glos.: the spacious 15th-century parish church interior, typical of the wool-growing regions of England

in East Anglia, where good building stone was not available and the churches themselves were built of a mixture of roughly squared stones and flints (Fig. 54). Their roofs show structural skill and invention as well as a high standard of craftsmanship in timber, using the hammer-beam and other devices to span the wide naves and being light enough in weight to make the elaborately buttressed walls of the stone-vaulted cathedrals unnecessary.

The fifteenth century saw some decline in trade following the loss of England's continental possessions and the confusion of the Wars of the Roses. Conditions became more settled under the Tudor kings, even though England was becoming increasingly cut off from the Continent – more so, inevitably, after King Henry VIII broke with the Roman Church. This was not a time of much church building; yet in the Tudor period the Perpendicular style of architecture reached its climax in several private chapels which are among the triumphs of English architecture but need not be discussed in detail here since they are separately described and illustrated elsewhere in these pages. In them the

54. The church of All Saints, Necton, Norfolk: early 15th-century hammer-beam roof

potentialities of Perpendicular Gothic were exploited as fully as the laws of mechanics and the considerable skills of the sixteenth-century masons allowed.

The adaptability of the Perpendicular style to the demands of secular as well as ecclesiastical building is shown in any number of buildings catering for a more developed society's growing needs: guildhalls, colleges, and hospitals, many of which were endowed by the powerful trade guilds. Their characteristic idiom, with its ranges of square-headed mullioned windows and frequent use of the four-centred arch, set the style also for domestic buildings. Unlike the medieval castle, these no longer needed to be designed primarily for defence, and country houses, many grand enough to be called palaces, are the outstanding monuments of the Tudor and Elizabethan age.

Some of the most exuberant examples were built by members of the new race of administrators and merchants who had superseded the ancient landed aristocracy as the rulers of England. These houses were still in a general sense medieval, with their irregular planning and picturesqueness of silhouette, the only new development being a wholly untutored use of elements from the Renaissance applied as decoration. Wollaton, Notts. (1560) (Fig. 55), Longleat, Wilts. (1572), Burghley, Northants. (1577), and Hardwick, Derbyshire (1590) are only a few of the great houses built at this time. Their style cannot however be described as exclusively English since the somewhat earlier French châteaux, such as Chambord (1519) and many others along the River Loire, display a similar mixture of styles in anticipation of architecture's complete acceptance of the Renaissance. Some of the great English houses may indeed have been influenced by these – Burghley is an example – but the Renaissance detail incorporated in others of the time is Flemish as much as French. The English houses however had one unique internal feature which I shall be coming back to later: the long gallery, an upstairs room often of astonishing length (good examples are at Hardwick and Blickling (Fig. 56); also at St John's College, Cambridge) which was used as a promenade in bad weather, for entertaining, for the display of trophies, pictures and the like and, it is believed, as a dormitory for some of the large number of servants retained in these great houses.

ABOVE RIGHT
55. Wollaton Hall, Notts. 1580.
Designed by Robert Smythson

BELOW RIGHT
56. Blickling Hall, Norfolk: the long gallery. 1616.
Designed by Robert Lyminge

The Stone
and Glass Cage

J. M. RICHARDS

ENGLISH Gothic architecture reached its climax in a number of private chapels built during the Tudor period. These have no parallel on the Continent which by then had finished with Gothic and was fully committed to the Renaissance. They brought to a logical conclusion, and developed to the ultimate practical degree, the ideals initiated when the Perpendicular style of Gothic took over in the fourteenth century.

These ideals included the unification of the interior to form one great aisleless space, comprehensible at a glance and only partially interrupted by screens – contrasting dramatically with the multiple subdivision of the parish church or cathedral. Other characteristics were a daring stone structure with only the minimum points of support and the maximum area of glass, so that the effect was of a stone-ribbed cage and the interior was flooded with light. A high roof was usually graced with fan-vaulting, and wall surfaces were covered with a vertical pattern of geometrical panelling.

A forerunner of the stone and glass cage a whole century earlier was the choir of Gloucester Cathedral (Fig. 1), completed in 1350 and comprising all the foregoing elements except the fan-vaulting (which was first used at Sherborne Abbey in 1446–59). The great east window at Gloucester was made so wide that the side walls slant outwards at the end to accommodate it.

The principal private chapels where this late Perpendicular achieves its ultimate development are, in order of date, that of King's College, Cambridge (1446–1515), seen here (Fig. 4) from the east end with the coming Renaissance represented by the carved oak screen added by Henry VIII, the work of Italian craftsmen; the chapel at Eton College (1449–75) (Fig. 5); St George's Chapel, Windsor Castle (1473–1516) (Fig. 3); and Henry VII's chapel in Westminster Abbey (1502–c. 1512) (Fig. 2). The last is shown from the outside to illustrate the structural system on which it and the other stone-cage buildings were based. The walls were stiffened, and the thrust of the roof-vaulting resisted, by buttresses at right angles. These were usually flying buttresses; that is, half-arches taking the weight down on to stone piers which were given extra stability by heavy pinnacles. At Westminster the pinnacles are carved and contoured to form the most striking decorative feature of the Abbey when seen from the east.

LEFT 1. Gloucester Cathedral: choir (completed 1350)

ABOVE RIGHT 2. Westminster Abbey: exterior of Henry VII Chapel (1502–c. 1512)

ABOVE FAR RIGHT 3. Windsor Castle: St George's Chapel (1473–1516)

BELOW RIGHT 4. King's College, Cambridge: chapel (1446–1515)

BELOW FAR RIGHT 5. Eton College: chapel (1449–75)

The second episode in architectural history that saw England taking a course of her own, in a different direction from the continent of Europe, is one with a wholly residential purpose: the Palladian mansion, which emerged quite suddenly early in the eighteenth century. In the first years of the previous century, Inigo Jones had brought from Italy the fully realized Renaissance language, a language based on antique models and – more important – requiring a building to be conceived as a whole, to which each part must be logically related. Jones had studied in Italy, but he began his English career as a designer of masques (the dramatic entertainments popular at the court of King James I) and it was only on his return from his second visit to Italy in 1615 that he turned to building. The style he adopted was not, however, the style then current in Italy but that of fifty years before, for he had become a devotee of the work of Andrea Palladio (1508–80); and he can therefore be said, when inaugurating the Renaissance in England, to have revived a past episode – though only recently past – in European architecture, another example of the English habit of being a little out of step with European developments.

57. Baroque tower of the church of St Mary-le-Bow in the City of London. 1670–83. Designed by Christopher Wren

Inigo Jones's Palladian style was but reluctantly absorbed into English architecture, being largely a fashion imposed by the Stuart court. While Jones was already at work in London, the newly rich and the landed aristocracy were still building their country mansions in the hardly altered version of the late medieval style referred to above. The Cecil family's Hatfield House in Hertfordshire was not completed until 1612 and Robert Smythson, the master-mason responsible for Longleat, Hardwick, and Wollaton, completed the eccentrically backward-looking Bolsover Castle, Derbyshire, as late as 1617. By that year Inigo Jones was already building the Queen's House at Greenwich, a pure and correct example of a style of architecture from a different world.

This Renaissance world was international and Britain soon became part of it, drawing her inspiration sometimes, as Jones had, directly from Italy, sometimes by way of France and, especially after William of Orange extinguished the Stuart dynasty, from the Netherlands. This Dutch influence, which was accentuated by close commercial links, assisted English architects from Sir Christopher Wren onwards to evolve a sober and relatively unpretentious style in brick that was to become the ancestor of the Georgian style of the later eighteenth century. It eventually therefore formed the basis of the squares and terraces that gave their dignity and regularity to British towns when they came rapidly to expand with the growth of commerce from the end of the seventeenth century onwards.

58. Holkham Hall, Norfolk. 1734. Designed by Lord Burlington and William Kent.
The south front, with all the characteristic features of the Palladian mansion

Although Britain had thus adopted the Renaissance styles established on the Continent, she eschewed the ambitions and elaborations of the Baroque architecture that developed there in the seventeenth century. Only some of Wren's church spires (Fig. 57), certain buildings by Hawksmoor, Vanbrugh's spectacular country mansions, and a few exceptional designs like Thomas Archer's for St John's church in Smith Square, London (1713), can be called Baroque, and none of them can compete with the far more theatrical Baroque found in France, Italy, Germany, and Austria. It was while architecture in these countries was at its most extravagant that Britain set out once again on her own — in a totally opposite direction.

This was the result of a revival of interest in the style of Palladio that had been pioneered in England a hundred years before by Inigo Jones. The revival began with the publication in 1715 of two books: a translation into English of Palladio's *I Quattro Libri dell'Architettura*, and *Vitruvius Britannicus* by the English architect Colen Campbell, which was a survey of recent English architecture with special stress on the attributes it had derived from Palladio and which Palladio had himself derived from his Roman master Vitruvius. The volume also illustrated designs for country mansions that Campbell had made in Palladio's style. There was already widespread interest in Italian architecture, and in the Classical learning out of which it had grown, because of the tradition that wealthy young Britons, as part of their education, should make the Grand Tour of Europe, culminating in a stay in Italy.

One of those who went on the Grand Tour was Richard Boyle, third Earl of Burlington, a patron of the arts who had been a subscriber to *Vitruvius Britannicus*. Burlington enthusiastically took up the cause of Palladian architecture, and in 1719 he returned to Italy to spend some months studying Palladio's buildings in the latter's home town of Vicenza, from which he brought back a collection of Palladio's own drawings. He also brought back William Kent, an English painter who had been studying in Rome, and employed him as a decorator and an associate architect when he himself began designing buildings. These were in a style based chiefly on Palladio and to a lesser extent on the buildings of ancient Rome — a style strikingly different from that then prevailing in England, where architecture remained largely under Wren's influence.

Burlington, who was determined to make the new style fashionable, was not only a patron but a talented architect in his own right. Among the influential buildings he designed with Kent's assistance were a villa for his own use at Chiswick on the western edge of London (1725), modelled on Palladio's Villa Capra near Vicenza, and a large mansion in Norfolk, Holkham Hall (1734) (Fig. 58), for his friend the Earl of Leicester. Holkham displays nearly all the features associated with the Palladian style that was to dominate country house building, and indeed English architecture generally, for the rest of

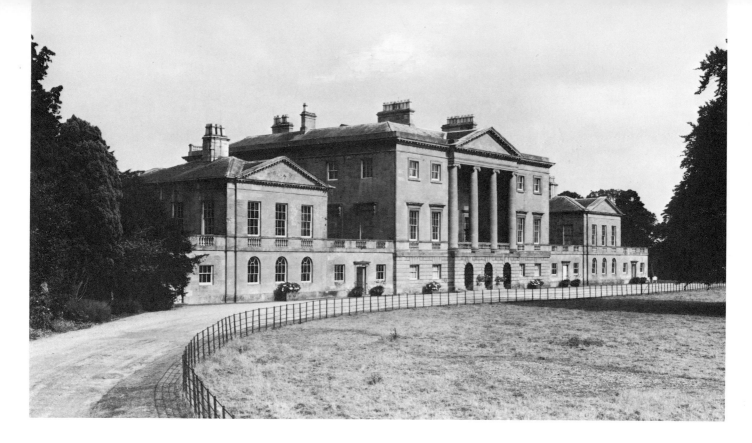

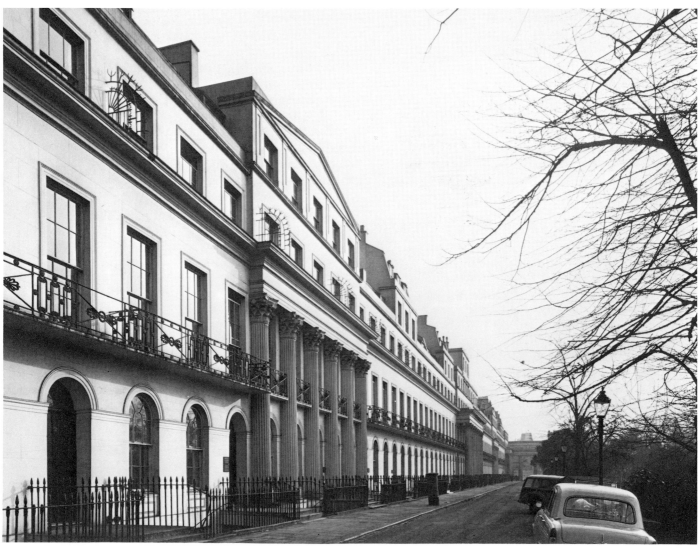

the century. Instead of the restless forms and dramatic silhouettes of the Baroque it had expanses of plain walling, level roofs interrupted only by shallow pediments, sparsely grouped windows (including the three-light 'Venetian' window, arched in the centre, that was to be a favourite with all the subsequent Palladian architects) and – most characteristic of all – a temple portico.

Palladio had been the first to use, as the central feature of a house, a projecting portico, composed of columns crowned by a triangular pediment and mounted on a flight of steps, such as the Greeks and Romans placed as the frontispiece of their temples. The first to use it in this way in England was John Webb, Inigo Jones's pupil and son-in-law, when he added such a portico to the garden front of The Vyne, Hampshire, a red-brick sixteenth-century house that he remodelled in 1650; but it did not become customary until Colen Campbell adopted it for the first large house he designed – Wanstead House, Essex (completed 1720; demolished a hundred years later). Burlington used the temple portico soon afterwards and it became the hallmark of the Palladian mansion, providing the stately entrances to the otherwise simple, symmetrical façades of innumerable houses standing in landscaped parks in every part of England (Fig. 59).

The eighteenth century was an age of widespread country house building, or alternatively of remodelling existing country houses when local squires or newly prosperous city merchants desired to bring their residences into line with the new Palladian fashion. The era of the latter overlapped the era when Romantic aspirations overtook contentment with a quiet Classical taste, but this new Romanticism found expression less in the architecture than in the layout and embellishment of the carefully contrived landscapes that surrounded many of the Palladian mansions, embellished in the case of the more wealthy and sophisticated with picturesquely placed structures like temples, obelisks, and urns. The landscaped park was another English speciality, though only on the fringe of architecture.

The rectangular, formally designed Palladian

houses were usually white. If stone was not available locally they were stuccoed and painted, and therefore stood out from their background of undulating grassland and carefully grouped trees, unlike their medieval and Elizabethan predecessors which merged discreetly into their settings. The Palladian fashion spread all over the country and every region had its local practitioners who, guided by pattern-books when not professionally educated, found the few and simple elements of the Palladian style not difficult to handle. John Carr of York is an example of a local architect whose work was as distinguished as any based on the metropolis. Further afield Ireland was endowed at this time with a number of handsome Classical mansions under Palladian influence by the landowners of the English Protestant ascendancy.

The influence of Palladianism was remarkably long-lasting. For example when the styles of interiors and furnishings were extended and enriched by the antiquarian researches of architects like Robert Adam, who found sources of decoration in many places besides Italy, the plain almost box-like house exteriors, with level roof-lines and pillared porticoes, maintained their popularity. The influence of Palladianism can be recognized in the work of successful Regency architects like John Nash (Fig. 60), debased and unscholarly though their Classical vocabulary may have become.

While the Palladian and the Georgian were still the accepted styles for country mansions – and indeed for town houses and city streets as well – developments in the world outside architecture were leading towards the third of the four main episodes in her architectural history in which Britain stood alone. The Industrial Revolution, of which Britain was the sole pioneer, had begun before the end of the eighteenth century. The nineteenth saw a dramatic acceleration of the process, endowing Britain with a range of new buildings unprecedented in their nature and purpose and formed simultaneously by the demands of a new industrial age and by the new technologies that made it possible to meet them.

As we have seen, many of the forward movements by which Gothic architecture was nourished occurred as the medieval master-masons discovered ways of solving problems they had been unable to solve before, such as spanning great spaces with stone vaulting and reducing the amount of solid walling so as to flood their interiors with light. In the eighteenth and nineteenth centuries, after architects had been content for nearly three hundred years with the static structural methods used by the Romans – the wall,

ABOVE LEFT
59. Basildon Park, Berkshire. 1776.
A typical Palladian country house

BELOW LEFT
60. Chester Terrace, Regents Park, London. 1825.
Designed by John Nash

the beam and the arch – there arose again a desire to explore more dynamic possibilities not unlike the desire to tread unknown paths that had inspired the Gothic masons.

Initially such experiments were not made by architects, who were increasingly concerned at this time with matters of style and scholarship, but by a new generation of engineers created by, and responding to, the demands of the new industrial age. Trade and industry, for example, required better transport, and the growth of new nation-wide transport systems – first road, then canal, then railway – and the construction of buildings to serve them encouraged trade and industry to expand still further. It was an engineer, F.T. Pritchard, working with Abraham Darby, one of the pioneers of the industrial production of iron, who built the world's first iron bridge across the River Severn at Coalbrookdale in 1779; and it was one of the greatest of the early engineers, Thomas Telford, who threw a suspension bridge an unprecedented distance across the Menai Strait in 1826 to carry a new coach-road from London to Holyhead (Fig. 62). The method of construction he used is still the basis of long-span bridges today.

61. Calver Mill, Derbyshire. 1785.
An early multi-storey cotton mill

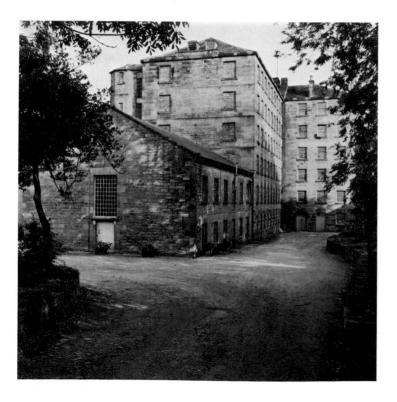

In due course the railways produced engineers like Robert Stephenson and Isambard Brunel who not only built equally remarkable bridges and viaducts but applied their vision and invention to buildings of several kinds, including the station buildings that brought the ordinary citizen – the now avid user of the railways – into close contact with the new engineering. In the growing cities the railway station was acknowledged as a major contribution to civic architecture. The terminal stations in particular (some key examples of which are separately described and illustrated in these pages) combined the drama of unprecedented forms of roof construction with an architectural presence that reveals the consciousness of their engineers, and of the architects with whom they collaborated, that they were not only solving technical problems but celebrating a new age of achievement.

The types of structure that Britain pioneered as a contribution to the Industrial Revolution did not, however, begin with these vital transport buildings, nor did they even begin in the towns in spite of the close connection between the growth of commerce and industry and the progressive urbanization of British life. The first notable buildings emerging from the Industrial Revolution were located deep in the English countryside. The manufacture of cloth had been for centuries the basis of Britain's export trade. At the time when the spinning process was mechanized at the end of the eighteenth century and substantial buildings were required to house the new machinery, manufacture was dependent on water-power, and textile mills were installed along the fast-flowing streams and rivers of Derbyshire and Yorkshire. Soon afterwards came the mechanization of the woollen industry, and similar mills were built where water-power was available near the wool-producing areas of the Cotswolds and in many other places. When the power-loom was introduced in the 1820s, weaving as well as spinning was industrialized and riverside mills were constructed in even greater numbers. Only when steam-power replaced water-power was the textile industry able to move to the towns, near to the supply of labour and nearer to the ports at which cotton, its raw material, arrived (and wool also when raw wool began to be imported from Australia) and from which its products were exported.

RIGHT
62. Menai Suspension Bridge, connecting Gwynedd to Anglesey. Begun 1818. Designed by Thomas Telford.
A pioneer example of monumental engineering

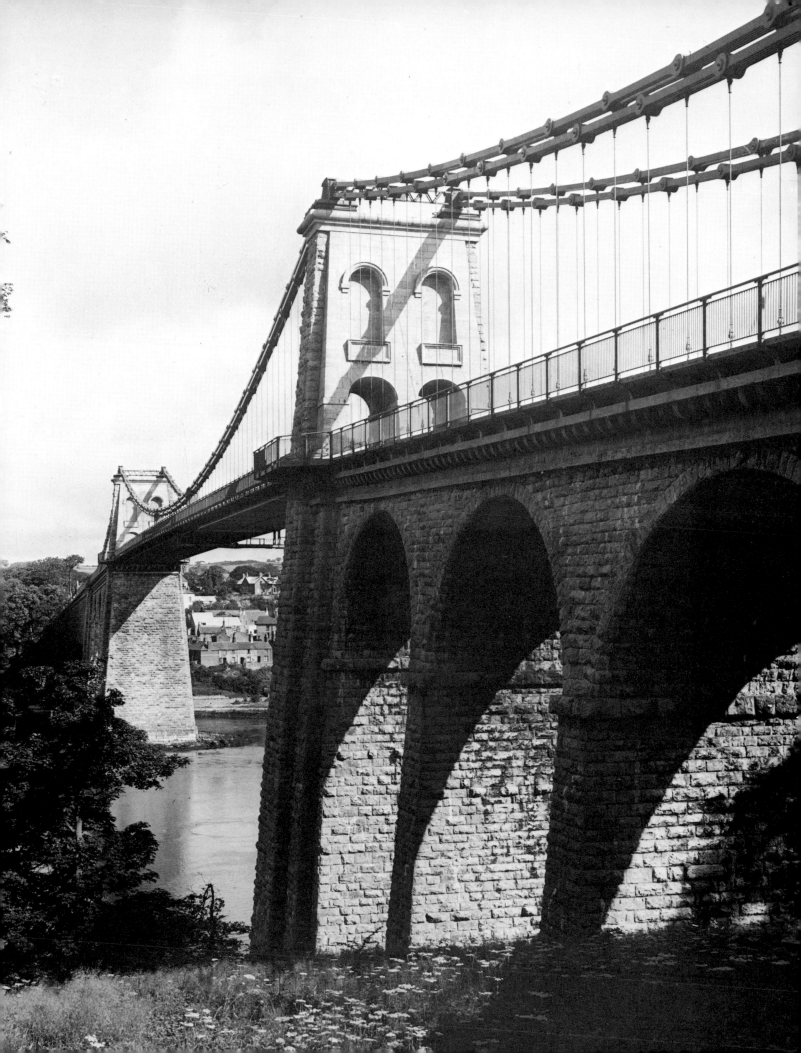

The Great
Trainshed

J. M. RICHARDS

THE arrival of professional engineers on the architectural scene around 1800 quite literally gave architecture a new dimension. The network of railways which followed helped introduce new building types and new forms of structure into all parts of Britain. Among the most dramatic of these were the major railway termini and in particular their trainsheds – the covered areas that shelter the platforms and the lines between. They were conceived by engineers and designed sometimes with the help of the architectural profession and sometimes without. The challenge these trainsheds presented was to roof over wide spaces with the minimum intermediate supports and at the same time provide adequate light and enough height for smoke, steam and noise to disperse. Pride in their

achievements led engineers and architects to aspire to something more than utility, and the cities to which the railways brought increased trade and importance were prepared to regard these stations as civic monuments.

In the first notable trainshed (Fig. 1), at Temple Meads, Bristol (1839, now disused), the engineer responsible was I. K. Brunel. He was content to return to historic precedent when designing his wide-span roof. Brunel built a hammer-beam roof in timber, based on the roofs of late medieval halls and churches and spanning 72 feet – 4 feet more than the hammer-beam roof of Westminster Hall.

An important breakthrough came nine years later when the architect John Dobson designed an iron and glass roof for Newcastle Central station (Fig. 2). This was the first trainshed with arched iron ribs forming a high vault, and it influenced station design all over the world. Trainsheds were still, however, concealed behind the more conventionally architectural façades of the station buildings; but at the King's Cross terminus in London in 1852 (Fig. 3) an engineer, Lewis Cubitt, provided an exterior that fully expressed the twin-arched trainshed behind. This was however of timber, though soon replaced by iron.

Other London termini followed Dobson's pattern. Charing Cross (by Hawkshaw, 1863), although hidden from the street by a hotel, took the same type of structure a stage further by covering lines and platforms with one curved span of 164 feet, eliminating the rows of columns that had supported Dobson's three parallel 55-foot vaults at Newcastle. Iron and glass trainshed roofs were also built at Paddington in 1850 (by Brunel), at Birmingham New Street in 1854 (demolished 1960), at Liverpool Central in 1874, at York in 1877 (Fig. 5), and elsewhere.

The most spectacular of them all was that at St Pancras, London (1868), though this too is hidden from the outside by a differently styled hotel. There W. H. Barlow threw a single span of steel and glass 243 feet across the whole width of the station (Fig. 4). It remained for nearly seventy years the widest span roof ever constructed over a permanent building.

LEFT 1. Temple Meads Station, Bristol. 1839. Designed by I.K. Brunel

BELOW LEFT 2. Newcastle Central Station. 1848. Designed by John Dobson

RIGHT 3. King's Cross Station, London. 1852. Designed by Lewis Cubitt

BELOW 4. St Pancras Station. 1868. Designed by W. H. Barlow

BOTTOM 5. York Railway Station. 1877. Designed by Thomas Prosser

63. Palm House, Kew Gardens, London. 1844. Glass and iron architecture by Decimus Burton and Richard Turner

These multi-storey textile mills, initially in the countryside and then in the towns, were the first of several new types of building created by the Industrial Revolution that bulked larger in the landscape than any buildings had done since the cathedrals and castles of the Middle Ages (Fig. 61). Their walls at first were of solid stone and their floors of wood, but the latter had to carry heavy machinery and their interiors as far as possible to be unimpeded by columns. These needs soon produced the means: the iron frame. Iron columns were used as early as 1792 in his mill at Derby by Jedediah Strutt, one of the pioneers of mechanized cotton-spinning, and the first multi-storey building with both beams and columns of iron was a flax-mill at Shrewsbury, designed by Charles Bage in 1796. This was the ancestor of the steel-framed building which has altered the very nature of industrial and commercial architecture.

These impressive monuments to the Industrial Revolution, the most prominent structures in the newly flourishing textile cities like Halifax, are only some among many. Britain's docks and harbours, rapidly enlarged to cater for her expanding ocean-going trade, were equipped with extensive ranges of warehouses. In London, Liverpool, Bristol and elsewhere dock and harbour buildings speak for the boldness and enterprise of the new race of architect-engineers, whose structures, while functional, now displayed considerable architectural refinement.

As the nineteenth century grew older, other types of building arose out of the successful exploitation of new, industrially produced materials and their application to new purposes. One of these was glass. From the growing interest in scientific study arose the elegant Palm House in Kew Gardens (Fig. 63), designed in 1844 by the engineer Richard Turner in collaboration, surprisingly, with the scholarly architect – a leading exponent of the then fashionable Greek Revival – Decimus Burton. Other glass and iron buildings were designed for the Duke of Northumberland in his garden at Syon House by Charles Fowler, who was also the architect of glass- and iron-roofed market buildings, and for the Duke of Devonshire at Chatsworth by Joseph Paxton, who went on to build in 1851 the most famous glass and iron building of all, the Crystal Palace for the Great Exhibition in Hyde Park, London. The new combination of glass and iron also made a significant contribution to the architecture of railway stations. In these and other types of industrial building the architects – even those previously preoccupied with scholarly studies – were now active alongside the engineers, creating some of the outstanding monuments in Britain's growing industrial cities.

These novel types of building, and their methods of construction, were in advance of anything being built outside Britain, but well before the end of the nineteenth century continental Europe – and America too – had caught up. Britain ceased to be an innovator except to a limited extent in her early explorations of first the romantic, and then the antiquarian, potentialities of the revival of Gothic (see below). This remained so until Britain once more asserted her influence over the architects of other countries when she led the way in a very different field: that of small-scale domestic building.

That is the fourth of the episodes referred to at the beginning when Britain made a contribution to architecture peculiarly her own. It began with William Morris, who preached against the artificiality of contemporary architectural styles and against the misuse of machinery to imitate hand-crafted ornament and mass-produce it, thus separating the role of the maker from that of the designer. He urged a return to the traditions of the medieval craftsman, and in 1861 he set up a workshop for the production of furniture, textiles and the like designed by him and his associates (who included several of the painters and writers who had lately established the Pre-Raphaelite Brotherhood). In 1859, with the help of a like-minded architect, Philip Webb, Morris built a house for his own occupation (Fig. 64).

This house, at Bexley Heath, Kent, was revolutionary in its day. It was informally planned, more like a farmhouse than the conventional gentleman's residence in the current Classical or Gothic taste. It had an irregular arrangement of chimney-stacks and variously shaped windows, and was built of local red brick and tiles instead of the usual cream-painted stucco or the terracotta and slates which the new railway network had permitted builders to import from distant parts of the country. For it must not be forgotten that one important outcome of the Industrial Revolution, apart from the new types of building that sprang from it, was that by means of the canal and road systems it had generated it opened up new markets for building stone, slate and manufactured building products, which were now employed far

64. Red House, Bexley Heath, Kent. 1859. Designed by Philip Webb for William Morris

65. Kinmel Park, Clwyd. 1868. Designed by W. E. Nesfield. One of the first examples of the 'Queen Anne' revival

away from where they were found or made.

The interest in good craftsmanship and the use of natural and local materials inspired by Morris and Webb opened the way for the Arts and Crafts movement and for other architects, following their leadership, to break away from the conventional range of academic styles. One of these was Richard Norman Shaw, who began by designing country houses in a romantic, somewhat nostalgic 'Old English' style, making use however of traditional, local materials, and who then – with W. E. Nesfield – introduced what became known rather misleadingly as the 'Queen Anne' style (Fig. 65). This was based on the type of gabled brick house built under Dutch influence in the seventeenth century, using red brick and much white-painted woodwork, with prominent chimneys and dormer windows, and was another style of architecture peculiar to England in its day.

Norman Shaw exerted a strong influence over the next generation of English architects and over the design of small houses in which they became pre-eminent. He it was, for example, who provided the layout, and set the architectural style, of Bedford Park in West London, the first garden suburb, started in 1877. It was located close to one of the new commuter railway lines that permitted those whose work had previously confined them to central London to move to quieter and less congested surroundings. Bedford Park was designed to attract professional people who wanted something different

from the standardized, essentially urban, environment provided by the streets of stock brick houses of which most of the newly expanding residential areas were composed – the kind of people who were beginning to buy Morris wallpapers and Arts and Crafts furniture.

Several of the coming generation of small-house architects built houses at Bedford Park, some following Norman Shaw's 'Queen Anne' idiom and others evolving, here and elsewhere, an informal cottage-like style, but all maintaining Morris and Webb's interest in good craftsmanship and the use of natural materials (Fig. 66). Among them was Charles Annesley Voysey who, in accordance with this new movement, liked to take responsibility for every detail of his buildings, inside as well as out. He designed a quantity of furniture, and his textiles and wallpapers, with which he first made his reputation under the guidance of another Arts and Crafts architect A. H. Mackmurdo, a friend of Morris and Webb, had a freshness and lightness of tone better suited to daily use even than the Morris workshops' products with their tendency towards a more sombre medievalism.

Voysey distrusted the influence of foreign fashions and believed that the best architecture of the past had grown out of local conditions and requirements. On a more cottagey scale than Norman Shaw, he turned domestic architecture back to its native traditions. His houses, employing the building methods and

materials of rural England, are deceptively simple, with roughcast walls, small-paned windows, and hipped or gabled roofs. Looked at today they appear more orthodox than they were in their own time because they were widely imitated in the suburbs that soon grew up round nearly every town and city. A debased version of the new cottage housing inspired by the Arts and Crafts movement has been the basis of suburban architecture ever since.

But in the 1880s and 1890s it was revolutionary. Other architects working in a similar informal style were Ernest Newton, W. R. Lethaby (chief assistant in Norman Shaw's office and an influential teacher as well as designer), C. R. Ashbee and M. H. Baillie Scott. To these may be added Guy Dawber and Sir Edwin Lutyens, although they occupied themselves more with larger houses for the better-off.

All the work of such architects, conceived in the spirit originated by Morris and his Arts and Crafts movement, and that of the Art Workers' Guild which sprang from the common endeavours of Norman Shaw's pupils, was the basis of a new conception of both architecture and domestic furnishing that spread in due course from Britain to the Continent. At first its dissemination took place within the architectural profession and through illustrations in magazines, especially *The Studio* which circulated widely overseas. Then, so high was the reputation of British architectural and interior design in Germany, the German government, in 1896, appointed a practising architect, Hermann Muthesius, as an attaché in its embassy in London with instructions to study and report on the British revolution in the domestic arts.

The outcome was a book, *Das Englische Haus*, published by Muthesius in 1906, illustrating the work of Voysey and his colleagues. It also paid attention to the designs of the highly distinguished Glasgow architect C. R. Mackintosh with whom Muthesius had become friendly. Mackintosh, however, in spite of the historical significance of his Glasgow Art School (Fig. 67), belongs historically – especially on account of his very individual designs for furniture – to the Art Nouveau movement which was of continental origin; he therefore lies a little outside the group of architects described above as the British pioneers in this field. Through their efforts, which Muthesius helped to make widely known, a vogue for their kind of reasonableness and simplicity and for a return to traditional craftsmanship, inspired especially by the houses of C. F. A. Voysey, spread first into Germany and then all over Europe (see also *Modern Studio Crafts*, p. 233, and *Industrial Design*, p. 242).

66. Norney Grange, Shackleford, Surrey. 1897. A design by C. F. A. Voysey which revolutionized domestic architecture in England and influenced later building on the Continent

67. Glasgow School of Art. 1898. Designed by Charles Rennie Mackintosh. A Scottish building that owes little to English precedent

Although the distinctive quality of British architecture emerges most clearly in the four episodes in her history described above – those that produced her Perpendicular churches, her Palladian country houses, the unprecedented structures serving and arising from the Industrial Revolution, and the small houses associated with her Arts and Crafts movement – it is also relevant to examine the more general characteristics of Britain's contribution to architecture over the centuries; to endeavour, that is to say, to identify those characteristics that make British architecture, whatever its style or period, distinguishable from that of other Western nations.

Several such characteristics are identified and illuminated in Nikolaus Pevsner's book of 1956, *The Englishness of English Art*, which includes one chapter devoted wholly to architecture. This chapter is entitled 'Perpendicular England' and in it Pevsner describes the Perpendicular Gothic architecture of the fifteenth and sixteenth centuries just as I have tried to do more briefly in the foregoing pages. But in the

69. Norwich Castle. 12th century. The blind arcading is a typically English form of linear decoration

68. 10th-century Saxon church tower, Earls Barton, Northants. The geometrical ornament is typical of the period (the top is later)

opening passages he shows how some of the qualities of Perpendicular are typical of English architecture through almost all its history. These provide a common thread that runs through English architecture and may be summarized as a preference for the geometrical simplicities of rectilinear rather than curvilinear forms, for a separation of spaces rather than a totality of internal space, and for decoration limited to flat surfaces rather than sculptural decoration exploiting all three of architecture's dimensions. The first stands out clearly in English Perpendicular and the second I referred to in connection with the differences between French and English cathedrals; but both characteristics go right back to the beginnings of English architecture – to Saxon churches, which are the earliest surviving buildings constructed by the English for the English (discounting such buildings as the Romans put up for their own use, which were the product of an alien culture and of which only fragments remain).

Saxon churches were primitively simple in form, but it is significant that all had square ends in spite of their continental equivalents having rounded ends, the only exceptions being some of those in the southeast of England where continental influences could be expected to be stronger. In accordance with the English preference for dividing interiors into a se-

quence of compartments, many Saxon churches had a row of chambers opening off their naves instead of continuous aisles. Enrichment too, when it was attempted, was flat and rectilinear, as in the pattern of strips of stone on the faces of the tower of Earls Barton church, Northamptonshire (Fig. 68).

After the Conquest the square end of the Saxon church persisted. The first Norman churches and abbeys followed continental practice with rounded ends and radiating chapels, but their builders soon reverted to the Saxon squareness, as at Romsey Abbey, Southwell Minster, and Hereford Cathedral. The typical English Gothic cathedral also has a square end, contrasting with, for example, the French preference for the curved apsidal end or cluster of chapels. Westminster Abbey terminates at the east in a cluster of chapels, but that only shows how eager King Henry III was, when he rebuilt the abbey in 1245, to follow the style of French cathedrals like Amiens and Reims.

Characteristic also was the linear enrichment em-

ployed in the interiors of Norman cathedrals; witness the incised geometrical patterns on the stout cylindrical pillars at Durham. On other Norman buildings, including some on which enrichment of any kind was not to be expected, such as the castle keep at Norwich (Fig. 69), the English liking for surface decoration is shown by the use of blind arcading. This was much favoured in England then and afterwards and was capable of creating effects of remarkable richness, as for example in the chapter house of Bristol Cathedral and the ruined west front of the Cluniac Priory at Castle Acre, Norfolk (Fig. 70). The west fronts of two of our greatest cathedrals, Lincoln and Wells, are embellished in one case with tiers of blind arcading and in the other with tiers of niches holding figures. These reflect the same decorative inclinations as the patterns of rectangular panelling that were in due course to be one of the hallmarks of Perpendicular church interiors, and were to reappear eventually on the exterior walls of Barry and Pugin's Houses of Parliament at Westminster.

70. Castle Acre Priory, Norfolk: the west front (1140), showing the use of blind arcading typical of the transition from Norman to Gothic

The seemingly impenetrable west façades of Lincoln and Wells Cathedrals (Fig. 71), barring off the interior and penetrated only by minimal doorways, contrast with French cathedrals which as often as not have huge portals, corresponding to the nave and aisles within and opening the internal space, as it were, to the greater space outside. Instead of the traditional English treatment of interiors as a series of spaces, linked to one another but visually separate, the French aim is a comprehensive moulding of space by means of unifying vaults. More typically English is the great length of some of our cathedrals and major churches. Their horizontality is often emphasized inside by the ridge rib along the crown of the vault, which was first used in the nave at Lincoln in 1235 and became standard English practice.

Is it too far-fetched, incidentally, to associate, as Professor Pevsner does, this English fascination with extreme length with the long gallery incorporated in many Elizabethan and Jacobean mansions, which seems to the eye to disappear into an almost infinite distance? Pevsner also relates it to the long perspectives created in the Georgian street with its repetition of identical doors and windows, and he even attributes the success of Morris wallpapers to the English liking for a flat all-over pattern.

For these English qualities of geometrical plainness, squareness of outline and instinct for surface decoration are not peculiar to Gothic architecture. The great Elizabethan mansion echoes the Perpendicular church in having its walls covered with a pattern of rectangular windows – see Longleat, Hardwick, Wollaton, and many others. It also usually has a level parapeted roof-line, or at least an outline composed of rectangular elements, which can be contrasted with the high-roofed turreted silhouettes of the contemporary French châteaux.

A similar geometrical simplicity, moving a couple

71. Wells Cathedral: the west front (mid-13th century) with tiers of niches and inconspicuous doorways

of centuries ahead, is characteristic of the Palladian country house, already described as typically English. However irregular its landscape setting became under the influence of the Picturesque movements in the mid-eighteenth century, the house itself continued to stand foursquare, level-roofed, and limited in its components to the simplest geometrical forms. The same severe components can be observed in the work of some of the most eminent English Renaissance architects: for example in the rigorous geometry of Hawksmoor's churches (Fig. 72), by academic standards a law to themselves. Other architects whose buildings, for some or all of the reasons outlined above, could not be anything but English include the Woods of Bath, Henry Holland, William Wilkins, George Dance, and Sir John Soane. The last three of these were, it is true, inspired by ancient Greece but they selected from the Greek only what suited their geometrical predilections. One could add the domestic, as distinct from the monumental, buildings of Sir Christopher Wren himself; for example the Royal Hospital at Chelsea, although it could be argued that this last is typically English only because Wren made it so.

So much for the formal qualities particularly to be associated with architecture in Britain whatever the period. Another quality of quite a different kind equally to be associated with it is British architecture's inherent conservatism. This is evident in its tendency to cling to established styles and practices even when fresh circumstances suggest architectural change. Warlike-looking English castles like Tattershall, Lincolnshire (built in 1434) and Hurstmonceux, Sussex (1441), though equipped with battlements and machicolations, portcullises and arrow-slits, were built at a time when the feudal age that created the English, Welsh and Scottish castles had passed, when such architectural features were no longer called for in serious warfare since artillery had made them obsolete. These so-called castles are no more than romantically dressed-up residences with an architectural character inspired by a feeling for the pageantry of the past. We can discern the same conservatism in the turreted gateways of many Oxford and Cambridge colleges, reminiscent of medieval castle gatehouses but not seriously designed for defence. Some Tudor palaces and country mansions of the sixteenth century are entered through similar gateways whose fortified aspect can have been no more realistically intended: Hampton Court Palace (1520) and St James's Palace (1532) in London; Cowdray Castle, Sussex (1525) and Layer

72. Christchurch, Spitalfields, London. 1723. Designed by Nicholas Hawksmoor: an example of his rigorously geometric approach

Marney Hall, Essex (1520) (Fig. 73) — the last, incidentally, illustrating the use of Italian Renaissance motifs for ornamentation while the form and structure of the building clung to familiar traditions. Country houses on a more modest scale continued to be built in the old-established styles as late as the seventeenth and eighteenth centuries as if the Renaissance had never happened, and there are seventeenth-century country churches by local builders which remain indistinguishable in style from their medieval predecessors.

73. Layer Marney Hall, Essex. 1520: gatehouse with vestigial fortifications and Renaissance-influenced ornamentation

74. Penshurst Place, Kent. 1341 onwards: the great hall looking towards the screened passage

A clear example of the conservative English adherence to familiar practices is to be found in the pattern of the great hall. This first emerged as the principal all-purpose room of the medieval castle or manor-house (Fig. 74). Its layout became completely standardized: a rectangular space extending the full height of the building so that smoke could find its way out through the roof (an arrangement that was not, however, changed after fireplaces were introduced); at one end a dais for the owner lighted in all but the earliest examples by a tall bay-window; at the other end a screen with openings into a passage which led to the external entrance and across which lay the buttery, kitchens and the like.

This type of hall persisted quite unchanged for centuries, only becoming better furnished and equipped as standards of comfort improved. It remained the central feature of nearly all houses and castles and was still to be found at the centre of Elizabethan and Jacobean mansions long after the owner, whose comfort and dignity it provided for, had moved into private chambers. When the Renaissance house had eliminated it from domestic building it survived, with its original arrangement of dais, bay-window and screened passage completely unchanged, in school and college halls (nearly every college at Oxford and Cambridge has a hall after this pattern, though built perhaps in the seventeenth century or even later) and in such halls as those of London's Inns of Court which were mostly built at the end of the sixteenth century.

The extended survival of this and other medieval practices brings us to what is perhaps the supreme example of English architectural conservatism: the initiation of a Gothic Revival some years before the nineteenth century's preoccupation with past styles developed fully enough to spread the Gothic Revival into Europe. So early, indeed, did the Gothic Revival begin in England that, as Kenneth Clark observed in his book, *The Gothic Revival*, published in 1928, it might just as well be termed the Gothic *sur*vival, an observation which underlines the conservatism inherent in its beginnings. In England, as noted above, it was not until the mid-seventeenth century that the Gothic style – or a style predominantly Gothic in its antecedents – went out of use in sophisticated circles, largely through the efforts and example of Inigo Jones. The Renaissance in its successive embodiments took over, and yet the use of Gothic persisted and flourished. Oxford is the best city to observe the Gothic spirit still dominant, although the library of 1623 at St John's College, Cambridge, has been called the earliest Gothic Revival building in Britain.

Archbishop Laud's buildings at St John's College, Oxford, are mainly Gothic in character although they date from the 1630s. They may have been influenced by Laud's High Church predilection for old forms and rituals, but they are not alone in reverting to a style belonging to an earlier age and culture. The beautiful fan-vaulting over the hall staircase at Christ Church (Fig. 76) dates from 1640 and can be regarded as a belated offspring of the fan-vaulting that forms so spectacular a feature of Tudor chapels. But fan-vaulting also reappears in a gateway at University College as late as 1716 – at the beginning, that is, of the Palladian age – and the front quadrangle of the same college (1634–77) (Fig. 75), with its Tudor windows and Perpendicular mouldings, might have been built a hundred years earlier.

The north quadrangle at another Oxford college, All Soul's, built in 1709, is self-consciously Gothic. Significantly this was not the work of some local master-mason looking back towards the tradition he had been brought up in, but of Nicholas Hawksmoor, a pupil of Wren and one of the outstanding architects of the English Renaissance. Twenty years later Hawksmoor built the Gothic western towers of Westminster Abbey. These were, of course, an extension of a medieval Gothic building, as was the Gothic-styled Tom Tower (1681) at Christ Church, Oxford, by Christopher Wren himself. Yet these are evidence of a continuing interest in Gothic on the part of Classically educated architects – something rather different from the efforts of untutored craftsmen building rural houses and churches in the style they had learnt from their forefathers, yet attributable to the same conservative instincts.

Gothic as a design fashion rather than a structural system was also much in evidence in the eighteenth century. At first its inspiration was literary, maintaining the Gothic mood exploited by poets and novelists and given architectural currency by such publications as Batty Langley's pattern-book, *Architecture Improved*, which appeared in 1742. The first significant building arising from this literary fashion was Horace Walpole's house, Strawberry Hill, near London, built in 1750, and it reached a dramatic climax at Fonthill Abbey, Wiltshire, built by James Wyatt in 1796. Another sign of the times was the gothicizing of many country houses and the almost total rebuilding in careful Gothic of historic castles – Arundel and Belvoir, for example, and finally Windsor Castle for King George IV in 1824.

All these, like the Gothic ruins built in the eighteenth century to adorn gentlemen's parks, were products of the romanticism of the age, but there was

75. University College, Oxford, the front quad. 1634–77. The type of Tudor domestic architecture that continued unchanged long after the arrival of the Renaissance

76. Christ Church, Oxford, the hall staircase with its fan-vaulting of 1640. A very early instance of the revival of Gothic

also an interest in Gothic architecture inspired by antiquarianism. Kenneth Clark suggests that this might have dated back even to the Reformation, when the people of England saw monasteries torn down and the libraries and other properties that had made them the centre of English culture dispersed. Be that as it may, an antiquarian interest in Gothic was a powerful intellectual force throughout the eighteenth century and persisted into the nineteenth; witness the popularity of Sir Walter Scott's novels. Along with the revival of interest in church ritual fostered by the Tractarian movement in the 1830s, it paved the way for the more serious, and in due course more scholarly, revival of the style in the later part of the nineteenth century, inspired by A. W. N. Pugin and then by John Ruskin.

Building in the Gothic style thus never died out, and the richness and variety of English Gothic throughout the nineteenth century – it was not till late in that century that Gothic was seriously taken up elsewhere than in Britain – cannot be regarded other than as further evidence of English architecture's innate conservatism.

There is one more characteristic of British architecture, evident in all ages, that can be more briefly defined. This is its exceptional regional diversity, resulting from the complexity of Britain's geological structure. It is this characteristic which makes the buildings, especially the vernacular buildings, of the different regions of Britain so fascinating a study. The architecture of each region is, in a literal sense, coloured by the different building materials locally available. In spite of Britain's relatively small area the differences between adjoining regions are for this reason more marked than in nearly all other countries.

The diagonal belt of limestone that runs from Dorset and Somerset in the south-west to Yorkshire in the north has already been referred to. It provides the best building stone, and the most ambitiously constructed and the most richly embellished churches are to be found along its path, because schools of expert craftsmen grew up where the opportunities were greatest (the major buildings, the cathedrals and great houses, were not of course so limited since those who were building them could afford more often to bring materials from afar). But every region had its local speciality, and many of the buildings that are regarded by the visitor from abroad as typically English derive their architectural nature from the local materials and the building techniques they inspired.

Vernacular buildings – that is, the humble cottages and farm-houses of the countryside – are dealt with elsewhere (pp. 94–9), but architectural differences between the regions are not restricted to these. East Anglia, for example, a region where the flourishing cloth trade, and the prosperity based on commerce with the Netherlands, encouraged building on an ambitious scale, had no good building stone. Like other parts of England in the same situation but with access to supplies of clay, East Anglia made fruitful use of brick (in the Middle Ages the first known use of brick, which had been used by the Romans but had then gone out of use for nearly 900 years, was in fact in a house in Suffolk – Little Wenham Hall, built in about 1270), but another freely available material was flint. Some of the most splendid East Anglian churches described above as among the outstanding examples of Perpendicular architecture are of flint. It was generally combined with roughly squared stones, and in domestic buildings with brick, but it was also put to nobler purposes and used to create all-over chequerboard patterns to enliven the walls of parish churches like Kersey and Eye, both in Suffolk, and knapped flints were set flush into patterns of stone tracery to create elegantly ornamental effects, as in the fifteenth-century gatehouse of St Osyth's Priory in Essex.

77. Little Moreton Hall, Congleton, Cheshire. 1559. A monumental use of local building materials

The black and white half-timbering traditional to the Welsh borders and north-eastern England is likewise not limited to modest farm buildings and cottages. It occurs in substantial sixteenth-century mansions – national monuments as well as local landmarks – like the famous Little Moreton Hall in Cheshire (Fig. 77) and Rufford Old Hall in Lancashire. Regions possessing stone of a less easily worked type, less susceptible to cutting and carving than the limestones of the south and east, produced their own more austere architecture. The granites, for example, of the northern regions of Britain, and notably Scotland, are the source of the latter country's characteristic reliance on simplicity of form and severity of detail. Differences in regional architecture, resulting from the building materials peculiar to them, are numberless.

Mention of the restricted range of native Scottish architecture, with which can be associated the unyielding simplicities of the Welsh vernacular based on the use of slate and other untractable materials, brings us to a final observation. It will have been noticed that although the subject is the architecture of Britain, nearly all the buildings mentioned and nearly all the changes and developments discussed have been English. There was no choice about this. The riches of British architecture *are* to great extent English.

It is no exaggeration to state that in Scotland, Wales and Ireland little of the distinguished architecture, as distinct from the humble vernacular buildings, is of native inspiration. The grandest buildings in Wales are the castles built by King Edward I as part of the process of subduing the Principality in the late thirteenth century. Their architecture, it may be noted, though not Welsh, is not even English. Castles like Harlech, Conway, and Caernavon, three of the finest examples of castle-building in Britain, were the revolutionary outcome of ideas brought back from the Near East by the crusading knights. The most eminent Scottish architects, the brothers Adam, had the same Italian training as the leading English architects of their day, and the style of their buildings, and that of the handsome squares and terraces

78. Moray Place, New Town, Edinburgh. 1822. Designed by James Gillespie Graham. English Georgian and Scottish Georgian architecture were clearly based on the same sources

comprising the New Town in Edinburgh (Fig. 78), can be said to be rooted in English culture. Likewise the streets and squares which, in spite of their recent mutilation, make Dublin so fine a Georgian city, and the unsurpassed Irish eighteenth-century country houses, were for the most part the initiative of the English Protestant ascendancy.

As to the reasons, there is no doubt something in the argument that the Celtic races have less sense of form – less of an instinct for the visual arts – than the Anglo-Saxon; their artistic leanings are towards music and poetry, and a handful of round towers and some fortified feudal residences, however typical of a particular nation or locality, do not make even the beginnings of an architectural tradition. But there is much more in the fact that throughout history the fringes of Britain have been poorer than the centre, and therefore the opportunities to produce fine architecture correspondingly fewer than in more continually prosperous England. Political and economic power thus show themselves in Britain, as they do everywhere, to be an essential source of sustained architectural achievement.

93

6

Building in the Vernacular

JAMES AYRES

79. The broach spire of St Mary's Church, High Halden, Kent. Characteristic of Kent and Sussex, broach spires were traditionally clad in riven shingles

COINCIDING with the arrival of the Renaissance in Britain, a division appeared between building and architecture, between craftsmen and architects. There were those edifices designed for prestige by architects, and there were those buildings designed and constructed by skilled craftsmen. The work of these craftsmen was enunciated in a dialect which, though capable of incorporating new phrases, remained in the vernacular. In other words it was native; it was local. This division between standards of building, brought about by the new profession of 'architect', represents a most important watershed in architectural history. In terms of engineering skill, however, the medieval master masons and carpenters were, at their best, every bit the equal of those who were to assume their position.

The essential materials of traditional building were wattle and daub, oak and thatch, and numerous other ingredients such as mud, cob, clay-bat, flint, clunch, and some stone. Timber was once the most widely available building material in the British Isles. While in much of continental Europe and in North America soft woods were used in the construction of framed buildings, in Britain oak was most usual, although other hard woods such as elm were used. Two of the earliest methods of building in timber were based either on the cruck or on stave-built edifices, which suggests Saxon or Scandinavian influence. Surviving examples of the cruck are reasonably common, but the use of staves in Britain is now known by only one substantial survival in Essex (Fig. 80).

More common were walls composed of a series of closely spaced vertical members (known as 'studs'), or the simpler use of more widely spaced vertical and horizontal timbers (the latter known as 'girding beams') (Fig. 81). Diagonal 'arched braces' added strength, a necessity that became multiplied and elaborated for decorative effect. Timber frame construction demanded a language of its own to describe its numerous and various components. The term 'pole plate' (literally 'head plate') has an exactitude

by comparison with which the 'wall plate' is vague if adequate for building in brick or stone. Where a multitude of similar 'scantlings' (such as joists in a floor frame) were morticed or notched into a common member (such as a 'summer beam'), timbers were numbered using one or two versions of Roman numerals. This 'building by numbers' facilitated accurate working and simplified assembly.

By the second half of the fifteenth century the expensive and decorative jettied storey had become fashionable as a means of showing the presence of an upper floor or floors on the external elevation of a building. The use of brick nogging as infill in place of wattle and daub served to emphasize the non-structural nature of this use of bricks.

In the south-east the inheritance of fine, but by the late seventeenth century 'old-fashioned', timber-framed buildings presented certain problems when it came to weather-proofing, insulation, and modernization generally. Such buildings could be weather-boarded, or rendered as in East Anglia, or tile-hung as in Kent, Sussex and Surrey. Cladding of this kind did not completely obscure the underlying and unfashionable structure. By the eighteenth century the 'mathematical tile' served as a subterfuge which in almost every respect resembled brickwork. It was the increased use of brick and stone coupled with the diminishing oak forests that resulted in the rapid decline of timber-framed building in Britain.

Stone was taken from quarries whose importance was generally local but could occasionally be national. Such was the case with limestone from the Isle of Portland and slate from Merioneth.

80. Timber wall of the Saxon period:
St Andrew's, Greensted-Juncta-Ongar, Essex.
A stave construction showing Scandinavian influence

The multitude of materials used in vernacular building were until the seventeenth century embellished both externally and internally with painted decoration, gaudy splendour being mainly reserved for more important buildings, domestic or ecclesiastic. The cheapest preparation was limewash or whitewash, two simple distempers mixed with a medium of size combined with either quicklime or chalk. The exteriors of cottages and farmhouses were often given a coat of this and it was considered to reduce the risk of fire when applied to thatch. For interiors an annual limewash provided an effective

81. Sweet Briar Hall, Nantwich, Cheshire: close studding, square framing and curved wind braces have been used for constructional strength and decorative effect

disinfectant in addition to the advantages of redecoration. More exotic pigments were also used in distemper including yellow ochre, verdigris and red ochre. The flamboyant use of colour on external elevations was an anathema to the ideals of the Renaissance which, being based upon a rather primitive archaeology, wrongly concluded that the ancient Greeks and Romans eschewed the use of polychrome painted decoration on the façades of their buildings and on sculpture. The august austerity that was now in favour was well summed up by Sir Henry Wotton in his *Elements of Architecture* (1624) whilst at the same time betraying a desire for such frivolities: '... various colours on the *Out-walles* of *Buildings* have always in them more *Delight* then *Dignity*'. This

sense of restraint consciously developed amongst the élite was ultimately to infect the whole body of architecture. Nevertheless as late as 1719 a delightfully exuberant fresco was applied to the first floor external walls of a house at Newnham near Faversham, Kent (Fig. 83).

Both literally and metaphorically, these painted charms, these 'Gothick' adornments, were superficial. In contrast, elaborate relief decoration was a more physical presence on the face of a building and was accordingly rejected with still greater force. In general, during the last quarter of the sixteenth century and the first quarter of the seventeenth, architecture in Britain adopted the vocabulary and construction of the Renaissance but retained much of

BELOW 82. The Old Shop, Bignor, West Sussex. A late-15th-century example of a Wealden 'hall house'

ABOVE 83. Painted decoration on plaster dated 1719 on Calico House, Newnham, near Faversham, Kent

the phrasing and planning of the medieval tradition. This inevitably hybrid period created a new vernacular but one that was as classless as many of its predecessors. Some with a purer knowledge of the Italian Renaissance objected to the 'incongruities committed by many surveyors [architects] ... who [were] minded more to show that they were skilled in describing of Columns, Pilasters, Cornishes and Frontispices (though for the most part placed as the wilde Americans are wont to put pendants at their Nostrils ...)'. This was certainly the view of Sir Bathazar Gerbier in his *Counsel and Advice to All Builders* (London, 1663).

It was the inability of the traditional craftsmen to orchestrate these new elements into cohesive compositions that established the necessity of, and security for, the architect's role – a position so dramatically illustrated in Britain in the work of Inigo Jones. On the other hand it is the incongruities of scholarship combined with the good sense displayed in the use of materials that gives much post-medieval vernacular building its charm as well as its practicality. Of course this work has a direct appeal to the senses, but its incongruities cannot be enjoyed without a knowledge of their origins and its logic cannot be appreciated without an understanding of materials. Vernacular building requires a sophisticated and intimate appreciation. In small domestic buildings, both rural and urban, it was not simply the materials and methods of construction that were part of a growing tradition but their basic planning as well. It is over the last hundred years or so that a body of research has developed that makes possible the identification of certain regional characteristics based upon the arrangement of rooms in smaller houses. The 'hall house' of the Weald with its pair of jettied storeys (Fig. 82) is most characteristic of Kent and Sussex, but it may also be found outside these counties. Geographical conditions are not easily ignored and this has imposed certain house types on specific regions. The so-called 'black houses' of the Hebrides (Fig. 84) in many ways conform to the notion of the 'long house' found throughout the highland zone of England and Scotland, but they are also a unique response to the climate of the Western Isles, and to the lack of timber and abundance of boulders. The stone 'hedges' in the fields of Cornwall similarly furnish livestock with shelter from the prevailing winds in a relatively treeless county.

The rich 'lowland' areas of the South and East of the British Isles produced a great diversity of planning in small domestic buildings. The 'long house' of the highland zone, with its cross passage separating under one roof those areas allocated for human occupation from those reserved for cattle, perpetuates the ancient tradition of man cohabiting with his domesticated animals, a tradition that provided both with welcome warmth in winter. Many of these buildings are of a single storey; only with the general introduction of the chimney flue in the sixteenth century were the attic spaces freed from smoke. It was this development that made staircases and ceilings essential, and in the seventeenth century their novelty encouraged the extreme elaboration of both.

It was in the seventeenth century that stone and brick replaced wood as the principal building material (Fig. 85). In districts where the local stone was difficult to work, as with the calcareous limestone of West Sussex, detailing was frequently in brick, brick quoins and brick window surrounds and mullions. In parts of Wiltshire and East Anglia where stone was scarce or had to be carried over a considerable distance, this procedure was reversed and walling was often of brick with details in freestone. In the oolitic limestone belt stretching diagonally through England from Dorset via the Cotswolds to Lincolnshire, stone was used for walling and even for roofing. However, even in these districts ashlar (dressed and coursed stone) was reserved for important structures or the principal elevations of lesser ones. Rubble walls were commonly used but were often roughcast or rendered, a process known in

84. Hebridean 'black house' at Arnol, Isle of Lewis, Scotland. An ancient type of dwelling which continued in use into the 20th century

Scotland as harling. For work of an intermediate quality, coarsed or alternatively 'snecked' random walling was widespread. The mortar in the pointing of these walls was sometimes given greater strength by the insertion of gallets, and in Surrey and parts of Sussex these were often of ironstone which created a decorative accent. In districts where rubble walls were common, lintels over doors and windows were usually given the auxiliary support of relieving arches. Clunch, a natural material related to chalk, was too soft for external use unless surrounded by harder materials. For this reason a chequerboard effect alternating knapped flint with clunch was used in parts of East Anglia (e.g., Kings Lynn) and Wiltshire (e.g., Wilton). Since chalk is found in association with flint this was a particularly happy solution.

Discounting the re-use of Roman bricks as at St Albans Cathedral, an early and important example is Prior Overton's tower (after 1437) at Repton, Derbyshire. In the seventeenth century, at the vernacular level, the continental origins of building in brick are implied by features like 'crow-stepped' and 'tumbled' gables, and terms like 'dutch gables' and 'flemish

bond'. It should be noted that 'english bond' (alternating courses of 'headers' and 'stretchers') is in fact earlier than 'flemish bond' (alternate 'headers' and 'stretchers' in each course). The use of rubbed brick laid on a fine lime mortar was an exquisite feature by no means confined to the élite. It was of particular importance for window- and door-heads from the late seventeenth century to the early nineteenth century. Since such details were designed to 'bond in' to the surrounding brickwork with its coarser bricks and consequently deeper beds, it was necessary for rubbed bricks to be of a larger dimension.

In contrast to the permanence of brick and stone or the almost eternal qualities of the granite found in Cornwall, Devon, Scotland and Wales, cob – a mixture of mud, gravel, straw and, where available, pulverized chalk (Fig. 86) – long remained a widely used if more ephemeral building material. It was also a surprisingly long-lived one provided it was sensibly used. In the words of the old adage, 'All cob needs is a good hat and a good pair of shoes.' Domestic buildings in Devon and Somerset, and even boundary walls in Wiltshire, were provided with a 'hat' of thatch; the 'pair of shoes' was a stone plinth-wall

85. Crossways Farm, Abinger Hammer, Surrey. Second quarter of the 17th century. Stone built with dominant brick detailing

which, to further resist the damp, was given a coat of tar.

A number of authorities, such as M. W. Barley, have referred to 'the death of vernacular tradition' by about 1725. Certainly, many pre-Reformation traditions that had lingered in the post-medieval world made their final appearance in the course of the seventeenth century or early eighteenth century, for example the love of colour or the delight in relief decoration not only in carving but also in pargetting (decorative relief plasterwork generally found on external elevations). In many areas the shift from the use of timber for fuel to the use of coal had far-reaching effects on the treatment and proportions of interiors, and the appearance of exteriors which were no longer dominated by substantial brick chimneys. Furthermore, regional characteristics of house plan declined in significance, owing less to their locality and more to the social standing of their occupants. In Ulster, for example, the characteristics of buildings related to either their Irish or 'Planter' origins. Despite all these changes, and they were clearly of great importance, many buildings continued to be designed by the craftsmen who made them. These craftsmen may have made reference to the swelling numbers of manuals such as Batty Langley's *Builders' Jewel* (1754), but they remained convinced of the worth of those craft traditions which were so evidently based on empirical rather than theoretical notions and which were communicated down the generations by example and by word of mouth. The strength of the dowelled 'through-tennon', the logic of the chamfer and the mason's mitre, the decorative possibilities of batting with the bolster – all these were evidently the result of centuries of experience by practical men and all remained valid no matter which style prevailed. For these practical and fundamental reasons it is my belief that the vernacular tradition survived in Britain until the middle of the nineteenth century and in some areas until its close.

There were two principal causes for the ultimate demise of this dialect of building. The gathering pace of industrial evolution was at the heart of both. The growing use of non-locally obtained components, and the consequent and growing power of architects, divorced buildings from their place in the landscape. Henceforth they could be designed in an office, and made and assembled anywhere and everywhere. In an increasingly urbanized country where the population was growing at a prodigious rate this approach to building had many practical advantages, but it would also account for the arbitrary nature of much Victorian and later architecture which owes little to the

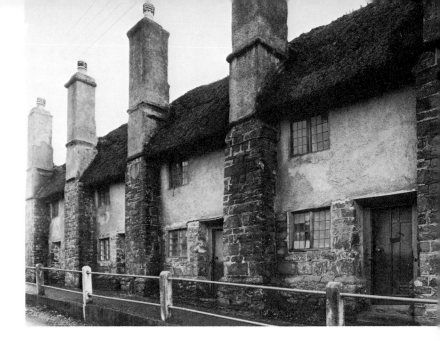

86. Almshouses, Cheriton Fitzpaine, Devon. Late 17th century. The projecting chimney stacks and ground-floor walls are of stone, with cob upper walls under a thatched roof

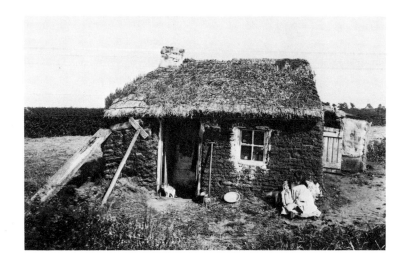

87. Single cell sod house, Toome Bridge, Antrim, Ulster. Photographed in 1916

environment in which it happens to be located. Buildings unrelated to their surroundings are at their most disconcerting in small communities. Architects such as Voysey and Lutyens attempted to reverse the trend by re-adopting local materials with their various textures and colours that are so sympathetic to the landscapes which gave them birth. Intelligent though some of these solutions were, vernacular architecture as such was dead. Its strength lay in the human touch of the hand-crafted object and the *genius loci* not of Pope and the Palladians but of an unconscious, non-literate and profound nature.

7

Stained Glass

DAVID O'CONNOR

STAINED GLASS has for so long been regarded as one of the minor arts of Britain that its major role in the past is easily forgotten. Only a fraction of the glass which once enriched our churches survives today. During the Middle Ages glass disappeared as buildings were remodelled or replaced; retaining old glass for use in new buildings as at York was rare. Many of the great works of the medieval glass-painters were destroyed at the Reformation in an outburst of Protestant iconoclasm. Iconoclasts were at work again a century later during the Civil War. The most vivid image of this period is of the Puritan, Dick Culmer, pike in hand on top of a ladder in Canterbury Cathedral, 'ratling down proud Becket's glassy bones'.

Stained glass windows have suffered also from the vagaries of taste. Seventeenth- and eighteenth-century windows were removed by the Victorians, who deplored their technical deficiencies, pagan imagery and decadent styles. A similar fate befell Victorian glass in its turn; until recently it was regarded as little better than a feeble imitation of medieval glass, lurid in colouring and sentimental in subject matter.

Yet Britain is still remarkably rich in stained glass. Although few major glazing schemes from the Middle Ages survive – places like Canterbury, York or Great Malvern are exceptional – many churches retain something of their original glazing, often a composite panel of fragments, easily passed by but containing pieces of historic interest and beauty. It will take the *Corpus Vitrearum* many years and many volumes to publish all the medieval glass in Britain.

In the post-medieval period Britain has no rivals, and the native tradition, stretching back for more than 1,300 years, is very strong. But it would be wrong to approach stained glass in Britain from too nationalistic a viewpoint because the country is a museum of European glass. Flemish roundels and domestic panels were popular with collectors here from the middle of the eighteenth century. After the French Revolution, whole windows were shipped here from the Continent and many of our churches, houses and museums contain important collections of foreign glass. Contacts with foreign glaziers have been strong since the seventh century. During most of the Middle Ages the coloured glass used by English glaziers was purchased from glass-houses in Normandy and the Rhineland. Stylistic influences were strong from these areas, particularly at the end of the Middle Ages when Flemish and German glass-painters settled in England under royal patronage, and in the seventeenth century when the van Linge family (Fig. 88) worked here. Foreign glass of nineteenth-century date is well represented in a number of works by the Gérente brothers, the Munich School, and Capronnier of Brussels. Among important modern works by foreign designers are the windows at Canterbury Cathedral by Ervin Bossanyi (resident here from 1934), the Chagall windows at Tudeley and Chichester, and the Gabriel Loire glass at Salisbury Cathedral (1979).

Although the Romans introduced window glass to Britain, it is not until the seventh century that there is evidence for stained glass. When St Wilfrid restored the Saxon Minster at York *c*. 670 'he prevented birds and rain from entering through the windows by means of glass, through which, however, the light shone within'. The thick-wall construction and tiny window openings of Saxon buildings gave little scope to glaziers, but excavations at Jarrow and Monkwearmouth in Northumbria have produced beautiful fragments of coloured window glass, known from the historian Bede to be the work of seventh-century

TOP LEFT 88. *Jonah and the Whale*, Abraham van Linge. Lincoln College, Oxford: detail of east window. *c*. 1630

TOP RIGHT 89. *Christ's Appearance to the Virgin*. St Mary's, Fairford: east window of Corpus Christi Chapel. *c*. 1500

BOTTOM LEFT 90. Figure reconstructed from glass excavated at St Paul's, Jarrow. Late 7th century. Jarrow Hall Museum

BOTTOM RIGHT 91. Seated Archbishop. Lincoln Cathedral, north rose. *c*. 1200–25

craftsmen from Gaul. These fragments, amongst the earliest stained glass in Europe, are unpainted and may have been simply decorative, though some pieces have been reconstructed into a figure (Fig. 90). Further archaeological finds from Brixworth, Repton, and Winchester show that coloured window glass was a standard material in important pre-Conquest churches.

No complete windows survive before the late twelfth century. Canterbury Cathedral houses the best collection of early glass in England: a major part of the great glazing scheme drawn up after the fire of 1174 and completed for the translation of St Thomas Becket's relics into the new east end in 1220. The glass, like the architecture, has close contacts with the French cathedral of Sens, south-east of Paris, and is crucial in charting the transition from Romanesque to Gothic figure styles. These changes can be followed in the clerestory figures of Christ's ancestors beginning with Adam in the 1180s. They are powerful large-scale figures meant to be seen from a distance and the work of artists who were masters of the medium. The windows at ground level, though large, contain small-scale scenes influenced by local manuscripts. The pieces of glass are small and thick, and the effect of the colour is a glowing intensity with a dominant impression of blue. The subject matter was carefully planned, with biblical events in the choir and corona represented in a typological way, the New Testament scenes being linked with the Old Testament events which foreshadowed them. For those who could read, Latin verses explained the connection. More popular are the windows which adorn the area around the shrine in the Trinity Chapel (c. 1200–20). They illustrate the life and miracles of St Thomas in a direct and dramatic way and must have been a source of wonder to the pilgrims.

At York only the scattered remnants of a superb series of windows of c. 1180 remain. The panels, originally in Archbishop Roger's choir, were re-used mainly in the fourteenth-century nave clerestory. They include scenes from the Old Testament, Life of Christ, Last Judgement and Saints' Lives, as well as many border pieces.

After Canterbury the best early thirteenth-century glass is at Lincoln. Apart from the imposing Last Judgement in the north rose (Fig. 91) the panels, which include typological scenes and Saints' Lives, are now scattered in the choir and south transept. There are also remains of an important series of grisaille windows; these were in white glass and were ornamental, either leaded into tile-like mosaic de-signs or painted all over with stylized foliage. In simple forms grisaille had been popular with the Cistercians in the twelfth century; in England it became a standard method of glazing Early English lancets, allowing much more light into the Gothic buildings. There was a splendid series of grisaille windows at Salisbury until its destruction by Wyatt; the outstanding surviving example is the Five Sisters Window at York Minster (c. 1240).

The rise of Decorated architecture with its huge multi-light windows brought tremendous opportunities for glaziers. The tall narrow lights and elaborate tracery openings posed problems, however, for the designers, especially when, from the early fourteenth century, tracery lights began to take on curvilinear forms. One solution, taken from France, was the band-window in which coloured figure panels were set in rows against a background of grisaille. The best examples are the chapter house at York (c. 1280) and Merton College, Oxford (c. 1296), where the band-window schemes present light and unified interiors. At Merton and in the vestibule to the chapter house at York (c. 1290) the architecture and glass are further united by setting the figures beneath architectural canopies. These became a standard feature of window design to the end of the Middle Ages and reflect stylistic changes in the architecture around them.

Heraldry formed an important element in Henry III's buildings and it was he who commissioned the earliest recorded armorial glass in England, for Rochester Castle in 1247. It was used extensively in the chapter houses at Salisbury, Westminster and York, the nave of York Minster (c. 1310–40) and at Bristol, Tewkesbury, and Gloucester. Donor figures are also recorded in royal accounts from 1250 and they became another important feature of Decorated windows where they are often associated with heraldry. York nave has a fine series of clerical and lay donors, some involved in trade scenes, others robed as pilgrims.

During the fourteenth century, a new technique was discovered which was to have far-reaching effects on the colours of stained glass (one of the earliest examples is the Heraldic Window at York of c. 1310). It was found that by applying yellow stain (a solution of silver nitrate) to the exterior surface, white glass would be turned yellow when fired in the kiln. Thus on one piece of white glass a head could be painted with yellow hair, beard, crown or nimbus, where previously separate pieces of pot-yellow would have been leaded in. The stain, along with a more translucent white glass which was now being pro-

duced, meant that by the middle of the century, as at York and Gloucester, grisaille figures could be used allowing very light interiors.

The Black Death may be one reason for the comparative scarcity of stained glass from the second half of the fourteenth century, but towards its end important stylistic changes were taking place. They are best documented in a series of windows by Thomas of Oxford for William of Wykeham's foundations at New College, Oxford, and Winchester College. The Oxford Jesse Tree figures (c. 1386), now at York, and the Winchester glass (c. 1393–1400) are in a style which uses fine-line drawing and stipple shading to create softer hair, beards and drapery; and influence from International Gothic Style painting on the Continent is apparent.

The outstanding example of International Gothic Style glass is the east window of York Minster (1405–8) (see picture essay), by John Thornton of Coventry. Here the possibilities of stained glass are exploited to the full. The highly theological programme of linked Old Testament and Apocalypse scenes and the jewel-like colour suggest that the intention was to make the choir of the cathedral an image of the Heavenly Jerusalem. Thornton's articulate use of landscape and architectural settings, his extraordinary sense of drama, and his technical brilliance in modulating light, make him a major artist. His influence on glaziers in York and the North lasted throughout the fifteenth century and can be seen in numerous windows in the Minster and parish churches of York, as well as places like Cartmel Priory and Durham Cathedral. Whether glass in Coventry itself, the Midlands, Hereford, and Great Malvern can be attributed to Thornton is another matter. Similarities in design are more likely to reflect the acceptance of International Gothic by other artists working in the major glass centres which, besides York and Coventry, included Chester, Exeter, London, Norwich and Oxford.

As many fifteenth-century windows are commemorative, and were erected in conjunction with chantry chapels and tombs (as at East Harling and Long Melford), donors played a vital role, not just in choosing the subject matter, but also in determining the design and colouring of the window. Some donors could perhaps afford only simple figures of saints set on repeated white quarries. The executors of Richard Beauchamp stipulated that the best foreign glass be used for John Prudde's exceptionally lavish windows at St Mary's, Warwick (c. 1447). Special jewelled effects and abraded ruby glass are used on the draperies; similar techniques are used in less sumptuous windows at Ludlow and Browne's Hospital, Stamford.

It is the Royal Window at Canterbury (c. 1482–6) which looks forward to the final phase of English medieval glass-painting when native glaziers slowly began to accept the new naturalism of Flemish art, a process accelerated under Henry VII, who settled Flemish and German glaziers at Southwark. In the Canterbury window, partially destroyed in 1642, Edward IV, Elizabeth Woodville and their children kneel at prayer-desks in front of rich brocaded hangings. The figures are portraits in the manner of the Flemish paintings which the king admired so much.

By the early years of the sixteenth century the new style was beginning to effect radically the conservative native tradition and the changes can be seen in places like Hillesden (Bucks.), Hengrave Hall (Suffolk) and, above all, in the glazing scheme of c. 1500 at Fairford (Glos.). The scenes spread across the lights and Gothic canopies give way to colourful landscape settings and realistic interiors reminiscent of the followers of Van Eyck (Fig. 89). A much richer variety of colours is introduced, and a heavy stipple shading used to heighten the realism. These tendencies reach a climax in the Renaissance windows at King's College, Cambridge (c. 1515–45), the work of the foreign glaziers Barnard Flower, Galyon Hone and their associates, and the last great glazing scheme in England before the Reformation. The majority of the huge windows are divided typologically to show the Life of Christ in terms of the Old and the New Law. The overall effect of the glass and the architecture is stunning, but the designs, which are based upon a bewildering number of continental sources, are often so crowded with detail as to cause problems of legibility. The richness of architectural and decorative motifs in these windows makes them a vital source for the introduction of Renaissance ornament into England.

The Reformation was a disaster for stained glass; with church commissions at an end the craft fell rapidly into decline and heraldry provided the majority of commissions until the Gothic Revival of the nineteenth century.

In the seventeenth century support for religious imagery came for a time from Archbishop Laud. He patronized the Dutch artists Bernard and Abraham van Linge who worked here for twenty years prior to the Civil War of 1642–6. The east window of Lincoln College, Oxford (Fig. 88) is a good example of the rich detail and bright colours of their biblical scenes.

York Minster

DAVID O'CONNOR

THE most extensive collection of medieval stained glass in Great Britain is housed in York Minster. All the major trends in English glass-painting – from the twelfth century to the present day – are here.

The earliest glass in the Minster dates from about 1180, and consists of panels from the earlier, Romanesque, cathedral, which were re-used by the Gothic builders in the clerestory of the present nave. *The Miraculous Draught of Fishes* (Fig. 2) illustrates the intense colouring and stylized forms employed by the Romanesque glass-painters.

By the middle of the fourteenth century, when the *Annunciation to Joachim* was painted (Fig. 1), artists were exploiting the new technique of yellow stain to the full. Against a richly diapered ruby background the figures and landscape are executed in white glass with details picked out in yellow stain of varying intensity. Washes of paint are used in a sophisticated way to give depth to the drapery.

The Great East Window of the Minster is the work of John Thornton of Coventry and was executed between 1405 and 1408. This forms a huge glass altarpiece for the choir, combining Old Testament scenes with a series of Apocalypse panels, culminating in St John's vision of the Heavenly Jerusalem; a city of glass, precious jewels, colour and light. Thornton's problem was how to make the small-scale figure panels in the main lights legible from ground level. *The Creation of the Birds and Fishes* (Fig. 4) comes from the top of the main lights. The fine-line drawing technique is very sensitive but the clear use of colour and the large pieces of glass make the design easily readable from a distance.

During the sixteenth century the deep pot-metal colours of the medieval glaziers were gradually replaced by coloured enamels. These were painted and fired on to the inner surface of white glass, allowing multi-coloured painterly effects to be achieved. William Peckitt, who painted the splendid figure of Abraham from designs by Biagio Rebecca in 1793 (Fig. 3), used a mixed technique of pot-metals and enamels. The leading, which in a medieval window formed one of the most important elements in the design, is here virtually reduced to an obtrusive gridiron effect.

The Victorians reacted sharply to this type of glass-painting which they regarded as decadent and pagan. The nineteenth-century Revival began as an 'archaeological' movement to recover the techniques, styles, and subject matter of the medieval glaziers. *The Flagellation* (1845) by John Barnett of York (Fig. 5) is a good example of Revival glass. Ostensibly a restoration of late thirteenth-century glass from the Chapter House, only one piece of the original actually survives. The craftsmen have done their best to match the colours, techniques, and styles of the original. It was on the basis of this revival of medieval techniques that later nineteenth- and twentieth-century English glass-painters were to build.

ABOVE 1. *The Annunciation to Joachim (or the Shepherds)*, workshop of Master Robert. York Minster, nave south aisle. *c.* 1340–50

RIGHT 2. *The Miraculous Draught of Fishes*. York Minster, nave clerestory south. *c.* 1180

LEFT 3. *Abraham*, Biagio Rebecca and William Peckitt. York Minster, south transept. 1793

ABOVE 4. *The Creation of the Birds and Fishes*, workshop of John Thornton. York Minster, great east window. 1405–8

BELOW 5. *The Flagellation of Christ*, John Barnett. York Minster, nave clerestory south. 1845 copy of glass of *c.* 1280

Although glass-painting ceased with the Civil War, its fortunes revived with the Restoration and by the end of the century religious works were being commissioned again. William Price the Elder painted a Nativity for Christ Church, Oxford, in 1686 and an east window for Merton College in 1702. Both have been removed but the latter is at the Ely Museum. Price's brother, Joshua, painted a fine series of picture windows to designs by Francisco Slater at Great Witley (1719–21). They show the pictorial approach beloved of the eighteenth century, when leading painters like Joshua Reynolds and Benjamin West designed glass, and many windows were adaptations of famous works by Old Masters.

The leading Georgian glass-painter was a York man, William Peckitt (1731–95), the first English glass-painter for whom a list of works survives. His early patrons included local clergy and gentry, but the nobility commissioned many armorials and he painted portraits, including those of dogs and racehorses. His York connections brought work in the Minster and commissions in cathedrals, bishops' palaces and deaneries all over England and Ireland. His work is Baroque in style with Gothick motifs which reflect the taste of his patrons Horace Walpole and the 'Goths'. Many windows were removed by later generations who found them crude and tasteless, but he was the leading glass-painter in Europe of his day and his experiments to produce pot-metal colours anticipated the Gothic Revival of the following century.

The enormous scale of church building in the nineteenth century led to an unprecedented demand for glass. It was this generation of English glass-painters who brought about a major revival of the art based on a deeper analysis of medieval styles and techniques. Restorers of medieval glass like Betton and Evans of Shrewsbury had to match their new work with the old. The leading exponent of this archaeological phase was Thomas Willement, glass-painter to Queen Victoria, who produced competent imitations of the various medieval styles. A. W. N. Pugin, the major propagandist of the Gothic Revival, produced outstanding designs and most of the leading Revival glass-painters worked for him: Thomas Willement, William Wailes, William Warrington, Michael O'Connor and John Hardman of Birmingham. The other outstanding figure in the Revival was Charles Winston, whose books *Hints on Glass-Painting* (1847) and *Memoirs Illustrative of the Art of Glass-Painting* (1865) set the history of English stained glass on a scientific footing.

The leading High Victorian architects, Butterfield, Burgess, Scott and Street, all had strong views on glass, which formed an important element in their highly coloured church interiors. Some of the leading Victorian firms emerged during the 1850s: Clayton and Bell, Heaton, Butler and Bayne, Lavers and Barraud, and Ward and Hughes. All were capable of producing good glass in rather solid early medieval styles; pressure of commissions was their undoing.

The foundation of the Morris firm in 1861 was as crucial for stained glass as it was for the other decorative arts. Edward Burne-Jones had already produced marvellous window-designs, including the St Frideswide Window at Christ Church, Oxford, for James Powell before he joined William Morris. Early glass by the firm such as Selsley (1862) is a revelation. Morris gathered around him some talented designers including Ford Madox Brown and Dante Gabriel Rossetti, while Philip Webb coordinated the design of the early windows. As Webb's role declined the windows became less architectural and Morris's gifts as pattern designer and colourist came to the fore. The Nun Monkton Window of 1873 has sumptuous Burne-Jones figures against flowing foliage by Morris. By this date Burne-Jones provided nearly all the figures and his designs were to become increasingly pictorial, culminating in the great series of windows at St Philip's Cathedral, Birmingham (1885–97).

The immediate followers of Burne-Jones were Henry Holiday (his successor at Powell's), 'aesthetic' firms like Shrigley and Hunt, and the Glasgow artists Daniel Cottier and Stephen Adam. But the real heirs of Morris were the Arts and Crafts designers of the end of the century. Reacting against the production-lines of the commercial firms they insisted on better quality glass and designers who were also competent craftsmen capable of taking responsibility for the execution of their own designs. Important figures like Selwyn Image, Walter Crane, and W. R. Lethaby were involved in the movement, but the leading figure was Christopher Whall who inspired a generation of British stained glass artists by his dedication to the craft, his inspired teaching and his book *Stained Glass Work* (1905). His windows at Gloucester Cathedral have been described as 'arguably the finest post-medieval stained glass in any of our cathedrals' and many of the pupils who worked there, including Veronica Whall, Karl Parsons, and Edward Woore, went on to distinguished careers. Another, A. E. Child, played an important role in the Tower of Glass Studio founded in Dublin in 1903. It was to produce some most original designers – Michael Healy, Wilhelmina Geddes and, most famous of all, Evie

Hone, whose powerful east window at Eton College (1952) caused some controversy. But perhaps the most brilliant of these talented Irish artists was the celebrated book-illustrator Harry Clarke (1889–1931), whose fantasies on religious and literary themes show a brilliance of colour and technique which has seldom been rivalled. In Scotland Whall had a considerable following among Arts and Crafts designers such as Robert Anning Bell, but perhaps the greatest contribution of Scottish glass came from the group of Art Nouveau designers associated with the Glasgow School of Art in the 1890s, Charles Rennie Mackintosh, George Walton, E. A. Taylor, and Jessie King.

English stained glass before the Second World War was less exciting; perhaps the great tradition of the Middle Ages and Gothic Revival was simply too strong. Jock Turnbull designed some semi-abstract domestic glass for Roger Fry's Omega Workshop (1914) and the 'colour-king', Alfred Wolmark, produced some quite outstanding Vorticist 'Creation' windows for St Mary's, Slough (1915). Described as 'an act of courage ... unrivalled in modern decorative art' they provoked a scandal but within a few years British churches were being filled with war memorials of dubious merit. Ironically it was in Germany during the 1920s and 1930s with Thorn Prikker and a group from the Bauhaus that the Modern Movement in stained glass really began, although because of the war their influence was slow to cross the Channel.

The major monument to English glass since the Second World War is Coventry Cathedral (consecrated 1962), a building in which a major role for stained glass was envisaged from the outset. The Baptistry glazing by John Piper and Patrick Reyntiens, and the abstract windows of the nave by Lawrence Lee, Geoffrey Clarke, and Keith New, exploit colour and its symbolism at a level not seen in Britain since the Middle Ages. These artists and their pupils have continued to produce some of the most interesting work of the last twenty years. The collaboration between Piper and Reyntiens has pointed the way forward, and Reyntiens has produced fine designs in his own right. Their recent windows at Robinson College, Cambridge, manage to combine technological achievements with a sense of mystery and magic. They should convert anyone who thinks that modern stained glass is dull.

Unfortunately, such commissions are few and far between. More glass is being destroyed than commis-

92. *The Cross*, Mark Angus. 1977. Ely Cathedral Stained Glass Museum

sioned by the Church, and the majority of new windows tend to be traditional and safe. However, a new generation of British stained glass artists is in the making. Many of them, such as Brian Clarke (Longridge; St Gabriel's, Blackburn; Queen's Medical Centre, Nottingham), have allied themselves to the architectural glass movement in Germany and the U.S.A. The Architectural Stained Glass Course at Swansea School of Art has produced promising students, some like Mark Angus (Fig. 92) from this country, others from overseas. The market may be increasing for small-scale domestic panels, but this was the situation in the sixteenth and seventeenth centuries. The next few years may be crucial in deciding the fate of British glass; whether it can become, as it once was, a major art form.

8

Garden Design

ARTHUR HELLYER

IT is widely accepted that the British have shown a great aptitude for garden design – indeed, it is sometimes asserted that this is the area in which we have made our most original contribution to the arts. Unhappily consensus vanishes the moment one tries to establish precisely what that contribution has been and when it occurred. Perhaps this is no surprise, considering the remarkably wide variations in style and intent which have characterized British gardens since they emerged from the confines of monastery and castle and began to acquire an entirely new importance as expressions of artistic feeling or as demonstrations of personal wealth.

For social and economic reasons this blossoming occurred later in Britain than in Italy or France, and so it was natural that, at first, gardeners here should look to those countries for inspiration. All the great gardens of the seventeenth century were regular in design, often completely symmetrical and highly architectural, with plants playing a subordinate role. Trees and evergreen shrubs were often trained or clipped to wholly artificial forms to assist in making the patterns on which nearly all garden design depended. Natural contours in the land were likely to be removed by levelling and terracing, or were made into smoothly sloping banks, sometimes with water cascading down a giant 'staircase' as it still does at Chatsworth in Derbyshire (Fig. 93).

A full century passed before there was any revolt against this tyranny of formality and even then the revolt was led as much by writers as by gardeners. Addison, Swift and Pope were among the writers who, early in the eighteenth century, began to ridicule universally accepted ideas of garden-making. In his *Moral Essays*, Pope mocks gardens in which:

> *No pleasing intricacies intervene,*
> *No conflicts to perplex the scene;*
> *Grove nods to grove, each alley has a brother,*
> *And half the platform just reveals the other.*
> *The suffering eye inverted Nature sees,*
> *Trees cut to statues, statues thick as trees.*

Pope's remedy was expressed in the much-quoted lines from the poem *Of Taste* in which he recommends garden-makers to:

> *Consult the genius of the place in all*
> *That tells the waters or to rise or fall,*
> *Or helps the ambitious hill the heavens to scale*
> *Or scoops in circling theatres the vale,*
> *Calls in the country, catches opening glades,*
> *Joins willing woods and varies shades from shades.*
> *Now breaks, or now directs, the intending lines,*
> *Paints as you plant, and as you work, designs.*

Here was the literary description of an entirely new concept of garden-making, but where were the visual examples to be found? Certainly not, at first, in any existing gardens: though nature had long been accepted as a guide by Chinese gardeners, only the vaguest accounts of their gardens had as yet reached Europe. In fact the new English landscape gardens, which were just beginning to struggle out of their formal cocoons, bore no resemblance to anything Chinese.

Much of the early visual inspiration came from the landscape paintings of mid-seventeenth-century artists working in Rome. These included Claude Lorraine, Gaspar Poussin, and Salvator Rosa, whose works were seen by many young English gentlemen profiting from the growing fashion of visiting Italy on the 'Grand Tour'. Young French aristocrats, on the other hand, appear to have stayed much more at court, and the French were not, in any case, under any pressure to change their formal, architectural style of garden-making.

At Studley Royal in Yorkshire it is possible to observe, in half an hour's walk, the development over a period of half a century of the new pictorial, poetic concept of garden-making. Here the original garden, started by John Aislabie in 1720, is still regular in the shape and disposition of its pools; but these are set in a valley whose wooded slopes are left much as nature might have planted them. Although the pools are

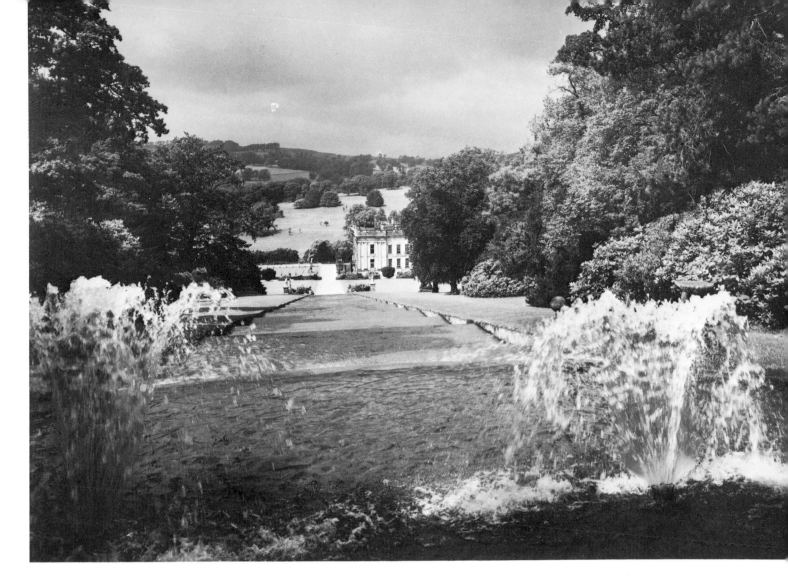

93. The Great Cascade, Chatsworth, Derbyshire.
A fine example of 17th-century formal garden-making

RIGHT
94. Edzell Castle, Edzell, Tayside. A completely enclosed
garden in the Italian style made by the owner,
Sir David Lindsay, in 1604

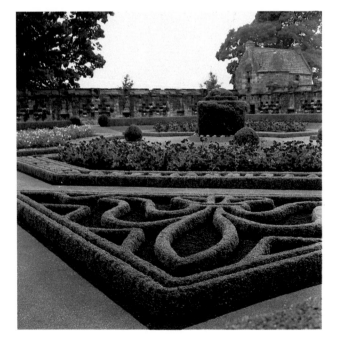

overlooked by various buildings in the classical style,
the garden is far removed from the dwelling house
itself, from which it cannot be seen and for which it
makes no kind of setting. In other words, this is a
garden to be visited and left; a poetic place intended
to create a mood by evoking what Pope so aptly
called 'the genius of the place'.

But this part of the garden is only a beginning.
Proceed up the valley and soon the last vestiges of
artificiality are left behind. Beyond a lake and a tree-
covered mound, the distant ruins of Fountains Abbey
are revealed. From this point onwards these Gothic
ruins are allowed to dominate the scene, man's

handiwork as a gardener being confined to widening the stream which flows through the valley and holding back the flanking trees so that the whole makes a perfect setting for the ruins. This final section of the Studley Royal garden was made, from 1768 onwards, by John Aislabie's son, William, who was able to buy the ruins of Fountains, where his father had failed.

By this time all the principles of landscape gardening had been established and Lancelot (Capability) Brown (1715–83), a gardener who had learned the art of landscaping under William Kent at Stowe, was busily applying his own ideas to some two hundred

95. Water-spouting Chinese pagoda, Alton Towers, Staffs. One of many romantic objects in this early 19th-century garden

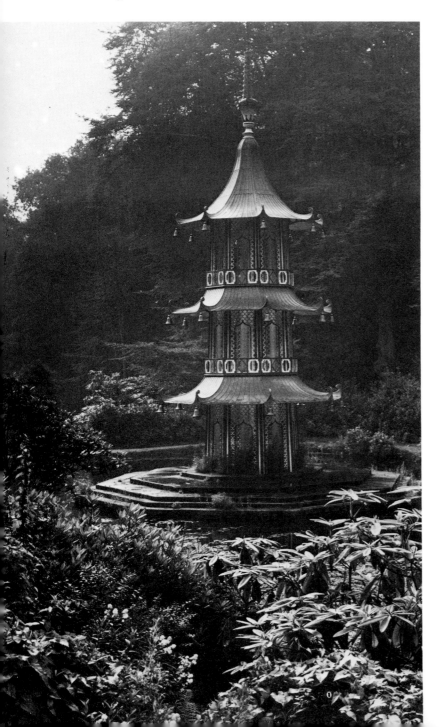

gardens all over England. In the process of this landscape revolution many of the old formal gardens were swept away – although less so in Scotland, where, in places such as Edzell Castle and Pitmedden House, some of the most authentic examples of original seventeenth-century garden design can still be seen (Fig. 94).

Capability Brown reduced landscape gardening almost to a formula, with smooth lawns sweeping right up to the house, a lake in the middle distance, a few classical buildings to act as focal points, and clumps and belts of trees to channel and contain the vistas. In the hands of Brown's successors, this was replaced by a more romantic vision. The landscape gardens became more rugged, the buildings were now ruins, hermitages or rustic cottages, and there was a greater emphasis on all those qualities which would delight a contemporary landscape painter.

A supremely beautiful but late example of this picturesque style is to be seen at Scotney Castle, Kent. Here, in 1836, Edward Hussey started to build a new house overlooking a valley in which lay a moated castle and the seventeenth-century villa where he had formerly lived. Hussey then deliberately made these old buildings into ruins to provide a centrepiece for a pictorial garden – a garden that looked like a painting. He planted exotic trees and shrubs to create a greater variety of colour, form, and texture than would have been possible had he used native species alone.

A more elaborate example of this new romanticism is at Alton Towers, Staffordshire. Here a neo-Gothic mansion, built by A. W. N. Pugin for the sixteenth Earl of Shrewsbury, overlooks a vast garden made by his father, the fifteenth earl, who had filled it with many strange objects, including a beautiful Chinese-style pagoda standing on a little island in a lake and spouting a great jet of water from its apex (Fig. 95). As this garden neared completion in 1833, J. C. Loudon, the most prolific horticultural writer of his day, described it as 'in excessively bad taste, or rather, perhaps, as the work of a morbid imagination joined to the command of unlimited resources'. Time and the growth of thousands of trees have mellowed it in a way that Loudon can never have imagined.

In the mean time Humphry Repton, who followed Capability Brown as the most popular professional garden designer, made an important innovation by restoring some formality in the immediate surroundings of the house. Here, where Brown would have had grass sweeping right up to the walls, Repton made terraces and flower beds and so opened the way for the use of many plants that could not be

accommodated satisfactorily even in picturesque landscapes. Also interesting is Repton's practice of creating a book for each garden he designed, describing in detail his recommendations and illustrating them with watercolour paintings showing them as they were and as they would look after his changes had been made.

With the Victorian era came a period of experiment. New plants were flooding into Britain from many parts of the world and the new class of prosperous merchants and manufacturers was anxious to establish its social importance in a conspicuous manner by building fine houses and creating elaborate gardens. Some garden owners became collectors of plants and found it necessary to make gardens to suit the plants in which they were interested. They planted pinetums for the many new conifers arriving from North America, and arboretums for a wider range of trees from many temperate regions of the world. Woodland gardens were established to suit the shade-loving rhododendrons, camellias and other new shrubs, many of them from Asia. Rock gardens, instead of being intended solely as landscape features, as in Capability Brown's day, were used for the cultivation of alpine plants, though not always with great success. Lakes were filled with new water lilies, many of them hybrids developed by the French plant-breeder Joseph Bory Latour-Marliac. Rose gardens became features in their own right, and herbaceous perennials took on a new importance as they were used in the creation of large herbaceous borders.

Some new plants from sub-tropical regions, though in need of protection in winter, were sufficiently hardy to be planted outdoors in summer. Many of these – geraniums, marguerites, heliotrope and lobelia among them – had a long flowering season and were therefore ideal for prolonged display. To make the most of them, formal terraces and parterres, somewhat in the seventeenth-century manner, were recreated, with numerous beds in which plants could be massed in single colours or in patterns made with many colours. The result could be garish or effective according to the skill and good taste of the planner. 'Bedding out', as it came to be called, was a method of gardening which attracted much criticism as being vulgar and out of character with the British countryside. But what finally killed it, except in public parks and small private gardens where it still thrives, was the increasing cost of producing and caring for large numbers of plants which had to be either renewed annually or overwintered in heated greenhouses.

Further change came in the latter half of the nineteenth century when the Arts and Crafts Movement, led by William Morris, renewed interest in traditional methods of building, decorating and furnishing. Gertrude Jekyll, an amateur painter and decorator who lived in Surrey and greatly admired the cottage gardens of that county, was prominent among those who applied these new ideas to gardens. Failing eyesight made her give up painting and devote most of her time to garden design and planting. She met the architect Edwin Lutyens when he was still a young man and they rapidly became close friends and collaborators, he designing the gardens for the many country houses he built and she using plants to fill them much as she might have used paints on a canvas or fabrics in a room. Both by example and by writing she sought to improve the quality of planting by careful consideration of the way in which one plant could enhance the beauty of another. In this she received much help from William Robinson, a professional gardener turned writer and editor, who shared many of her views and was able to publicize them in the gardening magazines he edited. He also wrote several books denouncing formalism and the use of temporary bedding-out plants: he recommended, instead, permanent or semi-permanent planting with trees, shrubs and herbaceous perennials used in what he regarded as 'natural' ways, though in fact they usually required a great deal of thought. His largest work, *The English Flower Garden*, first published in 1883, was extremely influential and was reissued in numerous editions.

The romantically traditional ideas which were the essence of the Arts and Crafts Movement have dominated English gardening ever since, and it is these qualities which are now widely regarded as most typical of the English garden. Two variants of this style may be recognized, one owing most to the preferences of Lutyens and Miss Jekyll, the other to Robinson. The first makes use of the very old device of dividing gardens into numerous separate sections each with its own design and planting. It is a method that has been supremely well carried out at Hidcote Manor, Gloucestershire, and Sissinghurst Castle, Kent, two of the most visited gardens in Britain now that they belong to The National Trust (Fig. 96). On a smaller scale this kind of garden can be seen at Great Dixter, East Sussex, as well as in many less publicized places. It is a style which has the merit of allowing a great variety of plants to be used in numerous different ways without obvious incongruity. It can also provide a considerable degree of protection for plants, as well as numerous different

aspects, each with its own micro-climate, all of which can be used to advantage by skilful gardeners.

The second variant of what may be called the Arts and Crafts garden adopts a more flowing and continuous ground plan, often with sweeping borders or island beds separated by grass paths or wider areas of lawn. It is characteristic of many thousands of privately owned gardens, both large and small, and may be seen in such very different places as Wakehurst Place (West Sussex), The Royal Horticultural Society's garden at Wisley (Surrey), and Threave School of Practical Gardening (Dumfries and Galloway). It is a system which owes something to the eighteenth-century involvement with natural landscape, whereas the divided garden derives more

96. Hidcote Manor, Glos. The summer houses in one of the carefully planned sections of the gardens

97. Sheffield Park, East Sussex. Varied and extensive planting during the 19th and 20th centuries has transformed the original open 18th-century landscape

from the medieval preference for enclosure. In both there is a greatly increased diversity of plants, most of which were unknown in medieval times and were unwanted by eighteenth-century landscapers.

At Sheffield Park, East Sussex, one may observe the impact on an eighteenth-century green landscape of extensive nineteenth- and twentieth-century planting (Fig. 97). Here rhododendrons, maples, swamp cypresses, giant gunneras and hundreds of other plant species from many temperate regions have completely altered the original character of the garden. Although this has brought criticism from historians, conservationists and some professional garden architects, it has greatly increased the popularity of the garden which now attracts very large numbers of visitors, many from overseas. On a more modest scale something similar has happened at Stourhead, Wiltshire, where nineteenth- and twentieth-century introductions of conifers, some with golden variegated leaves, and of rhododendrons, magnolias, and other flowering trees and shrubs, as well as daffodils naturalized in the grass, have made this a more colourful garden than was ever intended by Henry Hoare who created it as a classical landscape in the mid-eighteenth century (Fig. 98). Despite criticism The National Trust, which now owns Stourhead, has decided against any radical alteration on the grounds that the garden well illustrates the natural progression that is usual whenever an active interest in gardening has been maintained by a succession of owners.

Sheffield Park and Stourhead are wholly British in conception, both in their original landscaping and in the richer planting which they have subsequently acquired. These are both elements in which we may justly claim to have made a significant contribution to the art of garden design. Strangely they are also the characteristics which arouse the greatest contention. Most historians appear to regard the eighteenth-century landscapes as our sole claim to fame as garden-makers, dismissing the twentieth century as having produced nothing worthy of serious study. The popular verdict is almost precisely the reverse and it cannot be entirely without significance that our modern use of plants is what is now most copied in other countries. It also appears to be the greatest attraction to garden-loving visitors from abroad.

Another significant aspect of British garden-making – but one that is hardly ever noted – is that it has been dominated by amateurs. As early as 1604 Sir David Lindsay at Edzell Castle felt entirely

98. Stourhead, Stourton, Wilts. A mid-18th-century landscape garden made by Henry Hoare with the assistance of Henry Flitcroft; the exotic trees were a later addition

competent to design his own exquisite garden in the Italian manner. The greatest landscape inventiveness was shown by John Aislabie at Studley Royal, Lord Burlington at Chiswick House, Lord Carlisle at Castle Howard, Lord Cobham at Stowe, and Henry Hoare at Stourhead. It is true that all enlisted the help of professionals but it was they who dictated what was to be done.

Gertrude Jekyll was also an amateur: she never received any formal training in gardening. Hidcote was made by Major Lawrence Johnston, Sissinghurst Castle by Vita Sackville-West and her husband Sir Harold Nicolson, and Crathes Castle by Lady Burnett, all of them owners untrained in horticulture.

No doubt it is because amateurs have felt so ready to tackle the design of their own gardens that there has been so much experiment and such great variation in style. Also the modern plant-dominated garden requires constant attention and frequent renewal in order to keep things in scale and to correct miscalculations in the original planting. These are tasks for dedicated owners even when they do seek the assistance of professionals.

9

Sculpture

PAUL WILLIAMSON and NICHOLAS PENNY

Sculpture before 1500

ALL that remains of English sculpture carved before the Reformation is only a small percentage of the original output of medieval sculptors. Like more precious works in gold, enamel and metal which were wilfully destroyed under Henry VIII, stone sculpture was methodically attacked and broken. In view of this it is surprising and fortunate that there still survive beautiful examples of sculpture of the highest quality from every period in the history of English medieval art. Some pieces were saved due to their geographical isolation, some because they were built into walls high up on a building, or because they formed an essential structural part of a building, such as sculpted capitals; and smaller sculptures, ivory carvings for instance, could be hidden in times of danger. What has come down to us allows us to trace the development of sculpture in England from its glorious beginning in Northumbria at the end of the seventh century to the advent of the Renaissance. The three major periods divide quite easily: the pre-Conquest era (700–1050), the Romanesque or Norman period (1050–1200), and the Gothic age, which arrived late in England and stayed long (1230–1500).

An unusual aspect of pre-Conquest sculpture is that the most accomplished and important work occurred right at the beginning of the period, seemingly appearing from nowhere with no parallels in Europe. The flowering of the monastic arts in Northumbria at the end of the seventh century, although brought about by contacts with the Mediterranean cultures, possessed its own strongly native character which gives it an appearance that could rarely be confused with another country's.

Complementary to the great illuminated manuscripts of the Northumbrian age, such as the Lindisfarne Gospels (now in the British Library), are the two major stone crosses of Ruthwell and Bewcastle, both probably carved at the end of the seventh

99. The Ruthwell Cross (detail). Stone. Late 7th century. Ruthwell Church, Dumfries and Galloway

century. The Ruthwell Cross (Fig. 99), although sited near Dumfries on the west coast of southern Scotland, is as obviously 'Northumbrian' in style as the manuscripts associated with that region. On the front and back of the cross are large figural scenes, showing Christ treading the asp and the basilisk, and Christ with Mary Magdalene at his feet; smaller panels show the Annunciation, the Visitation, and St Paul and St Anthony meeting in the desert, a rare scene in the West. On the sides of the cross is vine-scroll ornament with pecking birds, and around the edge are Anglo-Saxon runes, recounting the poem *The Dream of the Rood.*

The Bewcastle Cross is similarly designed, although only the front has figural panels, showing the standing Christ and the two St Johns; on the back of this cross is vine-scroll ornament with pecking birds and the sides show ornamental patterns. These monumental crosses (the Bewcastle Cross is nearly five metres high) show clearly the elements that made up the Northumbrian Renaissance: there is the debt to Eastern Mediterranean models in the iconography and choice of scenes, and it has been shown that the vine-scroll ornament probably derives ultimately from models associated with sixth-century carvings such as the ivory throne of Maximianus in Ravenna. This is not surprising, as many of the dignitaries from the monasteries in Northumbria travelled abroad and brought back works of art for their own foundations. However, the end result is peculiarly English and there are no crosses of this type to be found on the Continent. The importance of the crosses is further enhanced by the almost total absence of any type of monumental sculpture on the European mainland between the years 500 and 1000.

The Ruthwell and Bewcastle Crosses are the outstanding surviving pieces of the Northumbrian school, but several other crosses (and fragments of crosses) attest to the widespread popularity of sculpture in the North from the end of the seventh to the beginning of the ninth centuries: notable examples are to be seen at Hexham (Acca's Cross), Jedburgh, Saint Andrew Auckland in County Durham, Croft in Yorkshire, Irton in Cumbria, and the Victoria and Albert Museum in London (fragments from the Easby Cross). Like the earlier examples, they show the sculptor's love of vegetal ornament, usually combining this feature with small figures of animals, birds, and the occasional human.

It was in the South and the Midlands that pre-Conquest sculpture developed after the ninth century, Northumbria gradually ceasing to provide the necessary creative impetus. Taking the place of the northern monastic centres were the newly-powerful kingdoms of Mercia and Wessex, the former centred on Canterbury, with its major monuments situated in the south Midlands. Essentially a more figurative art than that of Northumbria, Mercian sculpture was also dependent on foreign developments, being strongly influenced by Carolingian art. The most impressive and extensive display of Mercian sculpture may be seen on the walls of the church at Breedon-on-the-Hill in Leicestershire (Fig. 100); inserted into the later church are about twenty-five metres of sculpture in small frieze-like panels. The decoration of this frieze varies considerably from panel to panel but the major part is devoted to interlace and fretwork patterns interspersed with a variety of creatures and inhabited scrolls. Two large reliefs stand out, carved on a monumental scale in a totally different manner from the frieze: these show the standing Christ (or possibly an Angel) and a half-length figure of the Virgin, and are convincing evidence of the mingling of European styles which took place in the first half of the ninth century. Although very different in style and composition, all the sculpture at Breedon is probably to be dated to the same time, around the year 800 or shortly after. Not as accomplished, but undoubtedly from the same workshop as the Breedon sculptures, are a group of figurative panels at Fletton in Lincolnshire and a stone relief of a standing saint under an arcade at Castor in Northamptonshire.

Just after the middle of the ninth century, in 865, the Danes landed in East Anglia and proceeded to overrun the north of England. As a result, and because of the lack of a sculptural tradition in Scandinavia, there was a dramatic reduction in the amount of sculpture produced in the invaded areas. It is true that the Danes brought their own style with them, but this was essentially non-figurative and there is no evidence to suggest that they could produce anything to match the quality of the Mercian work. Inevitably, the centres of production shifted towards the South and South-West, to the Kingdom of Wessex and to Winchester.

100. Part of a decorative frieze. Stone. Early 9th century. Breedon-on-the-Hill, Leics.

101. Crucifixion. Stone. Early 11th century. Romsey, Hants.

In the tenth and early eleventh centuries, Winchester was the cultural centre of England and was rightly renowned for the high-quality works of art produced there, the most famous being the splendid Benedictional of Saint Aethelwold (now in the British Library), which was written and beautifully illuminated in about 980; marvellously worked walrus ivory carvings also exemplify the late tenth-century art of the city. There is nothing in monumental sculpture to compare with these smaller-scale masterpieces, but there are surviving representative pieces which illustrate the style of the time. Close in spirit to the smaller works is a striking relief of the Harrowing of Hell in Bristol Cathedral, which must be dated to the first years of the eleventh century; it compares well with a walrus ivory carving of the Baptism of Christ of the same date, now in the British Museum,

although there is none of the flowing delicacy in the treatment of the drapery on the larger relief. Two other stone carvings deserve mention: slightly earlier than the Bristol slab is the pair of angels in the little church of St Lawrence at Bradford-on-Avon, which may probably be dated to around the year 1000 and which undoubtedly formed part of a Crucifixion group above the chancel. To gain an impression of what this missing Cross, or 'Rood', might have looked like one can turn to the imposing over-lifesize sculpture set into the outside wall of the church at Romsey in Hampshire (Fig. 101), which is close in date to the angels. Here Christ is shown severely rigid but with no impression of pain; although now badly weathered, the sculpture has a truly moving aspect and the human figure is beautifully understood. It was to be almost two hundred years before such majestic figures could be produced again in England.

With the Norman Conquest in 1066 came a massive increase in church and cathedral building. Strangely, although great advances were made in the architectural sphere very little figurative sculpture adorned the great buildings which sprang up at the end of the eleventh century. What there is, and it is mostly decorative, is confined to the ornamentation of architectural members such as capitals. Viking patterns, with biting dragons and various other beasts, were clearly suitable for such a use and are seen in the North, on capitals of around 1100 in the nave of St Mary's Church, Kirkburn (Yorkshire), and on a tympanum of about the same date at Holy Trinity Church, Uppington (Shropshire). The earliest known figurative capitals, which are admittedly rather crude, are to be found in the Chapel at Durham Castle and may be dated to around 1072. From these hesitant post-Conquest beginnings there developed a deep understanding of the relationship between architecture and sculptural decoration, so that by the early twelfth century the ground had been laid for a more sophisticated narrative approach and a subtler use of the cushion capital.

The crowning glories of English capital carving are to be seen in the crypt at Canterbury Cathedral. Fortunately well-preserved and beautifully carved in both detail and general composition, the Canterbury capitals, which were executed *in situ* in about 1120 (Fig. 102), testify to the strong links existing between the illuminated manuscripts of the time and the sculptures. They were, of course, extremely influential: the vast repertory of iconographic themes illustrated on these capitals – the exotic beasts, the acrobatic *jongleurs*, the animals playing instruments – all appear again and again throughout the South in

102. Capital with mythical beasts. Stone. c. 1120.
Canterbury Cathedral crypt, Kent

sculptural programmes stand out in the first forty years of the twelfth century, but it must be emphasized that much is lost. The first, two large panels showing the Raising of Lazarus and Christ at Bethany (Fig. 103), are in Chichester Cathedral and would have originally formed part of a screen probably constructed in the second quarter of the twelfth century. Because of the losses from this era of English sculpture, the reliefs appear to be curiously isolated in style and have consequently been dated by earlier scholars to both before and after the Conquest. Except for a fragmentary relief, at Toller Fratrum in Dorset, of St Mary Magdalene wiping the feet of Christ, there is nothing like these reliefs surviving from English medieval art.

Closer to the mainstream of English sculpture in the first half of the twelfth century is the superb Prior's Door at Ely Cathedral, which has several points of contact with the Norwich capitals: the

103. Panel showing Christ at Bethany. Stone. 1125–50.
Chichester Cathedral, West Sussex

the following decades. Other foundations, growing in strength and material wealth, must have expended great sums in competing with one another in the decoration of their cathedral-churches. Cloisters provided a particularly suitable vehicle for sculpture: the open arcades around the cloister were all supported by capitals, and any foundation with pretensions to grandeur would have had these capitals carved. Unfortunately, two of the most impressive cloisters of the twelfth century, at Reading and Norwich, are no more: Reading Abbey's cloister, the capitals of which were probably carved in around 1130, was totally destroyed, but some of the capitals survive and are now displayed in the Reading Museum. Norwich's cloister was rebuilt in the thirteenth and fourteenth centuries, but again a few of the twelfth-century capitals survive; they are to be dated to about 1140. Perhaps surprisingly, the tenacious Scandinavian decorative patterns are still to be found on one or two of these capitals, but the most interesting development is the re-awakened interest in the human form for the first time (on a monumental scale) since the Conquest: at Norwich this is especially noticeable. Other notable capital carvings, especially for their narrative content, were produced at Westminster Abbey and Lewes Priory, and there are some magnificently carved capitals in the Winchester Museum – all of these are of about 1140.

Apart from the many sculpted capitals, two major

104. The Gloucester Candlestick. Gilt bronze. 1104–13. London, Victoria and Albert Museum

the end-result was always distinctively English – indeed, it would not be exaggerating to say that English sculpture could never be confused with the art of the Continent.

In sculpture on a small scale, there had been a greater continuity of style and form throughout the eleventh century and into the twelfth, so that it is often difficult to tell today whether a particular ivory carving, for instance, was carved before or after the Norman Conquest. After the Conquest, all types of religious objects were needed to furnish the altars and sacristies of the newly-built cathedrals and major monastic houses. Carvings in walrus ivory were applied to bookcovers and altar crosses, and liturgical combs and reliquaries were fashioned out of the same material. In metal, no less precious objects were cast and often gilded, but a great proportion of these were melted down at the Dissolution of the Monasteries – there is a contemporary description of many cart-loads full of priceless treasury objects leaving Canterbury Cathedral to be melted down, and we may confidently assume that this type of wholesale destruction was widespread. Thankfully, a few pieces of the highest quality have survived and these pieces attest both to the great skill of the artists responsible and to the intimate links the metalworkers forged with their related fields of manuscript illumination and monumental sculpture. One of the greatest products of the English twelfth-century metalworker is undoubtedly the Gloucester Candlestick, now in the Victoria and Albert Museum (Fig. 104). Thanks to an inscription on the stem, referring to Abbot Peter, we can date the Candlestick to between the years 1104 and 1113. Possibly made in Canterbury, the Candlestick has all the features to be seen in the manuscripts and capitals of the same time: the small men clambering amongst the foliate ornament, the lush acanthus swirls, and the lively dragons of the feet can all be paralleled in these other sources.

Around the middle of the twelfth century it is possible to discern the formation of regional schools of sculptors, such as may have existed in East Anglia. One of the most distinctive of these is to be found in Herefordshire, where there is a density of monuments quite disproportionate to the area's importance: this is due to the patronage of wealthy private individuals rather than the monasteries, and the churches are mainly small, simple structures. However, the sculpture attached to and placed within these churches is both accomplished and distinctive. It has been shown that the sculptors in this school made use of pattern-books and knew of developments abroad – both Spanish and western French influence is clearly

linear treatment of the foliate ornament and the carving of the small figures are similar enough to suggest that a local East Anglian school was at work on both sets of sculptures. However, at Ely there is clear indication of foreign influence, and it has been convincingly demonstrated that Italian Romanesque portal design considerably affected the form of the Prior's Door. Throughout the twelfth century English sculpture incorporated foreign designs and ideas but

105. Tympanum with Apostles. Stone. *c.* 1160–70. Malmesbury Abbey, Wilts.

evident and we know that Oliver de Merlimond, one of the patrons concerned, travelled to these places and would have seen the sculptures there. Despite these foreign influences, the style of carving retains a strong individuality. This individuality is best seen in the south portal and chancel arch of the church of St Mary and St David at Kilpeck, of around 1150. Close in style, but now badly weathered, are the two doorways and chancel arch from Shobdon, now standing in Shobdon Park: in both monuments may be seen the curious elongated figures with insect-like eyes and rubbery drapery so characteristic of the Herefordshire school. Two of the best-preserved examples of the Herefordshire style are the fonts at Eardisley and Castle Frome (Fig. 106).

106. Baptismal font. Stone. *c.* 1140. Castle Frome, Hereford and Worcester

Indisputably more important from an international point of view are the sculptures on the West Front of Lincoln Cathedral (*c.* 1145), which blend North Italian elements with ideas transmitted from the Cathedral of St Denis in France. The frieze at Lincoln, showing scenes from the Old and New Testaments, is clearly heavily dependent on the frieze at Modena Cathedral which was sculpted by Wiligelmo around the year 1100, but the details derive from St Denis. Influences from further afield are also evident at this time; the beautiful York *Madonna and Child*, were it not carved in local Tadcaster stone, might be considered Byzantine. In the second half of the twelfth century Western France plays an important role in the transmission of portal design, the most striking results of this being the portals of Rochester Cathedral (*c.* 1160) and of St Mary's, Barfreston (*c.* 1180), both in Kent.

Standing far above these portals in terms of quality of carving is the south doorway at Malmesbury Abbey in Wiltshire, of around 1160–70 (Fig. 105): the outer doorway has unfortunately lost much of its surface detail, but the real sculptural treasures lie within the porch. To either side of a tympanum with a representation of Christ in Majesty are six life-size figures of apostles, which originally would have been painted and gilded. These marvellously sculpted figures, so delicately carved but with such emotional and dramatic strength, are without doubt the outstanding works of the twelfth century and may be ranked alongside even the very best works on the Continent. With their religious feeling and constrained movement, in their studied juxtaposition to one another, these apostles carry English sculpture towards the Gothic. This transition, from Romanesque

107. Saint John. Stone. c. 1210. York, Yorkshire Museum

108. King from the West Front of Wells Cathedral, Somerset. Stone. c. 1230–40

in the quality of carving, the West Front (with its 176 full-length statues, 30 half-length angels and 134 smaller reliefs) is still one of the most majestic sights in Britain, and of course it was meant to be seen as a whole – a statement of Theology and Christian Faith. Many of the sculptures are rather badly weathered, but there are signs that recent conservation work has halted the erosion. The best of the statues (Fig. 108) have a grave dignity which, like the earlier sculptures, distinguishes them as being peculiarly English – there is none of the fluttering drapery so beloved of the French sculptors of the late twelfth and thirteenth centuries. Significant sculpture also lies within the Cathedral: particularly charming and amusing is a group of capitals in the south transept which tells the story of the fruit-stealers and their eventual punishment. These are slightly earlier than the West Front sculptures (the building of the Cathedral started at the east end and worked westwards) and were probably carved in about 1215.

In addition to the monumental scheme at Wells, many smaller sculptural programmes were embarked upon around the country: corbels were frequently carved with animated heads, sometimes grotesque or amusing, and the spandrels between the arcades of the nave were often filled with either single figures or historiated scenes. Outstanding examples of the latter may be seen at Worcester Cathedral (c. 1220), and the tradition carried on through the century with the narrative spandrels at Westminster Abbey (mid-century) and Salisbury Cathedral (about 1270). However, the supreme masterpieces of thirteenth-century sculpture are single spandrel figures, on either side of the south transept of Westminster Abbey (Fig. 109). These two angels were carved c. 1255 and not only are superbly modelled but also fill perfectly the very awkward space allocated to them. The elegant drapery, the beautifully rendered faces, and their overall gracefulness single them out as the work of a sculptor worthy of standing beside the great artists of any age. Nothing in the thirteenth century stands comparison with these figures, although much of interest survives from the second half of the century.

The Angel Choir of Lincoln, built between about 1256 and 1280, contains a veritable 'sculpture gallery' of small figures in the spandrels, high up above the gallery arcade, and was probably derived from the scheme at Westminster. The angels are not, of course, as well understood as those at Westminster but there is a great range of poses, and the figures are imbued with a vigorous and lively spirit. The great doorway on the outside of the Angel Choir (to the

to Gothic, was to be a slow process, not fully realized until the first decades of the thirteenth century, and the large figures at York (from St Mary's Abbey) of around 1210 exemplify this period (Fig. 107). Although derived from the early Gothic sculpture of the Île-de-France, these figures are not as advanced as their models in the treatment of the human form, and are markedly more classicizing, perhaps owing to an intermediary source of Byzantine inspiration.

With the sculpture on the West Front at Wells Cathedral, mostly carved in the years 1230–40, English sculpture moves firmly into the Gothic. Although it would be true to say that the individual sculptures in no way match French Gothic sculptures

109. Censing Angel. Stone. *c.* 1255. London, Westminster Abbey, south transept

South) – known as the Judgement Portal – was probably built in the 1270s: again, it is most probably based on developments at Westminster, this time dependent on the now-decayed Chapter House portal, and may well have been executed by the same masons. Christ is shown seated and blessing in the tympanum (unfortunately, the figure has been very badly restored), surrounded by flying angels, while in the voussoirs above and in the niches to the sides are wonderfully carved small figures; four life-size figures flank the portal. This marvellous collaboration between architect, mason and sculptor would not be rivalled again in the Middle Ages, because by the early fourteenth century the sculptor no longer worked as closely with the architect. He was now more independent, being described as an 'imager' in contemporary documents, and most of his work was on free-standing monuments or figures within the cathedrals or churches.

Of the fourteenth-century monuments the most impressive, and certainly the most historically important, are the tombs and Easter sepulchres. The most interesting major monument in the first category is the so-called Percy Tomb in Beverley Minster, Yorkshire, of between 1340 and 1350. It is an intricate structure, mixing lush foliate decoration with both

small and large figures into a virtuoso *tour de force* – the detail of the carving is especially fine. Also worthy of note are the many effigies of knights and other personages spread around the country. A particularly popular type of effigy was the brass, or more accurately latton, effigy: about 4,000 of these still remain in churches and it has been estimated that at least 150,000 were made between the fourteenth and early sixteenth centuries. Incised on flat plates, the designs follow the sculpted effigies and there is a similar diversity in type and quality. A fine early example may be seen at Draycott Cerne in Wiltshire, showing Sir Edward Cerne and his wife, Elyne (1393) (Fig. 110); and among slightly later examples are the brasses depicting prosperous wool-merchants, complete with woolsack, at Northleach in Gloucestershire (Fig. 111) (see also *Textiles*, p. 169).

110. Brass of Sir Edward Cerne and his wife Elyne. 1393. Draycott Cerne, Wilts.

Ivory Carvings of Medieval England

PAUL WILLIAMSON

Very few English medieval ivory carvings were carved from elephant ivory, which was scarce and had to be brought from afar. The vast majority were fashioned from walrus tusks.

The so-called 'Franks Casket' (Fig. 1) was actually carved in whalebone, and provides a small-scale example of Northumbrian sculpture around the year 700 strikingly different in its imagery and style from the contemporary high crosses such as at Ruthwell. In the late Anglo-Saxon 'Winchester School', well-known for its beautiful manuscript illumination, several ivories survive which closely resemble the late tenth-century books, one of the most beautiful being a small walrus ivory relief of the Virgin and Child, now in the Victoria and Albert Museum (Fig. 3).

After the Norman Conquest, the major workshops of ivory carvers were centred alongside the scriptoria in the great monastic houses, at Canterbury, Winchester, St Albans, and elsewhere. Bookcovers, liturgical combs, croziers, and tau-crosses were made to serve the needs of the major monasteries and churches, and it is from the twelfth century that many of the most outstanding pieces of virtuoso carving come – like the liturgical comb in the Victoria and Albert Museum (Fig. 2).

Probably the best-known English medieval ivory is the magnificent walrus ivory altar cross in the Cloisters Collection of the Metropolitan Museum of Art in New York (Fig. 4), most likely carved in the second quarter of the twelfth century. Towards the end of the century, in the period sometimes known as the 'Transitional' (between the Romanesque and Gothic styles), is found a small group of ivories, the most intricate of which is a crozier in the Victoria and Albert Museum with scenes from the Life of St Nicholas and the Nativity of Christ (Fig. 6): it is carved from elephant ivory and was

ABOVE 1. The 'Franks Casket'. Whalebone. *c.* 700. London, British Museum

RIGHT 2. Liturgical comb. *c.* 1120. Ivory. London, Victoria and Albert Museum

OPPOSITE LEFT 3. Virgin and Child relief. Walrus ivory. Early 11th century. London, Victoria and Albert Museum

CENTRE 4. Altar Cross. Walrus ivory. Probably *c.* 1145. New York, The Metropolitan Museum of Art, The Cloisters Collection

ABOVE 5. The Salting Diptych. Ivory. Early 14th century. London, Victoria and Albert Museum

BELOW RIGHT 6. Crozier. Elephant ivory. *c.* 1170. London, Victoria and Albert Museum

probably made in Canterbury in around 1170.

Between 1200 and about 1260 there seems to have been a lull in the production of ivory carvings throughout Europe, possibly because of a lack of raw materials or perhaps owing to a change in demand. However, by the second half of the thirteenth century the ivory carving industry was stronger than ever before. Paris was the centre of the trade, but there are a few ivories which may be attributed to England with certainty. One of these, the so-called 'Salting diptych' in the Victoria and Albert Museum (Fig. 5), a work of the early fourteenth century, shows a peculiarly English monumentality, a feature linking it with larger stone sculptures of the time. After the fourteenth century, ivory carving gradually diminished in England, and it was not until the eighteenth century that the country could boast of ivory carvers to equal the masters of the Middle Ages.

111. Brass of Sir John Fortey and his wife. c. 1458. Church of St Peter and St Paul, Northleach, Glos.

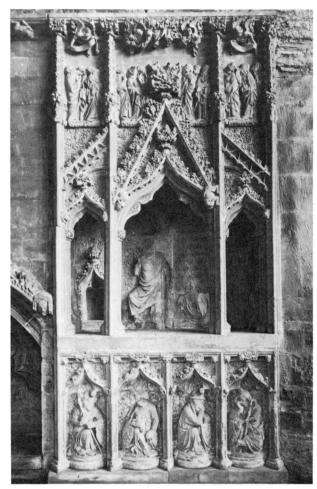

112. Easter sepulchre. Stone. c. 1330. Hawton, Notts.

Easter sepulchres were made to hold the Host from Good Friday until Easter Sunday and were particularly popular in Lincolnshire and the surrounding areas. Almost a counterpart to the Percy Tomb is the striking and ornate sepulchre at Hawton in Nottinghamshire, of about 1330 (Fig. 112). Here, as on other examples, the resurrected Christ is shown in the middle of the sepulchre with the sleeping soldiers underneath and the Ascension above.

The chief monumental commission of the fourteenth century is the West Front of Exeter Cathedral, instigated by Bishop Grandisson (1327–69), and carried out in two phases, in about 1340 and 1380. In comparison with the sculptures at Wells Cathedral of the preceding century, the Exeter figures bear little or no relation to their architectural setting, but are simply placed in ready-made niches. The individual figures are well-executed (especially those of the earlier phase) but are rather lifeless.

Lifeless is an adjective sometimes attached to the many hundreds of alabaster panels produced in England from the second half of the fourteenth century until about 1550. It cannot be denied that the carving of alabaster panels for retables or small altars reached a level of mass production and they were exported in vast numbers. But although the panels follow repetitive iconographic themes, there is often a great charm and narrative power in the carvings: with the original polychromy intact they offer a vivid picture of medieval religious drama (Fig. 113).

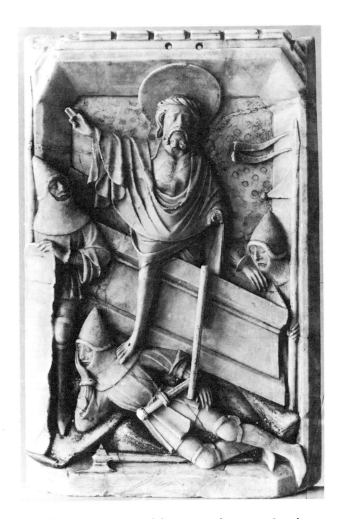

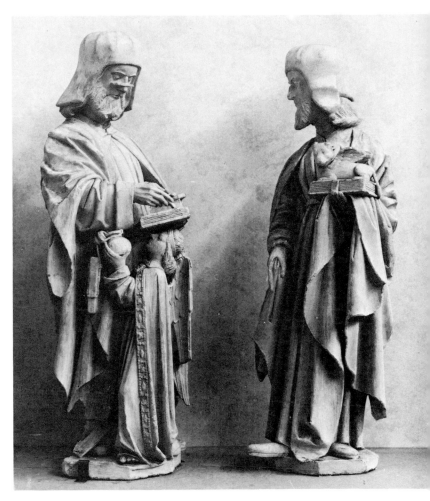

113. The Resurrection. Alabaster panel. *c.* 1400. London, Victoria and Albert Museum

114. St Matthew and St Luke. 1505–15. London. Westminster Abbey, Henry VII Chapel

Late Gothic sculpture in England is represented better at Westminster Abbey than anywhere else, in two royal commissions separated by about sixty years. The first is the Chantry of Henry V, which was probably not completed until 1450; the second is the Chapel of Henry VII (1502–*c.* 1512), with its numerous half-lifesize standing figures of saints at triforium level (Fig. 114). For the sixteenth century these figures are perhaps a little old-fashioned, with their artistic roots firmly anchored in the preceding century. But at ground level, in the centre of the Chapel, is the tomb of the king and his queen, Elizabeth of York, by the Italian sculptor Pietro Torrigiano. It was Torrigiano who brought the spark of the Renaissance to English sculpture.

PAUL WILLIAMSON

Sculpture after 1500

Pietro Torrigiano was one of the half-a-dozen sculptors, mostly from Tuscany, who settled in England and introduced the art of the Italian Renaissance to the court of Henry VIII. Torrigiano was employed between 1512 and 1518 upon the tomb of Henry VII, the founder of the Tudor dynasty (Fig. 116). The Chapel erected for this tomb was adjacent to the burial place of earlier English kings in the apse of Westminster Abbey. The architecture of the Chapel was Gothic, of a more elaborate and ornate style than the Abbey itself. The effigies of the king and his queen were, if not Gothic in style, then traditional in attitude. What makes the tomb a Renaissance work are the elements derived from ancient Roman architecture and ornament on the tomb chest – the elegant scroll on the white marble lid, the bronze Corinthian pilasters (enriched with Tudor devices) which articulate the sides, and above all the angels supporting the royal arms which are quite unlike any that had appeared in the Abbey before.

115. Monument to Sir Robert and Lady Barkham, by Edward Marshall. Marble. c. 1645. Tottenham, Middlesex

Such curly-haired, chubby putti, inspired by those marble ones which play so important a part in ancient sculpture, had been the fashion for the previous half-century in Florence, but were novel in northern Europe. Also new is sculpture which takes an evident delight in the beauty of the nude body (for the lower pair of angels at either end is undressed) and in the display of graceful freedom of movement that nudity permits. The angels here might be compared with the putto running with a dolphin which Verrocchio made for a fountain for the Medici, and of course they might very easily have been adapted as ornaments for the royal palace and gardens.

The secular and even pagan character which may be detected in these figures has nothing to do with the Reformation. But with the Reformation the character of commemorative sculpture did rapidly change in England. Above all such sculpture proliferated enormously. The Gothic interiors of numerous churches were systematically wrecked, and such devotional imagery as was permitted to survive was rudely challenged, by a shoddy competition for worldly immortality on the part of sections of society who had never previously been in a position to erect monuments. In Westminster Abbey, where a change in ecclesiastical authority coincided with Queen Elizabeth's policy of encouraging extravagance in her courtiers, her own tomb (like that of Mary, Queen of Scots) is dwarfed by vast and gaudy monuments, covered in mottoes and devices, as remarkable for their worldly pride as for their lack of artistic merit.

It would however be a mistake to exaggerate the secular character of either Tudor or Stuart commemorative sculpture, just as it would be a mistake to sentimentalize the piety of medieval monuments. Many English sculptures of the sixteenth century, and even more of the seventeenth, provide arresting models of piety. How passionate and earnest, for instance, are the devotions of Sir Robert and Lady Barkham in their half-length portraits (Fig. 115) carved by Edward Marshall in the 1640s for the parish church of Tottenham, Middlesex! Below them pray their children segregated by sex, the heir with his sword, the girls tightly packed and clasping on to each other, and those who predeceased their parents either sleeping beside a skull or holding one. The religious sentiment in such a work is more impressive than that in monuments of earlier centuries because

RIGHT

116. Tomb of Henry VII, by Pietro Torrigiano. Bronze. 1512–18. London, Westminster Abbey, Henry VII Chapel

by now conventions of a far more worldly character had grown up which were here rejected.

Whether or not tomb sculpture became more secular in the sixteenth and seventeenth centuries there was certainly a great increase in the sculpture that was secular in purpose. The Italians who worked for Cardinal Wolsey and Henry VIII introduced the bust portrait (a Roman art form revived in mid-fifteenth-century Florence), and the profile medallion portrait (inspired by ancient coinage). They also made heads of emperors, statues of heroes, and personifications of virtues, as solemn decorations for royal palaces, as well as more playful sculpture of gods for the garden fountains, of which, however, hardly anything survives.

A century after Henry VIII, Charles I also summoned foreign sculptors to his court. Hubert le Sueur and Francesco Fanelli were both expert bronze founders and Fanelli also an authority on hydraulics. They were, in fact, engineers as much as artists (to make a modern distinction). Le Sueur cast a series of copies of the most famous antique statues then to be seen in Rome and Paris. The king, following the example of the Earl of Arundel and the Duke of Buckingham, also acquired a collection of genuine antique statues. Fanelli cast the first small bronzes – charming pagan desk ornaments – ever made in this country; he also cast the very large Diana fountain, originally at Hampton Court.

For Charles I as for Henry VIII the most prestigious modern sculpture was certainly made in bronze, but white marble (from Carrara) was recognized as *the* ideal material for carved work – not least because it was the material favoured for such work by the ancients. There was little marble available in England in the early Tudor period. Even in the early seventeenth century the chief materials for tomb sculpture were alabaster and a black stone usually known as 'touch'. But under Charles I white marble was at last properly established as the standard material for all sculpture of any importance which was to be kept indoors.

By the end of the seventeenth century the sculptures most commonly commissioned for English interiors were bust portraits, and after about 1720 these became highly popular. The sitters are often portrayed as Romans, but also sometimes in their wigs, and not uncommonly in nightcaps and unbuttoned shirts. This last type of bust was the most informal and convivial. The finest examples are those by the French émigré Louis François Roubiliac, who possessed an astonishing ability to capture fleeting expression and endow a collar or a cheek with the

vivacity of contemporary rococo ornament (Fig. 117). The most notable successor to Roubiliac was Joseph Nollekens. His position was in turn taken over by Francis Chantrey, whose best portraits, executed in the 1810s and 1820s, were far less ornamental in composition, much heavier in their drapery, less particularized in the features and simpler in presentation than Roubiliac's. But the quality is quite as remarkable.

A material cheaper than bronze and more durable than marble which became popular outdoors in England in the early eighteenth century was lead. Founders such as John van Nost and Andrew Carpenter supplied figures to punctuate the skylines of the great classical houses whose pitched roofs were now concealed. Such figures, especially if sufficiently animated to catch the eye, were dangerously liable to erode if made of stone. The founders also provided, for the gardens, ornamental flower-pots, greyhounds, putti kissing and wrestling, and some adult rapes and murders (copied from groups by the Italian sixteenth-century sculptor Giambologna), besides copies of the most famous antique statues.

117. William Hogarth, by Louis François Roubiliac. Marble. *c.* 1740. London, National Portrait Gallery

These leads were never of a quality that can have much attracted the connoisseur, but one or two attempts were made to obtain original pieces of garden sculpture of high quality similar to those which were so admired at Versailles and Marly. The scarcity of such works may have been due to a recognition of the unsuitability of the English climate, but the new fashion in gardening in England is also significant. There was a reaction against formal plans such as that at Canons with its topiary and statuary.

Of surviving pieces of garden statuary the best is the marble group of *Vertumnus and Pomona* (Fig. 118), of about 1725, probably commissioned by the Duke of Chandos for Canons, from the Flemish sculptor Laurent Delvaux. This group must be one of the first full-scale, free-standing secular narrative groups carved in this country. Like Bernini when he created his Apollo and Daphne a century earlier, Delvaux seeks to portray the climax of a well-known tale from Ovid. Vertumnus has wooed Pomona, a goddess of the kitchen garden, in many guises, finally winning her in the person of an old woman, whereupon he reveals his true identity and tentatively extends a hand to touch her (or to disarm her of her scythe). The group is completed by Cupid who sits upon his sheath of arrows sucking a finger which he has cut perhaps on Pomona's scythe whilst picking at the fruit in her basket (a pretty allusion to love's first failures). The surface is weathered, but the flesh, especially Cupid's, is still soft and the expression subtle.

Delvaux also helped to introduce narrative into English tomb sculpture when he arrived from Flanders in 1720 to work on the splendid figure of Time carrying off the medallion portraits of the children of the Duke of Buckingham on the duke's tomb in Westminster Abbey. The allegories in later monuments, especially those in the Abbey executed in the middle of the century by Louis François Roubiliac, are involved, and involve us, in the most exciting dramas.

On a small scale, too, putti can provide a good deal of lively action, as, for instance, those on either side of the portrait of Philip de Sausmarez by Sir Henry Cheere (Fig. 119) – a medium-size monument fitted into the blind arcade of the Westminster Abbey nave. The putti are not very different from those first introduced into England by Torrigiano. The medallion portrait is also of a type that can be traced back to that period. It is the relationship of the two elements that is new, the one putto covering up the medallion whilst the other weeps over the symbols of

118. Laurent Delvaux, *Vertumnus and Pomona*. Marble. c. 1725. London, Victoria and Albert Museum

the dead man's learning, his justice, and above all his success as a sailor.

There are other elements in the work which merit attention. The inscription is cut in a shell with reeds behind it and framed by consoles garlanded with seashells and seaweed. This ornamental carving is worthy of the very best tradition established fifty years earlier in England during the embellishment of St Paul's Cathedral. The shell rests on a plinth, which is adorned – rather too much as a footnote – with a pictorial low-relief of a naval engagement. Some yellow Sienna marble is employed and there is a ground of dove-grey marble. Such coloured marbles were also popular at this period in chimneypieces.

Sepulchral Effigies

PAUL WILLIAMSON
and
NICHOLAS PENNY

In Britain, the desire to be represented in effigy over one's burial place came into fashion in the middle of the twelfth century, then continued without a break through the Middle Ages and into the Modern Age, so that even minor churches can usually furnish at least one example. One of the first slabs to show a recumbent figure, the standard design for the following centuries, is that of Bishop Roger (died 1140) in Salisbury Cathedral, carved from black marble (Fig. 1).

Towards the end of the twelfth century, and for the next hundred years, Purbeck marble became the dominant material for tombs. Easily available, it prompted a huge expansion in the manufacture of grandiose tombs, and by the thirteenth century we see representations of a good cross-section of English high society in effigy: bishops and leading ecclesiastics, distinguished knights dressed in mail, and royalty. Outstanding among the thirteenth-century royal effigies is that of King John (died 1216) in Worcester Cathedral (Fig. 3). His tomb was probably made some time after his death, around 1240. The king is flanked by the small figures of St Oswald and St Wulfstan, whose tombs were on either side of the king's.

Before 1500 very few sculptors are known by name as there are no signatures on the tombs and documents are scarce: but we have a skilled bronze caster from the Middle

Ages – William Austen. Austen was responsible for casting the remarkable effigy of Richard Beauchamp, Earl of Warwick, in the Beauchamp Chapel at Warwick in around 1454 (Fig. 2) – the earl having died some years earlier, in 1439. In the complexity of the casting and the overall design of the monument, with the angels and weepers below, it would be fair to say that this tomb matches anything produced on the Continent at the same time.

This high standard of bronze casting was revived by the Italian Pietro Torrigiano in his effigies of Henry VII and his queen. These are more naturalistic than earlier English effigies, but the attitude remains recumbent. A proposal for a kneeling posture such as had just become fashionable for the French kings was apparently rejected. However, for the small mourners around tomb chests, and for larger effigies, kneeling figures became popular. Epiphanius Evesham's tomb of Lord Teynham (1636) (Fig. 4) shows how the two conventions could be reconciled: Lady Teynham who commissioned the monument is alive and at prayer, as is her family in miniature, carved with great vigour, below.

By the early eighteenth century

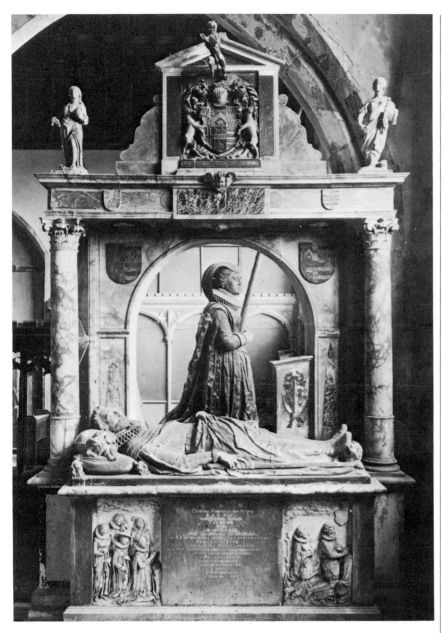

recumbent and kneeling effigies began to pass from fashion and were replaced by reclining effigies or by standing ones. The former had made an appearance as early as the mid-sixteenth century, the figures mostly propped stiffly upon their elbows. Now they sit up and look proudly out at the living world. Tomb chests are replaced in the case of some of the standing effigies by giant urns, such as the one beside Rysbrack's Sir John Dutton of 1749 (Fig. 5) – a superb example of the dignity achieved through classical drapery and hairstyle in the best marble effigies of this period.

Even before medieval conventions were revived, the recumbent effigy returned to favour. 'He is not dead, but sleepeth' we read on the neo-classical sarcophagus beneath E. H. Baily's effigy of Viscount Brome of 1837 (Fig. 6). Officially this is a metaphor for heavenly peace but the image is appealing as an agreeable alternative to the grim fact of death.

OPPOSITE FAR LEFT 1. Tomb of Bishop Roger, died 1140. Marble. Salisbury Cathedral
ABOVE LEFT 2. Tomb of Richard Beauchamp, Earl of Warwick. Bronze effigy cast by William Austen c. 1454
LEFT 3. Tomb of King John, 1240. Marble. Worcester Cathedral
ABOVE 4. Tomb of Lord Teynham, by Epiphanius Evesham. Marble and alabaster. 1632. Church of St Peter and St Paul, Lynstead, Kent
ABOVE RIGHT 5. Tomb of Sir John Dutton, by Michael Rysbrack. Marble. 1749. Church of St Mary Magdalene, Sherborne, Glos.
RIGHT 6. Tomb of Viscount Brome, by E. H. Baily. Marble. 1837. Church of St Nicholas, Linton, Kent

119. Monument to Philip de Sausmarez, by Sir Henry Cheere. Marble. 1747. London, Westminster Abbey

This monument, strictly speaking a cenotaph, commemorates a patriotic hero. Through competitive private enterprise (rather than public policy as some foreigners supposed) Westminster Abbey had, by the mid-eighteenth century, become a national 'hall of fame' – the first of its kind in Europe. We have already observed how the tombs of Elizabethan courtiers overshadowed the royal tombs in the apse. During the eighteenth century no royal tombs whatever were erected in the Abbey, but it became a place where one could appeal to and stimulate patriotic

sentiments with monuments not only to great warriors and statesmen but to such men as Newton, the first English thinker to dominate Europe, and Shakespeare. The English zeal to erect statues to great men also manifested itself in remarkable ways elsewhere. Handel was even celebrated by a lifesize statue in his own lifetime – an unparalleled privilege at the time.

Delvaux whose *Vertumnus and Pomona* we have examined, Scheemakers who made the statue of Shakespeare in the Abbey, and Rysbrack who made the monument to Newton (which the architect William Kent helped to design) all made copies of antique sculpture. Most interestingly, Rysbrack also created a large Hercules of his own invention for a garden temple. This was indebted to the famous antique Farnese Hercules, but was also a criticism of it. Yet it was only at the close of the eighteenth century that an English sculptor secured a commission for a set of poetic figures – the goddesses carved by Joseph Nollekens for Lord Rockingham.

Of equal quality but less well known is the splendid chimneypiece carved in 1778 by Richard Westmacott the elder for Cobham Hall, Kent (there is another version at Powderham Castle, Devon) (Fig. 120). The cross-legged piping boy is derived from an antique statue of a Faun (then in the Villa Borghese in Rome) and the girl from the gracious figures on ancient bacchic reliefs such as those on the famous ancient Borghese Vase (then also in the Villa Borghese). The whole of that vase is in fact also reproduced in miniature above the figures. The exquisitely carved low-relief tablet is derived from a celebrated painting, also in Rome, of Aurora by Guido Reni. The flavour of such a work of art requires, if it is fully to be relished, the education which English gentlemen received on the Grand Tour: it paraphrases and translates classic sculpture much as English poetry of the same period adapts or imitates the verse of Horace or Ovid.

There were many more commissions for modern classical sculptures in the nineteenth century than there had been in the eighteenth: some great noblemen even established galleries in their houses for the display of modern sculpture (Chatsworth, Woburn, and Petworth are the best examples). The subjects are sometimes heroic, more often poetic. Typically they are female figures employed keeping up an appearance of modesty. Many were made by English sculptors resident in Rome (of whom John Gibson and R.J. Wyatt were the most distinguished) and were brought back to inhabit the conservatory, or a less congruous setting – some soft nymphs may still be discovered cowering beside hard bristling suits of armour in the gloomy staircases of Gothic Revival houses.

120. Chimneypiece, by Richard Westmacott the elder.
Marble. 1778. Cobham Hall, Kent

More or less classical figures, again predominantly
female but usually draped, had served as mourning
widows and as personifications in the church monu-
ments of the late eighteenth and early nineteenth
centuries; but with the ardent religious revival of the
mid-nineteenth century there was a reaction. Such
monuments were considered to be inappropriate for
religious buildings, and those which were erected
often assimilate aspects of medieval style to accord
with the Gothic Revival of almost all new church
architecture. The altar tomb and the reclining effigy
enjoyed a new popularity, but even here we do not
find many examples of the adoption of medieval
dress or the strict imitation of a Gothic figure-style.

The monument by Matthew Noble to William
Heath and his sister Mary (both of whom died in
1872), in Biddulph Church, Staffordshire (Fig. 121),
is a fine example of the degree to which Gothic ideals
could affect Victorian sculpture. The emphasis on the
nude body found in classical sculpture, and the
articulation and weight of the figure through con-
trapposto, are rejected. Instead a sense of weightless-
ness, of the disembodied spirituality considered essen-
tially Gothic, is achieved. The gowns worn by both
Christ and the angels above which he hovers fall in
long clean curves relating both to the lines of Christ's
mandorla and to the pointed arch of the alabaster
frame.

A very different but no less distinct attempt to
break with classical formulas appears in the last

121. Monument to William and Mary Heath, by Matthew
Noble. Marble. 1872. Biddulph, Staffs.

decades of the century. Edward Onslow Ford, for
example, in the small sculpture (90.8 cms long) en-
titled *Snowdrift* (Fig. 122) which he carved in 1901, the
last year of his life, portrayed a bony prepubescent
girl sleeping in an attitude which, if not suggestive
of fevered dreams, is certainly not one of tranquil
repose. And she is sleeping on a bed of snow which
floats upon a block of smooth pale-green banded
onyx. The subject may come from a weird fairytale,
but more likely from the artist's own imagination. It
certainly does not come from Ovid, although the

133

122. Edward Onslow Ford, *Snowdrift*. Marble. 1901. Port Sunlight, Lady Lever Art Gallery

subject *is* perhaps metamorphosis, warm flesh melting cold snow or frozen by it, the one about to become the other. For the moment, however, the tight silky skin is distinguished from the powdery snow, which is dimpled where it thaws and smooth where it forms into icicles.

This is the period in English art where the craft of the sculptor and goldsmith were closest. The use of onyx here is typical of a tendency to supplement the sculptor's traditional materials with semi-precious ones. It is part of the subject of the sculpture as is (to a lesser degree) the lapis lazuli, the silver and the black marble of the base, and some other works in this period are spectacularly 'chryselephantine': one even finds ivory women, chained to granite rocks lapped by jade waves, who wriggle away from bronze dragons with gemstone eyes. *Snowdrift* represented a reaction away from stale classicism; but the private, slightly morbid and distinctly passive theme, the fastidious delight in contrasts between types of finish and materials, was bound to provoke a more violent reaction in its turn. Who, though, could have anticipated the monstrous *Rock Drill*?

Jacob Epstein's sculpture *Rock Drill* was shown in the Goupil Gallery as part of the 'London Group Exhibition' of March 1915. The idea of a group of young artists exhibiting independently as part of a self-consciously new 'movement' had grown up gradually over the preceding half-century. Now it was fully established, and so was the expectation of hostility from the art 'establishment'. An artist like Frampton was accustomed to his more private works being considered decadent or meaningless, but Epstein was creating sculpture which was intended, not only as an assault on traditional values, but as something which would disturb even those who were

most sympathetic to his art. As with so much modern art, the *Rock Drill* has no home and it is unlikely that the sculptor had any particular environment in mind when he created it. The only possible place for it was a museum of modern art where of course its impact was bound to be diminished.

The figure (made of white plaster) consisted of a menacing robot mounted upon a real tripod rock drill. 'Robot' was the artist's own word. The face wears a visor, or rather *is* a visor, which was no doubt suggested as much by the protective face shields used in industry as by ancient armour. But we should also remember that masks, especially 'primitive' wooden masks, were a subject of fascination for many artists at that date – Epstein had met Modigliani, Picasso, and Brancusi in Paris and would have been fully aware of this. The mask rejects the refinements of expression despised by modern sculptors as 'pictorial' and essential to narrative which was reviled as 'literary'.

The pose carries some suggestion of a vulture and the angular shapes and the articulation (impossible but for the work of the Cubists a few years before) call to mind an insect – 'a kind of gigantic human locust' according to one outraged contemporary. In any case animal as well as mechanical life is obviously important: the phallic character of the creature is hard to miss, but it also carries its unformed progeny within its ribs (this idea – of a soft form nesting in a hard cage – was one which Henry Moore would later adopt).

Epstein himself had mixed feelings about the *Rock Drill*. Perhaps he was unhappy about incorporating into the design a ready-made machine. In any case, in 1916 he cut off the upper part of the figure and cast it alone in bronze (Fig. 123). Others, however, took up the idea of involving objects of modern manufacture – sometimes even those in daily use – in works of art, and the challenge which this entails to the idea of art as imitation of nature and as craft still had some impact half a century later. During the years immediately following the Second World War, the idea of creating not a human figure but a totem composed of bird, insect and human also proved popular with sculptors – the best among them perhaps Reg Butler and Lynn Chadwick; Epstein himself, however, had by then withdrawn from it.

It was Henry Moore rather than Epstein who established himself between the wars as the leading sculptor in England, and unlike earlier sculptors in that position he enjoyed an equivalent international reputation. He created human forms which are more numinous by their association with 'primitive' sculp-

ture (African, Pacific, Mexican, Egyptian and Cycladic) and more monumental because of the stone of which they are made. The sculptor realizes that ideas of strength, permanence and monumentality may be conveyed by blocks from the quarry and still more by boulders which man has not even begun to shape.

There was a reaction, although not a final one, against white Carrara marble and an interest in more resistant, less 'versatile' materials which were hard to work at all and very hard to undercut. Sculptural forms won from these materials look 'blocky' and hewn and have no resemblance to any form that was originally modelled. That carving was an opposite process to modelling, and the idea that carving should be 'direct' – without preparatory models, mechanical aids and without assistants – was perhaps the most potent aesthetic idea to determine the character of sculpture this century. Sculptors had from the late eighteenth century onwards partici-

pated less and less in the actual carving of their works: now they became carvers above all.

Henry Moore's *Mother and Child* (Fig. 124) of Hornton stone, completed in 1925, is a superb example of work produced under the influence of this idea – or rather this faith, for both moral and spiritual ideals were involved. The subject is treated with elementary simplicity unprecedented in English sculpture. In the following decades Moore would be interested in the treatment of more complex and metaphorical ideas, sometimes in work which was far more abstract, although in fact even the most geometrical shapes he created are distinctly biological; but the monumental treatment of a maternal group has remained a central preoccupation of his art. The *Mother and Child* is in fact less than two feet high but it is certainly monumental. And we can tell immediately that its creator would be successful working on a massive scale.

123. Jacob Epstein, torso from the *Rock Drill*. Bronze. 1916. London, Tate Gallery

124. Henry Moore, *Mother and Child*. Hornton stone. 1925. Manchester, City Art Gallery

An almost equal reputation was enjoyed by Barbara Hepworth (1903–75) who remained more consistently preoccupied than Moore with carving, conceived of as an exploration of the qualities inherent in the material worked – whether marble from Ireland, Sweden, or Italy, or deep-bed slate, or, with particularly attractive results, wood (Fig. 125). She had no interest in modelling and emphasized that her bronzes were cast from plaster which she had cut down not built up. Her work is usually seductive to look at but the images are less memorable than Moore's. She gave her work titles such as *Single Form* or *Pierced Hemisphere*, but also subtitles such as *September* or *Crucifixion*. This perhaps betrays a certain uneasiness concerning the abstract status of her sculpture.

The international standing which was enjoyed by British sculpture chiefly because of the work of Moore and Hepworth has been retained by subsequent generations whose work has been of a very different character. There was a strong reaction away from the idea of the sculptor as carver in close communion with natural materials and elemental organic forms – Hepworth, it must have been felt, had taken this idea as far as it could be taken. Sculptors began to see themselves as more like engineers, making calculations on graph paper and welding metal. This became the favourite material, and was often employed in a manner which neither involves, nor relates to, modelling or carving.

If we wonder with what in earlier art we should compare the delicate brass cages and webs made by Kenneth Martin in the 1950s and 1960s, or the loose arrangements (sometimes dainty, sometimes rugged) of what seem to be spare or even scrap beams and sheets of steel made by Anthony Caro in the 1960s and 1970s – to cite two of the more acclaimed developments in modern British sculpture – the best answer is perhaps certain aspects of architecture (Decorated Gothic bar tracery or the elaborate ter-

minations provided by Wren for the towers of his City churches). But on the whole modern abstract sculpture has been happiest on a small scale. Sometimes it has found an appropriate purpose in a public space, as for instance in Kenneth Martin's stainless steel fountain for Brixton College of Further Education (1961) which playfully engages both mind and eye. But all too often the work on a large scale is pretentious. A certain rhetoric is almost inevitably involved in such work and yet this seems inappropriate if the work embodies no ideal or sentiment which the public is likely to share.

The American sculptor David Smith observed in 1964 that, 'Sculpture has been a whore for many ages. It had to be a commissioned thing.' The emancipation which this metaphor self-righteously justifies is in fact an entirely new product of a rather bewildered veneration for free individual expression which is unlikely to have much of a future. On the other hand it is hard to believe that there will be a return to the traditional purposes of sculpture, as private and public portraiture, and as poetic or religious narrative.

Public sculpture in Britain represents a separate theme which requires us to retrace our steps. If we define the public statue as one occupying an unambiguous public space outdoors – quintessentially the town square – then no public statue was erected in Britain in the seventeenth or eighteenth centuries to anyone outside the royal family. The grandest status symbol of all was the bronze equestrian statue, of which the first to be made in Britain was Le Sueur's Charles I of 1633, which was little more than a parody of the statue of Henri IV on the Pont Neuf in Paris, but which has assumed by virtue of its almost heraldic stiffness a certain charm.

This statue was set up at Charing Cross in 1667, but it had been commissioned by Lord Treasurer Weston for his garden at Roehampton to designs approved by the court. In England, unlike the rest of Europe, the court was seldom closely involved in work of this sort and the ruling monarch was often not the subject of the statue. The chief focus of patriotic sentiment was William III, not for his personal qualities or achievements but rather for what he was not, and of course because he embodied the 'glorious revolution' and the Whig constitution. When the city fathers of Bristol voted to commission a statue of King William for their principal square they were motivated by a desire to demonstrate their loyalty to the Crown, in a most general sense, and their Whig principles (not in fact always obvious in

125. Barbara Hepworth, *Corinthos*. Wood, interior painted white. 1954–5. London, Tate Gallery

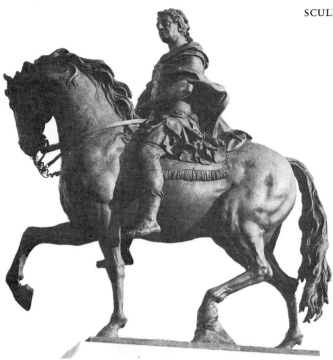

126. Equestrian statue of William III, by Michael Rysbrack. Bronze. 1735. Bristol, Queen's Square

Bristol); and of course to provide an ornament suited to their city's importance. Rysbrack provided them in 1735 with a remarkably powerful but restrained image of imperial authority (Fig. 126). The king, like almost all notable royal portraits in sculpture in the eighteenth century, is in antique dress.

George IV as king, and earlier as regent, was, for a British monarch, unusually interested both in art and in using it to project his magnificence. Among other ideas, he wanted his own equestrian statue in bronze on top of a triumphal arch in front of his new palace, and he wanted a still larger equestrian statue in bronze of his father on top of an artificial cliff of granite in Windsor Great Park. He also appreciated that the most public image of royalty was communicated in the miniature portraits which were stamped on the coinage. These of course enjoyed a 'currency' even greater than the popular prints, in which royalty was not always shown in a flattering light.

Throughout the Middle Ages the English coinage had been made by hammer and puncheon. The mill and press, which flattened metal to standard thickness, cut out regular blanks and stamped them, were invented in the sixteenth century, but successive monarchs failed to persuade the Mint to adopt these – it did not do so finally and fully until after the Restoration. The new methods made it possible for coins to have a sculptural relief akin to that of the struck medal (although less elaborate or exquisite)

beside which the old coins appear like milk-bottle tops into which a design has been impressed by a pencil. Under the Prince Regent there was another development: the Mint had again become old-fashioned and it was moved and the latest steam-powered machines installed. The Prince Regent also gave more attention than any previous English monarch to the appearance of the new coins issued under him. The finest English coins of earlier date had been those made by Thomas and Abraham Simon and by John Roettier for Cromwell and Charles II: significantly these men had made their reputations as medallists. Under the Prince Regent the responsibility for the design of the new coinage was given to the Wyons, a family of medallists, and to an Italian gem engraver, Benedetto Pistrucci.

Since James I English monarchs had been portrayed on coins 'laureate' and more or less Roman in dress. Under the regency and then the rule of George IV this was taken further: the king's expression, even physiognomy, is adapted to the stern and commanding ideals of Roman coin portraiture (Fig. 127). On the reverse of British coins Britannia, a Roman personification revived on the coinage of Charles II, assumes in this period a dignity (more like Pallas Athene than a nymph) and a strength of posture and clarity of profile which she retained until very recently. Pistrucci also devised as an alternative reverse the intricate and dynamic but compact group of St George and the dragon (Fig. 127), a work which shows as clearly as any larger work in sculpture executed in England the influence of the Elgin Marbles.

It is worth emphasizing George IV's success as a patron of miniature portraits, because even had he realized all his schemes for glorifying himself with colossal statues they could never have made an equivalent impact. This is because public sculpture had, shortly before his reign, ceased to be a royal monopoly.

127. Crown of George IV (obverse and reverse, twice actual size), by Benedetto Pistrucci. Silver. 1821. London, British Museum

Perhaps the chief reason for this change was the intensive patriotism engendered by the Napoleonic Wars. When Nelson died at the Battle of Trafalgar in 1805 there were numerous schemes for public monuments to him, many taking the form of bronze statues. Some of these were executed, including one in Liverpool completed in 1815 by Matthew Cotes Wyatt and Sir Richard Westmacott – then the largest and most elaborate bronze group ever cast in this country, and the most ludicrous. Nelson, heroically nude, treads on French corpses, a 'tar' advances by his side, Britannia sobs behind, Death reaches up to touch his heart and Victory bends down to drop crowns on his raised sword, whilst captives chained to the plinth groan.

128. William Pitt, by Francis Chantrey. Bronze. 1831. London, Hanover Square

National heroes were soon being honoured by gigantic memorials even before they died. A subscription for a gigantic bronze statue to honour the Duke of Wellington, the largest to be cast in Europe since antiquity, was under way even before Waterloo, and was completed by Westmacott in 1822. By then political leaders, too, had public statues. When Charles James Fox died his friends decided to commemorate him not only with a large marble monument in Westminster Abbey but with a bronze statue in Bloomsbury Square – yet again the work of Westmacott. Thereafter such double commemoration became standard practice for eminent politicians and of course party rivalry ensured that the practice quickly spread. By the 1860s such honours were also bestowed on mayors and local benefactors.

Just as in the eighteenth century the church authorities did nothing to discourage the practice of erecting monuments in the Abbey, so there was no central authority which could prevent the proliferation of outside statues in the nineteenth. Here again Britain led the rest of Europe, for no country there had quite this lack of court or government control over its public statues. Not that anything indecorous occurred in London.

Even when the classical robes which Fox wears passed from fashion there was a disinclination to emphasize modern dress or even traditional uniform, and heavy cloaks were much employed. In the case of Sir Francis Chantrey's statue of William Pitt in Hanover Square (Fig. 128) there is the added advantage that this gives monumentality to a notoriously frail form. This portrait possesses a genuine senatorial dignity which few statues of this class achieve, even though the raised head, the brow slightly knit in thought, and the scroll firmly clasped are repeated frequently. Action – the orator in full spate, the general leading a charge – is almost always avoided. Only at the end of the century was there any attempt to escape from the prosaic by an exaggeration of idiosyncrasies, both of contemporary dress and individual physiognomy, and even then the figures are given very little to do.

With the cities overpopulated with portrait statues the urge to produce some alternative commemoration increased. When the seventh Earl of Shaftesbury, a notable philanthropist, died in 1885 the usual memorial committee proposed, as usual, a marble statue for the Abbey and a bronze statue for an important public thoroughfare. The latter commission went to Alfred Gilbert, unquestionably the most brilliant sculptor in metal ever to have worked in this country. According to Gilbert himself he was de-

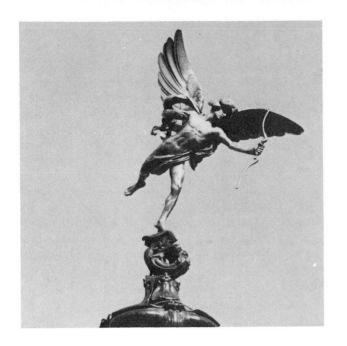

129. Eros Fountain (Shaftesbury Memorial),
by Alfred Gilbert. Bronze and aluminium. 1893.
London, Piccadilly Circus

130. Royal Artillery Memorial, by C. S. Jagger.
Portland stone. 1925. London, Hyde Park Corner

feated by a succession of philistine committees: however, the Eros fountain in Piccadilly Circus (Fig. 129), which was eventually completed in 1893, is one of the most poetic and hauntingly beautiful in the world (even though it now occupies a repulsive architectural setting).

It is hard to believe that Gilbert deceived himself that this fountain had anything to do with Shaftesbury, and it is astounding that the committees permitted him to get away with it. He frustrated all attempts to put some sort of effigy of Shaftesbury on it and even managed to leave blank the panels intended to illustrate his deeds. No one looking at the aluminium statue of the god, slightly melancholy but in vigorous flight, thinks of it as an emblem of selfless love; and no one looking at the wet bronze reliefs of wild boys and dolphins, at the swirling ornament, at the mouldings, swelling and tightening in turn, can think of the fountain as a metaphor for the overflowing charity of a Victorian philanthropist.

There are few public statues of any significance erected to individuals in this century, but a different type of public memorial became highly significant with the First World War – the sculpture commemorative of the hundreds and thousands of the 'fallen'. The rhetoric employed often seems rather hollow and the poetic ideas inappropriate, but among the hundreds of sculptures which were erected

some are dignified and a few are powerful – most obviously the Royal Artillery Memorial at Hyde Park Corner by C. S. Jagger which was considered to be aggressively modern because of the massive stone replica of a howitzer on top and the reliefs documenting the trench mud, barbed wire, gas masks, and the field telephone (Fig. 130). These reliefs possess great energy achieved by the densely superimposed planes, repeated angular forms, and the dramatic spaces between them. In complete contrast to the reliefs stand the bronze large figures, not at all conventionally grieving, but more, it would seem, stunned by the impossibility of responding appropriately.

Serving no obvious commemorative purpose, but nevertheless obviously embodying civilized values, and inviting such vague but potent notions as the 'dignity of man' and the 'sacredness of life' and 'maternity', are the works on a massive scale by Henry Moore which have been set up in recent decades as a foil to the fragile but grandiose glass architecture of the modern city not only in Britain but all over the world. Other British sculptors of our time have made their contribution, among them those discussed on pages 134–6, though none of them to the same extent as Moore. The result has been public sculpture of a kind, but of a kind never seen before either in Britain or elsewhere.

Nicholas Penny

Arms and Armour

G. M. WILSON

THROUGHOUT the Middle Ages and the Renaissance the art of the armourer was highly regarded and armourers were considered to be at least the equals of other artists. Nevertheless it must be admitted that this art consisted more of producing efficient weapons, or defences against weapons, than of making highly decorated products for prestige and show, although these were very much sought after by wealthy patrons. During the Middle Ages the finest arms and armour were made on the Continent, especially in southern Germany and northern Italy, in cities such as Milan, Augsburg, Nuremburg, Passau and Solingen. There is much evidence of the manufacture of arms and armour in Britain in this period but unfortunately very little that is recognizably British has survived from before the sixteenth century. However some British weapons were justly famous, such as the long-bow, and the particularly English form of bill (a staff weapon deriving from the agricultural implement of that name) which was developed in the fifteenth century. The long-bow remained popular in Britain, apparently especially so in Wales, from the Saxon period, and following its successes in the early part of the Hundred Years War, its use spread once more into other parts of north-west Europe, particularly Flanders.

By the Tudor period a considerable number of recognizably British types of weapons were developing, including a distinctive form of basket-hilt which reached its fullest development in the Scottish Highland broadswords of the seventeenth and eighteenth centuries. Henry VIII's army was still equipped with the 'national' weapon, the bow, with bills, and with various other weapons which foreigners were not accustomed to seeing. In 1513, for instance, the Venetian ambassador to Henry's court wrote that 12,000 of the English army were equipped with 'a weapon never seen until now, six feet in length, surmounted by a ball with six steel spikes'. Nevertheless, the majority of weapons used by Henry's armies were imported, chiefly from Italy. The import of munition arms and armour was quite acceptable by the standards of the time, but it must have been something of an embarrassment to Henry that at the beginning of his reign he had no royal workshops, staffed by professional armourers, to make splendid armours either for his own use or for presentation to others. Early in his reign, therefore, he began to bring over foreign craftsmen, chiefly from Milan and Brussels, to make high quality armour for him, and in 1515 he established a royal armour workshop near his palace at Greenwich. Initially this too was staffed solely by German and Flemish armourers, but gradually more and more armourers of English origin were employed.

The Greenwich workshop soon developed a distinctive although rather derivative style in which Italian, French, and German influences can be traced. Apart from some of the armours made for Henry VIII himself, which bear decoration that can perhaps be attributed to such foreign artists as Hans Holbein and Giovanni da Maiano, the products of the workshop do not compare in quality with the best armours made in the main German centres such as Augsburg and Nuremburg. Even in the late sixteenth century the style of much of the decoration on Greenwich armour suggests strong influence from Augsburg, and a truly British style of armour decoration seems never to have developed. Nevertheless, the group of highly decorated armours, closely following civilian fashions, which were made at Greenwich for the courtiers and favourites of Elizabeth I remains a unique expression of the confidence and flamboyance of the Elizabethan era (Fig. 131). The Greenwich workshop continued production until the outbreak of the Civil War in 1642, but after 1630 it lost its privileged position and was forced to produce munition armours for the royal army.

Henry VIII's reliance upon foreign craftsmen was not restricted to armour. It is known that Hans Holbein designed both swords and daggers for the

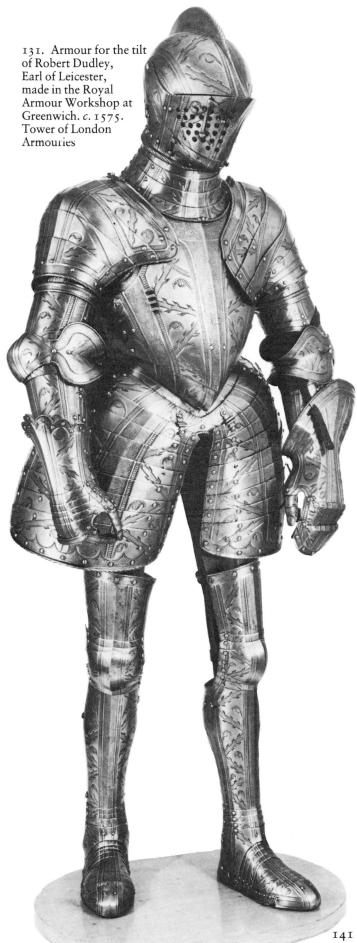

131. Armour for the tilt of Robert Dudley, Earl of Leicester, made in the Royal Armour Workshop at Greenwich. c. 1575. Tower of London Armouries

English court, and foreign swordsmiths of renown, such as Diego de Çaias, were also employed to make edged weapons for the king. Nevertheless, so far as is known, comparatively few magnificently decorated arms seem to have been made in Britain at this time. In contrast, on the Continent artist-craftsmen such as Albrecht Dürer, Giulio Romano, Benvenuto Cellini, and Wenzel Jamnitzer were employed to design lavishly decorated weapons, and swordsmiths such as Othmar Wetter produced weapons of extraordinary beauty and technical perfection, true works of art.

132. Breech-loading gun made for Henry VIII, probably by his gunmaker William Hunt. Dated 1537. Tower of London Armouries

Firearms have been made in Britain since the fourteenth century, but the earliest surviving gun which can confidently be said to be of English manufacture dates only from the reign of Henry VIII (Fig. 132). It was made in 1537 for the king's personal use, almost certainly by William Hunt, who in the following year was appointed Keeper of the King's Handguns and Demi-hawks. Now in the Armouries of the Tower of London, it is a breech-loading gun, and both the technical proficiency of the design and the quality of the decoration attest to the high standard of English gun-making at the time. Later in the century English gun-makers seem largely to have copied the designs of weapons and styles of decoration that were popular elsewhere in North-West Europe and especially Holland, and no truly English style was developed.

In Scotland at this time, however, firearms of a very distinctive pattern were being produced, and a national style developed which lasted until the nineteenth century. One of the characteristic features of these Scottish firearms is the form of the decoration, which frequently covers all the metal parts and generally consists of panels engraved with foliate scroll-work, guilloche ornament and other Renaissance motifs. Many Scottish pistols were made with left- and right-hand locks, so that they could be worn on either side of the body and used in either hand. From the early seventeenth century onwards a number of all-metal firearms were produced in Scotland. At first these were made of brass and later steel, and by the later eighteenth century the all-steel pistol was an accepted part of full Highland dress.

By the beginning of the seventeenth century, various English types of sword-hilt had appeared, and it is possible to recognize English-made rapiers, basket-hilted broad swords, hunting hangers, and robe swords of the first half of the century. A feature of many of these is the fine counterfeit-damascening, and sometimes gold or silver encrusting, with which many are decorated. This form of decoration was also popular on the Continent and it is often only possible to establish the origin of these swords by reference to the form of the hilt. However, despite this, and the fact that much of the encrusting and damascening may have been done by immigrant craftsmen working in England, some of the decoration is distinctive enough to be confidently ascribed to this country. The finest of these English swords are of extremely high quality, such as the cross-hilted robe sword (now in the Wallace Collection, London) which was made in about 1610 for Henry Frederick, Prince of Wales, probably by the London cutler Robert South (Fig. 133). The blade of this sword was made by Clemens Horn of Solingen, whose name appears on the blades of several of the finest English swords of this period. Until the seventeenth century it seems to have been common practice for English makers to import blades for mounting with their best hilts. However, in the second quarter of that century the native industry was given a considerable stimulus by the establishment of a blade-making 'factory' at Hounslow, largely staffed by German smiths, some from Solingen. The Hounslow 'factory' did not survive the Civil Wars and Interregnum, but by the time of the Restoration a large sword-smithing industry was established in the Birmingham area. In 1687 a further group of Solingen smiths emigrated to England and set up a blade factory at Shotley Bridge; from this there is a direct descent to the Wilkinson Sword Company which still produces distinctive and high-quality British swords.

In the seventeenth century the style of English firearms continued to be dominated by continental influences, at first Dutch and then French. In the mid-century English guns were practically indistinguishable from those made in Holland, and indeed perhaps the most influential maker working in England at this time, Harman Barne, may have been of Dutch origin. In the last quarter of the century some English gun-makers began to produce arms of great beauty as well as efficiency, but the decoration was entirely French in style, based upon the series of pattern-books published by French makers and designers at this time. This French influence spread beyond the best of the London makers to provincial gunsmiths such as Henry Ellis of Doncaster and Nicholas Paris of Warwick. In the last two decades of the seventeenth century the English gun trade was largely dominated not only by continental styles but by foreign craftsmen, many of whom came to England to avoid religious persecution in their own countries. It is difficult to over-emphasize the importance of such immigrant makers as James Ermendinger (a German), Andrew Dolep (probably a Dutchman) and Pierre Monlong (a Frenchman), all of whom enjoyed royal patronage and exerted a great influence upon English gun-making at the end of the century. Indeed, Pierre Monlong was responsible for what may well be the finest pistols ever made in England – a pair of holster pistols (now in the Tower of London Armouries), with chiselled steel mounts and stocks

133. Sword of Henry, Prince of Wales. Hilt probably by the London cutler Robert South, blade by Clemens Horn of Solingen. c. 1610. London, Wallace Collection

decorated with inlaid panels of engraved silver (Fig. 136). The ornament of these pistols, which derives from various pattern-books published in Paris in the second half of the seventeenth century, includes what appears to be a portrait bust of King William III and it is possible that they were made for the king himself.

In the eighteenth century, London makers came to dominate the English gun-making trade, and English makers the London trade. It was at this time that a truly English style began to develop, based upon the traditional English love of simplicity, and English guns of this period generally avoid the profuse ornamentation frequently found on contemporary continental firearms. The quality of English workmanship was of an increasingly high standard, both technically and artistically. In the last quarter of the eighteenth century, gun-makers throughout Europe were seeking ways to improve the performance of flintlock firearms, which technically had altered little for a hundred and fifty years, and it was English gun-makers who led the way. The restrained English style, in which line was more important than ornament, proved easy to adapt to the demands for greater efficiency and accuracy. English makers pioneered improvements both to the barrel (such as the patent breech and the platinum-lined touch-hole) and to the lock (such as waterproof and self-priming pans, and stronger forms of cock). London makers of the late eighteenth century, such as Henry Nock and the brothers John and Joseph Manton, developed the flintlock gun to its ultimate perfection, and have a leading place in the history of gun-making.

Britain's main contribution to the development of firearms in the nineteenth century was also of a technical rather than an artistic nature. This was the invention by the Reverend Alexander Forsyth, some time before 1806, of a practical system of percussion

134. Pair of brass stirrups decorated with 'Surrey' enamel. *c.* 1660. Tower of London Armouries

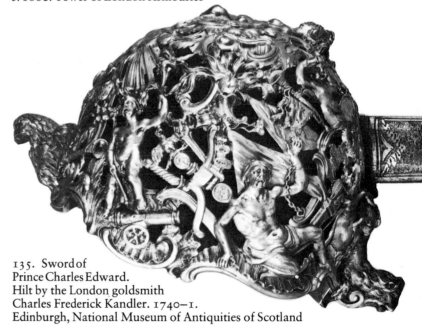

135. Sword of
Prince Charles Edward.
Hilt by the London goldsmith
Charles Frederick Kandler. 1740–1.
Edinburgh, National Museum of Antiquities of Scotland

136. Pair of flintlock holster pistols made by the French Huguenot gunmaker Pierre Monlong in London. *c.* 1695. Tower of London Armouries

143

ignition, which in an improved form soon supplanted the old flintlock guns, and which led to the development of the types of self-contained cartridge still used in modern firearms. Following this invention almost the entire energy of the gun-maker was put into improving and refining firearms as weapons of destruction, and artistic, decorative considerations were largely forgotten, especially with the large-scale adoption of mass-production methods in the mid-nineteenth century.

In the second half of the seventeenth century, the form and decoration of English swords was once more largely dominated by continental styles, especially those in fashion in Holland and France. However, some uniquely English styles did occasionally emerge, such as the group of cast-brass hilts for hunting hangers, stirrups (Fig. 134), and other hunting accoutrements, dating from the period of the Restoration. These are decorated with a particular form of enamelling that in the past has often been referred to as 'Surrey' enamel; there is in fact no evidence that it was made in Surrey. Indeed, the similarity of this enamelling to some known to have been produced in London may suggest that the whole group was made there. In the first half of the eighteenth century the fashionable small-sword was usually made in imitation of French forms and styles. However, distinctively British forms of military swords did develop, and the best of these are of the very highest quality. Officers tended to carry decorative versions of these military patterns, and for officers of noble rank the best goldsmiths and silversmiths in England were sometimes called upon to produce most highly decorated swords. One of the finest of these is the sword said to have been taken from the baggage of Prince Charles Edward after Culloden, and now in the National Museum of Antiquities of Scotland (Fig. 135). This has a basket-hilt of cast silver, richly decorated with figures and trophies in high relief amid pierced rococo scrolls. It was made, apparently in 1740–1, by the renowned London goldsmith Charles Frederick Kandler.

By the second half of the century a distinctive English style of small-sword decoration had also emerged; the hilts were usually pierced with tightly coiled spirals and scroll-work, often resembling filigree, and sometimes enriched with faceted studs which gave the sword a jewelled appearance. The popularity of such mock-jewelled hilts seems to have led to their imitation in cut-steel. Such cut-steel hilts had been introduced into France by 1765, but attained their greatest popularity in England,

where the most famous maker was the industrialist Matthew Boulton of Soho, Birmingham, who produced these from 1762 until 1800. Some were set with cameos supplied by Thomas Wedgwood, and these, especially, are fine and successful examples of early industrial co-operation. Similar cut-steel hilts were also produced in the Oxfordshire village of Woodstock from at least 1753 until the early nineteenth century. Indeed, this style of sword became so popular in England that it has remained in use for wear with civilian court dress until the present day.

The best English swords of this period were undoubtedly those produced in the last twenty years of the eighteenth century by the London goldsmith and enameller James Morisset, and in the first twenty years of the nineteenth century by his successors, John Ray and James Montague. These makers specialized in the production of presentation swords of the highest quality, and their work is characterized by fine quality neo-classical decoration and by the use of panels of enamelling, usually consisting of areas of naturalistic painting set within a border of translucent enamel in one of the primary colours. There is evidence to suggest that some of the designs for the naturalistic enamelling on these swords were supplied by the celebrated marine painter Robert Cleveley. Such sumptuously decorated swords were presented to many of the major British commanders of the French Revolutionary and Napoleonic Wars, by citizens and merchants who spared no expense to show their gratitude; those that survive attest to the quality of English craftsmanship and design at its very best.

Since the early nineteenth century there has been a continuing demand for presentation swords, but the quality of these enamelled swords has never been equalled. However, in the mid-nineteenth century distinguished London goldsmithing firms such as Hunt and Roskell produced a number of very fine presentation swords. One of the best of these, now in the Tower of London Armouries, was presented in 1856 by the legislature of Nova Scotia to Sir William Fenwick Williams to mark his notable, though ultimately unsuccessful, defence of the Turkish town of Kars against overwhelming Russian forces. However, the designer of this sword was a French artist, Antoine Vechte, who set up a studio in London after 1848. Thus, this sword, like so many other fine British-made pieces of arms and armour, owes its decorative scheme not only to foreign influence but to a foreign craftsman.

11

Ceramics

GAYE BLAKE ROBERTS

THE DEVELOPMENT of one of the finest ceramic traditions in the world has its origins in the availability in Britain of abundant quantities of good quality clay, wood and coal, the basic requirements for the growth of a pottery and porcelain industry. From the earliest times these natural products were exploited to manufacture useful and domestic vessels. After the departure of the Romans, in the early fifth century, there was an almost total breakdown in the previously highly organized pottery production. It was not until the seventh century that any further attempts to manufacture pottery were made in England.

The Roman ceramic tradition, however, did survive unbroken in the area of the Rhine, and the Rhine had a close trading association with East Anglia. From this connection a revival of the ceramic industry occurred in Ipswich (Suffolk), which was to remain the centre of pottery making in England for the next five hundred years. Most of the pots produced were of a grey colour and unglazed, and late Saxon wheel-thrown pieces of this nature continued to be made until the middle of the twelfth century.

A dramatic change took place with the introduction of applied strips or pads of clay which replaced the simple incised or impressed decorations. This enabled the individual potter to produce highly decorated forms, particularly jugs and pitchers, which were common during the years 1250–1350, a period which marked the peak of the medieval potter's craft. Many of the pieces made during this period were covered with a lead glaze, making them impervious to liquid, with the uniform green colour being achieved by the addition of copper oxide to the glaze (Fig. 137).

The ability to control more accurately the temperatures within a kiln gave rise to an improved pottery industry in the post-medieval era. The influence of Europe became more obvious, and new shapes and items such as cups were introduced for the first time.

The Renaissance in Europe had little effect on the lead-glazed pottery industry of England though its influence can be seen in the 'Tudor Green' ware, where a bright copper green glaze was placed over a buff-coloured body. The surviving pieces, which include cisterns, wallsconces, stove tiles, and dishes, often bear the stamped initials of the reigning Tudor monarch, together with some Renaissance decorative motifs. After the reign of Elizabeth I (1533–1603) there was an uneventful period and it was not until the late seventeenth century that a major change in the production of lead-glazed earthenware occurred.

137. Jug. English earthenware, partial green lead glaze. Excavated in Whitefriars Street, London. Late 14th or early 15th century. Museum of London

In Europe, Italian potters are thought to have begun decorating tin-glazed earthenware (known as Maiolica) during the eleventh and twelfth centuries. The technique of applying a glaze opacified with tin oxide to a relatively low-fired ceramic body gradually spread throughout the Continent; the style is typified by the pottery of Delft in Holland. The Chinese had for centuries understood the secret of using cobalt oxide as a means of underglaze decoration. The oxide had the effect of producing attractive blue hues which were then protected by the transparent glaze. In addition, fewer firings were involved when compared with overglaze enamel colours, thus avoiding casualties in the manufacturing process with a resultant reduction in cost and an increased supply. Chinese porcelain was exported to England and other countries in vast quantities as supercargo on the tea clippers, growing in popularity as a necessary addition to tea-drinking which was rapidly developing as a habit in Britain. It was inevitable that the indigenous potters should wish to follow this trend by emulating the Oriental imported ware.

Tin-glazed earthenware developed in three main parts of England – London, Bristol, and Liverpool; though there were a variety of smaller concerns scattered throughout the country. The decoration closely resembled the Dutch style, hence the term 'English Delftware' which was commonly applied to the English product. The majority of potters established manufactories and gathered around them a competent work-force, seeking to produce wares for every section of the community with production techniques and prices graded accordingly. Nearly every domestic item was produced, from large bowls and jugs through to teaware and apothecaries' equipment (Fig. 138). The location of the tin-glazed earthenware factories on the coast of England gave rise during the second half of the eighteenth century to a number of specially commissioned pieces for ships' captains depicting their vessels. Other pieces were manufactured for visiting seafarers and are inscribed accordingly.

English delftware was never sophisticated, but because each piece was individually painted it retains an undeniable charm. In viewing particular examples in museum collections it is important to remember that present-day scarcity values in some cases bear no relation to the original purpose and volume of items produced.

The development during the seventeenth century of 'slipware', the generic term for earthenware decorated with white or light-coloured slip (liquid clay), was a natural development of the potters' brown-and red-bodied domestic ware. The most impressive slipware objects came from the North Staffordshire area, where the local natural resources provided conditions ideal for the development of a specialized pottery industry. The slipware tradition reached its peak during the reign of Charles II, with the spectacular slip-trailed platters produced by the potters Thomas and Ralph Toft and Ralph Simpson. These large dishes, dating from around the 1670s, were almost certainly intended for display rather than for everyday use.

While lead-glazed earthenware was being developed in England, on the Continent another ceramic body was being perfected, particularly in Germany, namely salt-glazed stoneware. Stoneware, which has a non-porous body, is covered by a glaze produced by shovelling common salt into the hot kiln, whereupon the salt volatilizes and is combined with the silica and alumina already present in the clay to form a thin, colourless, glassy surface pitted like orange peel. This form of ware was exported from Germany in large quantities from the medieval period onwards.

138. Jug. Bristol Delft blue and white, inscribed and dated. 1730. Formerly London, Christie's

Various attempts were made by English potters to produce stoneware during the sixteenth and early seventeenth centuries, but no examples have been positively identified. It was not until 1671 that John Dwight of Fulham in London was granted a patent for 'The Mistery of Transparent Earthenware, Commonly knowne by the Names of Porcelain or China and Persian ware, as alsoe the Misterie of the Stone Ware vulgarly called Cologne Ware'. During 1693 and 1694 Dwight began legal actions against potters whom he felt had infringed his patent of 1684, which was an extension and expansion of the original 1671 patent. Among the people named in the suit were members of the Wedgwood family of Staffordshire, and James Morley of Nottingham, which provides an indication of the rapid increase in the manufacture and popularity of this stoneware product. In the development of English ceramics the accusations made against John and David Elers, also of Fulham, were to be the most significant. As a direct result of the legal action they moved from London to Bradwell Wood, Staffordshire, to continue their production of fine red stoneware teaware derived from the imported Chinese Yi-hsing wares.

The Elers brothers were born in Holland, but travelled to England with William II, for whom they manufactured several silver objects in their capacity as silversmiths. This experience in metalworking was invaluable in their ceramic enterprise. They are generally regarded as being the first potters to introduce a lathe (used for turning off excess clay) into the pottery industry. Their work was often decorated with both enamel colours and gold, but it is most notable for the technique of finely moulding sprigs of clay in the form of birds and flowers taken from metal die-stamps, which was a major innovation. The work of the Elers brothers probably provided the impetus within the North Staffordshire area for the rapid development of the industry and its subsequent long tradition.

In the early years of the eighteenth century there was a general refinement of Staffordshire stoneware, with the introduction of a 'white' salt-glazed stoneware, though in reality it was a pale buff colour. By 1720 this ware became considerably paler through the use of a surface layer of white Devonshire clay being placed on to each piece. This improved colour became generally known as 'white stoneware' or 'common white' and rapidly gained in popularity, so that between 1740 and 1760 nearly every potter in England was manufacturing this type of ware (Fig. 140). Once the potters had mastered the technical difficulties, they were soon using stoneware for some

of their most attractive pieces. Coloured enamel decoration on salt-glazed stoneware was first introduced in about 1740 in Cobridge, one of the small areas forming 'The Potteries', and it often has a jewel-like quality with the enamel raised above the surface. Other decorative motifs included a technique called 'scratch-blue', where the surface is incised with a design into which is rubbed cobalt oxide that, when fired, emphasizes the pattern. Some of the most attractive items of salt-glazed stoneware are the wide range of figures, many of which exhibit a charming naïveté and illustrate everyday eighteenth-century activities, for example the 'pew groups' and equestrian figures.

139. Épergne or 'grand plat ménage'. Leeds pottery. Cream-coloured earthenware. c. 1750. Cambridge, Fitzwilliam Museum

Staffordshire stoneware was eventually superseded in popularity and production by cream-coloured earthenware, which contains the same ingredients: Devonshire white clay and calcined flint. Creamware pieces, however, were fired at a lower temperature and were covered with a lead glaze giving them a totally new and different appearance. During the eighteenth century cream-coloured earthenware (Fig. 139) was to gain world-wide renown. Initially the ware was covered in its unfired state with powdered galena (lead ore) mixed with finely ground flint and fired only once, and the result was a bright and brilliant glaze. The manufacturing process, however, was highly dangerous due to the large percentage of lead in the atmosphere of the works.

One of the most important men in the development of creamware in Staffordshire was Thomas Whieldon (1719–93), a master potter working in Fenton, who is generally regarded as one of the most influential potters of the period. He was thought of as a philanthropist, being very willing to impart his knowledge to young aspiring workmen. It is particularly important to the development of Staffordshire's pottery industry that during his lifetime Whieldon employed and gave tuition to some of the greatest names in the history of ceramics including Josiah Wedgwood, Josiah Spode and William Greatbatch.

Whieldon's influence was to extend into many aspects of English pottery but his name is now associated only with one particular type of product.

140. Pair of swans. Staffordshire salt-glazed stoneware decorated with enamel colours. c. 1750. London, Victoria and Albert Museum

The ware which bears his name has a cream-coloured earthenware body, fired once, on to which are sponged oxide colours under a lead glaze. When fired this ware has a mottled or 'tortoiseshell' appearance. As was common at the time, many of the shapes are based on designs which are associated with metal-work, particularly silver originals with gadrooned edges.

Josiah Wedgwood is probably the most famous potter of the eighteenth century. Born in 1730, the son of a third generation potter at the Churchyard Works, Burslem, Wedgwood received an elementary education before being apprenticed to his elder brother, Thomas, who had inherited the family pot bank in 1739. At the age of twenty-four Wedgwood became a partner of Thomas Whieldon. It was during this partnership that Wedgwood began to conduct experiments designed to improve ceramic products and processes. His first achievement was the development of a green glaze which was placed on naturalistically moulded useful ware, in emulation of the European rococo style.

In 1759, Wedgwood started business on his own account in rented premises known as the Ivy House Works. There, a year later, he began a series of many thousands of experiments to improve and perfect cream-coloured earthenware. In 1764 he moved to larger premises, 'The Brick House' (which was also known as the 'Bell Works'); here he was able to produce a fine, light creamware body with a brilliant, clear, thin glaze. With the successful completion of a tea-service in 1765 for Queen Charlotte, wife of George III, Wedgwood was permitted to style himself 'Potter to Her Majesty' and call his creamware body 'Queen's Ware', the name by which it is still known today.

Wedgwood had an arrangement with the specialist firm of John Sadler and Guy Green of Liverpool for the application of transfer prints to his creamware. Many pieces were also transported north to Leeds for hand enamel decoration to be added by the firm of Robinson and Rhodes. Later, large quantities of hand-painted pieces were decorated within Wedgwood's own factory, including specially commissioned armorial ware. Probably the most important individual order was received in 1773, from Catherine II, Empress of Russia, for a vast service to be painted with English landscape subjects.

Josiah continued his policy of experimentation and perfected a black stoneware body known as 'Black Basalt', from local clay known as 'Egyptian Black'. This new body which was ideal for all forms of ornamental objects could be decorated in a variety of

ways including engine turning, applied bas-reliefs, or encaustic painting with designs copied directly from classical Greek and Roman antiquities. In 1769, a patent was taken out for the process of encaustic decoration, and was the only patent application ever made by Josiah Wedgwood the First, despite his many discoveries and inventions.

Wedgwood's great success is attributable to his thorough practical understanding of the pottery industry as it existed in his day. His ceaseless striving and experimentation to achieve perfection expanded the limits of ceramic knowledge so that all classes and tastes could buy his wares, from the aristocracy to the inn-keepers, both at home and abroad.

He developed a large export trade to Europe and America through his connections with the port of Liverpool. Much of this trade was undertaken by Thomas Bentley, who became Wedgwood's closest friend, confidant and later partner. To facilitate these greatly expanding manufacturing activities Wedgwood purchased 350 acres, known as the Ridgehouse Estate, and began the construction of a purpose-built factory which was sited parallel to the Trent–Mersey canal. The works were officially opened on 13 June 1769, and were called Etruria, under the misguided conception that all classical ceramics were made by the Etruscans. This year also saw the beginning of ornamental ware production under the partnership of Wedgwood and Bentley. With the change in taste in English decorative arts towards neo-classicism – due partly to the gift to the British Museum by Sir William Hamilton of his superb collection of antiquities, and partly to the architectural innovations of men such as Sir William Chambers and the brothers John and Robert Adam – it was hardly surprising that Wedgwood started to search for a new ceramic material which would, he hoped, be compatible with this new decorative style. Between 1771 and 1774 he made over three thousand individual trials until finally, in January 1775, he was able to claim that he had a new body capable of taking an oxide stain throughout, and that sea-green and blue had been perfected. Jasper (Fig. 141), as this new material was named, after the gem-stone which it resembled, has now become synonymous with the name of Wedgwood and is arguably the most important of all his contributions to English ceramics. The introduction of Jasper bas-reliefs also meant that outside artists, such as John Flaxman and George Stubbs, were employed to create new classically-inspired subjects. Other designs were adapted by the two principal modellers, William Hackwood and Henry Webber, at the factory.

141. Centrepiece made by Josiah Wedgwood. Blue Jasper, with white, yellow and green ornamentation. c 1785. Barlaston, Staffs., The Wedgwood Museum

Initially Jasper was used for flat objects such as medallions, plaques and cameos, and it was not until after Bentley's death in 1780 that Jasper vases were perfected, with a wide range of forms and shapes becoming readily available. The quantity and diversity of Wedgwood's Jasper wares are extraordinary, and in order to compete with this fine-grained, smooth body many other potters in both England and Europe began to emulate his unique product.

Through his pioneering achievements, in both the discovery and the manufacture of a number of new ceramic bodies, and his contribution to the rise in importance of the Staffordshire potteries, Wedgwood's influence on contemporary potting was enormous and far-reaching.

Apart from Josiah Wedgwood, probably the most influential North Staffordshire potters were the Wood family of Burslem, who are renowned for their manufacture of figures. Aaron was the principal modeller and, with his brother Ralph, they produced figures covered with coloured glazes where the subtle tones merge into each other (Fig. 142). Other manufacturing centres in England made ceramic bodies and shapes similar to those produced in the Midlands.

Landscape on Ceramics

GAYE BLAKE-ROBERTS

LANDSCAPE subjects have always played an important part in the decoration of ceramics, and often occur on the more expensive items. Few views executed on ceramics were original, the majority being taken from topographical books and later from pictures in magazines or on postcards. The scenes were thus completed by artists who often never travelled further than the area in which they lived, though the range of topographical subjects is enormous.

One of the most prestigious landscape services of the eighteenth

century was produced by Josiah Wedgwood for Catherine II, Empress of Russia (Fig. 1). The dinner and dessert service consisted of 952 pieces, each painted with a different view of English country houses and parks. When the pieces were displayed in Wedgwood's London showroom they caused a considerable stir, with thousands of people visiting Soho to see them. The views were derived from a number of sources including the camera obscura and original paintings, as well as traditional printed books.

Probably the largest group of landscape subjects occurs in the huge range of underglaze-blue transfer-printed earthenware of the nineteenth century. These pieces, mass produced for home and foreign markets, bear every landscape imaginable – from stately homes and cathedrals to landmarks of entirely local interest (Fig. 2). European and even Indian scenes were adapted from paintings by travelling artists, and quantities of such wares were exported to America.

Other landscape subjects are equally attractive. A few dessert services in soft paste porcelain from Caughley were painted in underglaze-blue with different architectural scenes (Fig. 3). The views were copied exactly from engravings by Paul Sandby, published in 1778, entitled 'Virtuosi Museum, containing select views of England, Scotland and Ireland'.

With the Industrial Revolution it was natural for the ceramic manufacturers in Shropshire, the birthplace of the movement, to use local landmarks. The double-handled cup (Fig. 4), produced by John Rose and Company, depicts 'The Big Wheel' near the Ironbridge, while scenes on other pieces often show kilns or the interiors of potteries.

The View of Dovedale by Zachariah Borman (1738–1810), one of the early painters at Derby, was decorated as a ceramic picture (Fig. 5). It is interesting that many Derby painters were also proficient watercolour artists, using their own sketches for their ceramic work.

The use of meticulously recorded landscapes on ceramics is not, however, a purely British phenomenon: the concept has been used throughout the world, from the Oriental landscapes of the earliest times through to the present day, and has always been considered a tasteful indication of the owner's wealth and status.

OPPOSITE ABOVE 1. Dessert dish with a view of Stoke Gilford, Gloucestershire. Cream-coloured earthenware. Trial piece for a service ordered by Catherine II of Russia from Josiah Wedgwood. 1773. Barlaston, Staffs., The Wedgwood Museum

OPPOSITE BELOW 2. Dish with a view of Bristol, Hotwells. Earthenware, transfer-printed in underglaze blue. Pountney and Allies. c. 1830. Bristol City Art Gallery

ABOVE 3. Dessert dish, painted in underglaze blue, with a view of Wenlock Abbey. Caughley. c. 1780. Telford, Ironbridge Gorge Museum

RIGHT 4. Commemorative tankard depicting 'The Big Wheel' near Ironbridge. John Rose and Company. c. 1830–40. Telford, Ironbridge Gorge Museum

BELOW 5. Plaque with a view of Matlock High Tor, painted by Zachariah Borman. Derby. Dated 1797. London, Victoria and Albert Museum

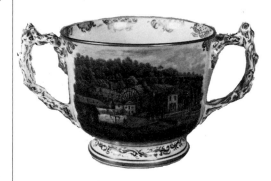

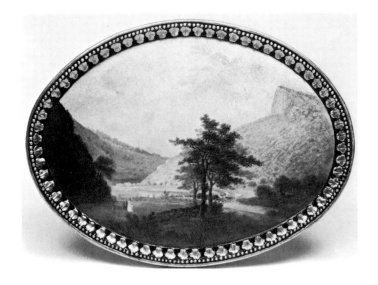

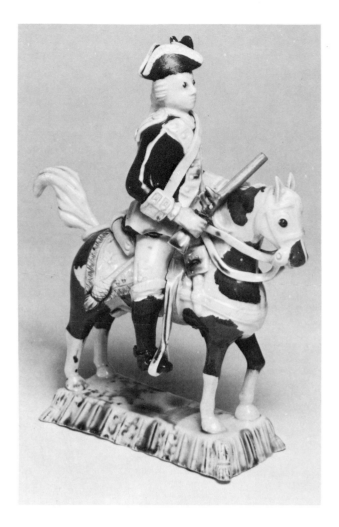

142. Figure of a mounted cavalry officer.
Staffordshire cream-coloured earthenware. *c.* 1750.
London, Victoria and Albert Museum

Undoubtedly the most prolific of these was that in Leeds, though equally thriving centres were established at Liverpool, Swansea, Newcastle, and in Yorkshire.

The introduction by Wedgwood in 1779 of 'pearlware', a pale creamware with cobalt added to the glaze, which gave the pieces a bluish tinge, provided the basis for the development of a commercialized ceramic industry in the nineteenth century, when underglaze blue transfer-printed earthenware became extremely popular and the mainstay of production. Hundreds of small, often anonymous works proliferated as a result of the Industrial Revolution. Every form of domestic ware was made. It was printed with popular, political, imaginary or topographical subjects, and often the decoration was adapted from existing engravings. These printed pieces were mostly

produced at low cost for cheap sale and therefore in most instances the designs were executed in monochrome. The method for producing multi-coloured printed patterns was devised by the firm of Felix Pratt of Fenton in the late 1840s, though the vogue for this type of ware had died away by the third quarter of the century.

Styles and forms continued to change according to current fashions. For the Great Exhibition held in London in 1851 the Staffordshire potters produced some of their most impressive items. Among the new styles displayed were several based on earlier French works. The term 'Majolica' was introduced to describe models and relief decoration under brightly coloured lead glazes. The technique appears to have been perfected for the Minton Company by Léon Arnoux, a Frenchman working at the factory, and this new ware soon became immensely popular.

The middle of the century saw Staffordshire 'flat-backed' figures beginning to spread into every working-class home. They were representational, simple and inexpensive. The subjects, of which there were several hundred, included the royal family, contemporary celebrities, politicians and literary figures amongst others. They were manufactured easily, using flat sheets of clay which were then pressed into moulds. The figures always have a completely flat back so that they can stand on narrow mantelshelves. For economic reasons they were painted on the front only, and were often inscribed in a cartouche with the name of the subject of the figure.

As the nineteenth century progressed there were many changes in style which the ceramic manufacturers followed avidly. Shortly after 1850 the revived rococo style gave way to classical and Renaissance forms, which in turn were replaced, as a direct result of a display of Japanese arts at the International Exhibition held in London in 1862, by the Japanese style which ultimately was to inspire the Art Nouveau period (Fig. 143).

A change in the organized method of factory production also took place with artist-potters setting up their own studios to produce pieces with a totally individual character, no two being identical. In England, the first indication of the success of this method occurs in the liaison from 1871 between the Doulton Company of Lambeth and the local school of art, through which subsequently many famous ceramic decorators were introduced to the industry. The rise of the Arts and Crafts movement, instigated by people who were strongly opposed to mass-produced factory products, provided the impetus for many art potteries to be established, such as the

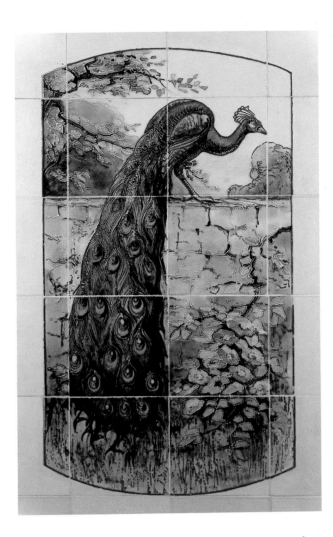

143. Panel of tiles in enamel colours, made by Maw and Company, Benthal Works, Shropshire. c. 1928. Telford, Ironbridge Gorge Museum (Tile Collection)

Martin Brothers at Fulham and the De Morgan Pottery Works, and so laid the foundations for the studio pottery of today.

A parallel industry, that of porcelain, began to develop in England during the middle of the eighteenth century. Porcelain is the term used to describe a unique ceramic body which when fired becomes translucent. The material has its origins in the Far East where porcelain is first thought to have been made about AD 700. In England the industry was established on lines totally separate from the already flourishing continental porcelain factories. In Europe, the porcelain factories were normally financed by the royal household or by a leading nobleman as a matter of prestige; for example, Meissen was patronized by Augustus the Strong, Elector of Saxony, while Louis

XV provided the financial backing for Sèvres. In England the royal family tended to be more interested in practical matters, such as agrarian reform, and as a consequence the English factories developed through the enterprise of men already established in the field of other decorative arts.

Two main types of porcelain were manufactured in eighteenth-century England: hard or true porcelain in Plymouth and Bristol, and soft or artificial porcelain at most of the other centres. The name 'soft paste' derives from the chemical composition of the body which differs from 'hard paste', the latter being typified by Oriental and European porcelains.

Porcelain, both hard and soft paste, has characteristics which make it preferable to earthenware. These include neater potting shapes, better underglaze and overglaze decoration, pleasantness of touch, and translucency of body. Customers' taste was largely controlled by their means, with the wealthy in the eighteenth and nineteenth centuries able to afford superb porcelain examples from Meissen and Sèvres, Chelsea, Worcester, and Derby, requiring as much style, colour, and gilding as was practical or acceptable. Underglaze decorated porcelains had their share of the market, with simple utilitarian earthenwares providing the majority of everyday ceramics.

The proprietors of the newly founded English factories used many sources of inspiration for their wares. Large quantities were produced in direct emulation of the Chinese and Japanese ceramics being imported through the East India Company, while other pieces owe their form and decoration to European examples, particularly from Meissen in Germany and Sèvres in France. English porcelain was decorated in a variety of ways, including handpainting in underglaze blue cobalt or overglaze enamel colours, as well as transfer printing, a method by which an identical design can be easily mass produced. Gilding, composed of ground pure gold leaf mixed with honey for ease of application, was added to enhance some of the more expensive pieces.

It seems probable that the earliest soft paste porcelain factories were established within the London region: among the first was that of Bow, in the East End in the parish of West Ham, Essex. The factory, which began production about 1747, was originally known as 'New Canton' after the Chinese city through which its products were shipped.

Slightly earlier, in 1745, two Huguenot silversmiths, Nicholas Sprimont and Charles Gouyn, established a soft paste porcelain factory in Chelsea.

This factory was to receive more European-style patronage than any other English works – from men such as the Duke of Cumberland and his secretary Sir Everard Fawkner. In 1763, when George III and Queen Charlotte wished to present her brother, the Duke of Mecklenburg-Strelitz, with a service, it was the Chelsea Porcelain Company which received the commission. Horace Walpole saw the service and was not impressed: '... it is complete, and cost twelve hundred pounds! I cannot boast of our taste.'

The production at Chelsea can be divided into several distinct periods usually categorized by the marks used, commencing with an incised triangle from 1745 to 1749, and followed by the more celebrated anchor marks which occur in various colours. Many of the early pieces owe their shapes to Sprimont's own silver designs. During the period of the raised anchor (1750–2) and the red anchor (1753–8) quantities of figures were produced. Among the most attractive are a series of approximately twenty birds modelled from the plates in *The Natural History of Uncommon Birds* by George Edwards, first published in 1743. One of the most outstanding hand-painted series produced by Chelsea proved to be the botanical subjects often erroneously referred to as 'Sir Hans Sloane Plates', after the patron of the Royal Physik or Apothecaries Garden nearby. These are now known to have been painted by Georg D. Ehret from Heidelberg, Germany, who had settled in Chelsea in 1737.

With the rococo influence prevalent in English taste it was not surprising that Chelsea produced naturalistically moulded tureens in the form of vegetables and animals, emulating those already made by Meissen. The flamboyant rococo movement also provided the impulse for extremely ornate hand-painted designs on tableware, often with excessive burnished gilding applied over coloured grounds adopted from contemporary Sèvres examples.

The figures made during the later period (1758–69), marked with a gold anchor, were some of the most elaborate and extravagant ever to be made in this country. They are usually relatively small figures on ornate scroll bases and backed with enormous bocages of individually made flowers and leaves, with the result that the subjects can be appreciated only from the front.

In 1769 Sprimont sold the Chelsea works and the premises passed into the hands of a clock-maker, James Cox. Within a year William Duesbury of Derby had purchased the concern, running it in conjunction with his own factory until 1784, when he closed the premises, concentrating his works in Derby.

The original draft agreement for the Derby Porcelain Manufactory was drawn up in January 1756. Its early production was of exceptional quality, with finely proportioned and decorated useful wares, many of which were painted in overglaze enamel colours with flower heads on thread-like stalks. Many of the pieces also have scattered single flowers or insects over their surface, which serve an ingenious double function of both being decorative and covering small blemishes in the glaze. Like all eighteenth-century factories Derby followed the fashion trends by producing figures (Fig. 144a, b). Many of these were inspired by Sèvres models. Some, when absolutely perfect, were left unglazed and sold as 'biscuit' figures, but they could also be glazed and enamelled. The enamel colours at Derby have a particularly distinctive tone, with the turquoise being susceptible to a brownish-green hue causing it to be nicknamed 'Dirty Turquoise'.

The amalgamation of the Chelsea and Derby manufactories coincided with the change in taste to neo-classicism, and by 1772 the company was advertising that their wares displayed elegance and taste and were based on antique originals. From the period of the neo-classical revival many of the pieces were decorated by artists such as Richard Askew, with hand-painted figures adapted from wall paintings in the buildings recently excavated at Herculaneum and Pompeii. It is for the exquisite painting of scenic views that the Derby artists are usually remembered: for example, Zachariah Borman was responsible for many delightful scenes of the Derbyshire countryside, while other painters worked on seascapes, flowers, fruit, and botanical subjects, including the Brewer brothers John and Robert, George Complin, George Robertson and William 'Quaker' Pegg.

When Duesbury died in 1786 the business was continued by his son; indeed it exists today under the name of The Royal Crown Derby Company. Another porcelain manufactory still in existence likewise has its origins in the eighteenth century – The Royal Worcester Porcelain Company, which was founded in Bristol in 1749. It was started in a former glass-house within the city by Benjamin Lund, a brass and copper dealer, and William Miller, a banker. Although the majority of pieces produced at Worcester were essentially utilitarian, it is for the superb transfer-printed designs that the company is particularly

famous (Fig. 145). These were rarely based on original ideas, but were usually adapted from the work of famous artists and various source books, such as Pillement's *Ladies' Amusement*. Amongst the original partners was Robert Hancock, who was an exceptional copperplate engraver, and undoubtedly responsible for the introduction of many underglaze blue transfer prints, as well as for the overglaze black or 'jet' enamel printed patterns found on Worcester porcelain.

By 1769, Worcester was advertising pieces decorated 'in the beautiful Colours of Mazarine Blue and Gold, Sky Blue, Pea-green, French-green, Sea-green, Purple, Scarlet and other Variety of Colours, richly decorated with chased and burnished Gold'. Most of these pieces were also decorated with reserves containing figures in landscapes, birds and flowers, or

146. Tankard, made by William Cookworthy, Plymouth. Hard paste porcelain, painted in overglaze enamel colours. 1768–70. Plymouth Museum and Art Gallery

fruit, according to the different requirements of the customer. A fishscale effect was also introduced on these ground colours. This was achieved by painting the surface with a very weak solution of the required colour before adding, by hand, in a deeper hue, the semi-circular scale forms.

The closest rival of the Worcester company was the Shropshire factory at Caughley, transformed from an earthenware manufactory in 1772. Thomas Turner and his partner Ambrose Gallimore started producing soft paste porcelain of a very high quality, both artistically and technically. By 1775, Turner was able to utilize many transfer prints similar to those of his rivals because Robert Hancock, having left Worcester, settled nearby, managing the 'Salopian China Manufactory Warehouse' for Turner. Caughley was taken over in 1799 by the nearby firm of John Rose of Coalport, who were to play a very prominent part in ceramic developments during the nineteenth century.

During the eighteenth century several other soft paste porcelain factories were established, some in existing ceramic-producing areas such as Liverpool and Staffordshire. Others, such as Lowestoft, East Anglia and West Pans near Musselburgh, Scotland, were isolated from the traditional centres. All were producing fine ceramic objects and contributing to the success of eighteenth-century English porcelain production.

The hard paste porcelain factories of Plymouth and Bristol can be considered as one concern despite the geographical difference of their locations, since the Plymouth factory, founded by the Quaker William Cookworthy, was moved to Bristol two years later. Cookworthy, a chemist, had located and identified the necessary materials for the manufacture of true porcelain, namely china clay (kaolin) and china stone (petuntse), in the late 1740s, but he did not apply for a patent to produce hard paste porcelain at his Coxside Works in Plymouth until 1768 (Fig. 146). Initially there were many manufacturing difficulties, including the recruitment of skilled workpeople, so in 1770 the manufactory was moved to Bristol.

The ware has a grey-white coloured body and frequently the underglaze blue colour fires to a distinctive greyish-black. At the Bristol works the enamel decoration was perfected to include a series of large vases finely painted with exotic birds in landscapes.

In 1774 when Cookworthy retired the patent was transferred to Richard Champion, one of the original partners. In 1775 Champion applied for an extension to the patent which would ensure the Bristol factory's

147. Pair of egg-shaped vases, by John Rose of Coalport, painted in the Sèvres style. *c.* 1835.
Telford, Ironbridge Gorge Museum

exclusive use of the hard paste formula. The application was opposed by a group of Staffordshire potters led by Josiah Wedgwood. Champion was successful in renewing his patent for porcelain, but the Staffordshire potters were permitted to use the same ingredients, china clay and china stone, to produce 'opaque pottery'. The loss of the exclusivity of the Bristol works undoubtedly shortened the working life of the factory. Though the patent extended until 1796, Champion approached Wedgwood in 1780 with the intention of selling him the formula and

patent for hard paste porcelain. Wedgwood, who was not personally interested in the formula, put Champion in touch with a group of Staffordshire potters who were, and eventually six of these men became partners in order to form the New Hall Company in 1781. New Hall, at Hanley, Staffordshire, produced fairly large quantities of teaware, many pieces of which were based on silver and metal originals. The most common patterns found are Chinoiserie scenes, and simple cottage-type sprays and borders of naturalistic flowers.

The eighteenth century was remarkable for the rise of ceramic entrepreneurs, and for pioneering developments; thus the nineteenth century was able to build upon the foundations laid by these men, with the result that more innovations and developments followed. One of the most dramatic changes was a direct result of the invention in 1799, by Josiah Spode, of Bone China, a ceramic body which has over 50 per cent calcined animal bone in its composition. Bone China is an extremely translucent, white, durable material, and the product has remained unique to England. After its introduction most manufactories changed their production to include Bone China, which is one of the bodies still produced in very large quantities today.

The beginning of the nineteenth century saw the extravagant and flamboyant style of the Prince Regent, epitomized in the construction of the Brighton Pavilion and the revival of the vogue for anything with Oriental connotations. In consequence all the major factories were producing ware of an extremely high quality, both in the composition of the ceramic material and in the decoration.

In May 1820 another innovation was introduced in the form of a leadless glaze. Lead, which had previously always been used in the industry, was injurious to health and many efforts had been made to find a suitable substitute. On 30 May 1820, the Society of Arts awarded a gold medal to the firm of John Rose & Co. of Coalport, Shropshire, for a

148. Pot-pourri vase. Minton porcelain, decorated with hand-made flowers and painted in enamel colours. c. 1825–30. Stoke-on-Trent, Minton Museum

leadless, felspathic glaze created from ground felspar suspended in water. The company celebrated the event by incorporating the fact into their back-stamp. Many of the contemporary porcelain manufactories followed the trend set by Coalport.

During the period 1825–35 many of the pieces produced by factories such as Coalport and Minton were decorated with applied hand-made flowers after the Dresden examples. These were extremely popular and occur with many variations in the surviving factory pattern-books. Naturally, due to the delicacy of the individual blooms, very few pieces have retained mint condition (Fig. 148).

The accession of Queen Victoria in 1837 accelerated another change in the decorative arts of Britain, culminating in a style now known as 'Victoriana'. The term covers a wide range of items from simple pastille burners in the form of cottages to the most extravagant and elaborate pieces produced for the Great Exhibition of 1851.

Possibly one of the greatest revivals in style was the influence from Sèvres. French ceramics had earlier been used as a source of design, but from the middle of the nineteenth century direct copies were made from Sèvres pieces. Coalport was even permitted to send modellers to the French factory, and employed French craftsmen to supply moulds for the purpose of reproducing the ware exactly (Fig. 147). The ground colours used by all the major English works were based on Sèvres colours of a century earlier, including claret, Rose Pompadour, blue celeste and Mazarine blue. Coalport and Minton both excelled at this style of revived rococo design, which was widely displayed to great acclaim at both the Great Exhibition of 1851 and the London Exhibition of 1862.

Another outstanding discovery of the nineteenth century was made by Messrs Copeland – the use of unglazed biscuit porcelain, which closely resembled white marble, for manufacturing figures and statues. Because of its close resemblance to marble from the Island of Paros it became generally known as Parian, though the Wedgwood company preferred to name its version 'Carrara' after the snow-white natural stone. The new body provided an ideal medium for many sculptors, and the results fitted perfectly into the typical Victorian interior décor.

There were two further developments from the Parian body: the first was the development of the Irish porcelain factory of Belleek, situated in County Fermanagh, the products of which were first introduced at the Dublin Exhibition of 1865. The factory used a Parian-like body modelled in the form of shells and other marine objects, with a characteristic nacreous glaze. The second development was at Minton's: this was a technique called *pâte-sur-pâte*, which is a method of building up a low-relief decoration by painting layers of white slip usually on to a dark coloured body. Parian was found to be ideal for this purpose since it had the right degree of hardness, and could be fired at a relatively low temperature.

The nineteenth-century porcelain industry, like that of the eighteenth century, produced a number of major innovations. Like textiles, mining, engineering and construction, the pottery and porcelain industry benefited from the new-found knowledge which had its roots in the Industrial Revolution. But the ceramic industry was unique in one respect: it was able to move rapidly into the sphere of mass production while retaining individual craftsmen and artists.

12

Glass

CHARLES HAJDAMACH

ENGLISH glass has been of international importance for four hundred years; nonetheless, the overall impression is of native craftsmen consolidating and expanding the ideas of foreign glass-makers. In their attempts to compete with continental rivals, the English glass-makers looked for inspiration to the great glass centres of Europe, especially the Bohemian and Venetian traditions. By learning from example they evolved their own personal styles which, in turn, influenced and altered the course of glass-making. Each hundred years produced new advances, sometimes associated closely with individual personalities whose output perhaps lasted only a few years, at other times associated with a national style which maintained its energy for a whole century.

The beginnings were modest. The making of window and vessel glass was founded by German and French itinerant glass-makers in the Weald of Sussex and Surrey during the middle part of the fourteenth century. The industry then expanded in fits and starts for the next two centuries until the Crown, realizing that the demand by nobility and gentry for the new fashionable material was being met by continental glass-houses, decided to speed up the formation of an English glass industry. Numbers of Venetian glass-workers had come to England by the mid-1500s via the large glass-making centre of Antwerp, and their arrival must have encouraged the government in its ambitions. In 1570 a glass-house was set up at the Crutched Friars in London by Jean Carré; it was taken over in 1572 by the Venetian glass-master Giacomo Verzelini, who was the first important personality in the history of English glass-making.

The high social standing enjoyed by the gentleman glass-maker in those early days enabled Verzelini to obtain a twenty-one-year monopoly from Queen Elizabeth I in 1575: this stated that he was responsible for 'the makynge of drynkynge glasses such as be accustomablie made in the town of Murano and hathe undertaken to teache and bringe uppe in the

149. Goblet made at Newcastle upon Tyne and enamelled with the Royal Arms of England by William Beilby. c. 1762. Cambridge, Fitzwilliam Museum

said Arte and knowledge of makynge the said drynkynge Glasses owre naturall Subjectes'. The monopoly also prohibited any imports of foreign glass which would result in loss of trade for Verzelini. Such financially rewarding guarantees no doubt created much ill feeling from fellow traders. Recently discovered information from the London Records Office reveals important details about a second hitherto unrecorded glass-house at Newgate which Verzelini worked from about 1575 until 1579; this may have been built to maintain glass-making operations while the main works were reconstructed after a disastrous fire which occurred in September 1575. Verzelini continued to work the Crutched Friars glass-house until 1592 when he retired as a wealthy citizen to Downe, in Kent, and was immortalized after his death in 1606 by a brass tablet in the parish church.

The glasses which can be attributed to him, no more than ten at present, all bear diamond-engraved inscriptions, initials, various heraldic beasts, and dates from 1577 to 1586, their original commemorative purpose accounting for their survival. One goblet, dated 1590 and attributed to Verzelini, is decorated solely by gilding. Whatever form of decoration was predominant, the surviving glasses undoubtedly equalled the great contemporary achievements of the glass-makers back in Murano. They form the first impressive group of glasses to be made and decorated in England and as such demonstrate the success achieved by the Crown in establishing glass-making on an industrial basis (Fig. 150).

Perhaps Verzelini, in his attempt to protect his monopoly, did not altogether meet his obligation to teach native glass-makers. After his retirement the industry was taken over by English entrepreneurs who provided the financial backing and reaped the profits but who relied on others for the technical expertise. Such a combination was hardly conducive to further innovations and it was not until another hundred years had passed that glass-making received its most important contribution from a native English glass-maker, George Ravenscroft.

Right up until the 1670s glass-makers had been searching for a pure crystal glass, one that had no blemishes or discolouration. The ideal to be imitated was natural rock crystal. The eventual solution was born of the political, social, and scientific conditions surrounding the accession of Charles II. The formation of the Royal Society in 1662 was symptomatic of a scientific and cultural renaissance which led to the founding of the Glass Sellers Company in 1664. Two years earlier Dr Christopher Merrett translated Antonio Neri's *The Art of Glass* and gave glass-

production a scientific basis without the mystique and secrecy of previous generations. The steady increase of imports of Venetian glass due to the effects of the Civil War led the Glass Sellers Company, the controlling glass body, to commission Ravenscroft to search for a new type of glass which would remove the dependence on Italian glass.

Secured with a patent for seven years to discover a 'new sort of crystalline glass resembling rock crystal', Ravenscroft employed Italian workmen and began to experiment in 1673. Unfortunately many of the early

150. Goblet made at the Verzelini glass-house, London. Diamond-point decoration probably by Anthony de Lysle. Dated 1578. Cambridge, Fitzwilliam Museum

Cameo Glass

CHARLES HAJDAMACH

AMONG the many innovations introduced by the glass-makers of the Roman Empire none was more spectacular, more expensive or more difficult to make than cameo glass. The most complete example to have survived is the Portland Vase, and it brilliantly demonstrates the effect created by two layers of different coloured glass carved with a mythological scene. Eventually the Portland Vase found a permanent home in the British Museum where it was smashed in a dramatic incident in 1845. This event resulted in renewed efforts by English glass-makers to master the Roman cameo technique, supported in one instance by the offer of £1,000 prize money.

The honour for the first accurate copy fell to John Northwood of Wordsley, near Stourbridge, who began hand-carving his version in 1873 (Fig. 1). With its completion three years later he established the fashion for cameo glass, the major artistic and technical achievement of the Stourbridge and therefore of English glass-makers, rivalling their Roman counterparts 2,000 years earlier. During the next six years Northwood added another five major cameos to his impressive achievement and became the most celebrated of glass designers.

The larger Stourbridge firms quickly organized themselves for the production of high quality cameo glass. At Thomas Webb's the Woodall team replaced classical designs with Egyptian, Islamic, and Chinese influences (Fig. 2). Unique pieces sold

for high prices, but the cost was subsidized by the vast output of 'commercial cameo'. George Woodall

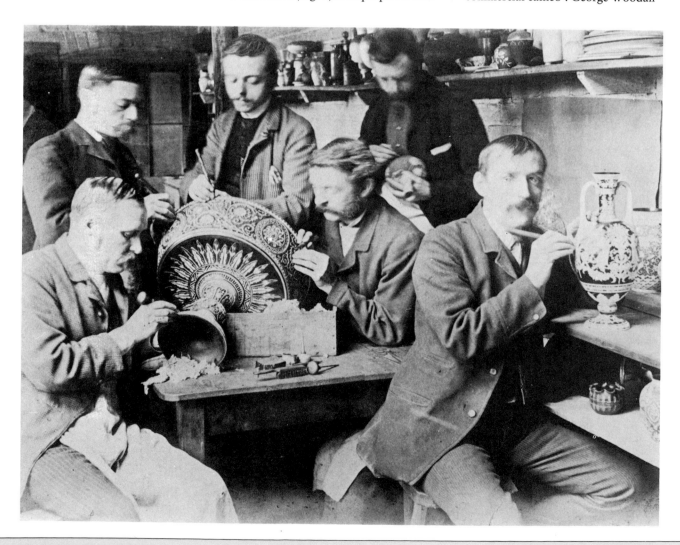

OPPOSITE TOP I. Copy of the Portland
Vase, by John Northwood.
Carved white glass on a blue body.
Completed in 1876. Corning (N.Y.),
Corning Museum of Glass

OPPOSITE BELOW 2. The Woodall Team:
(back, left to right) Tom Farmer, Harry
Davies, Tom Woodall; (front) William Hill,
J. T. Fereday, George Woodall. Photograph
taken at T. Webb & Sons, Amblecote, in
1889

ABOVE 3. Original photograph of cameo
vases from Richardson's of Wordsley. Mid-
1880s. Kingswinford, Broadfield House
Glass Museum

RIGHT 4. Cameo vase by Thomas Webb &
Sons, with carved green lilies on a clear
glass body. 1930s. Kingswinford,
Broadfield House Glass Museum

ABOVE RIGHT 5. Cameo lamp with 'Flight
of the Mallard' design. Made by Chris
Smith at Webb Corbett's. Sandblasted red
cameo glass. 1979. Amblecote, Webb
Corbett Ltd

employed up to seventy decorators to
supply the huge demand, relying on the
speedier methods of acid etching and
wheel engraving. Richardson's
developed a range selling from
between 24 and 70 shillings (Fig. 3).

Economic depressions in the 1890s,
followed by changes in taste, reduced
the quality and output of cameo in
Stourbridge; but the technique
received fresh impetus from
continental glass-makers. Emile Gallé's
fascination with the Stourbridge
cameo on show at the 1878 Paris
Exhibition gave him one of the starting
points for his own supreme cameo
creations extolling nature, patriotic
fervour, and symbolism. In England
the reaction to cameo, overloaded with
memories and inhibitions, continued
into the 1930s but then firms,
including Webb's, attempted new
variations in keeping with
contemporary styles (Fig. 4). In 1978
cameo was revived again at Webb
Corbett Ltd, by David Smith and his
son Chris, using their greatly
developed skills of sandblasting (Fig.
5). The most novel twist to the story of
cameo is the interest now shown by
studio glass-makers who, with their
inventiveness and enthusiasm,
guarantee the survival and continued
success of cameo glass.

glasses were susceptible to crizzling, an internal crazing of the glass which produced a frosted effect. This problem Ravenscroft soon overcame by adding oxide of lead in exactly the correct quantity. The result was a brilliantly reflective, heavy and durable glass which, by 1676, was given final approval by the Company in the form of an applied glass seal bearing a raven's head. The discovery has justifiably been called the Ravenscroft Revolution for it ousted the already declining Venetian industry: now there was an urgent European demand for '*verre à l'Angleterre*'. The so-called 'lead crystal' which Ravenscroft invented continues in use throughout the world today. The new lead glass, more viscous and hardening at a lower temperature, did not lend itself to the delicate and frilly decoration on Venetian-style glass; so a new simple, well-proportioned style, exemplified in the remarkable jug from the Cecil Higgins Gallery (Fig. 151), quickly gained acceptance and set a precedent for the following century.

151. Jug made by George Ravenscroft. Lead crystal glass with Raven's head seal. *c.* 1676–8. Bedford, Cecil Higgins Art Gallery

In the eighteenth century table glass came to be considered an essential rather than a luxury. Newspaper advertisements by glass dealers mention plain, cut and 'flowered' glass of every possible description, while the diaries of the period give vivid accounts of the use of table glass at parties and dinners. Only three or four specific groups of glasses stand out as artistic landmarks, but the vast production of items ranging from decanters and wineglasses to chandeliers and candelabra, all of good quality and design, make eighteenth-century glass a national achievement; for the first time glass could be identified as 'English made'.

The heavy baluster-stemmed goblets of the very early years of the century remain the classics of English glass-making and show off to best advantage Ravenscroft's lead glass. By 1715 the accession of George II and the influence of German fashions altered that strong national style, but the other import, the techniques and styles of glass-cutters and especially engravers, led to new methods of decoration which eventually became completely English in character. The adherents of the Jacobite cause to restore Bonnie Prince Charlie on to a Stuart throne commissioned glasses engraved with various combinations of the prince's portrait, Jacobite mottoes, inscriptions and anthems, symbolic roses and other flowers. The glasses remain as nostalgic reminders of a romantic personality whose cause never received sufficient commitment from his followers to guarantee success.

It is ironic that the growth of English glass, so ably organized by the Crown in the sixteenth century, should have been hampered by the same patron at a time when the glass industry promised great things. The Glass Excise of 1745, on the weight of raw materials, restricted the size of glassware and the nature of the decoration, especially cutting, and customers had to be attracted by engraved and enamelled decoration. Enamelled glass appears in London, Bristol, and South Staffordshire from the middle of the century, and eventually this was included in the Excise of 1777, but not before the brother-and-sister partnership of William and Mary Beilby, working at Newcastle upon Tyne between 1762 and 1778, had decorated some of the finest enamelled glasses we have. Once the technical problems of firing the enamel into the surface of the glass were overcome, the Beilbys painted a wide variety of subjects in the rococo style including fruiting vines, hunting and pastoral scenes, architectural follies, and classical temples; but the most magnificent examples are goblets with coats of arms – especially the goblet

with the Royal Arms and the crest of the Prince of Wales (Fig. 149). The goblets are in themselves superb examples of Newcastle glass-making, but they are further enhanced by enamelling which is majestic, in both senses of the word.

Then, in the Midlands around 1800, cut glass was radically transformed by the technical innovation of steam-power to drive the cutting wheels. Formerly the wheels were hand-driven by apprentices: now the new system of a central driving shaft with pulleys attached to individual lathes gave a fresh initiative to the glass-cutters. They responded with designs of deep mitre cuts combined with panels of diamond cutting which were widely copied by American, French, and Belgian factories. Often in combination with panels of fine engraving, the style became a great favourite of Regency England. The magnificent Londonderry service made in Sunderland in 1824, consisting of over two hundred pieces and valued at two thousand guineas, is one of the most impressive services to have survived (Fig. 152). As a popular style it has continued with variations to the present day.

Ornate cut glass had survived the worst years of the Excise, and when that tax was finally abolished in 1845 the way was clear for further experiments and new ideas. The section on glass at the 1851 Great Exhibition told its own story of the advances made in that short time. Some writers compared the designs unfavourably with those of their continental neighbours, but overall the English section was equal to its contemporaries and presaged the dominance which those factories were to exert in the next half of the century. The illustrations of cut, cased, engraved, and enamelled glass from the Manchester firm of Molineaux, Webb & Co. (Fig. 153) echoed the displays of the Stourbridge, Birmingham, and London firms. Before long the two largest towns failed to maintain their early promise (with the exception of the Whitefriars firm in London), where-upon Stourbridge, in the Black Country, stepped in to take the lead as the most important area for the production of table and decorative glass.

The glass industry in the Stourbridge area had been established in the sixteenth and seventeenth centuries by glass-makers from Lorraine. For the next three

ABOVE RIGHT 152. Decanter, honey jar and jug from the cut and engraved armorial table service made by the Wear Flint Glass Company for the 3rd Marquess of Londonderry. 1824. Sunderland Museum and Art Gallery (on loan)

RIGHT 153. Page from 1851 Great Exhibition Catalogue showing the range of glass exhibited by Molineaux, Webb & Co. of Manchester

hundred years it was their descendants who perfected the skills which finally burst out in a profusion of colours, shapes, and techniques during the late nineteenth century. The sheer number of glass factories and decorating shops in the Black Country overshadowed every other district. So intense was the rate of development that the best engravers, cameo carvers, enamellers and gilders from Bohemia, France, and Germany began to settle in the area to take advantage of the new economic and artistic boom. Cameo glass was the premier technique; a close second was rock crystal glass, a deeply cut, engraved and highly polished sculptural glass in imitation of Oriental rock crystal carvings, which paralleled the cameo development and was often engraved by the cameo decorators. Cased glass, latticinio, moss agate, silver deposit, acid etching, threading, air-trap, ice glass, lamp work, opalescent glass and furnace-applied decoration were a few of the other techniques that were often made in different combinations. Permutations were endless.

Stourbridge also provided one essential material for glass-making, the fireclay needed to build glass-house pots. The high quality of the fireclay deposits had been remarked upon as early as the seventeenth century; by the nineteenth century it was exported to most glass-making countries including America, which in one year imported five million firebricks.

Glass-makers who left Stourbridge also created their own legends. In 1785 John Hill took between fifty and seventy workmen from the district to establish the Waterford factory in Ireland. The most famous of the emigrants was Frederick Carder who left Stourbridge in 1902 for America and set up the Steuben works at Corning, N.Y., an outstanding twentieth-century company which continues unrivalled as the producer of the finest crystal.

By 1914 the golden age of English glass-making was over. The industry was unable to re-establish itself between the wars with up-to-date styles that could rival European products. But glass history repeated itself and in mid-century new ideas began to appear. In the 1950s Pilkingtons invented the float glass process which revolutionized the manufacture of window glass, following a hundred years after Chance Brothers of Birmingham expanded production to cope with the glazing requirements of the Crystal Palace. The formation of the Guild of Glass Engravers in 1975 has witnessed one of the success stories of the industry. The Guild can now boast a staggering seven hundred members. Perhaps as the most important recent development, the meteoric rise of the studio glass movement, inspired by earlier American experiments, continues the story of revival and progress which features as the dominant theme of English glass.

13

Textiles

JOAN ALLGROVE MCDOWELL

At no time in her recorded history has Britain not been involved in fibre or cloth production. This trade has left its legacy everywhere in British life, from the lumpy Woolsack, the Lord Chancellor's seat in the House of Lords, to place-names like Worstead, surnames such as Shepherd, Dyer, Fuller, and Shearman, titles like spinster, and vernacular terms like 'spinning a yarn', 'dyed-in-the-wool', and 'a tissue of lies', as well as the more tangible medieval wool churches, Cloth Halls and clothiers' homes. In John Burton's house at Holme, Newark, a stained glass window bears the legend:

I thank God and ever shall
It is the sheep has paid for all.

Twenty years ago, this introduction would have been based only on written records, a few tools, and some textile fragments. But new archaeological techniques and vital on-site first aid, including freeze-drying, coinciding with textile finds at Vindolanda (Chesterholm), London and York, have revealed that Britain exported her chief textile fibre – wool – from at least her Bronze Age, about 900 BC. They have also revealed that sheep provided wool, milk, meat, manure, and parchment on mixed farms in the pre-Roman Iron Age, from about 500 BC, on the South Downs, in West Sussex and in Cambridgeshire.

Early sheep resembled today's Soay breed of St Kilda, with dark, coarse hair (kemp) and wool, which moulted in summer and was plucked in autumn; this was superseded by the Roman white breed which could be sheared. Three basic types of sheep survived into the eighteenth century: folding breeds with short wool for woollen cloths, pasture sheep of marshes and fens, with larger fleeces combed for worsteds, and hill sheep, yielding wool for weather-proof cloth and carpets.

Our ancestors' methods of shearing, sorting, grading and washing wool, combing or carding it, and roving it on to a distaff for hand-spinning are used today in peasant communities. 'Primitive' tools need not result in coarse textiles, but can produce fine yarns and complex weaves in the hands of a sensitive worker. Later innovations have been chiefly in selective sheep-breeding, improved tools, and greater efficiency in making and marketing.

Of Britain's other major fibre, linen, little evidence survives. Flax was cultivated in pre-Roman times but only a few fragments, chiefly of plainweave, survive, together with stone and glass polishers.

The large warp-weighted loom was used, weaving cloth two metres wide. The wefts were packed tightly with combs, swords or pin-beaters of bone or antler, found on the Iron Age sites of Glastonbury Lake Village and the Scottish brochs. Surviving tapestry-frames, two-band looms for starting-borders, and weaving-tablets indicate the range of weaving, from basket and half-basket weave and plainweave tabby to more complex twills. Herringbone twill, ancestor of modern men's suitings, has been found at Armoy, Co. Antrim. Few dyed textiles are known, despite the presence of madder and the famous woad. The only British colour-patterned textile to survive is the Falkirk tartan (third century AD), a herringbone twill with different undyed wools making the check pattern.

The Romans, conquering Britain in 43 AD, took advantage of existing industries. Diocletian's Prices Edict of AD 301 states that tough British woollen rugs and capes fetched high prices. Finer, soft-finished cloth is also mentioned, which argues skill at fulling. Further invasions followed the Roman withdrawal in AD 410, notably by the Vikings, who eventually, in the eighth century, settled around York as farmers and traders. Coppergate's shops, workshops and dwellings in York have revealed in water-logged conditions bone and wood spindles, whorls of jet, amber and pottery, shears, clay loom-weights, bone pin-beaters, weaving-combs, pins, and needles. Textile finds include one wool sock (with leather shoes), linen plainweave and worsted twills, a cap of

undyed Byzantine or Near Eastern silk, and a purse-reliquary with, inside, a scrap of cloth, perhaps from a saint's tomb.

The Anglo-Saxons excelled at embroidery, the earliest surviving pieces being the stole and maniple of St Cuthbert, Bishop of Lindisfarne, who died in AD 687. They were commissioned by Aelfflaed, Edward the Elder's queen, for Fridestan, Bishop of Winchester from 909 to 931, according to their inscription, PIO EPISCOPO FRIDESTANO, and were probably made in Winchester between 909 and 916. It seems, however, that Fridestan did not receive them for in 934 Edward's successor, King Athelstan, offered at St Cuthbert's shrine at Chester-le-Street 'one stole with a maniple, a girdle and two bracelets of gold', and these were all found when his final tomb in Durham Cathedral was opened in 1827. On grounds of surface-couched gold in textured patterns are the tall, thin standing figures of popes, deacons and prophets, giving the Latin benediction. Framed by foliated canopies, they seem to gaze mysteriously through a dark, softly-shimmering gold veil.

The Bayeux Tapestry, which commemorates another invasion, was mis-named in the nineteenth century, for it is not a woven tapestry but an embroidery, worked on linen with coloured wools in coarse laid-work, which is well suited to covering large areas. In seventy-nine scenes, supplemented by Latin inscriptions, it gives a didactic account of the Norman invasion of Britain in 1066.

Harold Godwinson, Earl of Wessex, is sent to France by Edward the Confessor, but he and his men

154. The Bayeux Tapestry: King Harold is warned of Halley's comet. Wool embroidery on linen.
Late 11th century. Bayeux, Bayeux Tapestry Museum

are captured by Guy of Ponthieu. William, Duke of Normandy, orders their release and Harold later fights bravely in William's Brittany campaign, for which William rewards him with arms, thereby tacitly making Harold his vassal. Harold is shown in Bayeux, swearing an oath (presumably of loyalty to William) on relics, before returning to England.

Edward's death is preceded (surprisingly) by his funeral procession to Westminster Abbey, so recently consecrated that a frantic figure is positioning the weathercock as the cortège arrives below. Harold is enthroned as King of England, but he is told of the appearance of Halley's comet, a fearful omen of disaster. Here the lower border shows ghostly ships, prophesying the retribution to come (Fig. 154). Hearing of Harold's broken oath, William prepares an invasion fleet, with tree-felling, ship-building, and the loading of armour, horses and supplies. The Normans cross the Channel, the horses enjoying the trip tremendously, and one ship flies the papal banner given by Pope Alexander II in support of William's enterprise. They disembark and dig in at Hastings to await Harold's arrival from Yorkshire, where he has just defeated Harald Hardrada, King of Norway and another contender for the English throne, at Stamford Bridge.

In the battle, on 26 September 1066, the English fight on foot and the Norman knights on horseback, supported by archers. William is identified by his mace and Odo, his half-brother and Bishop of Bayeux, rides into battle wearing a jupon. The battle seems indecisive but eventually Harold falls and, without their leader, the English flee pursued by Normans. According to a poem by Baudri de Bourgeil, written between 1099 and 1102, the Tapestry had two further scenes, showing the Normans capturing towns and William acclaimed king.

William is a shadowy figure in the Tapestry; Harold is shown as brave but disloyal, although none of the contemporary chroniclers, not even William of Poitiers, the Conqueror's chaplain, mention his climactic oath. While every British school-child believes that Harold fell at Hastings with an arrow in his eye, the only evidence for this is the Tapestry itself, and that is inconclusive, for the inscription HARO.L.D. REX. INTERFEC. TUS. EST. (Harold is killed) spans two figures, one grasping an arrow in his eye and the other felled by a Norman sword.

The conspicuous role of Odo, battling Bishop of Bayeux and, later, Earl of Kent, supports the theory that he may have commissioned the Tapestry, perhaps for Bayeux Cathedral, consecrated in 1077, or as a secular piece for one of his palaces which was

later transferred to the cathedral. But this leaves one difficulty. How would a fragile textile have survived the two fires in the cathedral, in 1105 and again in 1159, when the building was devastated? The hanging described in Baudri's poem, mentioned above, decorated the chamber of the Conqueror's daughter Adela of Blois – poetic licence, a second Tapestry, or the one in Bayeux?

It is now generally regarded as English work. It may have been designed by Kentish artists of the Canterbury school of illumination, which was in the heart of Odo's fief. And English embroidery made a strong impression on the Normans, for William of Poitiers described English embroidered robes 'which made all that France and Normandy had beheld of the same kind seem mean by comparison' and the will of William's queen, Matilda, mentions embroidery made for her 'at Winchester by Alderet's wife'. These were of rich materials, unlike the Tapestry which, with its story of feudal treachery and its lewd humour, is closer to the tradition of Norse narrative hangings. These, however, were also made in England, for one such, commemorating the battle between Brythnoth and the Danes in 991, was presented to a church in Ely by his widow.

The Tapestry remains a unique eleventh-century document of court life, feudal relationships and, particularly, of warfare, showing the Normans' horses, armour, weapons and even their extraordinary punk haircuts, as well as their dragon-prowed ships which so closely resemble the resurrected longships at Gokstad, Oseberg and Roskilde, and it gives the strong impression that its designers actually witnessed the last Norse invasion of Britain.

Throughout the Middle Ages sheep were reared by Yorkshire and Welsh small-holders, Cistercian monks, and prosperous villagers near London, Leicester, Lincoln, Oxford, Cirencester, Bristol, and Winchester. A new class, the Merchants of the Staple, was established by 1354 to regularize the collection, packing and export of fleeces and fells (sheepskins) in the English Staple towns, where they were also inspected and taxed on behalf of the Crown. Then the little ships, England's earliest mercantile marine, took the woolpacks from the southern ports to the Staple towns of Bruges, Antwerp, Ghent, and Calais, to become part of the network of European trade.

The early output was raw wool, as Britain lacked dyeplants and fixing agents, while the Flemings were skilled in dyeing and finishing. The two countries remained interdependent until Britain herself began to make cloth for export. In 1331 Edward III invited John Kemp and other Flemish weavers to England 'to teach it [weaving] to such of our people as shall be inclined to learn it'. After the inevitable cool welcome, many of them settled in Norwich and introduced their secrets of wet cloth fulling, stretching on tentering frames, and raising the nap with teazles. Among their 'new draperies' were worsteds, previously undeveloped, taking their name from Worstead in Norfolk. Nevertheless, the principal output, fine woollen broadcloths, were still exported white and undyed.

Fifteenth-century clothiers grew as wealthy as the Merchants of the Staple, supplying raw materials to craftsmen and collecting finished goods to sell. This 'putting-out' system, which was based on cottage industries close to water, thus avoiding the regulations of the city Gilds and, incidentally, using child labour, lasted until the eighteenth century.

Because the plain and checked fabrics were in daily use, few have survived. This great industry, the country's chief wealth, is recorded not by fabrics but by family documents like the Celey, Paston and Stonor Papers and is remembered in parish churches like Northleach, Oxfordshire, where John Fortey, in his brass effigy (Fig. 111), lies with one foot on a sheep and the other on a woolpack, and in the houses of clothiers like Thomas Payecocke at Coggeshall, Essex, which gave its name to 'Coggeshall whites'.

From the mid-thirteenth century Opus Anglicanum, the 'English work', is increasingly mentioned in European inventories, referring specifically to ecclesiastical embroidery. Matthew Paris, historian and monk of St Albans, records in his *Historia Major* that in 1246:

'My Lord Pope [Innocent IV] having noticed that the ecclesiastical ornaments of certain English priests . . . were embroidered in gold thread after a most desirable fashion, asked whence came this work? From England, they told him . . . Thereupon the same Lord Pope . . . sent letters . . . to well nigh all the abbots of the Cistercian Order . . . in England, desiring that they should send him without delay these embroideries of gold which he preferred above all others . . . The command . . . did not displease the London merchants who traded in these embroideries and sold them at their own price.'

This account reveals that English embroidered vestments, many of which survive in Italian, French, Spanish, and German treasuries, were workshop-made trade-goods.

Their 'Englishness' lay in the use of two common techniques. Firstly, fine split stitch was used to 'draw'

drapery folds and to model hair and facial contours. The second technique was underside-couching, which covered grounds with gold, the fastening stitches being brought from the underside then pulled tightly back in a tiny loop; this invisibly anchored the gold, which was laid vertically in patterns, and gave delicate relief to the vestment. Fine needles of drawn wire were indispensable, and the coloured silks used were imported from Cyprus or the Near East. These techniques decorated orphreys (ornamental bands) and vestments; the centre back of copes and chasubles being reserved for narrative scenes familiar to unlettered congregations.

The earliest incidence of underside-couching is on fragments from the tomb of William of St Carilef (c. 1069–90). Both techniques first appear together on fragments from the tomb of Walter de Canteloupe, Bishop of Worcester from 1236 to 1266, but the earliest complete vestment worked in both techniques is the Clare chasuble, dating from the mid-thirteenth century, now in the Victoria and Albert Museum.

The Opus Anglicanum figure-style continues the English tradition, characterized by dramatic intensity, arbitrary choice of colour and whimsical humour. It is close to stained glass and illumination, and required skilled designers. It was customary for major artists to turn their hands to designing for embroidery. Henry III paid William of Gloucester, his Court Painter and Goldsmith, for work on an altar-frontal for Westminster Abbey and one of the king's nine named embroiderers, Mabel of Bury St Edmunds, worked on a frontal for the Abbey. The 'family resemblance' between pieces suggests workshop pattern-books, like the sketch-book now in the Pepysian Library, Cambridge, with birds, animals and grotesques, in use from about 1250 to the late fourteenth century.

The chief subjects were the lives of the Virgin, of Christ and the Apostles, and of prophets and saints. English saints and kings, like Dunstan, Edmund, Thomas of Canterbury and Edward the Confessor, are often included. Angels are another English feature. They vary from the six-winged seraphim of the Book of Revelation, their wings in work of the 'Great Period', from about 1300 to 1350, decorated with glowing peacocks' eyes, to angels holding books, scrolls and censers and even playing musical instruments while on horseback.

The Vatican cope (c. 1280) is the best of the early vestments and resembles the Syon cope (c. 1300) at the Victoria and Albert Museum, though its figures are finer and more expressive. A golden net of eight-

and four-pointed stars covering the rose silk twill ground encloses, in the places of honour down the centre back, the Assumption of the Virgin, the Crucifixion and the Virgin and Child. Surrounding them, in their own star-shaped niches, are standing Apostles and Saints while in the smaller stars are six-winged seraphim standing on wheels, their wings about them.

With silk still rare in the Great Period, linen grounds were covered with increasingly complex compositions, single figures becoming narrative scenes, framed by fanciful arcading on intricately-patterned grounds. The finest examples of this type are the Pienza cope (1315–30) and the Jesse orphrey in Lyons (Fig. 155). The Tree of Jesse, an old favourite theme, literally interprets the prophecy: 'There shall come forth a rod out of the stem of Jesse' (Isaiah, 11:1), the stem springing from the recumbent old man's body to form Christ's genealogical Tree. The Virgin and Child and the Crucifixion occupy key positions, with King David and King Solomon, both of them elegant young men in fourteenth-century court style. Subsidiary branches enclose Old Testament prophets who foretold His coming: Isaiah, Daniel, Ezekiel, and Jeremiah, each growing flower-like from the Tree, which powders the gold ground with vine-leaves and grapes. At the main intersections are a bird on her nest, the pelican feeding her young with her own blood, and the phoenix rising from the flames, symbols of motherhood and resurrection.

Such pieces represent the highest achievement of Opus Anglicanum. It was challenged by imported Italian velvets, for velvet is difficult to work on. Linen had to be placed over it, the embroidery taken through both layers and the excess linen cut away. The velvet contrasts splendidly with gold embroidery, but the technical problem demanded simpler compositions. The Chichester-Constable chasuble (now in the Metropolitan Museum, New York), the Butler-Bowdon cope, and three red velvet panels (in the Victoria and Albert Museum), all dating from about 1330–50, illustrate this style. The panels depict the Lives of St Anne and the Virgin beneath naturalistic ogee arches, with the arms of Poyntz and Bardulph in the spandrels. Fig. 156 shows the Nativity, the Journey of the Kings, and the Angel Appearing to the Shepherds, which is of great charm. The old, bearded shepherd looks up in wonder at the Apparition, while his young companion sits unconcerned on a hillock playing his bagpipes, their sheepdog howls and sheep gambol over the grass. The humour is redolent of the Miracle Plays, where shepherds provide comic relief and this scene, re-

156. Panel from an alb: (left to right) *The Nativity*, *The Angel Appearing to the Shepherds* and *The Journey of the Kings*. Silk and gold embroidery on velvet. *c.* 1330–50. London, Victoria and Albert Museum

peated on the Pienza cope, could be an overt reference to the grass-roots of the wool industry.

Of medieval secular embroidery – hangings and ceremonial robes, tented pavilions, and trappings for man and hound – scarcely any examples survive, though the jupon of Edward the Black Prince does give a glimpse of lost splendour. Edward's will left instructions for his funeral procession to Canterbury Cathedral in 1376:

> 'that two coursers [horses] covered with our arms
> and in our helmet shall go before ... our body ...
> the one for war with our arms quartered, the other
> for peace with our badge of ostrich feathers'.

His 'achievements', the heraldic arms which commemorated his feats in battle, consisted of an iron helm and leather cap of maintenance with a lion crest, gauntlets with embroidered linings, a belt and scabbard, a shield with the Arms of England and a jupon *en suite*. All of these survive; only the sword, spurs and banners are lost from the place where they were hung – according to custom, above his tomb in St Thomas's Chapel, in the cathedral of Canterbury.

The short-sleeved jupon is made up of velvet squares, alternately red with the English lion/leopards and blue with the French fleur-de-lis, a device which had been assumed by his father, Edward III, and defended by the Black Prince at Crécy and Poitiers. The gold-embroidered leopards and lilies, applied to the velvet, were mounted on

LEFT 155. Chasuble orphrey with the Tree of Jesse. Silk and gold embroidery on linen. *c.* 1315–35. Lyons, Musée Historique des Tissus

171

157. Tapestry of *The Miraculous Draught of Fishes*, from the set woven for Charles I. Wool tapestry on linen warps (the image reversed from the cartoon). *c.* 1630. Paris, Musée du Louvre

158. Cartoon for *The Miraculous Draught of Fishes*, by Raphael. Sized colours on paper. 1515–16. H. M. the Queen, on loan to the Victoria and Albert Museum, London

linen with a padded interlining, then quilted vertically (gamboised). Early jupons were worn under armour to protect the wearer from heat; this one, like Odo's in 1066, was worn over armour and pro-

claimed the wearer's credentials. Edward III's Wardrobe Accounts list many, and it is tempting to think that this jupon was not made specially for the funeral but came from the Black Prince's own wardrobe.

By the fifteenth century skilled labour was scarce, after a period of political instability, and embroidery was reduced to narrative orphreys which were applied to grounds of extravagantly-patterned Italian silk or velvet with, occasionally, the figures of the *nouveau riche* donors. Designs were influenced by Flemish realism and were less happy than the fantasy world of Opus Anglicanum. The 'storied' vestments, which had placed England on the international art map, became no longer possible or appropriate, for the medieval aesthetic which had held goldwork, carving, painting, and textiles of equal importance was swept away at the Renaissance.

The tradition's last inheritors were the funeral palls of the London Livery Companies, themselves survivors of the medieval trade gilds. After the Dissolution of the Monasteries in 1537 vestments became obsolete and those remaining were hidden (like the unique Fetternear Banner, now in Edinburgh), smuggled abroad, burnt for their gold, or bought at public sales by thrifty souls like Bess of Hardwick. Peter Heylin's *History of the Reformation*, published in 1661, comments: 'It was a sorry house that had not somewhat of this furniture in it, though it were only a fair large cushion made of a cope, or an altar-cloth to adorn the windows'.

The sixteenth-century wool trade saw greater specialization in the different districts. With so much wool to hand, it is curious that Britain should have supported little tapestry-weaving. This can hardly have been due to lack of patronage as, for instance, both Henry VIII and his Chancellor, Wolsey, were keen collectors of fine hangings, principally Flemish. The first English tapestry workshop was started by William Sheldon, a wool merchant, at Barcheston, Warwickshire, in 1561, weaving small bookbindings and cushions until Richard Hick and his son Francis made the busy Sheldon tapestry maps of English counties. But large tapestries were still imported, and not until Charles I, the greatest British royal collector, formed the Mortlake workshop did Britain enter the mainstream of European tapestry-weaving.

In 1620 Charles's secretary, Sir Francis Crane, brought to Mortlake fifty skilled weavers from Brussels, led by Philip de Maacht. Early pieces, *The Story of Venus and Vulcan* and *The Months*, were well-known Flemish designs with new borders. In 1623 Charles made his historic purchase of Raphael's tapestry cartoons for *The Acts of the Apostles*,

commissioned for the Vatican in 1515–16 (Fig. 158). Francis Cleyn designed borders with the Royal Arms for the first set, destined for the king and now in Paris. In all a dozen sets were woven at Mortlake, including one with the arms of Philip, Earl of Pembroke and Montgomery, the King's Chamberlain. Now owned by the Duke of Buccleugh, several of these hangings are in the Victoria and Albert Museum with the cartoons. Raphael's powerful figures are less of a problem for the weaver than the nuances of shading and misty middle-distance, seen in *The Miraculous Draught of Fishes* (Fig. 158), which are very difficult to translate into tapestry, despite the fine, careful weaving – the hallmark of Mortlake. By Raphael's time painting had moved far from the exploitation of bold pattern and surface texture, so sympathetic to tapestry, to explore problems of space and modelling. As paintings the cartoons are great works of art, but as tapestry cartoons they are a disaster, not least because they do not appreciate that the low-warp weaving technique reproduces the cartoon in reverse, so that the great right-to-left sweep of compositions such as *The Miraculous Draught of Fishes* loses momentum when seen from left to right. Moreover, they became so influential, being reproduced in tapestry and engraving throughout the seventeenth and eighteenth centuries, that the tapestry ethic itself was destroyed and weavers were condemned to reproduce the subtleties of the brush, with woven picture-frames, until rescued by William Morris in the nineteenth century.

Francis Cleyn wove other tapestries, from Titian and Veronese, and the workshop survived into the Restoration in 1660 under two master-weavers, Francis and Thomas Poyntz. They wove *The Battle of Solebay* set, from Willem van der Velde's designs of the encounter between English and Dutch fleets in 1672, and the Duke of Montague, Controller of the workshop from 1674 to 1691, ordered a set of an earlier design, *The Triumphs of Julius Caesar*, with his own arms. Francis Poyntz later moved to the Great Wardrobe in Hatton Garden, where tapestries were woven, cleaned and repaired. Other weavers dispersed to Soho and elsewhere, and finally the Mortlake workshop was closed in 1703. Soho made some finely-woven but undistinguished Chinoiserie hangings in about 1710. Always dependent on patronage and therefore precarious, tapestry had an ephemeral history in Britain until the nineteenth century.

The Tudor dynasty saw the end of one embroidery tradition – Opus Anglicanum – and the culmination of another – this time domestic needlework. Early Tudor portraits show costume of Italian silks with touches of embroidery and needle-made lace. But, as domestic comfort increased, not only the nobility and gentry but, according to Holinshed's *Chronicle*, written some time before 1580, 'many farmers learned to garnish their cupboards with plate, their joined beds with tapestries and silk hangings'. Professional work was done, but the late sixteenth and seventeenth centuries were the heyday of the amateur. People were materialistic and proud of it. Sewing skill was expected of upper- and middle-class girls, while in large houses female servants stitched when not occupied elsewhere.

The great employed 'broderers' to make designs, but for most needlewomen illustrated books were the main source. These included botany books and herbals like K. Gesner's *Catalogus Plantarum* (1542) and *Historia Animalium* (1560), John Gerrard's *Herball* (1597), and Topsell's *History of Beasts*. A design could be transferred from a printed book by 'pouncing' (Fig. 159): pricking holes through a page round a motif's outline, placing the page over fabric, and dusting charcoal through the perforations. This practice led to the haphazard mingling of flowers, birds, insects, and human figures which is a notable feature of the embroidery. Another favourite was the emblem, a form of intellectual exercise in drama, poetry, and needlework, the chief source for which was Geoffrey Whitney's *A Choice of Emblems and Other Devises* (1586). The two types of book fed two embroidery styles: one, devoted to furnishings, was closer to the late Renaissance; the other, for dress, developed a uniquely English flavour.

159. Page from the 1632 edition of *A Schole-House for the Needle*, published by Richard Shorleyker, London, showing 'pounced' design. London, Victoria and Albert Museum

Furniture was sparse, but ornament was lavished on bed-hangings, consisting of curtains, upper and lower valances, pillows and coverlets. Tables and cupboards were covered with carpets, rarely the real thing and more often in 'Turkey work' or knotted needlework, or in tent stitch with biblical and classical scenes or idealized contemporary landscapes.

Knowledge of the country house of about 1600 owes much to the preservation of original furnishings at Hardwick Hall, completed in 1597 by Bess of Hardwick and enhanced by her Inventory of 1601, listing its contents and their disposition, some of the embroideries by her own hand. The hangings of *Sciences* and *Virtues* (c. 1573) have her monogram, and a table-carpet with the *Judgement of Paris*, dated 1574, has her initials, ES. There are also numerous long cushions, for benches and windows, with subjects varying from *Europa and the Bull* and *Diana and Actaeon* to a view of old Chatsworth, the *Fancy of a Fowler*, and floral 'slips' (plant cuttings), which were also applied to bed-hangings. Bess and her fourth husband, George Talbot, Earl of Shrewsbury, were for fifteen years the gaolers of Mary Stuart, Queen of Scotland, and the two ladies must be the most famous of all named embroidresses.

160. Panel from the Oxburgh hangings, worked by Mary Stuart and Bess of Hardwick. Silk embroidery on linen, applied to velvet. 1570. London, Victoria and Albert Museum

Mary was a keen needlewoman and employed several 'embroiderers' at her Scottish court. One of these, Pierre Oudry, was eventually allowed to join her in captivity and Mary and Bess, who can have had little else in common, embroidered together, the first five years of their acquaintance resulting in work attributable to Mary. She made two cushions now at Hardwick, one with her cypher of roses, lilies and thistles. With Bess she also embarked on the so-called Oxburgh hangings (Fig. 160) of individual square, octagonal, and cruciform units in silk tent and cross stitch on linen canvas, applied to green velvet. The subjects were a personal choice, with creatures from the *Historia Animalium* and emblems from C. Paradin's *Devises Héroïques*. Some panels have the monograms of both Mary and Bess, others have Mary's motto-monogram: SA VERTU M'ATTIRE, for MARIE STUART. Each centre panel has the queen's arms and an emblem referring to her predicament, while the smaller ones have real or mythical beasts, flowering plants, and mottoes, some of which are unidentified.

Embroidery received fresh impetus from botanic discoveries, as well as from the new interest in gardens with their formal layout, plants with symbolic and medicinal properties, and 'herbes and rootes for sallets'. Romantic rural landscapes enhanced biblical, courtly and mythological scenes, and 'slips', lifted from botany books, were embroidered individually and applied to hangings. To common plants were added exotica like the Turkish tulip and the even costlier fritillary, both of which appear with mice on a pair of early seventeenth-century gloves, now at the Whitworth Gallery, Manchester. But fantasy surpassed itself in the staggering finery of Queen Elizabeth I, who wears an over-dress in her Hardwick portrait with irises, birds, fish, a sea-horse, a sea-serpent, and a spouting whale. The early Stuart decades, from 1603, remained under the queen's spell and some 'Elizabethan' pieces should correctly be dated to the seventeenth century. However, under continental influence clothing gradually grew less flamboyant, with softer, small-patterned fabrics.

Samplers are associated with the seventeenth century, although the earliest, by Jane Bostock, is dated 1598. At this time these were long narrow strips and were intended as a vocabulary of stitches and motifs, which formed part of a young girl's education. She would make a coloured sampler, with random flowers and figures, and one of whitework with cutwork and reticella, before progressing to a cabinet of raised or bead work. Four such pieces by Martha Edlin (born 1660), worked between the ages of eight

and thirteen, are in the Victoria and Albert Museum.

Embroidered pictures became popular, deriving from pattern-books now published with the needle-woman in mind, like Richard Shorleyker's *A Schole-house for the Needle* (1624) (Fig. 159) and James Boler's *The Needle's Excellency* (1631). The fashion for raised or 'stump' work had begun, creating three-dimensional effects by using wooden moulds or cotton padding as a base for figure embroidery. Subjects included Old Testament and mythological stories, and royalty – there were references to Charles I with the caterpillar and to Charles II with the oak. The frequent appearance of some subjects, also found on mirror-frames and cabinets, suggests that it might have been possible to purchase designs already drawn on to fabric.

Hannah Smith's casket is a key piece, dated by a letter found inside it, written by her to remind herself later that she began the work in 1654, when she was ten. In 1656 the finished embroidery was made up into the cabinet; inside it are bottles, a box, and a mirror, and there is room for other treasures. The subjects of the embroidery seem pretentious for a young girl (Fig. 161). The lid with its one padded figure (the earliest dated example of raised work) shows *Joseph and his Brothers at the Well*. The tent-stitch doors show (left) *Deborah and Barak* and (right) *Jael and Sisera*, a particularly nasty murder. The sides, in laid-work, show *Autumn*, personified by a lady in a cornfield, and *Winter*, an old man huddled over a fire with an outsize tabby cat.

In some respects, the seventeenth century is a watershed in British textile history. Before the century ended Chinese influence was replacing Indian, and calico-printing and silk-weaving, the major industries of the eighteenth century, were established. From 1601, the date of its charter, the British East India Company brought Indian goods into the country, including large cotton hangings, printed and painted with strange designs, known as 'palampores'. These novelties became wildly fashionable. Although surviving pieces date only from the 1650s and show a hybrid style, in reds and blues, made to conform to British taste, they are nevertheless exotic, with a large single tree or stem, bearing different leaves, flowers and fruit, and growing from a hilly landscape on which unknown birds and animals disport themselves. The demand for them always exceeded the supply and the designs were copied and adapted for embroidery. Ultimately, however, their greatest influence lay in the manner of their production: printing on cotton, which led to experiments in Britain later in the century, aimed at copying this technique.

161. Hannah Smith's casket: (left) *Deborah and Barak* (right) *Jael and Sisera*. Silk embroidery on linen and satin. 1654–6. University of Manchester, Whitworth Art Gallery

The industry of silk-weaving became established in England in the late seventeenth century, when two waves of refugee silk-weavers came over from France and Flanders, fleeing religious persecution. The weavers settled in London, the fashion capital, notably at Spitalfields, and in Norwich, which was already a centre producing half-silks. By about 1705 English hand-loom patterned dress fabrics (chiefly damasks and brocades) could compete with French silks, although they were still influenced by swiftly changing French fashions. Surviving pattern-books record seasonal trends, from formal 'lace' designs of the 1720s and very large repeats in the 1740s to an identifiably 'English' style of the 1750s and 1760s, associated with the only significant named designer, Anna Maria Garthwaite (1690–1763). This style consisted of pale, often white, silks with a self-coloured sub-pattern and a main pattern of naturalistic floral sprays, brocaded in colours and scattered artlessly over the ground (Fig. 162), a fashion later superseded by a French fancy for stripes.

Manchester: Cottonopolis

JOAN ALLGROVE McDOWELL

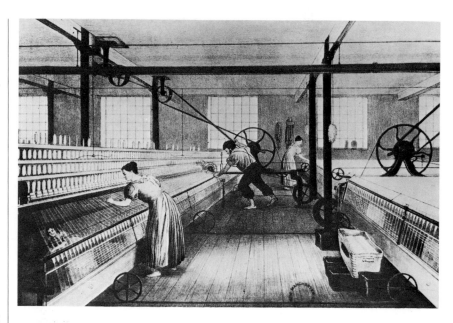

MANCHESTER was unimportant before 1730, producing cheap linen/cotton *fustian* or *jean*. But its humid hinterland provided water to power early machinery, which was developed by local men. Manchester, the heart of the factory system, soon became a centre for world trade as well, relying on American cotton in exchange for printed goods from about 1720 to 1750 and later exporting its products to Africa and India.

After John Kay's Flying Shuttle had speeded up weaving, James Hargreaves's Spinning Jenny spun improved weft-yarn, and Richard Arkwright's Water Frame made strong cotton warps, while Samuel Crompton's Mule could spin either, using water power by 1790. Quarry Bank Mill at Styal, Cheshire, was one of the first water-powered rural cotton mills, built in 1784 by Samuel Greg (Fig. 1), providing pauper apprentices with work, food, housing, and education.

The imaginary landscape in madder colours on white (Fig. 2) was block-printed in 1812 by A. Peel & Co., one of Lancashire's first printers. The founder's grandson became the reforming statesman, Sir Robert Peel. Rotary printing from engraved metal rollers brought a radical change, printing up to six colours. Fig. 4 shows a fine Lancashire roller-discharge print on manganese bronze, one of a series based on Audubon's *Birds of America* (1831). By the 1870s rollers could print sixteen colours, and William Perkin's discovery of mauveine in 1856 led to the development of chemical dyes which, however, were harsh and catered to Victorian taste for multi-colours.

There were exceptions to cheap mass production. Thomas Wardle made block and resist 'Art' prints, some on cotton velvet evolved from fustian and famous in Europe as

'Manchester goods'. Wardle, who conducted Morris's dye-experiments (see p. 181), printed designs like Lindsay P. Butterfield's *Crown Imperial* (*c.* 1895) for Liberty (Fig. 3). A principal export, unknown at home, were goods printed exclusively for the colonies by firms like the Calico Printers' Association. They met, for instance, West African demand for rich, dark colours, and even for *batik*, by perfecting a cheap printed version which, although invented in Holland, became known as 'Manchester batik' (Fig. 5).

Before the First World War, 2,000 merchants operated at the Manchester Cotton Exchange. The decline goes back to the post-1918 period, due to Japanese undercutting, and accelerated after the Second World War. Today the majority of mills are silent and the Royal Exchange houses a theatre. Nonetheless, Manchester is the northern headquarters of Courtaulds and ICI, and Lancashire still prints much of Britain's wallpapers and textiles.

OPPOSITE ABOVE 1. Cloth production at Quarry Bank Mill, Styal, Cheshire, in the 1780s

OPPOSITE BELOW 2. Block-printed cotton with an imaginary landscape. 1812. A. Peel & Co., Church, Lancs. London, Victoria and Albert Museum

LEFT 3. *Crown Imperial*, designed by Lindsay P. Butterfield. Block and resist 'Art' print on cotton velvet by Thomas Wardle, Leek. *c.* 1895. University of Manchester, Whitworth Art Gallery

ABOVE 4. Floral cotton with birds taken from Audubon's *Birds of America*. Roller and discharge print, Lancashire. 1831. London, Victoria and Albert Museum

BELOW 5. Machine-printed batik for the West African trade. Printed cotton. 1905. Manchester, Calico Printers' Association

Silk-weavers were always vulnerable. They lacked the royal patronage enjoyed in France, were constantly threatened by French silks and English printed cottons, and were organized in small units. Spitalfields, with 12,000–15,000 looms in the mid-eighteenth century, was declining a mere fifty years later. Only specialist areas like ribbon-weaving survived in the nineteenth century, so long as they served fashion's whim to trim muslin dresses or bonnets. Ribbons had been woven in Coventry and London since the seventeenth century, on single hand-looms or engine-looms, capable of weaving several simultaneously. Coventry maintained its superiority after the coming of the Jacquard loom, with floral ribbons like M. Clack's design for the Great Exhibition of 1851, a weaving *tour de force*. Picture-ribbons of the 1870s were intended to stimulate a dwindling demand, with humorous subjects like 'The Last Lap' – of a penny-farthing cycle race – manufactured by Thomas Stevens in 1879.

The shawl, fashionable from the late eighteenth century, fostered another industry imitating Indian imports, this time the light, soft Kashmir shawl, hand-woven in delicate *boteh* (cone) designs. The earliest were made in Norwich but the Paisley industry gave its name to the genre. Growing from the early narrow, long shape to a size large enough to accommodate the crinoline – and to drape over table and piano – they were also more elaborately patterned in the 1850s (Fig. 163). Demand led to their mass production by jacquard-weaving or printing, until the fashion faded in the 1870s.

Characteristically Scottish and Irish industries have added to Britain's textile riches, some of them initiated to reduce poverty. Imported table-linen was superseded by a sponsored industry at Lisburn, Belfast, founded in 1698 by Louis Crommelin, a Huguenot refugee, and specializing in fine table damasks. Other Irish industries included calico-printing, cotton poplin, lace, and white embroidery.

Although Scotland's weaving industry is ancient, her famous clan tartans date only from the seventeenth century. They were suppressed after the 1745 rebellion and revived in the nineteenth century when, thanks to Queen Victoria's patronage, tartans became favourite dress fabrics. Raeburn's portrait of Sir John Sinclair shows the tartan trews which predated the kilt.

LEFT
162. Spitalfields dress silk. Brocaded silk. 1760s. London, Victoria and Albert Museum

163. Paisley shawl with the typical Paisley pine-cone pattern. Woven wool and cotton. *c.* 1860. Edinburgh, Royal Scottish Museum

164. Pictorial sampler worked by Sophia Ellis. Silk embroidery on linen. 1785. Cambridge, Fitzwilliam Museum

Finding embroidery patterns was always a problem for the amateur. The *Lady's Magazine* published patterns from 1749, making possible silk pictures, often with watercolour detail, while samplers became pictorial (Fig. 164) and map-samplers were added to school curricula. In the 1840s patterns imported from Berlin, on squared paper or on canvas with bright embroidery wools, appeared, and 'Berlin woolwork', in floral designs, became enormously popular for upholstery, bell-pulls, and gentlemen's slippers and braces. Paintings by Winterhalter and Landseer were also enthusiastically copied, including the latter's immortalization of Queen Victoria's pets (Fig. 165). Criticized in its own time, it met the same demand of idle hands as 'stumpwork', and drew on contemporary design sources. Reaction was led by professionals: Morris and Co., the Royal School of Art Needlework (1872), the Leek Embroidery Society (1879), and the innovative Glasgow School, pioneered by Jessie Newberry and Anne Macbeth, whose simplistic designs were to influence the 1920s and 1930s.

The amateur was more successful with patchwork. From the earliest surviving examples – the bed-furnishings at Levenshall (*c.* 1708) – a corpus of named designs evolved by the early nineteenth century, composed of pieced geometric units or appliqué, and using calico prints. A thrifty craft,

165. The macaw, lovebirds, terrier and spaniel puppies belonging to Queen Victoria, with Osborne in the background. Berlin wool work, from a painting by E. Landseer. *c.* 1840. Formerly London, Sotheby's

units, were embroidered in feather and stem stitches.

The seventeenth-century Indian printed goods which stimulated a new industry were fine, multi-coloured and fast, and Britain was in the van of experiments aimed to copy them. Initially printing was done by wood-block. The earliest prints from engraved metal plates are now known to have been made at Drumcondra, Dublin, in 1752 by Francis Nixon. He brought the skill to Merton, Surrey, in 1756, and was the first of several quality printers around London to produce large-scale furnishing cottons with fine detail. Another was Robert Jones of Old Ford, Poplar (active 1760–80), who printed mythological and pastoral landscapes based on engravings, in one colour on white (Fig. 167). However, the infant industry moved north, to Glasgow in 1732, to Carlisle in 1750, and to Manchester, which was to become the centre of technical developments, in 1751. By 1820 London firms printed only special items like commemorative handkerchiefs.

Weaving was also revolutionized by the Jacquard loom, patented in France but not used in Britain before about 1840. This could emulate damask, net, ribbons, lace, or 'poor man's tapestry' pictures in many colours, by using a pierced-card system power-operated by one person.

166. Patchwork cover with purchased 'centre'. Cotton. *c.* 1810. London, Victoria and Albert Museum

patchwork was also a social activity, for several women could work on a bed-cover, put together with nice juxtaposition of shapes and colours, perhaps finished with purchased 'centres' and borders and quilted for warmth (Fig. 166). Patchwork, quilting (for which Durham and Wales were noted), and smocking were the nearest approach to folk-crafts in Britain.

The smock (Anglo-Saxon for 'shift'), a comfortable working garment, appears in the Bayeux Tapestry and was once in general use in rural England. Made of homespun linen, it was customarily green in Hertfordshire, Essex, and Cambridgeshire, and blue in Leicestershire, Derbyshire, and Nottinghamshire, although the Sunday smock was universally white. Patterns became more elaborate in the mid-nineteenth century, and these referred to the wearer's trade, which was useful at the Hirings, where cart-wheels identified wagoners and carters, crooks and hurdles were worn by shepherds, and milk-churns by dairy-maids. The 'tubing' or gathering was worked in stem-stitch patterns, requiring skill to maintain the tension, while the flanking 'boxes', built up in simple

Not until the 1840s was the cheap mass production associated with the Industrial Revolution technically possible, with well-known results. The designer was made obsolete by the adaptation – often clumsy – of old designs, overcrowded with detail and in multiple garish colours. A child-like pride in the machine's virtuosity was evident at the Great Exhibition of 1851, which Morris pronounced as 'wonderfully ugly', and the 'satanic mills' grew darker until factory conditions for ill-paid labour, usually women and children, began to arouse the social conscience. Britain dominated the world textile map up to 1913, when the cotton industry accounted for 24 per cent of her exports. But this was achieved only by using cheap labour and by imposing her exports, if necessary, on her colonies, stifling native crafts.

Antidotes were firms such as Warners and Liberty, who in the 1870s combined good design with up-to-date methods. The major figure, however, had an unflinching hostility to the machine: William Morris (1834–96). An architect with diverse interests, Morris was closely involved in all his company's activities, which from 1873 included printed fabrics. His search for natural dyes led to twelve years' collaborative experiments with Thomas Wardle, recorded in the Wardle Pattern Books at the Whitworth Gallery in Manchester. These contain trial pieces of *Honeysuckle* (1876) (Fig. 168), *African Marigold*

LEFT
167. Copperplate printed cotton with pastoral scenes by Robert Jones, Old Ford, Poplar, London. 1761. London, Victoria and Albert Museum

168. *Honeysuckle*, designed by William Morris. 1876. Experimental block-print on linen by Thomas Wardle, Leek. University of Manchester, Whitworth Art Gallery

(1876), *Borage* (1883), and others. His printed designs, later produced at Merton Abbey, most clearly reveal his talent for clothing a structured repeat in such a way that it appears organically natural, even in the sub-patterns, which were influenced by his own Safavid Persian carpet.

For woven fabrics a more formal repeat is necessary, and the influence of Italian silks, which Morris had seen at South Kensington Museum (now the Victoria and Albert Museum) is apparent in the series of wool cloths with birds and mythical beasts, one of which is *Peacock and Dragon*, woven in the 1870s.

But his most ambitious enterprise, begun in 1878, was tapestry, which he thought 'the noblest of the weaving arts'. Characteristically, he taught himself to weave before setting up at Merton Abbey an atelier on medieval lines, and his friend Edward Burne-Jones designed figures for tapestry and embroidery until he died in 1898. *Flora* and *Pomona* (1885) (Fig. 169), the first large-scale figure-subjects, are also important because Morris played a larger part in their composition than those of the later, grander tapestries like the *Holy Grail* series, designing grounds and borders and writing the quatrains. Flora and Pomona, personifying Summer and Autumn, their draperies treated as flat pattern in simple, strong colours, are gentle, remote but wholly at ease in Morris's rich acanthus verdure, closer to the 'millefleurs' tapestries of about 1600 than truly medieval works. Flora, holding finely woven flowers, is surrounded by pheasants, frolicking rabbits, roses and carnations (Morris advised against 'eccentric' plants); and Pomona, holding an apple bough, is framed by grape-clusters.

Morris, whose amazing output was continued by the firm until 1940, might be remembered for any one of his enterprises. He placed Britain on the tapestry map, influencing Lurçat to revive the moribund French industry in the 1930s, while his own weavers founded the Edinburgh Tapestry Company in 1908. Today he is a cult figure and his wallpapers and chintzes, still printed by Sandersons, are best known. But his major achievement must be the revival of the spirit of hand-crafts, the finest legacy of a man who believed that art should be for all – even though it was doomed by his own perfectionism to 'ministering to the swinish luxury of the rich'.

LEFT
169. *Flora*. Tapestry figure designed by Edward Burne-Jones, grounds, borders and quatrain by William Morris. Wool tapestry, woven at Merton Abbey. 1885. University of Manchester, Whitworth Art Gallery

170. Double cloth designed by C. F. A. Voysey. Silk and wool, woven by Alexander Morton, Darvel. 1897. University of Manchester, Whitworth Art Gallery

Like a colossus, Morris overshadowed other brilliant architect-designers, among whom are Godwin, Mackmurdo and C. F. A. Voysey. Voysey, born in 1857 and twenty-three years Morris's junior, dominated English architecture for thirty years, attending with unifying thoroughness to gardens, interiors, and furnishings. Another supreme pattern-designer, he came to terms with machine-production, although he was fortunate that his designs were so sympathetically translated into weaving by Alexander Morton of Darvel. He was 'inclined to admit plants and beasts on condition that they were reduced to mere symbols' (*Studio* I, 1893), and his placid birds perch in comfortable foliage or fly in flocks through enchanted forests (Fig. 170), his medieval interest prompting the choice of the legless martlets of medieval heraldry. His economy of line and pure, soft colours – not 'greenery-yallery' but bronzes, dark greens and purples – make him a precursor of Art Nouveau. But, like Walter Crane and others, he

The Floral Tradition

JOAN ALLGROVE McDOWELL

THE British climate has created a nation of gardeners. The worst of British weather has also encouraged pursuits like embroidery, bringing the garden indoors. This love of Nature in her gentler form reached full expression in sixteenth-century blackwork, used for decorating bodices, caps and coifs, as in the Hilliard portrait of Queen Elizabeth I (Fig. 1). Later, silver-gilt thread and spangles were added and the perishable black was replaced by coloured silks.

By the end of the seventeenth century came the first wave of Chinoiserie. The satin coverlet of Sarah Thurstone (Fig. 2) is signed and dated 1694 (her sister's is in the Fitzwilliam Museum, Cambridge): it has Chinese pavilions, bridges, phoenixes, and grasses, spiky tulips and fanciful flowers, tied with ribbons, and an English oak tree vying with date-palms.

Delicacy and naturalism were the keynotes for both male and female clothing in the later eighteenth century. Black-figured velvet enhances the satin-stitch daffodils, narcissi, lilies-of-the-valley and forget-me-nots which garnish the coat and breeches of about 1775–90 from Sir John Stanley of Alderley's considerable wardrobe (Fig. 4). From the 1780s to the 1850s white cotton 'Ayrshire' work became an industry in Scotland and Ireland, competing with Indian gown muslins. It was worked from professional designs by poorly-paid women in the home – their children receiving a penny a week for threading needles – then made up in Glasgow for sale in Britain, the Continent and the U.S.A. After muslin dresses went out of fashion this embroidery of formalized flower-sprays, all in white on translucent muslin, remained popular for collars, caps, and baby clothes (Fig. 5).

The rose, inextricably British, has undergone changes at the hands of designers as well as gardeners. The flat, heraldic 'Tudor' rose bears little resemblance to the tight little bud or roseball, 'The Spirit of the Rose', in appliqué of milky pastels, designed by Frances Macdonald (1900–5) (Fig. 3). With her sister Margaret, she formed the feminine membership of the Glasgow School's 'Four'. Their sinuous figures and sparse plant ornament were a strong influence on Margaret's husband, Charles Rennie Mackintosh, leader of the group whose distinctive style spanned the Art Nouveau and Modern Movements, this roseball becoming a *leitmotif* of the 1920s.

ABOVE
1. Queen Elizabeth I in a blackwork smock under a jewelled robe. Attributed to Nicholas Hilliard (1547–1619). Oil. Liverpool, Walker Art Gallery

OPPOSITE TOP LEFT
2. Centre of coverlet with Chinoiserie design inscribed 'Sarah Thurstone, 1694' (detail). Silk embroidery on satin. London, Victoria and Albert Museum

BOTTOM LEFT
3. *The Spirit of the Rose*, design for appliqué by Frances Macdonald (Macnair). 1900–5. University of Glasgow, Hunterian Art Gallery

TOP RIGHT
4. Court dress of Sir John Stanley
of Alderley. Silk embroidery on
figured velvet. *c.* 1775–90.
Manchester, Gallery of English Costume

BOTTOM RIGHT
5. Baby's gown in Ayrshire work (detail).
White cotton embroidery on muslin.
c. 1825–30. Edinburgh, Royal Scottish Museum

171. The Whitworth Tapestry, designed by Eduardo Paolozzi. Wool tapestry woven by the Edinburgh Tapestry Company. 1968. University of Manchester, Whitworth Art Gallery

denounced continental Art Nouveau as frivolous and sick, apparently unaware of its elements in his own work. Voysey did, however, recognize his influence on the Modern movement which he outlived, dying in 1941, many years after he had ceased to practise.

In the first half of this century synthetic fibres were developed from mid- to late nineteenth-century prototypes, with a multitude of new finishes to enhance wearability – new tapestries, for instance, are nowadays moth-proof. Since 1945 new reactive dyes with chemical linkage of fibre and dye during the fixing process, and screen-printing refined by photographic methods, have offered new freedom to the designer. Impressive large-scale furnishing prints were a feature of the 1960s, with Heal's and Hull Traders winning design awards. At the same time there was the short but fruitful period when Edinburgh Weavers, under Alastair Morton, were making superb woven fabrics by notable contemporary artists, including Ben Nicolson, Marino Marini, William Scott, and Keith Vaughan.

Similar collaboration is also marked in the work of the Edinburgh Tapestry Company, one of the world's most distinguished tapestry workshops, founded with Morris weavers and firmly based on the Morris tradition. After designs by Hans Tisdall, Harold

Cohen, and David Hockney had been woven, there was a departure from the European mainstream for the Whitworth Tapestry (Fig. 171), commissioned in 1967, with a 'Pop' design by Eduardo Paolozzi, commemorating Manchester's role in computer development. It became an influential piece, for the Dovecot Studio, in Edinburgh, wove further Paolozzi designs and there was a marked change in the work of Archie Brennan, the Director of Weaving.

The nostalgic revivals of Morris designs and the floral calico patterns of Laura Ashley have coincided with a strong trend back to natural fibres, aiding the survival of ancient industries such as Yorkshire and Welsh woollens and tweeds from Donegal and, more recently, Harris. Britain is still enriched by the happy chance of craftsmen from overseas settling here. One such immigrant is Kaffe Fassett, an American painter influenced by Scotland's softly-coloured countryside to work in mixed media and to design canvas-work for the amateur.

Above all, there has been a resurgence of amateur interest in textile crafts like patchwork (always favoured in hard times) and embroidery, as the pleasures of needlework are re-discovered, and increased use of museums enables the amateur to draw on the *richesse* of Britain's textile history.

14

Jewellery

ANNA SOMERS COCKS

THE glorious tradition of Anglo-Saxon gold-smithing ended with the Norman Conquest in 1066. Judging by funerary effigies and the surviving early medieval pieces it was replaced by a solid, relatively plain style which found expression in brooches, belt-mounts, mantel clasps and rings, and individual jewels sewn on to the dress. Gold, silver or gilt metal were the materials most often used, and the stones were simply polished or *en cabochon* (that is, with a polished, rounded top), but not faceted.

This simplicity lasted into the high Middle Ages, as is shown by, for example, the jewels on the body of Edward I (1239–1307), revealed in 1774 when his tomb was opened: his mantle was fastened with a ring brooch, his stole was decorated with quatrefoils of chased gilt metal, and his gloves had a jewelled quatrefoil on the backs. These quatrefoils illustrate what was true of most medieval jewellery: that it took its ornament and sometimes its actual structure from the idiom of Gothic architecture. Throughout the Middle Ages inscriptions were very common on jewellery, and these were usually of an amatory, devotional, or magical/prophylactic sort (Fig. 173). The change from rounded well-spaced Lombardic lettering to vertical, compressed Gothic in the mid-fourteenth century helps date many of these pieces. The tradition of rings with inscriptions on them ('posy' rings, from the word 'poesy') was one which continued into the eighteenth century.

From the fourteenth century onwards more money was spent at court and in the towns on conspicuous display, as the sumptuary laws and inventories reflect. The making of goldsmiths' work was finally regularized when the London Guild of Goldsmiths was incorporated by Letters Patent in 1327. While jewellery did not have to be marked, its production was subject to the same regulations as the making of plate. New techniques began to be used to decorate the metal, in particular translucent enamelling and encrusted enamel (*émail en ronde bosse*), both four-teenth-century importations from France.

A wider range of jewellery was now worn, includ-ing chains, hat badges, jewelled cauls, waist pen-dants, and brooches not merely of ring form. The finest example of a high medieval English brooch in the newly fashionable figurative style, ornamented with *ronde bosse* enamel on the leaves of the lily, and translucent enamel on the wings of the angel, is the M brooch given by William of Wykeham (1324–1404) to New College, Oxford (Fig. 178). Jewellery set with translucent enamelled plaques was also popular: in the Victoria and Albert Museum there are a number of miniature folding altarpieces with religious scenes, and a flat box (perhaps a scent container) with a knight fighting a wodewose. From their hanging rings, it would seem that these pieces must have been worn from the waist.

To distinguish between English and French ex-amples of such jewellery is not always easy. Rings and, more rarely, brooches of a peculiarly English type appear about 1400 and last into the second decade of the sixteenth century. These are charac-terized by the saints or religious subjects which are engraved on them, the lines usually filled with black enamel for extra emphasis. The rings are engraved on the shoulders, or have a bezel which is dished two or three times, with a saint on each surface. The brooches, which are circular, have the saints en-graved so as to follow the curve of the metal. Probably the only grand English medieval rosary to survive is engraved and enamelled in this technique; it depicts a hundred and ten saints and religious subjects (Fig. 176). Rosaries were, of course, impor-tant forms of jewellery right up to the Reformation, and inventories record examples of gold, coral, amber, jet, and enamelled work.

The decorative idiom of the Renaissance, with its elements of classical architecture, its Roman letter-ing, its putti, acanthus leaves and grotesques, prob-ably affected jewellery before it did painting, sculp-ture and architecture in England. Certainly, most personal seals were in the Renaissance manner by

ABOVE

172. *Portrait of Anne of Denmark*, after Paul van Somer.
Oil. *c.* 1617. London, National Portrait Gallery

ABOVE, TOP RIGHT

173. Ring brooch with inscription. Gold.
Late 13th or early 14th century. London, British Museum

ABOVE

172. *Portrait of Anne of Denmark*, after Paul van Somer.
Oil. *c.* 1617. London, National Portrait Gallery

ABOVE, TOP RIGHT

173. Ring brooch with inscription. Gold.
Late 13th or early 14th century. London, British Museum

ABOVE

174. Pendant and chain. Designed by C. R. Ashbee and
made by the Guild of Handicraft. Silver and gold, set with
pearls, diamond sparks and a garnet. *c.* 1903. London,
Victoria and Albert Museum

OPPOSITE

175. Part of the Cheapside Hoard. Elizabethan and
Jacobean jewellery and assorted finds discovered in 1912
on the site of a goldsmith's house. Museum of London

about 1530. Hans Holbein the Younger (1497/8–
1543) brought the South German version of Renais-
sance design to the court of Henry VIII and a group
of jewellery designs by him survive – the only designs
known to have originated in England in the sixteenth
century (most of them are now in the British Museum).

There is a distinctive group of jewellery from the
second and third quarters of the sixteenth century
which can definitely be identified as English. The core

of the group are some circular jewels with figure
groups enamelled *en ronde bosse*, such as the hat
badge, with Christ and the Woman of Samaria and
an English inscription, in the British Museum. A
related girdle book (Fig. 177) and pair of plaques,
probably also from a girdle book, are also in the
British Museum, and the former can be positively
dated after 1539 because its English inscription first
appears in the Cromwell Bible printed in that year.

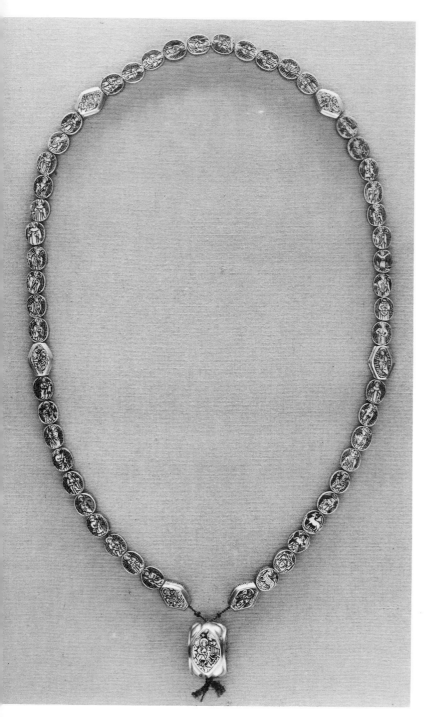

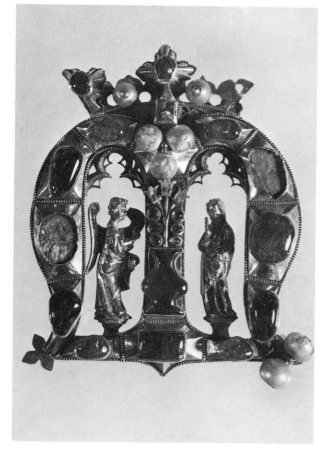

ABOVE 176. Rosary from Houghton Hall, Sancton.
Enamelled gold. *c.* 1490.
London, Victoria and Albert Museum

ABOVE RIGHT 177. Girdle prayer book. Enamelled gold.
After 1539. London, British Museum

RIGHT 178. Enamelled gold brooch, set with cabochon
rubics, cmeralds and pearls. Probably the central ornament
of William of Wykeham's mitre. Late 14th century.
Oxford New College

The Reformation obviously eliminated certain types of specifically devotional jewellery, such as rosaries, reliquary capsules and iconographical rings, but the wearing of crosses and IHS (Iesus: IHS are the first three letters, in Greek capitals, of 'Jesus') pendants continued, as seen in the portrait of Anne of Denmark, the wife of James I (Fig. 172).

Only a small amount of Elizabethan jewellery survives, but the portraiture of the day, with its precise depiction of the outward display of the sitter, fills the information gap, showing that all forms of jewellery current on the Continent were also worn here: dress jewels sewn to the clothing, waist chains, pendants (often of a figurative nature), jewelled headdresses and sprays, bracelets, and a multiplicity of rings. A relatively large number of bejewelled and enamelled miniature cases survive. As miniature painting was particularly popular at the English court, it seems likely that these were an English speciality; Anne of Denmark is shown wearing one pinned to her bosom. A number of these cases, like the Drake jewel (in a private collection), contain portraits of Queen Elizabeth: in fact her image appears on a high proportion of the surviving jewels of the period.

Inventories record that, as well as the grand state jewels, the queen owned a large number of small, amusing and emblematic pieces of jewellery, and some of these were almost certainly inherited by Anne of Denmark, who has numerous small jewels scattered over her standing band (Fig. 172). The best, indeed almost the only, examples of the small delicate jewels of the early seventeenth century to survive are in the hoard found in 1912 when a house in Cheapside was being pulled down. This includes plate, watches, unmounted stones, and jewellery of a lace-like fragility touched with subtle pale shades of enamel colour (Fig. 175).

The portrait of Anne of Denmark also illustrates the trend, which grew stronger and stronger from the early seventeenth century onwards, for grand jewellery to be densely set with stones, a display of the gem-setter's craft, while the finely chased gold and polychrome enamelling retreated in importance, literally, to the backs of the pieces, and in the eighteenth century vanished altogether. The dominant new shape for this kind of jewellery was that of a ribbon tied in a bow, launched almost certainly in France in the second quarter of the seventeenth century. The main cutting and trading centre for gems in northern Europe from the same period was Amsterdam, so it is very possible that much English court jewellery, especially after the accession of William of Orange, was imported from there.

While little of the valuable jewellery of the seventeenth century survives, there remain quite a number of the more informal pieces: the clasps and lockets, especially the commemorative ones, either remembering a dead friend or relation, or showing allegiance to the Royalist cause. The former are at the beginning of the flourishing English tradition of sentimental jewellery which survived until this century.

In the eighteenth century the divide between expensive gem-set jewellery and the less valuable, more diverse day-time jewellery grew even wider: the former tended to be conservative, with only minor variations on the forms introduced in the seventeenth century, especially the bow, while the latter was freer to innovate. The goldsmiths' contribution, as opposed to that of the gem-setters, was revived in the work on the watch-cases, etuis (cases for small instruments), and chatelaines (key chains worn at the waist) which everyone now possessed. The finest of all these are generally thought to be the French ones, but in England some skilful embossed and chased work was produced, the finest exponent being the Swiss immigrant, George Michael Moser (1707–83), who worked in London from 1726 until his death.

Cheap versions of these secondary types of jewellery – that is buttons, buckles, chatelaines, etc. – were made in base metal by the increasingly industrialized 'toy' industry of Birmingham. Also made in Birmingham was cut-steel jewellery, popular in England from the early eighteenth century until the early nineteenth. The best wares in this technique, by no means cheap, were made not at Birmingham but at Woodstock in Oxfordshire. They include necklaces, bracelets, brooches, as well as watch chains, buckles, chatelaines and their implements, and sword hilts (see also p. 144). While cut-steel was not unknown on the Continent, it does seem to have been most popular in England, and there are accounts of English work being exported to France.

Sentimental and mourning jewellery was especially favoured from the last quarter of the eighteenth century onwards. Again, while French, German and Dutch examples do exist, there is no doubt that in England the fashion flourished more than anywhere else. The rings, clasps, brooches, and pendants are often shuttle-shaped, with perhaps a grisaille painting under glass of a mourning figure by an urn and under a weeping willow, often executed in hair. Others are set with plaited hair and initials in gilt wire, or with a plaque of translucent blue enamel, again with initials in pearls or diamonds. Simpler rings which were

made in quantities for distribution at funerals often have the name of the deceased in gold against a black enamelled ground.

In the nineteenth century mourning jewellery became yet more elaborate: whole parures (sets of matching jewellery) were woven from hair in the 1830s to 1850s; lockets and clasps to contain portraits of the deceased abounded; and the jet industry of Whitby, which produced carved jewellery suitable for wearing with mourning, was given additional impetus by the death of the Prince Consort in 1861. This put Queen Victoria into life-long mourning and set a standard for the display of grief imitated by many of her subjects.

In general, the nineteenth century saw a vast increase in the types of jewellery worn and in the styles available. Every degree of dressiness was catered for, from a few simple gold pieces, or some amusing novelties to be dotted about the person, to the full formal splendour of diamonds and pearls worn in the evening. As before, the greatest stylistic variety came with the less formal pieces which progressive industrialization was capable of producing quite cheaply. The scale of this industrialization is illustrated by the fact that between 1866 and 1886 the number of people employed by the Birmingham jewellery trade rose from 7,500 to 14,000. This was no doubt helped by the legislation of 1854 which permitted the use of 15, 12, and 9 carat gold in addition to the 22 and 18 carat qualities permitted earlier.

The naturalistic forms which dominated the 1830s and 1840s were replaced after the middle of the century by a wide variety of styles, influenced by various strands in the culture of the day, such as the Romantic interest in the Middle Ages and the Renaissance, nationalist folklore, famous archaeological discoveries, and the opening up of Japan to the West. For example, A. W. N. Pugin (1812–52), the architect, designed Gothic jewellery which was shown at the Great Exhibition of 1851. The finely granulated and classical forms of jewellery, variously called 'Etruscan', 'Greek', or 'Roman', which were partly rediscovered and partly invented by the Roman goldsmith Fortunato Pio Castellani (1793–1865), were brought to England by his son Augusto (1829–1914), who lectured to the Archaeological Association on the subject. The style flourished here for twenty years and was still being mass produced in a debased form by the Birmingham industry at the end of the century.

There was, however, a strong movement reacting against the mass production of all the arts, and against the ostentatious and dull bedizening with diamond fashionable for evening attire. The artists of the Pre-Raphaelite Brotherhood chose instead Indian, Chinese, and peasant jewellery to adorn their models. Some, like Edward Burne-Jones (1833–98), produced jewellery designs, though relatively little of this was actually made up. The new ideal was that the artist who designed the piece should also be its maker, and this led a number of artists in the 1880s, such as the sculptor Alfred Gilbert (1854–1934), to try their hand at goldsmithing. The Arts and Crafts Exhibition Society was formed in 1888 to show their work, and the jewellery displayed there was characterized by the use of intrinsically quite cheap materials – silver more often than gold: glass, enamel, and semi-precious stones cut en cabochon rather than faceted – and an obvious 'hand-made' look.

Despite the ideal that the artist should also be the craftsman, it tended nonetheless to be the craftsmen who made most, if not all, of the pieces: this was certainly the case with one of the most successful and influential members of the Arts and Crafts Movement, C. R. Ashbee (1863–1942) and his Guild of Handicraft (1887/8–1907) (Fig. 174). This particular venture had great influence on artists of the Vienna Secession such as Joseph Hoffmann (1870–1955). The Art Nouveau jewellery of the Continent was also affected by the Arts and Crafts Movement's ideas about materials, and its characteristic 'whiplash' curve seems to derive ultimately from England, though both the Viennese work and the pieces made by Parisian firms such as Vever show a technical professionalism uncharacteristic of English jewellery. The reason for this is that they employed fully trained commercial craftsmen to execute their designs.

The Arts and Crafts style of jewellery was popularized (and reduced in price) from 1898 onwards by the London firm of Liberty and Co. which, ironically, turned to the factories of Birmingham and Sheffield to produce it. As a fashion it survived into the 1920s, but as a spearhead movement it was already dead by 1905. Between the wars and until the late 1950s English jewellery remained either traditional or an imitation of continental models. Since then, however, an independent modern movement has also grown up, which has brought vigour and imagination back into English jewellery, so that the contemporary scene is far from moribund as once seemed likely. Jewellery has become one of the most active of the modern studio crafts (see p. 236ff.).

15
Silver

PHILIPPA GLANVILLE

ENGLAND'S relative prosperity over the past
four centuries has always found expression in
silver. People with money have usually invested
some of their wealth in it, and a national bent,
peculiar to the English, towards moderation and
continuity, has shown itself in a consistent taste for
silver that is handsome and heavy, but relatively
undecorated compared with that of France, Germany
or Scandinavia. Extremes of ornament have been
popular only briefly and even then only among a
limited circle of cognoscenti. So, rather than treat
antique plate as a series of aesthetic phenomena, this
account focuses on the social context within which it
was fashioned, considering plate as an expression of
society's changing values.

Very little medieval plate survives today. About
three hundred pieces, including spoons, made before
1525 are known. Most have belonged for many years
to colleges, churches and livery companies and have
been preserved only through the conservatism of such
institutions and their respect for the memory of past
benefactors.

The finest pieces, known now only from descrip-
tions in royal and ecclesiastical inventories, were
elaborately worked, gilded and engraved, and often
incorporated enamel plaques and jewels. New Col-
lege, Oxford, possesses two of the dozen medieval
salts: in one, the Monkey Salt, a chimpanzee holds up
a bowl of rock crystal; the other, Warden Hill's Salt,
is shaped like an hour-glass and topped with Gothic
cresting. Both demonstrate a taste for display plate in
fantastic shapes (Fig. 179).

Silver – or rather silver-gilt – drinking vessels, large
display salts, ewers, and basins are the domestic
objects most frequently referred to; but candlesticks
and wall sconces, caskets for jewels, massive pie
dishes, bells for dogs and hawks, graters, strainers,
and cisterns for wine, all appear. The sheer weight of
silver quoted, coupled with fifteenth-century illus-
trations of banquets showing the buffet (literally
'cup-board') dressed several tiers high with silver-

LEFT 179. Warden Hill's Salt. Unmarked. Silver-gilt,
with painted glass panels set into the cover.
London (?), c. 1490. Given to New College, Oxford, in 1494

RIGHT 180. Standing cup. Maker's mark 'S' on a cross
(Isaac Sutton?). Silver-gilt and crystal. London, 1573.
Private Collection

gilt vessels, reminds us of the proverbial value attached
to silver as a sign of status.

How far the ownership of silver reached down the
social scale is uncertain; few private inventories
survive before the mid-sixteenth century. Individual
apostle spoons are recorded as baptism gifts before
1450, and those who could not afford an entirely

silver drinking bowl aspired to a mazer bowl of turned wood tipped with a silver lipband, or to a latten (base metal) bowl gilded to look like silver. The Swan mazer given to Corpus Christi College, Cambridge, exemplifies the taste for fanciful table silver: it has a silver swan, perched on a central turret, which syphons off excess wine when it is about to slop over. Silver given for church use was often equally elaborate; before the Reformation a large town church such as St Peter Mancroft in Norwich owned hundreds of ounces in worked plate, accumulated by gift or bequest. The largest altar cross owned by St Peter Mancroft was of silver-gilt with enamel roundels; it had a group of saints and angels at the foot and weighed 166 ounces. Smaller town churches owned at least a chalice and paten of silver-gilt. All this church plate, with the exception of a single chalice and paten left to each parish, was melted down or sold for secular use by 1560, and this flood of metal was a far more significant factor in the increase of domestic silver than the often-quoted 'new silver mines' of South America or Germany.

The general rise in domestic comfort and even luxury in Tudor England, remarked on by William Harrison, Philip Stubbes, and others, included a much wider demand for table silver. Italian visitors commented on the splendid effect of the goldsmiths' shops massed along Cheapside (see Fig. 175).

This boom in Tudor goldsmithing is clear both from the greater number of extant pieces and from the lists of plate accumulated by institutions. Henry VIII's 'new men', his agents in organizing the flow of plate from the religious houses and cathedral treasuries between 1536 and 1547, were among the first to benefit. Although most of the confiscated religious plate went to the Mint to be melted down, jewels and stones, and particularly the rock crystal casings from reliquaries and monstrances, were eagerly purchased by goldsmiths and worked up into elaborate salts and standing cups. The Stonyhurst Salt, now in the British Museum, was assembled in 1577 from a somewhat miscellaneous selection of fragments. A more integrated example of mid-Tudor design is the Bowes Cup of 1554 at the London Goldsmiths' Company, although in this piece the central crystal cylinder has been replaced by lead glass. Crystal was valued for its rarity, its clarity and its supposed quality of clouding in the presence of poison (Figs. 180 and 181). The same wondering, credulous attitude to exotic rarities lay behind the taste for ostrich-egg cups and horn (usually rhinoceros or narwhal but believed to be unicorn) mounted into flagons.

The engraved or enamelled armorials on Tudor plate attracted antiquaries such as William Barrett of Lee in Kent; by about 1720 he owned the Parr Pot (now in the Museum of London), a glass ale pot with mounts of 1546, enamelled with the arms of William Parr. These, misread as those of Queen Katherine Parr, his niece, ensured the survival of this piece. The antiquarian taste for early plate was to flourish in the following hundred years; the most interesting pre-Victorian collector is the eccentric William Beckford who, in his concern to recreate a historical environment at Fonthill, not only sought out antique plate but commissioned pieces in imitation of Tudor and Jacobean styles.

The civic plate of London is well documented and illustrates vividly why so little domestic plate has survived intact. Of the ewers, basins, trenchers,

181. The Gibbon Salt. Maker's mark three trefoils slipped. Silver-gilt and rock crystal, containing a gilt figure of Neptune. London, 1576. Given to the Goldsmiths' Company in 1632 by Simon Gibbon

spoons, and livery pots listed for the Lord Mayor's use in 1567, none remained unaltered even by the end of the century. Usually the goldsmith supplied something within one ounce or two of the weight of the original but in a more up-to-date form. The standing cups of 'antique work' given by Sir William Denham as a fine in 1542 were regilt in 1586, exchanged before 1633, and exchanged again in 1640 for cups 'all gilt matted fashion', that is, covered with the then-fashionable small punching. Exchanged twice more, Denham's cups finally froze into the two cups made by Benjamin Pyne in 1721, still in the Mansion House plate.

References to alterations and replacements are a reminder that inscriptions with dates do not necessarily date the piece. Among the magnificent silver used by the Lord Mayor of London today are some silver plates; these, the descendants of two dozen silver-gilt trenchers given by Lady Elizabeth Nicholas, widow of a Lord Mayor, before 1586, became 'battered and bruised' from heavy use at city dinners. They were exchanged or refashioned at least three times before Paul de Lamerie supplied the present set to the Mansion House in 1737, but each time the goldsmith engraved Lady Elizabeth's arms on the replacements to keep alive the memory of her gift. College bursars and churchwardens have taken the same approach to old plate, although the latter sometimes had even the form of the original piece copied; St Peter le Poer, Muswell Hill, has a pair of 'Jacobean' basins, one made in 1607, the other by John Eckford in 1744. Both are embossed with marine monsters; there was no prejudice against such secular ornament on church plate.

Many German stoneware mugs were mounted up by the Exeter goldsmiths John Jones and John Eydes. Their quality is perceptibly higher than that of the general run of London-mounted pieces, reflecting the greater personal control of a small workshop. At least from the mid-sixteenth century much London silver was produced in standard designs with workshops specializing in, say, spoons or salts to satisfy the growing citizen market. Cast components in frequent use, such as handles, thumbpieces and finials, were purchased from a specialist, and the punches with which to reproduce the ovolo or floral bands on Tudor mounts again came from specialist cutters, with the same designs occurring on plate by several different makers. A group of Elizabethan salts from Mostyn Hall (now at the Victoria and Albert Museum) by various makers have closely comparable panels of embossed flowers in strapwork; printed designs for engraved and embossed ornament circu-

182. Mermaid ewer and basin. Maker's mark TB in monogram. Silver, embossed with marine motifs and engraved with the arms of Sir Thomas Wilson. London, 1616. London, Victoria and Albert Museum

lated widely and an embosser would be expected to adapt the design to any scale. Although Simon Owen is known particularly for his ewers and basins embossed with marine monsters after designs by Adrian Collaert, these plaques occur on much English plate from the 1570s to the 1630s (Fig. 182). The tiny quantity of surviving plate makes generalization about a particular goldsmith's speciality a statistical nonsense unless documentary references confirm the assumption. The early Stuart goldsmith Clement Punge, for example, was linked to a mark on several distinctive salts by a reference to him as 'pulley saltmaker'. Marks of some twenty specialist spoon-makers have been identified recently, working in London and elsewhere. Although we have too few spoons to distinguish their products, certain cast finials, for example, can serve as an extra clue to confirm the reading of a poorly-struck or rubbed mark.

This paucity of examples from which to plot a goldsmith's output is partly counterbalanced in one specialized area only, that of church plate. From 1562, across the country diocese by diocese, the bishops campaigned vigorously to force parishes to convert their medieval mass chalices into 'decent communion cups'. This brought a rush of business to both London and provincial goldsmiths. To be compatible with the Protestant view of the sacrament as a common meal, the design of these post-Reformation cups was based on the simplest contemporary wine cup – a beaker on a foot. Although there are regional variations – the cups from East Anglia and the West Country are distinctive – the form and

decoration is less interesting than the evidence provided by this great body of maker's marks, which can be closely dated and sometimes tied up with churchwardens' accounts. In Norwich for instance the much-debated mark of an orb and cross has recently been firmly identified as that of William Cobbold, on the strength of an unambiguous reference to his making a cup, which still exists, for the church of St John Maddermarket.

Two misconceptions are sometimes quoted to explain the character of early Stuart plate; the first is that its relative simplicity and the general reduction in gilding and ornament were due to Puritan attitudes, and the second that its rarity is due to the demands of the Civil War armies. Rather more significant is the economic situation: England's economy was in decline from about 1620, with a series of expensive foreign ventures coinciding with a collapse in the European demand for English cloth as a result of the Thirty Years War.

When money was short, it was essential for the goldsmith to be able to cut the cost of 'fashion', i.e., of making up the piece and embellishing it by embossing, chasing or engraving, and subsequent gilding. Hence the popularity of light, almost flimsy pieces whose minimum weight is counterbalanced by their punched decoration of grapes, plums, and flowers. Cups, porringers, and sweetmeat dishes were produced by London goldsmiths to standard designs; those by William Maundy are notable only because his mark has been identified. Matting (overall punching with a small-headed hammer) was combined

183. Inkstand, by Alexander Jackson, assay master. Silver, embossed with grotesque masks and set with cast plaques. Later armorials. London, 1639. Private Collection

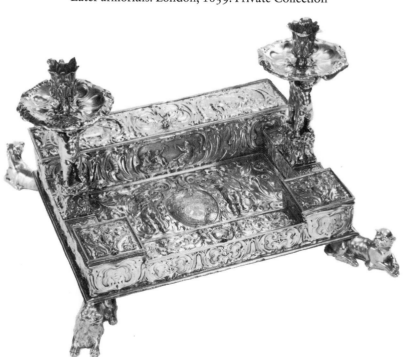

effectively with areas of plain silver, especially in tankards and winecups; this technique remained popular until after the Restoration; and flat-chased formalized flowers continued the Elizabethan taste for flowers in strapwork panels. All these were relatively cheap forms of ornament, adding little to the cost of 'fashion'; however, not all customers were constrained to adopt these cheaper styles. Charles I and his courtiers such as the Duke of Northumberland and the Earl of Salisbury patronized the Utrecht goldsmith Christian van Vianen, who arrived in London about 1630 as a young man (Fig. 183). His auricular style, first evolved by his father Adam, was to influence English goldsmiths later, after the designs were published in 1650. Fleshy lobes and grotesque masks characteristic of the style were incorporated into the foliage and fruit embossed on Restoration plate, particularly porringers and salvers.

Some of the major court commissions were for church plate; the swing towards high Anglicanism stimulated by Bishop Lancelot Andrewes (1555–1626) led to a demand for 'Gothic' plate incorporating early versions of cutcard work and applied beads. The unidentified maker whose mark is a hound sejant made several sets for private chapels in the 1650s; the earliest by him is the superb group from Staunton Harold, now exhibited at the Victoria and Albert Museum. Van Vianen's set for St George's Chapel, Windsor, was admired by contemporaries but was looted in 1642.

Provincial goldsmithing was in marked decline during the seventeenth century; fewer local craftsmen took up the craft, and apart from minor repairs and small orders for spoons, cups and church plate, customers bought their silver from the London shops which carried a ready stock of standard items. The London season, already a factor in changing country shopping patterns before the Civil War, was effectively to drain custom away from all but a very few major provincial centres in the next hundred years.

The swing back to greater expenditure on silver, by both institutions and private customers, is apparent even before the Restoration, but the great increase in plate brought for assay in 1660/1, 37,000 lbs' weight, clearly demonstrates an upswing in demand when compared with the previous decade when the highest annual figure was only 32,000 lbs. This does not include all the commissions made for private sale, since until 1696 these did not legally require hallmarking; very few of the splendid examples of contemporary silver furniture, for example, bear even a maker's mark.

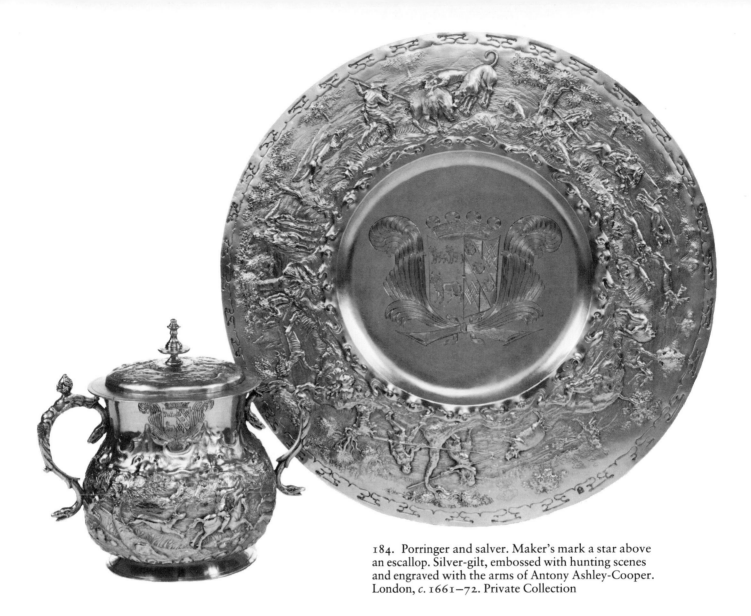

184. Porringer and salver. Maker's mark a star above an escallop. Silver-gilt, embossed with hunting scenes and engraved with the arms of Antony Ashley-Cooper. London, *c*. 1661–72. Private Collection

Between 1660 and the 1690s, business was booming for the London goldsmith. The returning court brought its experience of the luxury of French court life and a taste for the lavishly embossed silver of Holland; while the Dutch influence on silver, apparent since the 1640s, was to be replaced by French forms after about 1670, it was the French appetite for massive display silver which the king, his mistresses and his courtiers took up. European dining refinements were widely copied; forks, coming in just before the Civil War, were more usual, and as the custom of washing after the meal declined, so the ewer and basin vanished. Dining chambers were smaller and no longer dominated by a buffet laden with gilt cups. Men drank from wine glasses, either imported Venetian crystal or, from 1675, Ravenscroft's lead glass (see *Glass*, p. 161ff.). The ceremonial standing salt disappeared, except for formal and institutional use, replaced by small salt-cellars shared by two or three diners; sets of cylindrical casters for pepper, sugar, and dry mustard also appear from the 1670s. Rarer today but widely used then were silver chafing dishes and cruets for vinegar and oil, the latter to develop into the glass bottles and stand of the Georgian dining-table. Menus now included cold mayonnaise-like sauces and the early sauce-boats rested directly on the table, but as hot sauces and gravies came into fashion, so sauce-boats were supplied with feet, and sometimes stands to take a ladle.

Display plate in the dining-room now consisted largely of salvers and porringers (see Fig. 184). This type of vessel, while used indiscriminately both for alcohol-based desserts similar to syllabub and for savoury mixtures eaten with a spoon, was also considered appropriate for presentations; several are known to have been gifts from Charles II at the New

Drinking

PHILIPPA GLANVILLE

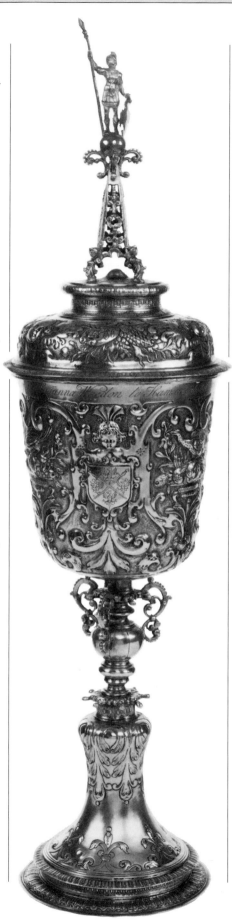

MEN need rituals; the sharing of drink, alcoholic or not, has been treated as a ceremony in which the drinking vessels themselves acquire significance. Those who could afford to express their own standing, as well as the honour they wished to confer on their guests, offered silver or silver-gilt to drink from, although not necessarily to eat from. As a result a large proportion of silver has always been made to contain or serve beverages of one kind or another.

Town dwellers always preferred metal to locally-turned wooden drinking vessels. The taste spread across the country at least into the yeoman class until mazer bowls virtually fell out of use after 1600. Silver was preferred, whether for wine cups, flagons, or nests of footed beakers, despite the competition from London-made wine glasses (Figs. 1 and 2). After Verzelini established his glass-house at Crutched Friars in 1575, the two materials stood side by side on the buffet for a hundred years; then glass finally replaced silver for both serving and drinking wine.

For the goldsmith the most profitable long-term innovations of Charles II's reign were the new beverages – tea, coffee, chocolate, and punch. Each required both serving and drinking vessels together with other utensils such as caddics, milk jugs and teaspoons, most of which have since become standard items in the English home. Although some silver teacups exist it was gradually accepted that silver was unsuitable for hot liquids, since the metal burnt the lips. There was considerable experimentation with shapes derived from Turkish and oriental ceramic prototypes before the familiar forms emerged early in the eighteenth century (Fig. 5). Chocolate pots, often supplied *en suite* with

coffee pots, were distinguished by a hinged lid on the cover, through which a swizzle stick was poked to mix the chocolate. Early (pre-1730s) sets of a small teapot, hot water jug, and sugar bowl, sometimes retain their original lamp; tea was drunk milkless in the Chinese style and cream jugs only appear in the 1730s.

Handsome salvers of the 1740s and later have cast openwork borders incorporating heads of a Turk, a West Indian, a Chinaman, and a Brazilian, each wreathed with the plant indigenous to his region, referring to the coffee, sugar, tea, and chocolate dispensed from such salvers. Sets of tea caddies were differentiated by the tea plants incorporated into their knops; while by convention strawberry leaves or fruit identified a sugar bowl.

Teapots and tea-urns reflected every extreme phase of design between about 1720 and 1850; then urns were relegated to institutional use as domestic tea-drinking became less ceremonious and more a matter of convenience. The simple undecorated base-metal pot familiar today emerged a century ago, the original designed by Christopher Dresser as a conscious echo of Japanese ceramic drinking vessels (Fig. 3).

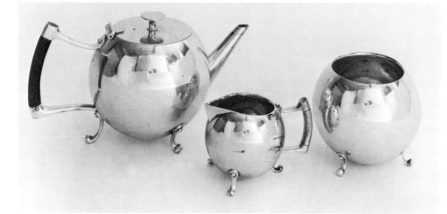

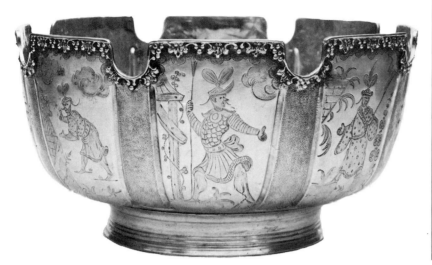

OPPOSITE LEFT
1. Steeple cup. Maker's mark RB. Silver-gilt, embossed with birds and figures. 1629. Given to St John's Church, Hampstead, in 1747. London, Victoria and Albert Museum

OPPOSITE RIGHT
2. Peg tankard, by William Plummer. Silver, engraved with fantastic flowers. York, 1657. London, Victoria and Albert Museum

ABOVE
3. Tea service, by James Dixon & Son, designed by Christopher Dresser. Electroplated nickel silver. Sheffield, 1880 Registry mark. London, Victoria and Albert Museum

CENTRE
4. Monteith bowl (for serving cooled wine), by George Garthorne. Silver, chased with chinoiseries. London, 1686. London, Victoria and Albert Museum

BELOW
5. Teapot, chocolate pot and kettle on stands, by Joseph Ward. Silver, cast octagonal. 1719. London, Goldsmiths' Company

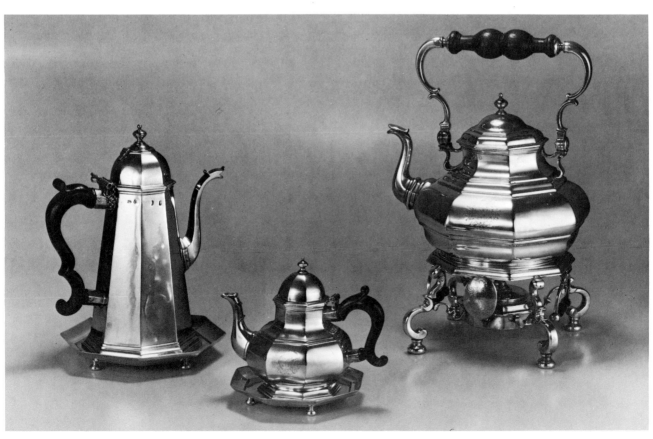

Year. At the top of the social scale massive silver cisterns were ordered, to be used both as wine coolers and as basins for washing glasses; a few families also had fountains with taps to contain water.

Other domestic silver of the 1670s is also influenced by French interior decoration; as the various functions of rooms became more clearly defined, so the 'withdrawing room' was marked out by its mantelpiece and corner cupboards dressed with porcelain and silver vases and garnitures, and its suite of silver-mounted mirror, table, flanking candle stands, and andirons. Survivors from such suites can be seen in the royal collection at Windsor and at Ham House, Richmond; these are usually unmarked and were probably embossed by foreign craftsmen, working for the goldsmiths employed by the Jewel House. Silver toilet services are characteristic of this lavish period; comprising twenty to thirty items, including candlesticks and snuffers, bowls on stands and boxes of various sizes for patches, brushes and cosmetics, as well as the inevitable mirror and jewel casket, they rarely survive complete and were usually private orders, so not fully marked (Fig. 185).

Plate was accumulated by many routes – gifts, bequests, in payment for favours received or expected, or as a purchase. Because it was seen as a gauge of a person's standing and wealth, most significant occasions in life were marked by a gift of plate – apostle spoons or bowls at baptisms, cups at weddings, a cup or a spoon when a man gained the livery of his craft company. Fines for refusing a turn at one of the many unpaid public service posts such as

185. Box from a toilet service.
Maker's mark WF with a knot. Silver,
embossed with acanthus and set with cast plaques.
London, 1683. London, Victoria and Albert Museum

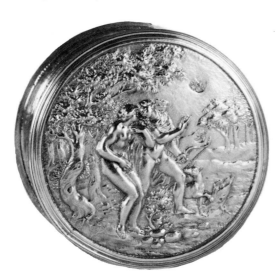

scavenger or sheriff were often paid in plate. Patronage, the cement of early modern English society, was sweetened by gifts of plate, which usually flowed upwards to those higher in the social scale. Samuel Pepys's career vividly demonstrates this; as he rose at the Navy Office, so his gifts of plate from contractors and captains anxious for a good posting increased in number and value.

Gifts to the monarch at New Year were carefully chosen, often elaborate and expensive, expressions of the donor's duty and love, for which in return he received a ticket entitling him to apply to the Jewel House for a piece of standard plate proportionate to his office, ranging upwards from a set of spoons to a flagon or porringer and salver.

Occasionally royal gratitude took a more generous form; Charles II, notoriously lavish in providing his mistresses with silver furniture and toilet services, also recognized more public service. Sir Edmund Bury Godfrey received an 800-ounce wine vessel in recognition of his work during the Plague and Fire. Sir Edmund had this massive piece refashioned into flagons and tankards, suitably inscribed in memory of his royal gift, for presentation to his friends. Much of the plate engraved with royal arms was never in use in the royal household but made for official issue, to ambassadors or leading public servants such as the Speaker of the House of Commons. Other pieces with royal armorials or crests were gifts to household servants, such as the tureen, now at Christ Church, Oxford, given by Frederick Louis, Prince of Wales, son of George II, to his physician Doctor Lee.

Since the sixteenth century French taste has been a recurrent element in English decorative art, transmitted through engraved designs, individual cross-Channel commissions, and the willingness of French craftsmen to work in London. The 1680s saw the largest influx of such craftsmen during the campaign of official anti-Protestant action which culminated in Louis XIV's revocation of the Edict of Nantes. Provincial goldsmiths crossed the Channel in large numbers, bringing a familiarity with the refinements of French baroque silver. Their plate, to designs by Bérain and Lepautre, was cool, angular, and massive, relying on its line for effect, and incorporating restrained classical gadroons or acanthus borders rather than the lavish embossed foliage of English silver. Their workshop dynasties, cemented by intermarriage, ensured the continuing quality of their silver; the Courtaulds, the Le Sages and the Willaumes are examples.

This 'Huguenot' style, rapidly taken up by the leading English silversmiths such as Benjamin Pyne,

Anthony Nelme and George Garthorne in response to their clients' demands, predominated until the 1720s (Fig. 187). The Britannia standard for silver, almost identical with the Parisian standard, produced a metal very suited to casting, a technique appropriate to baroque applied ornament. Meanwhile some goldsmiths, particularly those in Exeter, continued to work in a lighter, more flimsy style; the tankards of Seth Lofthouse, for example, which survive in large numbers, are repetitive, with little individuality in the punching and the same slightly scaly cartouche on each.

Enriched by further additions from French Régence silver, in the form of cast and applied lambrequins or tongues, the Huguenot or 'Queen Anne' style flourished until the 1720s (Fig. 186). In contrast to earlier plain surfaces, intricate engraving by Simon Gribelin, William Hogarth, and Joseph Simpson embellished salvers and boxes (Fig. 188). Initially either figurative or formal and repetitive, these panels broke up around 1730 into irregular scrolls flanked by scalework, shells and flowers, the first appearance on English silver of the rococo style. This flourished in France from the 1720s, exemplified by the silver of J. A. Meissonier (1695–1750).

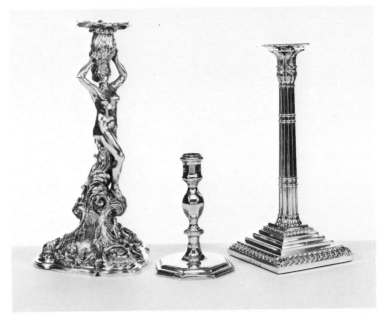

187. Cast silver candlesticks: (left) Diana, after a design by G. M. Moser, unmarked, c. 1750; (centre) cast and faceted, by Thomas Farren, 1718; (right) neo-classical style by Ebenezer Coker, 1770. London, Victoria and Albert Museum

188. Tea canister, by Isaac Liger; engraver probably Simon Gribelin. Silver-gilt, engraved with animals in foliage and the arms of the Earl of Warrington. London, 1706. London, Victoria and Albert Museum

186. Caster, by Paul de Lamerie. Silver, with cast applied interlacing in Régence style. London, 1734. London, Victoria and Albert Museum

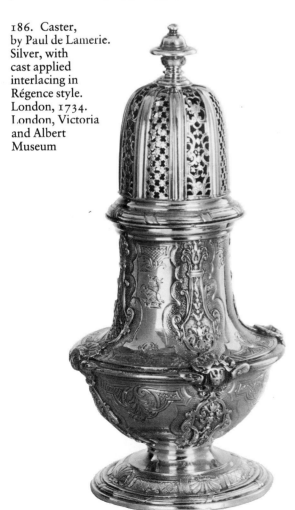

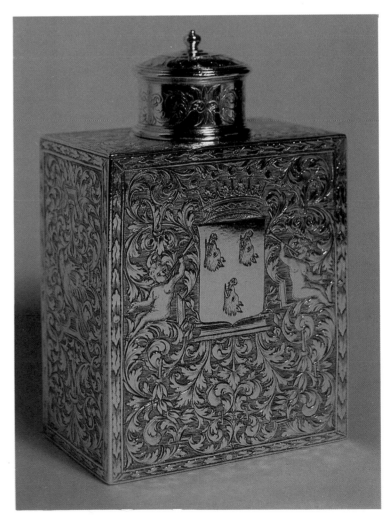

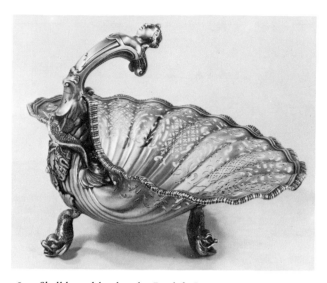

189. Shell bread-basket, by Paul de Lamerie.
Silver with cast border and dolphin feet, and pierced body.
London, 1747. Oxford, Ashmolean Museum

The name originated in 'rocaille' or shellwork; some of the most successful pieces use cast and realistic crab, fish and shells appropriately on tureens for fish soup and on sauce-boats. Paul Crespin, Paul de Lamerie and the German Charles Kandler were the most interesting and inventive exponents of this undulating, writhing style; their most satisfying work appeared as individual items in the decade after 1735 when fashionable clients were anxious to equip their tables with silver in 'an entire new taste'. The swirling movement is not confined to the applied vines, insects or marine motifs but is integral to the form so that even feet are shaped, as if lifting or turning (Fig. 189). Later the style became an anglicized pot-pourri of exotic ingredients, with certain standard elements considered peculiarly appropriate to the service of tea and coffee, such as embossed chinoiseries.

We are fortunate in being able to observe the workings of one Georgian goldsmith's business: the ledgers of George Wickes (1698–1761), goldsmith to Frederick Louis, Prince of Wales, were discovered in the 1950s, along with the records of Parker and Wakelin and their successors in business. Much of Wickes's business was in repairing or 'boiling and burnishing' old plate, renewing engraved armorials, and making to match earlier items. He also hired out plate for large dinners (borrowing from colleagues) and sometimes, for a special commission, made up orders with existing old stock from another workshop. Of the distinctive serpent-handed cup and salver supplied to the prince for presentation to the City of Bath in 1739, the salver had been made by

Louis Pantin in 1733 and the pair were only married together by engraving the armorials of the prince and the city on each. Wickes's account book demonstrates that the usual source of metal for a goldsmith was old plate brought in by the customer; this, rather than civil wars or taxation, is the reason why, relatively speaking, so little antique plate survives. The prince, needing a new dinner service, gathered up old plate from the royal household for delivery to Wickes; his secretary Colonel Pelham, anxious to commemorate his appointment by commissioning a gold cup, produced 58 ounces of metal in the form of gold boxes, no doubt accumulated gifts. He was therefore charged only for the cost of 'fashion'. If a client wanted a particular design, he specified it, but the bulk of sales were of stock items, personalized only by the client's armorials.

A large commission, such as the 220-piece dinner service made for the Duke of Leinster between 1745 and 1747, might take a couple of years to complete, the pace dictated by both the client's financial resources and the workmen's other commitments. Such large sets of tableware rarely survive; but in the case of the Leinster set, we have not only the service but a fully itemized bill, and so even unusual items such as condiment urns and shells for oysters, for example, can be firmly identified. Of the centrepiece or épergne Leinster purchased, only the charming pergola and its 'plateau' or stand remain. Such elaborate creations, with a series of baskets for dessert, were an essential feature of the rococo dining-table, and were another refinement introduced from France about 1720; they sometimes incorporated casters, sauce bottles, and salt-cellars also. When a client demanded something elaborate in the latest rococo style, Wickes submitted specimen designs or even lead castings before the commission was finalized, charging separately for this work.

One characteristic of later English rococo silver is that ornament, embossed or engraved, meanders around the body of the piece, encroaching on a central panel of plain silver which itself is broken by an elaborate armorial cartouche, set off-centre and balancing, as it were, on one toe. While the technical skill of many mid-eighteenth-century goldsmiths is undeniable, the style had become stereotyped by the 1760s and was rapidly supplanted, not only in the fashionable world but across a far wider range of purchasers.

The new style, neo-classicism, swept through all branches of the decorative arts; Greek and Roman forms were copied exactly from archaeological publications, such as *The Ruins of Palmyra* (1753) and

Robert Adam's *Palace of Diocletian* (1764). In this conscious attempt to create the perfect style in 'the beautiful spirit of Antiquity', the Adam brothers were the leading proponents, combining in their successful design business both influential private commissions and designs widely copied in silver, ormolu and ironwork. Their aristocratic patrons required totally consistent interiors, down to the plate in the dining-room. Some even modified their existing tableware in line with the most recently published evidence on Greek vases, as at Kedleston where in 1771 Viscount Scarsdale supplemented his largely Phillips Garden service with sets of condiment vases by Louisa Courtauld and George Cowles. These were directly copied from a Greek urn in D'Hancarville's *Collection of Antiquities ... of Wm Hamilton* (1766–7), with the anthemium border and distinctive engraved figures of deities amalgamated from several other plates in the book.

For the first time a style that had evolved in England swept Europe; the classical urn, although ceramic in origin, lent itself to translation into metal, and goldsmiths were quick to adapt it to sauce-boats, coffee-pots, race-cups, caddies, and even tureens. Motifs from archaeological pattern-books were combined particularly successfully by John Schofield in candlesticks and cruet frames. The Courtauld workshop excelled in vases and coffee-pots in which cast plaques or applied ribbons and swags contrasted with plain burnished or matt surfaces.

Variations of the new style were to become effectively universal for the sixty years or so after 1760, since those who could not afford silver could now be supplied with an identical but cheaper version, in fused plate. The plating technique, attributed to Thomas Boulsover about 1742, stimulated large-scale production of cheap tableware in both Sheffield and Birmingham. The innovating Soho Manufactory of Boulton and Fothergill also made high-quality silverware, notably to designs by James Wyatt which embody lighter post-Adam classicism; Boulton's technical innovations, such as the use of the swage block to produce silver ribbons to strengthen hollow-ware, and his improved drawbench producing extruded wire for open-work baskets, ensured the continuing competitiveness of Birmingham-made silver (Fig. 190).

Another innovation drawn from the silver-plating process, die-stamping, speeded up the production of silver candlesticks. Components in various shapes were stamped out from sheet silver and assembled to create a range of designs at low cost; the lightness of the sheet metal was compensated for by a core of

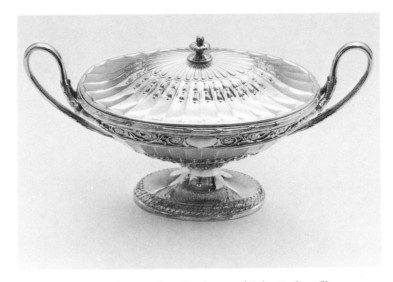

190. Sauce tureen, by Matthew Boulton and John Fothergill, to a design by James Wyatt. Silver, with cast applied ornament. Birmingham, 1776. London, Victoria and Albert Museum

resin. Birmingham became noted for small silver-wares from about 1800; die-stamping and engine-turning enabled distinctive vinaigrettes, snuffboxes and caddy spoons to be cheaply made and finished in large numbers.

Through much of the last century, educated taste continued to prefer historically-based designs, with a strong swing towards naturalism from the 1830s. A further archaeological pattern-book, Charles Tatham's *Designs for Ornamental Plate* (1806), lamented the loss of massiveness and the light bright quality of contemporary neo-classical silver. Rundell, Bridge and Rundell, royal goldsmiths until about 1842, induced the sculptor John Flaxman to produce designs; plate supplied to the Prince Regent, the Earl of Ormonde and the Duke of Wellington (now at Apsley House) shows the successful outcome. Their Greenwich and Soho workshops were headed by two extremely skilled goldsmiths, Benjamin Smith and Paul Storr, each of whom subsequently set up on his own. Many Rundell designs were produced by both men. The 1820s saw a revived demand for rococo plate. Rundells and Garrards produced amalgams of old designs relying heavily on reproducing natural forms such as shells, flowers, and crabs. Many owners had earlier plain pieces heavily embossed in the rococo manner, to the confusion of collectors.

Although early commissions for Gothic plate, inspired by Augustus Pugin's campaign to revive the style, were largely confined to church plate, medievalism was popular for domestic plate too by 1862.

The techniques of gemsetting and enamelling were

revived by the Medieval Metalworkers. The outburst of church building and refurnishing from the 1840s brought a steady flow of orders for 'medieval' plate to two firms, John Hardman of Birmingham (Pugin's manufacturer) and John Keith of London; church plate was often made up from designs by architects such as Butterfield and Street.

From the mid-nineteenth century the basis for studying decorative art changes drastically. From exhibition catalogues, the *Illustrated London News*, and illustrated price lists, we can assess what was regarded as fashionable, significant, or likely to be successful commercially, so we are no longer dependent on the chances of survival.

The Great Exhibition of 1851 exposed the jumble of current styles (Fig. 191); the anxious search for that fluid concept 'good design' was stimulated by further exhibitions and by the conscious use of French virtuoso craftsmen such as Elkington's Emile Jeannest and Hunt and Roskell's Antoine Vechte. Such heavily chased and embossed masterpieces as H. H. Armstead's shield, shown at the 1862 exhibition, had little visible influence on the firm's domestic plate but enhanced its standing.

The electroplating process patented by Elkingtons of Birmingham in 1840 was to kill the Sheffield plate industry. It quite reversed the older plating process, in which hand-finishing and applied silver borders were a crucial final stage. Once a perfect initial cast existed, often modelled by a sculptor, pieces silvered by the new plating process required only a final polish and could of course be replated as the silver coating wore away. The process itself was cheaper, as was the base material; instead of pure copper, a cheaper alloy called German silver or nickel silver was introduced about 1834, with the advantage that its greyish surface merged well with silver and did not glow through, in the manner of worn Sheffield plate.

Elkingtons dominated the silver trade for many years; they were quick to respond to the fascination with Japanese ornament promoted by the International Exhibitions in London in 1862 and Paris in 1867. Bamboo handles, fan-shaped trays, and etched japonnaiseries were the distinctive features of the fashion, which had great commercial success.

A certain lifeless historicism characterized much silver designed after 1860; although the most florid 'Louis Quatorze' styles were no longer fashionable, plate in the style of almost every period from the late Middle Ages was available. Relief from this repetition came with the designs of the botanist Christopher Dresser (1834–1904), an exponent of the Henry Cole attitude to industrial design; he produced, for Frederick Elkington, James Dixon of Sheffield, and other firms, functional plain – almost geometric – shapes, sometimes with such overtly Japanese features as ebony handles. Further design innovations were due to the Arts and Crafts Movement, which encouraged admiration for the 'handmade' look. Several artist-designers ran classes in London and Birmingham for amateurs to learn goldsmithing techniques. Charles Ashbee's Guild and School of Handicraft (est. 1888) was the most influential (Fig. 192). The commercial success of Liberty's 'Cymric' silver was due to their successful fusing of elements from Celtic plate with a hand-finished look, with industrial production methods.

The handcraft tradition, revived a century ago in revolt against the impoverishment of commercial plate, and expressed most markedly by Omar Ramsden (1873–1939), continues to flourish in Britain. Stimulated by the colleges of art and design the practice of the craft has refined into a healthy balance between innovatory design and technical competence. Successful craftsmen designers such as Gerald Benney and Leslie Durbin have, with encouragement

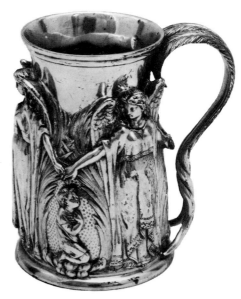

LEFT
191. Christening mug, by S. H. and D. Gass. Designed by Richard Redgrave for the Summerly Art Manufacturers and shown at the Great Exhibition of 1851. Silver. London, 1849. London, Victoria and Albert Museum

RIGHT
192. Bowl, by the Guild of Handicraft, to a design by C. R. Ashbee. Silver, embossed and chased with a leaf design; the legs are cast. London, c. 1893. London, Victoria and Albert Museum

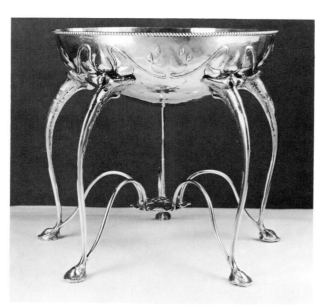

from Goldsmiths' Hall, attracted commissions from around the world. Since few private individuals today have the means or the will to commission silver their major patrons are corporate bodies needing ceremonial plate. Many institutions regard provocative non-traditional silver as a touchstone of their forward-looking attitudes; some of the finest English contemporary silver is to be seen on cathedral altars, in college halls or in company boardrooms.

Hallmarking

The hallmarking system is so-called because the Wardens of the Goldsmiths' Company of London have since 1478 had the duty of assaying and marking at the Hall all London-made silver. Although it is often claimed that the English originated the silver marking system, the three quality control marks introduced between 1300 and 1478 – sterling mark, maker's mark and date letter system – were taken from current French practice.

From 1300 the first official mark, the leopard's head or King's mark, was to be punched on all worked plate to demonstrate that it was of sterling standard, and of the same silver content as the coinage (92.5 per cent, or eleven ounces two pennyweights in twelve ounces Troy, the silver being alloyed with copper for strength).

The first mention of maker's marks came in 1343, but regulations were enforced with only partial success. In 1478 the Company introduced a system of annual date letters, so that any marked but substandard piece could be traced back. Since 1660 the annual cycle has started on 29 May, the day of Charles II's return to London from exile.

The sterling standard for wrought plate was retained until 1697. Alarmed by the post-Restoration demand for silver, which was believed to draw vast quantities of coin into the goldsmiths' shops, and by the poor condition of the coinage, the Mint then introduced new milled coins (to prevent clipping) and raised the silver content of plate to 95.8 per cent. This was known as the Britannia standard, since the two new marks, one a seated figure of Britannia, and the other a lion's head erased, replaced the leopard's head and lion passant. Also each goldsmith had to register a new mark at the Hall, consisting of the first two letters of his surname; the earliest surviving registers of marks date from 1697. Between 1720 and 1757 the government imposed a duty of sixpence per ounce on wrought plate, to be paid at the time of hallmarking. To save their clients the cost of the duty,

goldsmiths sometimes struck the base with the maker's punch only, setting out four impressions so that to a casual glance it appeared to have been hallmarked. Alternatively, where an exceptionally heavy piece was due for marking, the goldsmith cut out marks from a small item already submitted for assay and inserted this plate of silver in the base of the larger piece. These 'duty dodgers' are sometimes found with much earlier date letters.

In the later sixteenth century, recognizing the advantages of corporate status, several towns introduced marks. In 1565 the demand for church plate stimulated Norwich goldsmiths to form a company and to initiate a (short-lived) date letter system and a town mark. The York date letter system started earlier, in 1559; Exeter also started a town mark and date letter system from 1575. Other towns, where one or two goldsmiths worked, had no mark; particularly in the West Country, spoonmakers often marked their wares with a maker's stamp only. Chester, as one of the mint towns where an assay office was re-established after 1700/1, assayed plate from Birmingham, especially from the Silver Manufactory of Matthew Boulton and John Fothergill. Die-stamped silver, mass produced in Sheffield, was brought to London for hallmarking and retail, to the disadvantage of the Sheffield industry; in response Matthew Boulton campaigned successfully for two new assay offices to be set up at Birmingham and Sheffield, in 1773.

During the last hundred years or so all the English assay offices outside London except these two have closed. The Birmingham office now deals with more than a third of English wrought plate annually. Since 1975 platinum has been treated as a precious metal, and stamped at assay with its own orb and cross mark.

With the emergence of collectors during the last century, and a more general understanding of the hallmarking system, has come a great reliance on marks as a means of attributing and dating antique plate. Legible hallmarks greatly enhance the market value of a piece; simultaneously the temptation has grown to 'improve' an unmarked but genuine item, either by transposing marks from something else or by marking with false punches, cast from an original piece. Fortunately, such falsely marked pieces are relatively rare; the Assay Office at Goldsmiths' Hall and the Antique Plate Committee regularly assess silver believed to have contravened the hallmarking regulations.

16

Furniture

GEOFFREY BEARD

ONE of the leading achievements within the wide range of the British decorative arts has been the creation of fine furniture of surpassing quality. Furniture-makers, particularly those active in London in the eighteenth century, were possessed of extraordinary technical skills. What they fashioned, often in imported woods such as mahogany, had an innovative capacity and attention to detail beyond the reach of most foreign competitors. Their craft was based on a repertory of robust forms, skilful adaptations of engraved designs, and a thorough and proved system of training by apprenticeship, a process which achieved England's acknowledged superiority in furniture-making from the time of Charles II's restoration to the throne. On 31 May 1660 the diarist Samuel Pepys wrote 'this day the month ends ... and all the world in a merry mood because of the King's coming'. The change was welcome, the mood joyous, even if the furniture trades did have to contend with foreign influences on what they made. English (and French) makers led Europe, and much of what they created was to act as a later inspiration to makers in Boston and Philadelphia, as the earlier indigenous forms of English oak furniture had done throughout the Americas (see *North America: The British Legacy*, p. 266 ff.)

In charting what was essentially characteristic of furniture-making in the British Isles the persistent intervention of foreign artisans has to be considered. The Royalist exiles had endured lack of money and possessions and only saw a rising hope of return to England when Cromwell died in 1658. They had always sought out luxury, and saw it constantly in the manners and actions of the court of Louis XIV. The Great Fire of London (1665) in its flickering selectivity destroyed considerable quantities of sound oak furniture in the ravage of some 10,000 dwelling houses. There was a chance for change and renewal. The diarist John Evelyn noted that the ancient trades of joiner and cabinet-maker, who before were 'vulgar

and pitiful artists', were now emerging to produce works 'as curious for the fiting, and admirable for their dexterity in contriving, as any we meet with abroad'. Most of it was in walnut, and fashioned in a different character from the heavy baulks of oak (Fig. 193). The arrival of French and Dutch immigrants, fleeing from religious persecution, made a further contribution, for they brought with them elaborate floral marquetry skills, by which slivers of wood, some stained to different colours, were inlaid over a contrasting wood background. Learning from the Dutch, the English makers produced patterns more complex and elaborate, and ranged farther in their search for coloured and unusual woods, particularly those from the East and West Indies. England had a

193. Centre or games table. Walnut, top inlaid with parquetry of various woods. *c.* 1580. Chesterfield, Hardwick Hall

unique setting in its country houses and City Company Halls for such exotic creations, and patrons were busy shaking away the restrictive repercussions of the Civil War. And, as Sir Roger Pratt noted in 1660, if for this rebuilding 'you are not able to handsomely contrive it yourself, get some ingenious gentleman who has seen much of that kind abroad ... to do it for you'. These knowledgeable gentlemen had to direct many of lesser accomplishments.

The apprenticeship system by which all craftsmen trained had been set out in the early years of Elizabeth I's reign. Having sought out a suitable master, the parents of an intended apprentice paid an apprenticeship premium, were issued with an indenture setting out the conditions of training, and the boy or girl moved into the family circle. It was hoped that, during their seven years of training, they would not only be taught their master's trade, but be set an example of good workmanship. They assisted on commissions, and as they progressed in ability and knowledge in the several branches of their 'mystery', they were entrusted with more specialized tasks. When the apprenticeship was finished, the test work undertaken was examined carefully by representatives of the Livery Company – many furniture-makers belonged to the London Joiners' Company – and if no one objected at three subsequent 'callings', the apprentice was sworn in as a freeman of his guild. It was perhaps a failure of the method of training that guild members were ill-equipped for competition from foreign craftsmen. Sir Christopher Wren had indicated in 1694 what he felt was a fundamental weakness in English training. Writing to the Treasurer of Christ's Hospital he noted: '... our English artists are dull enough at inventions but when once a foreigne pattern is sett, they imitate soe well that commonly they exceed the originall ... this shows that our Natives want not a Genius but education ... in designing or drawing ...'

Wren's words were heeded by the school at least – it appointed a drawing master. The foundation of drawing academies early in the eighteenth century, increasing travel abroad by architects, by patrons, and by some craftsmen, and the import, from about 1724, of mahogany allowed the furniture trades to develop rapidly. They also made use of technical improvements to the machinery needed to saw their wood. While a machine had been invented in 1629 for cutting timber into plank or board and other squares, machinery for cutting timber generally belongs to the period when steam-power replaced the waterwheel, with two further exceptions: in 1683 John Booth invented an engine for sawing timber,

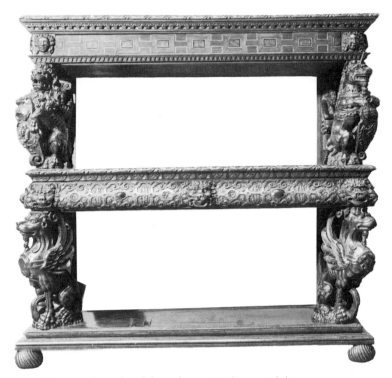

194. Court cupboard, sideboard type. Walnut, with lion and gryphon supports. An early example, dated 1606. Oxford, Ashmolean Museum

and in 1703 George Sorocold a horse- or water-powered sawing machine. There were also early seventeenth-century engines for cutting thin veneers, which enabled the floral marquetry and furniture embellishment trades to flourish. The last half of the eighteenth century consolidated this progress. Several developments in woodworking machinery occurred – machines for planing and fluting, for making joints, and for grooving and tonguing floorboards and panels.

In the late seventeenth century, as we have noted, walnut was the most popular wood for furniture, and its lavish use encouraged the seeking of further supplies from Virginia and from France. A great deal was available in England, however, and led to a splendid period of furnishing activity (Fig. 194) with its use both in the solid or as a veneer. The wood has an attractive and rich figuring in its grain, especially when cut at an oblique angle into thin sections. These were arranged to form a flat pattern of 'oyster shell' veneers in elaborate geometric patterns. Chairs in the Carolean period were also usually of walnut or beech with backs and seats of caning set into turned uprights. They competed with the important groups of 'Turkey work' or other upholstered chairs and gradually replaced the use of velvet fabrics and

The Impact
of the East

GEOFFREY BEARD

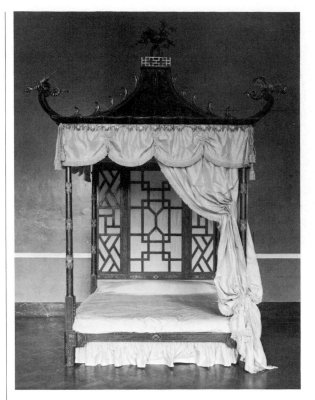

UNTIL about 1685 the Dutch East Indies Company served to provide Europe with a variety of oriental imports – particularly lacquered cabinets. Such cabinets had been imported into Britain since the days of Elizabeth I with the term 'Indian' applied indiscriminately. What English makers were able to do was to apply the skill of the carver and provide stands and crestings of carved wood – often pine – covered with a paste of size and whitening (gesso) which was then incised with pattern, and gilded or silvered (Fig. 2).

So long as trading vessels brought home an infinite variety of lacquered goods the demand was insatiable. There were basically two kinds: Coromandel lacquer decorated in colours, and lacquer with a one-colour ground and raised gilt decoration. But inevitably demand soon outstripped supply, and most lacquer furniture in Britain became entirely of home manufacture. The Eastern lacquer, 'a sort of gummy juice', was applied in several coats, each being given time to dry. Captain William Dampier, who had observed the process in travels to the Orient he made in 1688, wrote: 'It grows blackish of itself, when exposed to the Air; but the Colour is heightened by Oil and other ingredients . . . when the outside Coat is dry, they polish it to bring it to a gloss . . .' This shellac was unobtainable in the West.

The European substitute which demand produced was fashioned by less elaborate methods with the carcase wood being overlaid with varnishes of black, red, chestnut, blue, or olive (Figs. 3 and 4). The raised decoration depicting animals, figures, trees, and buildings was accomplished by applying a paste of gum arabic, sawdust, and whitening with a rush pencil and then colouring, gilding with metal dusts, and polishing. Lacquering

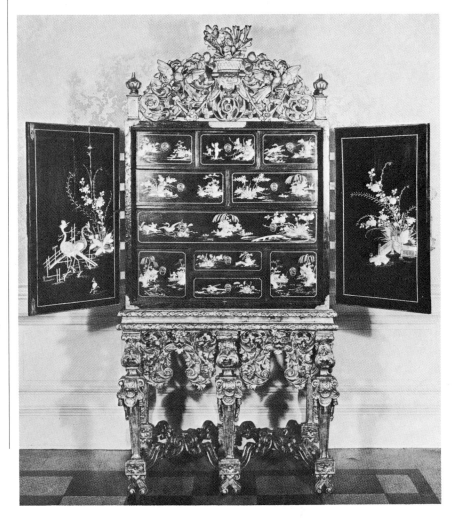

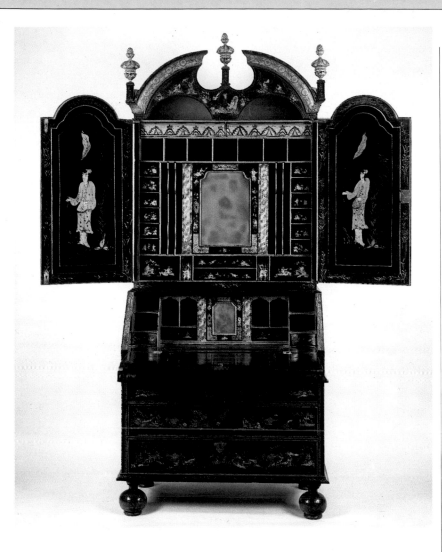

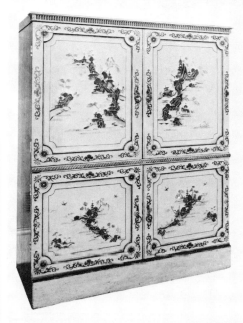

now became a pastime and a fashionable attainment.

Towards 1730 in England japanned work lost most of its appeal and character, but the fashion was revived about 1750 by eminent makers like Thomas Chippendale. Lacquered furniture in the 'Chinese taste' was provided for use in bedrooms (Figs. 1 and 5), set against coloured Chinese wallpapers. French engravers such as Pillement provided hundreds of patterns which furniture makers and ceramic modellers plundered. The issue of over 1500 of these engraved plates as *The Ladies' Amusement or Whole Art of Japanning Made Easy* was an invaluable crib, and the process was refined by having only one coat of varnish in place of the lavish preparations of earlier days. The art persisted into the early nineteenth century, giving artefacts of lasting curiosity.

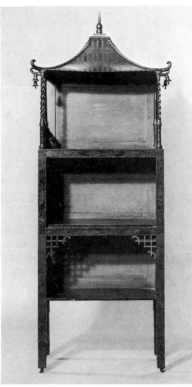

leather. The turner was making a considerable contribution to furniture-making from the 1660s, and Richard Price, who provided walnut chairs to the Crown in 1681–3, noted in his account that they were 'turned of the Dutch turning'.

The demands of a household, the introduction of a fashion (such as tea-drinking), or the arrival of a new king or queen from abroad (as with William and Mary), led to subtle changes in furniture style and purpose. After William's accession to the throne in 1688, many Dutch cabinet-makers came to England and worked for such imperious patrons as the first Duke of Lauderdale, not only the king's minister in Scotland, but the builder of Ham House on the banks of the Thames, near London. The diarist Evelyn noted in August 1678 that Ham House was furnished 'like a great Prince's', and the activities of cabinet-makers such as Gerreit Jensen enriched not only the duke's houses but the king's residences at Hampton Court and Kensington Palace, which he, and his queen, much preferred to Whitehall. The Ham House inventories of the late 1670s and early 1680s show that the furniture was largely made of walnut and cedar, with 'Indian' screens, boxes and panels, set amid damask and gilded leather hangings, and surmounted and flanked by paintings in gilt frames.

The Queen's Bedchamber at Ham House epitomizes the lavish nature of English interior decoration in the 1670s (the room was completed in 1673). The contemporary visitor would be faced by a great State Bed standing on a raised dais at the far end of the room, and resplendent as a creation of 'cloth of tissue in gold and blue' – that is, a cloth of gold with blue velvet flowers. Such a rich and elaborate bed was expensive to make and furnish and was provided with protective cases of shot blue taffeta – the beds and hangings were, however, changed for summer and winter use. The chairs, noted in each of the three inventories, were covered to match the fabrics on the various beds they accompanied, with protective covers of green velvet to set by the fourth bed the room had housed within five years. Finally the floor itself was made in a style worthy of the finest cabinet-work. It was given a complex pattern of cedar inlaid with walnut on the raised dais, and interlaced strapwork motifs in parquetry, with the combined ciphers of the duke and duchess under a coronet set into ovals flanking a central rectangle.

At the start of King William's reign the custom of joiners producing most seat furniture was replaced by makers who specialized in its manufacture. But despite the strong Dutch emphasis, the ruling canons

of taste were still dictated by France. When the Edict of Nantes granting religious toleration was revoked in France in 1685 Huguenot craftsmen had left hurriedly for Holland and England. One of the most talented and successful, Daniel Marot, was summoned to attend Queen Mary in 1694, and made at least three more visits to London from Holland in the following ten years. He became the focal point of a group of Anglo-French and Anglo-Dutch cabinet-makers and upholsterers active in London. His engraved designs, masterly baroque exercises of great flamboyance, were published in 1702, and makers such as Jensen provided many pieces to the Royal Wardrobe in his style. His walnut was ornamented with pewter, or by brass inlays set into tortoiseshell, and his 'seaweed marquetry' was done in many contrasting coloured woods, owing as much to filigree metal patterns as to those suitable for furniture. These talented foreigners, given asylum in London, also enriched the State Beds found in most grand houses (Fig. 195). With names like Lapierre, Dufresnoy, Casbert or Poitevin listed in the accounts, it was to be expected that the elaborate carved components of tester and bed-head were covered with glued-on damasks, and fringed, silk-corded and tasselled to a riot of decoration. They provided the climax, as at Ham, Dyrham or Knole, to the baroque progression through state apartments – a parade of exact precedence and unrivalled richness set out in an enfilade of high, dark and dramatic rooms.

The luxurious nature of furniture of the late seventeenth century, well characterized by State Beds, has a further exemplar in the upholstered Day-Beds. A settee and day-bed (Fig. 196) supplied to the first Duke of Leeds by Philip Guibert some time after the duke's creation in 1694 (probably about 1700–5) is made of beech, painted black with gilt carvings, and covered in Genoese cut-velvet, with a floral and arabesque pattern in crimson, green and cinnamon on a dark-cream satin ground, edged with tasselled fringes. Guibert had worked for the Crown at Windsor Castle and Kensington Palace in 1697–8, and his London workshop obviously specialized in lavish upholstered suites, possibly made to designs by Marot. At the same time the patterns of form and construction which formed the basic designs for furniture in the following years was set out. These included writing bureaux, some with upper sections fitted as bookcases, pedestal desks or dressing tables. The main features of this walnut furniture and the lacquered versions were the flat surfaces and rectangular form: serpentine and recessed fronts were left to French makers.

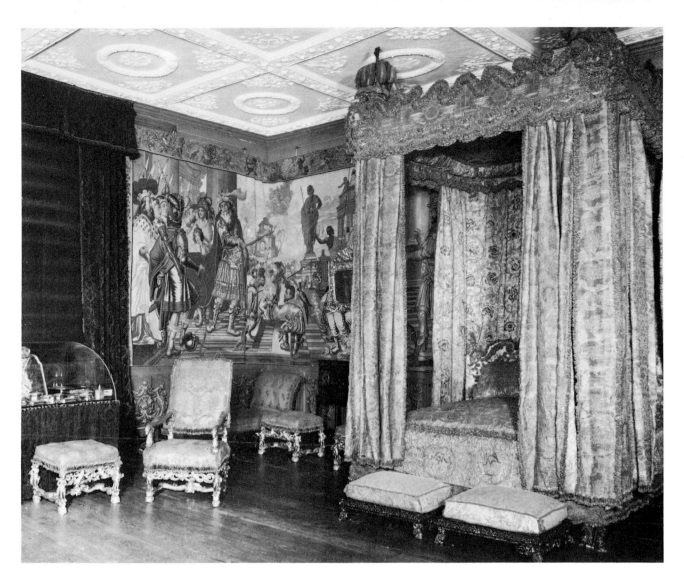

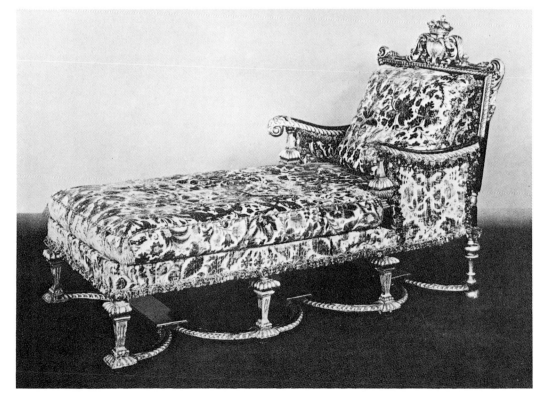

ABOVE

195. State bed, the tester
bears the royal insignia
of James II.
Probably by Thomas Roberts.
Upholstered in green
and gold velvet. *c.* 1688.
Sevenoaks, Knole House

196. Day-bed, probably
by Philip Guibert,
made for 1st Duke of Leeds.
Beech, painted black
with gilt enrichment,
upholstered in Genoese
cut-velvet. *c.* 1700–5.
Leeds, Temple Newsam House

By 1700 London was a growing commercial and manufacturing centre having both the court and the seat of government within its bounds. It was wealthy, and craftsmen were attracted to settle there because of the high wages and the availability of luxury and consumer trades, including furniture-making. The forms of furniture established in the late seventeenth century were retained in the reign of Queen Anne (1702–14) but under George I (1714–27) considerable change occurred. Perhaps the two most important factors which aided change were the import in increasing quantities of mahogany, and a growing interest in the architectural form of interiors and furniture. In whatever way, and at whatever cost, the timber arrived, and apart from its many building uses was the stock-in-trade of the cabinet-maker. In

1700 alone some 240 ships arrived in Bristol, some carrying cedar planking from South Carolina. The trade with Scandinavia through Hull was also very active, but it was the use of Spanish mahogany which gave impetus to the making of fine furniture. Introduced into England about 1724, it was imported from Cuba, Jamaica, Hispaniola, and San Domingo. It was held to be superior to Honduras mahogany, which, however, held with glue better than any other wood and was popular with the cabinet-makers as well as the general building trades.

The introduction of gilded plaster or *gesso* allowed architectural forms of furniture to be covered with stamped ornament. Complex patterns were punched into the surface while wet. Being both novel and easier to create, such furniture gradually replaced the

197. Chair for the Derbyshire house of Nicholas, 4th Earl of Scarsdale. Walnut, gilt metal and *verre églomisé* mounted. *c.* 1724

198. Side table (with detail), probably by Matthias Lock. One of a pair, pine, painted white with gilt enrichment. *c.* 1740. Leeds, Temple Newsam House

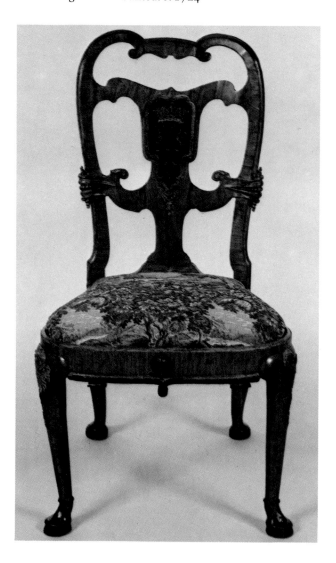

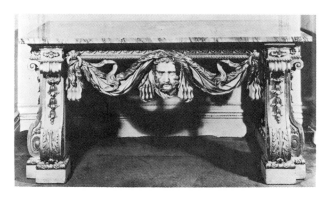

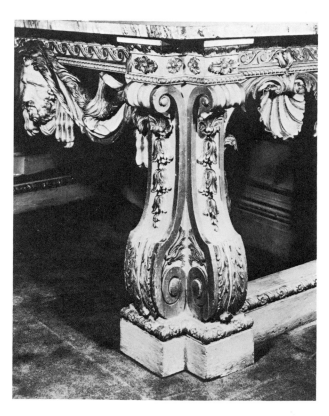

marquetry pieces which, whilst fashionable, were time-consuming to make. This swing in taste matched the important patronage which was extended by a group of early eighteenth-century noblemen, and in particular the Earls of Burlington, Leicester, Pembroke, Bathurst, and Oxford – the 'Earls of Creation' as they have been titled. Rebelling against French baroque and supporting Italian classicism they encouraged not only the gifted architect-painter William Kent (1685–1748), but a host of cabinet-makers of the calibre of Benjamin Goodison and Matthias Lock (Fig. 198 and detail) for whom Kent prepared designs. They made this flamboyant gilded 'William Kent' furniture incorporating giant shells, bracket supports in the form of lions' masks, and heavy garlands of simulated fruit and flowers. It

was Italian baroque in character, invested with an English attention to detail in the gilding and architectural ornament. Candlestands were riots of gilded caryatids holding baskets on their heads, chairs and settees were heavy with gilded nailing and cut-velvet upholstery. All were set before opulent pier-glasses made at the glass manufactories which the second Duke of Buckingham had set up at Vauxhall. When John Evelyn went there in September 1676 he recorded that he saw 'looking glasses far larger and better than any that come from Venice'. Vauxhall continued as the main supplier of mirror plates for most of the eighteenth century, overcoming the threat of imports from Venice and France.

The gilded riches of English Palladian-style furniture – Lord Burlington and William Kent had revived

199. Cabinet on stand. Chinese style, doors veneered with amboyna, and with different woods for each drawer front. *c.* 1755. Port Sunlight, Lady Lever Art Gallery

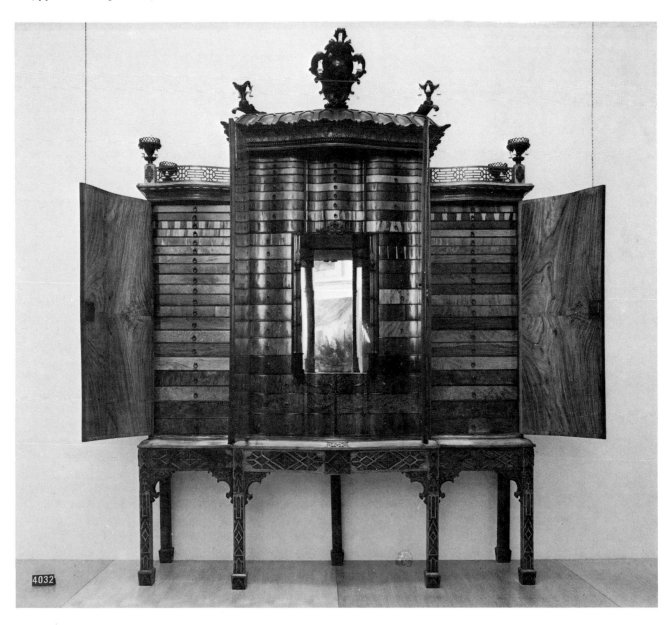

interest in the drawings and ideas of the sixteenth-century Italian architect Andrea Palladio and encouraged adaptations of what he did – gave way to furniture of more restrained architectural form made in dark, straight-grained mahogany (Fig. 201). It needed less surface ornamentation, carved well, was resistant to wood-boring insects, and complemented

200. Cabinet on stand, probably by John Channon. Mahogany, with inlaid brass and ormolu mounts. *c.* 1740. London, Victoria and Albert Museum

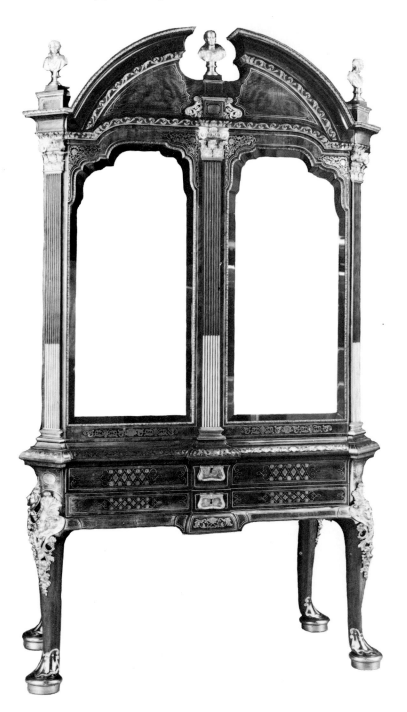

the rich fabrics used in upholstery. The adherence to pattern-books was strong and the most original adapters of the French rococo style were the cabinet-makers who bought up the new books eagerly. In 1736 Gaetano Brunetti published *Sixty Different Sorts of Ornament* in which the engraved plates show contorted shell-work suitable for furniture embellishment. Other books followed with titles such as *Six Tables* (1746) and *A New Book of Ornaments* (1752). Whilst some of the authors were ruthless exploiters of the ideas of others, all were endeavouring to indicate useful motifs that were asymmetrical, balanced, and a blend of French and Chinese influences (Fig. 199). One who emerged as an innovative designer and maker with more than ordinary talent was the Yorkshireman, Thomas Chippendale (see pp. 218–9).

Chippendale's *Director* established his reputation but there were many almost as competent, and some who may be held to have exceeded his accomplishments (Fig. 200), who have remained lesser known. The study of English furniture must concern itself as much with the careers of the men who designed and made furniture as with what they made. Had William Vile, royal cabinet-maker to George II, and for a short time to George III, issued a pattern-book he, too, might have been as well known as his contemporary, Chippendale. Vile, who had trained under William Hallett, set up shop in St Martin's Lane – in 1750, a year or two prior to Chippendale. Within ten years, and aided by royal patronage, Vile produced some of his finest work. The jewel cabinet for Queen Charlotte (1761) or the bookcase (Fig. 201) for the 'Queen's House in the Park' (Buckingham House as the Palace was then called) are the most exceptional pieces of mahogany furniture ever made in England. The jewel cabinet was described in Vile's account as 'made of many different kinds of fine wood on a mahogany frame richly carved, the front, ends and top inlaid with ivory in compartments neatly engraved'. The two central doors of the lower part of the bookcase have rococo foliage roundels surrounding the Garter star. These 'ovals of laurels' are typical of Vile's work, and whilst much careless attribution has arisen because of their appearance on inferior pieces, their present usually denotes matchless quality. No other country at this point could produce such superb pieces of furniture – the contribution was a unique blend of training, materials and skills – and craftsmen from abroad were not slow to set up business here. One such was an immigrant French *ébéniste*, Pierre (or Peter) Langlois, born in Paris about 1738.

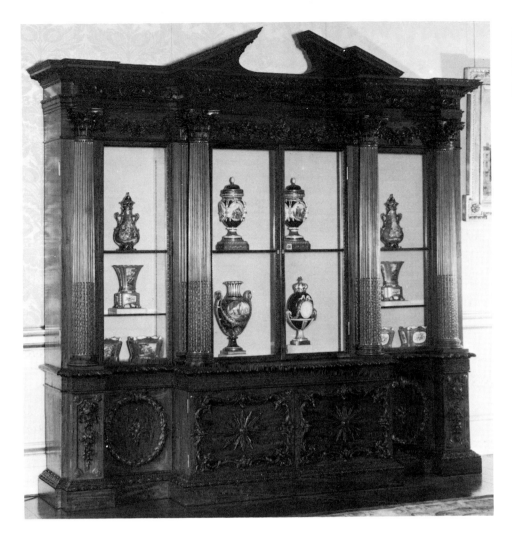

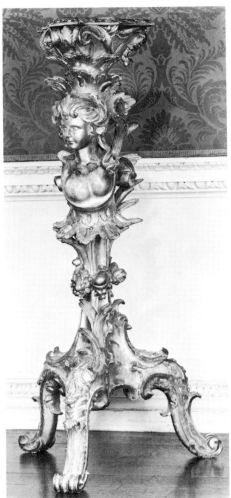

201. Bookcase by William Vile, made for Queen Charlotte.
Mahogany. 1762. Buckingham Palace.
By Gracious Permission of Her Majesty the Queen

202. Candlestand, one of four,
probably by Thomas Johnson.
Gilt pine. c. 1758. Leeds,
Temple Newsam House

Not much is known about Langlois's origins but he came to London in the late 1750s. There he issued a trade card when he set up business in Tottenham Court Road stating that he made 'all sorts of Fine Cabinets and Commodes, made and inlaid in the Politest manner with Brass & Tortoiseshell ...' His first known commission was for the fourth Duke of Bedford (1759) and suggests that by this time he had settled and established a London reputation. Commodes (which in this context implies a piece of furniture with drawers and shelves: a chest of drawers) were his speciality. They were created in bold *bombe* form. The doors had coloured marquetry inlays with flowers and trophies of musical instruments set against light-coloured veneered backgrounds; the tops were inlaid with brass or marquetry and laid over carcases of deal. The ormolu (gilded brass) mounts wreathing down the curved legs were presumably imported from France or cast from French examples.

Langlois, with the skills gained from his presumed apprenticeship to a Parisian *ébéniste*, and his ability to satisfy the tastes of English travellers who had ventured abroad, must have needed to employ many English craftsmen. As the 1760s progressed his style of marquetry became bolder and he was patronized by the demanding connoisseurs Horace Walpole and the first Duke of Northumberland. The high quality of his work remained constant, as it needed to do to equal or outpace his business rivals. The best of these realized the importance of issuing their own pattern-books ('choosing from the catalogue') or of being more secure in royal employment. Chippendale's seminal work, surrounded by a host of more minor offerings of engraved suites in six or eight parts, was almost equalled in 1759 by the first part of Ince and Mayhew's *Universal System of Household Furniture*.

William Ince and John Mayhew advertised their stock as Chippendale had done by issuing single

engraved sheets, and by April 1760 were able, through the *Gentleman's Magazine*, to 'return their utmost thanks for the kind reception their designs have met with'. They soon gathered three hundred of them into a large folio (1762) dedicated to the Duke of Marlborough, Lord Chamberlain to George III, and saw that the book was equipped with both English and French titles and notes to the plates. They were trying to widen their trading base – a characteristic of all successful entrepreneurs – and had a large stock to support their claims. Citation of it will show how far English makers had progressed in providing a complete service to their patrons. They divided their designs into those suitable for delivery after manufacture – the case furniture – and those needing subsequent embellishment in the carving shop. Bookcases, library tables, beds, organ cases, sofas, candlestands, were all drawn out, and there was a group of plates devoted to metalwork including grates, fire-dogs, and staircase railings. They had brought furniture-making out of a period of sentimental regard for the work of an individual craftsman, and turned it into 'a manufacture and a trade'.

The firm were concerned with many patrons, and with the ormolu productions of the Birmingham manufacturer, Matthew Boulton. They combined with him on one of the most important commissions undertaken by any eighteenth-century firm – a cabinet made in 1774–5 for the Duchess of Manchester. It shows English workmanship at its finest. The cabinet was made to house eleven marble intarsia panels which had been made in Florence in 1709, and had been acquired in the late 1760s by the duchess. Robert Adam provided the cabinet design, which 'consists of a series of mahogany panels veneered with satinwood and rosewood and richly inlaid with classical motifs'. Set on six legs, the capitals, beadings and leg mounts were created in ormolu and pinned over the satinwood, rosewood, and mahogany carcase and friezes. With borrowings from the temple of Aesculapius at Spalato (Adam had surveyed Diocletian's Palace there in the mid-1750s) the design was an important statement of inspiration dominated by classical sources.

It was a category of accomplishment in which English cabinet-makers excelled. They had to serve patrons who had seen the actual sites from which ornamental motifs were drawn, and who knew, as the first Duke of Northumberland did, when they had been 'ill executed'. The duke wrote to Robert Adam in 1766 that he would suffer 'nothing to be set up at Syon which is not finished to your entire satisfaction' – an early instance of control over quality, and one

which furniture-makers did their best to adhere to. Admittedly there were occasions when they disliked the architect's interference. Sir William Chambers, Adam's most accomplished rival, fancied himself, as he wrote in 1773, as 'a very pretty Connoisseur in furniture...' Lord Melbourne, his patron, was employing Chippendale to provide furniture for his London house, and argued with both about gilded ornaments. He wrote that he did not want any gilding on the furniture and Chambers was equally concerned to see that 'the dead coloured silk with which the sofas are to be covered must have gold to relieve it'.

Finally in this survey of cabinet-makers working in the Adam style, all of whom made a singular and typical English response to the craft of furniture production, we must reckon with William and John Linnell. William trained as a carver and set up in business about 1730. At his death in 1763 his son John, then aged 34, took over a well-established workshop and went on to become one of the leading makers and designers of furniture of the second half of the eighteenth century. He produced items of high quality and challenged in reputation other distinguished contemporaries – Chippendale, John Cobb (William Vile's partner and successor), and Ince and Mayhew. Over one thousand clients supported the Linnells' achievements: these included two royal dukes, at least ten dukes of slightly less exalted rank, some twenty earls, and many viscounts, barons, and baronets. One of these, the fourth Duke of Beaufort, gave them a commission for a magnificent bedroom suite in the Chinese taste. The bed, until recently attributed to Chippendale, has a canopy of pagoda form japanned in black and gold. Carved dragons in gilded wood are set upon the four corners, and the bedhead is of open fretwork japanned in red and gold. It had *en suite* eight armchairs, a dressing commode, and two pairs of standing shelves. The firm worked in several houses where Adam was retained as architect, and notably for Lord Scarsdale at Kedleston, and the banker Robert Child at Osterley (Fig. 203).

Whilst more evidence needs to be unearthed to establish the exact working relationship between Adam and the cabinet-makers, there is no doubt that the production of fine neo-classically styled furniture owed much to the ambitious architect and the patrons who accepted what he decreed. He was however designing for individual patrons, for specific rooms in their houses, and much that we regard as 'Adam furniture' was made by a wider group of craftsmen. Of these, George Hepplewhite's name has

endured and his pattern-book, *The Cabinet-Maker and Upholsterer's Guide*, became the most influential manual, with some 300 items therein. By 1794 it was in its third edition and had been calculated to appeal to 'Countrymen and Artizans, whose distance from the metropolis makes even an imperfect knowledge of its improvements acquired with much trouble and expence'.

Hepplewhite (?–1786), who had been apprenticed to the successful firm of cabinet-makers, Gillow of Lancaster, had established himself in London by 1760. He did not set out to strike any individual style, and the *Guide* merely illustrated modified Adamesque patterns. It allowed the makers in country towns to issue their own further modified forms, typified as in the 'Hepplewhite style', made of inlaid satinwood and embellished with popular motifs of the day – the Prince of Wales' feathers, wheat-ears, urns, and festoons of drapery and flowers. Many variants of the shield-back chair were illustrated, and after Thomas Sheraton had gibed that the 'designs, particularly the chairs' were not in 'the newest taste', the third edition contained both square-back chairs and many ornamented tapered chair and stool legs. The window stools, *confidantes* and *duchesses* (settees to which chairs were added at each end), sideboard tables, pedestals for urns, plate-warmers, knife cases, pier tables, wine tables, card tables, and knee-hole library tables were all available in mahogany, or more exotic woods. The secretaire bookcase in particular, with glazed doors to the upper stage and a writing flap hiding pigeon-holes and small drawers, became most popular. It was possible to vary the arrangement of the glazing bars to imply symmetry, or denote adherence to pointed Gothic or neo-classical styling.

When Sophie von la Roche visited George Seddon's workshop in Aldersgate Street, London, in 1786 she noted that he employed 'four hundred apprentices on any work connected with the making of household furniture ... In the basement mirrors are cast and cut. Some other department contains nothing but chairs, sofas and stools of every description, some quite simple, others exquisitely carved and all varieties of wood, and one large room is full up with all the finished articles in this line, while others are occupied by writing-tables, cupboards, chests of drawers, charmingly fashioned desks, chests, both large and small, work- and toilet-tables in all manner of wood and patterns, from the simplest and cheapest to the most elegant and expensive ...'

It has become fashionable, without good cause, to regard much furniture as made by Hepplewhite or by

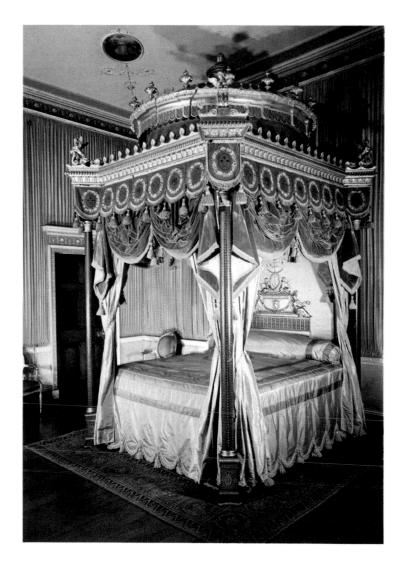

203. Bed, designed by Robert Adam for Robert Child. Painted and gilded pine. 1776. Osterley, Osterley Park

Thomas Sheraton (1751–1806), whereas both rested their reputations on books for others to use. Hepplewhite's *Guide* was popular, and Sheraton's *The Cabinet-Maker and Upholsterer's Drawing Book* was published in parts between 1791 and 1794 and contained 113 plates. It showed all the fashionable furniture available in the last decade of the eighteenth century, and over 600 makers, in London and far away in the country, subscribed to it. Much survives, variable in quality but including many pembroke tables which served both as breakfast table and lady's writing desk. Ingenious mechanisms allowed part of the upper structure of drawers and pigeon-holes to be pushed down to form one plane with the table-top itself.

Thomas Chippendale

GEOFFREY BEARD

Nostell and Harewood (Fig. 1), all three designed by Adam.

Chippendale's output in the last years of his life includes splendid pieces of marquetry furniture. The pier tables commissioned for various rooms at Harewood House (Fig. 2), together with the sumptuous 'Diana and Minerva' commode, might imply the employment of a specialist marquetry worker. London could provide the most accomplished craftsmen, sub-contracting their skills to established

IN 1754 Thomas Chippendale announced in his *Gentleman and Cabinet-Maker's Director* that the publication contained a 'large collection of the most Elegant and Useful Designs of Household Furniture in the Gothic, Chinese and Modern Taste'. It was a pattern-book, dedicated to his patron the Earl of Northumberland, and it made Chippendale's name. Following this success, he moved to fashionable premises in St Martin's Lane, where his firm was to remain. His 'Cabinet and Upholstery Warehouse', with a chair for its sign, was the storehouse for much in 'genteel taste' and much that was new and exotic.

The *Director* included sixty-four plates of Chinese-type furniture (Fig. 1), with lattice-work, domed beds with dragons, pagoda shapes, mandarins, and tinkling bells, and much furniture survives to illustrate the frivolous 'extravagances that daily appear under the name of Chinese'. The balancing-act of matching business survival to ruling fads was one of great concern to cabinet-makers. Chippendale had to reckon with incorporating rococo in its Chinese and Gothic Revival forms into his repertoire, and by the early 1760s to incorporate the neo-classical style to supply the patrons of the energetic architects (and rivals) Robert Adam and Sir William Chambers. Chippendale lacked the formal artistic education that these patrons enjoyed on the Grand Tour, so to have incorporated neo-classical furniture designs into the third edition (1762) of the *Director* is therefore the more remarkable. He was able over the next five years to submerge the sprite-like curves and flourishes of rococo within a fluent anthology of classical details (Figs. 3 and 5) – outstanding examples of his work are to be found at Newby,

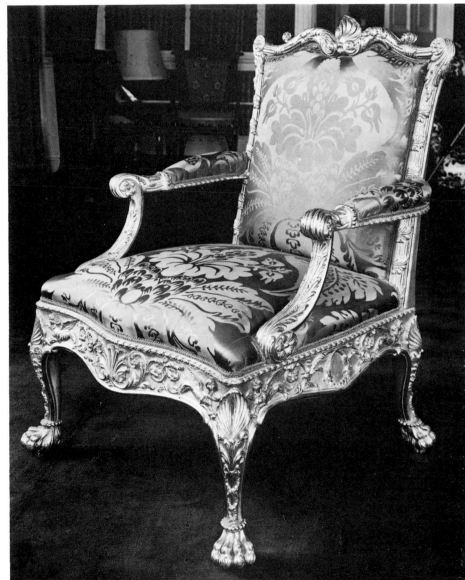

makers. The evidence in Chippendale's case is too sparse to permit firm conclusions. What is undeniable is that the finest masterpieces of English eighteenth-century furniture were produced by one who was well regarded by his contemporaries. Ince and Mayhew called him 'a very ingenious Artificer', Thomas Sheraton alluded in 1793 to Chippendale's 'extensive and masterly' work, and George Smith in 1828 pronounced him 'the most famous upholsterer and cabinet-maker of his day'.

By this time, in the 1790s, England had established an international reputation for the quality of inlaid furniture with multi-purpose uses. It was technically at its most accomplished, and whilst lacking the robust vigour and heavy ornament of earlier periods, led through to the English regency (Fig. 204), a style formed partly by strict observation of archaeological classicism. The fashion had been given impetus by regency designers imitating the symbols and motifs found in Greece, Rome, and Egypt. Greek and English cornices and the fulcrum type of bed and couch were well displayed in the early nineteenth-century pattern-books of Thomas Hope, George Smith, and others. These broke away from the Adam tradition of classically inspired ornament to suggest the making (in rosewood or mahogany) of furniture worthy of the Pharaohs. Massive, well-polished, and inlaid in precision with pierced brass frets, 'portions of leonine anatomy', or dominant sphinx or lion supports, the style lingered for only a few years before giving way to the crocketed finials, pointed arches, and polylobed friezes of the pseudo-Gothic style.

The outstanding representative of mid-eighteenth century interest in Gothic had been Horace Walpole. Descended from a great line of Norfolk landowners, he had decorated his own house, Strawberry Hill, to a point where it was difficult to discern what was an original fragment or one copied. It provided the exemplar others followed and in the early nineteenth

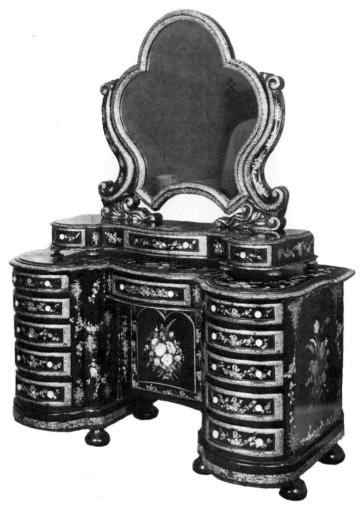

205. Dressing table, with swing mirror. Papier mâché. c. 1851. Leeds, Temple Newsam House

204. Sofa table. Rosewood and amboyna with ormolu mounts. Early 19th century. Formerly London, Christie's

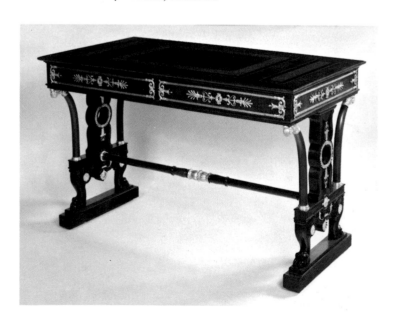

century the outstanding representative of revived medieval ornamentation was the architect A. W. N. Pugin (1812–52). But, like Robert Adam, Pugin preferred to adapt Gothic ornament to the models which, in his case, were those in the classical mood purveyed by regency designers. Imitation of the past allowed all styles of furniture to enter the repertory from Tudor through Queen Anne – an Elizabethan revival, a rococo revival, and worship of all things 'japonnaise'. All of them were influencing the massive assemblage of furniture at the Crystal Palace exhibition held in London in 1851.

There is little doubt that the exhibitors of furniture at the Crystal Palace abandoned all the rules of good taste. The exhibition pieces were in no way representative of the normal well-to-do household. Amid the exhibits themselves – twenty-four tons of coal in a single block, the largest sheet of plate glass ever

made, and a model of Liverpool Docks with 1,600 fully rigged ships may be held as representative – spreading over eighteen acres in vast iron and glass galleries, the furniture-makers made their showing. Henry Eyles of Bath exhibited a carved walnut and marquetry 'easy chair' which had an inset porcelain panel painted with a portrait of Prince Albert. The exhibition catalogue indicated that the furniture exhibits demonstrated a high level of national prosperity. All were covered with carved ornament and there was room for the display of 'novel inventions' (Fig. 205) at which the British excelled. 'There were mechanical invalid chairs ... cupboards that contained beds', a table which turned into a bed 'and into almost every other piece of furniture'.

Throughout the remainder of the nineteenth century the English makers were constant exhibitors of furniture in Paris and elsewhere. The 1862 International Exhibition held in London was the first in which William Morris and his friends, trading as 'Morris, Marshall, Faulkner, and Company', exhibited furniture. The architect William Burges also showed the massive, over-styled furniture made to his

206. Chair, by Charles Rennie Mackintosh, linear design showing Art Nouveau and Japanese influences. 1901–2. Glasgow, Hunterian Art Gallery, Mackintosh Collection

207. Chair, designed by Robin Day for multiple production by Hille. Polypropylene. 1963

208. Tomotom, designed by Bernard Holdaway. First shown 1964

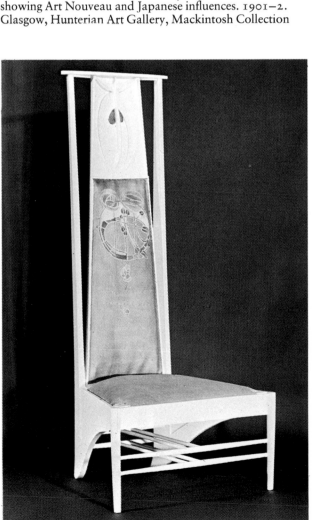

designs, and there was a significant showing of Japanese items to overturn the allegiance of even the most dedicated Anglophile. The exhibition pieces, flamboyant and over-decorated, gave way gradually to furniture suited for domestic use. Whilst the Paris Exhibition of 1900 was a meeting-ground for all interested in the sinuous Art Nouveau, only seven British firms troubled to send items. Morris and his designers Philip Webb and Bruce Talbert had revived the use of oak and produced designs which relied on line rather than ornament. The success of this movement led to the establishment of the Arts and Crafts Exhibitors' Society which did much to affect what was made, both in Britain and in Europe.

Running almost parallel with Morris's 'honest achievements' were those which stemmed from the work of the architect E. W. Godwin, a friend and admirer of William Burges, and, like him, fascinated with Gothic-Japanese mixtures for his designs. Godwin explained himself in 1877 thus: furniture 'cannot be an artistic work by any happy-go-lucky process. Little things of this kind, to be artistic, imperatively demand no inconsiderable amount of thought and much careful full-sized drawing.' It was a state of mind which did much to influence the linear fantasies of the architects C. F. A. Voysey and Charles Rennie Mackintosh (Fig. 206). Their work also affected much made subsequently in Scandinavia – one of the main sources for twentieth-century furniture design – and in England by Ernest Gimson, Ernest and Sidney Barnsley, and others. The Barnsley brothers used traditional materials and skills 'to produce furniture that has a solidity and technical competence that distinguishes it from much Arts and Crafts production'.

The commanding lead which Morris gave to English furniture-makers – even if the products were expensive and, in the case of the painted pieces, limited to acquisition by a mere handful of patrons – was gradually eroded after the First World War. The impressive achievements of the Gimson circle took their place, but after the financial upheavals of the 1930s modern furniture on a commercial scale was restricted mainly to the output of Heal's in London. A more innovative approach was adopted by Ernest Race and Noel Gordon who respectively designed and manufactured the cast aluminium and upholstered BA chair in 1945. At this time wood and fabric were difficult to obtain and aircraft scrap was melted down to provide the aluminium. The quarter of a million BA chairs produced between 1946 and 1969 has only been surpassed in England by the outstanding success of Robin Day's polypropylene chair launched by Hille in 1963 (Fig. 207). A classic, it has sold more than ten million units, and was hailed at its appearance as 'the most significant development in British mass-produced design since the war'. This outstanding partnership has gone on to produce more designs such as the Polo (1975) and Ibex (1979) ranges, and Fred Scott's Supporto chair (1979). The last might be held to indicate that the Arts in Britain can still be innovative and useful. Visually exciting because of its form and colour, Scott's chair incorporates gas cylinders which facilitate the adjustment of angles and heights. 'Novelty with an assurance of comfort' is the new criterion.

17

Clocks and Watches

CHARLES AKED

For a century and a half – from 1670 to 1820 – Britain produced most of the major inventions for clocks and led the world in their design and production. Never as elegant as those made by the French, British clocks have nonetheless been unique in design, style and execution, and some of them have been running continuously since they were made more than three centuries ago, still keeping time accurately enough for modern daily life.

Time has been measured in Britain at least since the period of the Romans. During their occupation sundials of the hemispherical pattern were imported for their villas. Fifty years following the departure of the Romans, the Anglo-Saxons invaded Britain, and an early sundial attributable to them is to be found at Bewcastle, Cumbria, a simple dial set on the face of a magnificent Runic cross (*c.* AD 670). Brief mention of sundials is made in *Historia Ecclesiastica Gentis Anglorum* (AD 731) by the Venerable Bede; and Asser, biographer of King Alfred the Great, credits the king with the use of candles burning in a lantern with horn windows to regulate his working periods (*c.* AD 870).

Some Saxon sundials still exist, and the most notable is at Kirkdale Church, Yorkshire (*c.* AD 1060); many were destroyed by the Normans after the Conquest of 1066 AD, being considered archaic by the invaders because the Saxons divided their night and day into eight 'tides', each being of three hours duration. Our use of the term 'even-tide' has survived from those days.

When, a millennium ago, the Church was the sole repository of knowledge, with responsibility for keeping the calendar for observance of religious events, its religious communities required an indication of time to control their ecclesiastical affairs, services and prayers. For this purpose a keeper was appointed to sound a bell, and to relieve the man of a tedious yet vital task, methods of mechanical timekeeping were developed. Our word 'clock' originates from the Latin word *cloca* for a bell, and the sole purpose of the earliest time-mechanism was to inform the keeper when it was necessary to sound the bell. These early mechanisms are known today as 'monastic alarms', though few survive.

Late in the thirteenth century a number of mechanical clocks suddenly appeared in England – at Dunstable Priory, Bedfordshire (1283), Exeter Cathedral (possibly 1284), and Old St Paul's Church, London (possibly 1286). No dials were fitted to these clocks, the hours were struck on a bell, and these were possibly the first public clocks in the world. Each abbey and cathedral desired to have one, so their use spread slowly throughout the whole of Britain.

209. Early turret clock with original foliot and verge escapement. Unknown maker. Wrought iron construction. 16th century. London, Science Museum

Salisbury Cathedral has preserved its original clock dating from about 1386. Now in the nave, it is the oldest working clock in the world. Figure 209 shows one of the few turret clocks retaining the original foliot which was in use in the earliest clocks. Fifty years earlier, a much more wonderful clock was fashioned by the Abbot of St Albans Abbey, Richard of Wallingford, and at the time it was the most complicated astronomical clock in Europe. Unfortunately it has not survived, but modern replicas of it now exist.

Expensive luxuries, domestic clocks began to appear in small numbers at the start of the sixteenth century. These were small editions of church clocks, made of iron only, and fabricated by blacksmiths. Refugee clockmakers, and British clockmakers trained in Europe, introduced clocks to Britain similar to those made in France and Germany. Bartholomew Newsam, clockmaker to Queen Elizabeth I from 1572 to 1593, was one of the few then working in London. Some of his clocks have survived, and one now in the Victoria and Albert Museum indicates a trend towards a uniquely English clock, known as the lantern clock. Simple in design and execution, the

BELOW
210. Lantern clock, by John Drury, London. Early 18th century. London, Science Museum

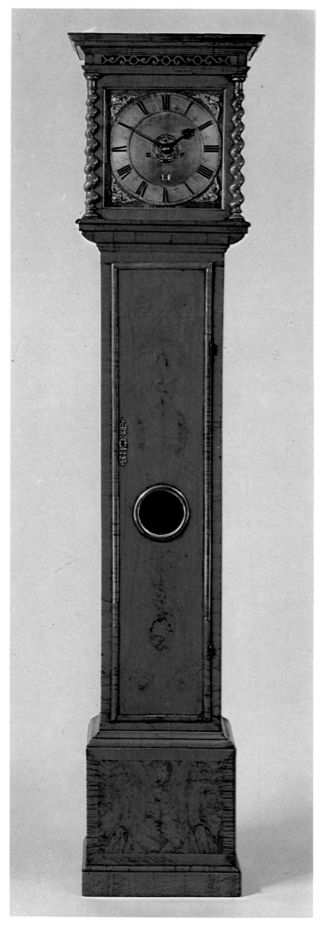

mechanism was housed in a sheet brass case; a large balance wheel was used to control the timekeeping, the hours being struck on a large bell on the top (see Fig. 210). David Ramsay (1575–1655), chief clock-maker to James I in 1618, spanned the era of change into typical English designs. Later he became clock-maker to King Charles I, and made many clocks for these two monarchs. Possibly the most famous lantern clock is the one presented by King Henry VIII to his bride Anne Boleyn (the clock is now kept in the Royal Library at Windsor Castle).

Christian Huygens's invention of the pendulum clock in Holland in 1657 was brought to England the following year by John Fromanteel, and this initiated an era in which English clockmakers achieved a mastery of aesthetic design and quality of execution exceeding any in Europe. Brilliant clockmakers such as Edward East, Henry Jones, the Fromanteels, the Knibbs, and John Hilderson, to mention just a few fine craftsmen, produced exquisite architectural designs for clock cases made of ebony-stained fruit-wood, in which gilt spandrels, silver chapter rings, and gilt case decorations were blended to perfection. Two main types emerged, spring-driven portable clocks known as table or bracket clocks, and larger fixed clocks driven by weights known as longcase clocks – short light pendulums being used in both types. Early longcase clocks thus have a slender elegance since the trunk houses the driving weights only (Fig. 211).

A most important English clock invention in 1669, that of the anchor escapement, caused a controversy lasting over three centuries. To this day the true inventor is unknown, but Joseph Knibb or William Clement appear to have the best claim. The longcase clock became a precision timekeeper when fitted with the anchor escapement and long pendulum; however, the older verge escapement continued to be used in bracket clocks for over another century since it is far more tolerant of being out of beat – a circumstance which causes a clock fitted with an anchor escapement to stop.

Another major invention made in England was that of rack and snail striking which was originated by Edward Barlow in 1676. Not only did this eliminate the incorrect striking the earlier count wheel system was prone to, but it enabled repeating clocks to be made which allowed the owner to know the time in the hours of darkness.

LEFT
211. Longcase clock, by Joseph Knibb, London. Walnut and olivewood c. 1682–5. Formerly London, Christie's

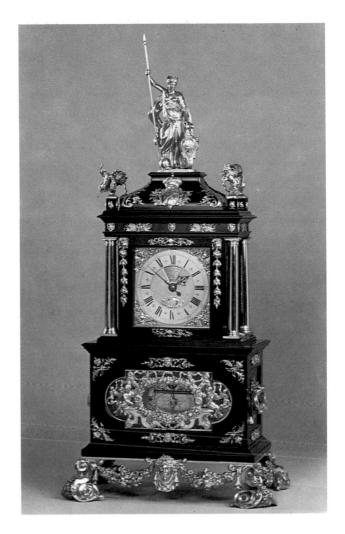

212. William III's Spring clock, by Thomas Tompion, London. c. 1695–1700. London, British Museum

Until 1657 clock cases were invariably of metal. Later veneered oak or stained fruitwood was used to match the furniture fashion of the day. A few of the early clocks were encased in wood by cabinet makers; however, their efforts were clumsy compared to those of the true specialist case-makers who supplied a number of clockmakers, as indeed did engravers of dials and movement back plates, and the makers of case decorations. Unfortunately very little is known about these specialists, but the use of their products explains why clocks by different makers often have features in common.

Although contributing little himself in the way of invention, Thomas Tompion (1669–1713) was England's greatest clockmaker and is generally recognized as the 'Father of English Clockmaking'. Originally a blacksmith, born at Ickwell in Bedfordshire, he was famed in his day, and has been ever since, for the excellence of his work. His *magnum opus*, William III's Spring clock, is shown in Figure 212.

Tompion's assistant, 'Honest George' Graham (1673–1751), made far greater contributions to the accuracy of timekeeping, notably the invention in 1715 of the dead-beat escapement, which continued to be in use in the most accurate clocks for a further two hundred years; he also invented, in 1721, the mercury compensated pendulum, which overcame the problem of the variation in rate with temperature change for the first time.

John Harrison (1693–1776), originally a carpenter, was the first to construct an accurate sea-clock for finding longitude at sea. He was greatly aided by George Graham in 1726 when Harrison first visited London to secure financial help. Harrison also invented a compensation pendulum, using a grid-iron formed from brass and steel rods, a feat considered impossible by Graham; he eventually gained the government prize of £20,000. His marvellous sea-clocks can still be seen in running order at the Greenwich Maritime Museum. English supremacy in the field of timekeeping at sea was never challenged, the development of the marine chronometer being continued by such fine craftsmen as John Arnold, Thomas Earnshaw, Edward Dent, Charles Frodsham, Thomas Mercer, and others in the late eighteenth and nineteenth centuries.

Being considered out of fashion, longcase clocks were no longer made by London craftsmen after 1750, whereas country clockmakers persisted in making them for another century, turning out large numbers of thirty-hour duration clocks instead of the more usual eight-day duration of the earlier longcase clocks. Low-cost production was essential, so painted dials supplanted brass dials and silvered chapter rings, giving the added advantage of improving the clarity of indication. In the latter half of the eighteenth century bracket clocks continued in greater variety. Musical bracket clocks enjoyed two or three decades of popularity, the most famous makers of these being Claude Duschesne, Stephen Rimbault, Charles Clay, and George Prior. Many English musical clocks were exported to China and Turkey; often these included automata to give animated scenes in the arch of the dial.

The finest creator of English automata clocks was James Cox (died 1788), whose mechanic Merlin produced masterpieces of mechanical elegance. Some of Cox's work is preserved in the Hermitage Museum, Leningrad, and the Peking Museum and Palace in China. A fine perpetual clock by Cox may be seen in the Victoria and Albert Museum, although it is not working as it lacks the 150 pounds of mercury needed to motivate it.

After 1780 bracket clock cases constantly changed in design, none ever reaching the earlier elegance; by 1850 the English clock trade was in serious decline because of severe competition from cheap mass-produced clocks from abroad. The majority of clocks sold in England after 1850 carry the retailer's name on the dial, not the maker's.

The first electric clock in the world was made by Sir Francis Ronalds at Hammersmith, London, in December 1814. However, it was the genius of Alexander Bain (1810–77), a Scot born at Watten, Caithness, who laid down the foundations of electrical timekeeping in the late 1830s. William Hamilton Shortt, a railway engineer, developed in the second decade of the twentieth century a free pendulum clock which became the world time standard from 1921 until the quartz crystal clock, developed in the 1930s by Louis Essen at the National Physical Laboratory, Teddington, toppled the pendulum clock from the supreme position it had occupied for three centuries. Today the atomic clock developed by Essen in 1955 is the timekeeping standard of the world; accurate to within one second in 30,000 years, it reveals daily variations in the earth's rotation.

Watches have a history rather different from that of clocks. Their origin lies in either Germany or France, and Peter Henlein (1480–1542) of Nuremburg is generally credited with their invention, though there is no proof of this. No English watches were made until the latter half of the sixteenth century, by craftsmen who were invited from the Continent or came over as refugees from persecution. Very early English watches follow the French pattern, using brass and steel for the mechanism; the Germans used iron only. Bartholomew Newsam, Randolph Bull, Michael Nouwen, Ferdinado Garret, and Robert Grinkin are some of the early English watchmakers working in London in the late sixteenth and early seventeenth centuries; examples of their watches may be seen in the British Museum and Clockmakers' Company collections.

From the start English watches incorporated a device known as a fusee to equalize the uneven force of the mainspring driving the watch train. This device was essential to obtain uniformity of timekeeping with the verge escapement and uncontrolled balance used in the earliest watches. In the first quarter of the seventeenth century, pig bristles were used to give a measure of control of the balance; nevertheless these early watches were more notable as jewellery adornments than as serious timekeepers.

The invention of the wheel-cutting 'engine' about 1670, usually credited to Robert Hooke, allowed the

quality of the teeth of the wheels employed to be much improved; otherwise not much improvement in the making of watches had resulted in 150 years. Watches were transformed into reasonably accurate timekeepers by the invention of the balance spring, first proposed by Robert Hooke in 1657. The first one was made by Thomas Tompion in 1675, and was presented to King Charles II. Thomas Tompion became the best English watchmaker and his fame was such that many continental makers, notably the Dutch, put his name on their movements to increase the value. The high quality of his work was emulated by many (see Fig. 213), and Edward East's watches were particularly valued – King Charles II often presented one of them as a prize when playing real tennis.

213. Early English pocket watch made by John Wise, London. Outer case with pin-work decorated leather. c. 1675. Private Collection

In 1676, repeating watches were made possible by Edward Barlow; both he and Daniel Quare made examples which were presented to King James II. In 1695 Barlow and Tompion, in conjunction with William Houghton, took out a patent for a new cylinder escapement for watches. Little more was heard of it until George Graham improved it in 1725, making watches which could keep time to within a few seconds a day in a constant temperature. English watches were by now superior in accuracy to any others, although continental watches were better decorated, as well as much thinner and lighter.

George Graham's apprentice and successor, Thomas Mudge (1715–94), a brilliant craftsman, invented the famous lever escapement in 1754, first using it in a clock. His first lever-escapement watch, in a gold case hallmarked 1759, was presented to Queen Charlotte, wife of George III. Few watches incorporated this escapement until the nineteenth century, since it was difficult to make.

Early in his career, John Arnold (1736–99) made a marvellous repeating watch set in a ring which he presented to King George III in June 1764. He invented the chronometer escapement about 1770, devising also a compensated balance which he first used in marine chronometers and then in watches, these being very accurate timekeepers. His foreman, Thomas Prest of Chigwell, invented keyless winding for watches by a button set in the pendant; until then all watches had been wound by a key.

Not long after the craft of watchmaking began in England, and for reasons now quite unknown, watch movements were made in the rough by workers in Lancashire, and then sent to London to have escapements fitted, plates gilded, dials and hands fitted, and finally to be cased. Over a hundred different specialists could be employed in the making of a watch. Most of the watchmakers' tools came from Lancashire, too, including wheel-cutting engines, fusee engines, turns, and files. Pinion wire was another Lancashire speciality; Prescot and Warrington were two of the areas where these crafts were practised.

In 1792 Peter Litherland, working at Ormskirk and Liverpool, invented the rack lever escapement which enjoyed popularity for a time, and some horologists believe it was the basis for the English lever watches from about 1815. Even so, the faithful verge escapement, because of its robust character, continued in use until 1850 for farmers' watches, often fitted with a gaily painted dial.

Clerkenwell, London, became the great centre for finishing watches in the nineteenth century, when English watches were renowned for accuracy and quality (see Fig. 214). Yet even in 1800 the watch

214. Pocket chronometer, signed Ilbery, London. Gold and enamel. c. 1800. Formerly London, Christie's

trade was in serious trouble because it had failed to provide watches for the masses. The gap was filled by the Swiss, using Graham's cylinder escapement to make watches which were smaller, lighter, more elegant and less expensive than the heavy English watch. Often the value of the metal in an English watch case was more than that of the entire Swiss watch. Even more severe competition arrived halfway through the century from imported American factory-made watches, cheaper and just as accurate. Often American and Swiss movements were sent to be cased in England.

Too late the English trade turned to factory production with its great advantage of interchangeable parts, unlike the hand-made watch for which individual parts had to be made. Factories were started, the most famous at Coventry, and towards the end of the nineteenth century at Prescot (though the latter had failed by 1910). In fact, failure was inevitable because of the severe competition from Switzerland and America with their simpler watches and more efficient methods of production. Working conditions and rates of pay for English craftsmen became atrocious, yet even so beautiful watches were still produced by individual craftsmen working for firms such as Ashley and Sims of Clerkenwell right up to the outbreak of the Second World War. The last pocket watches in gold cases were made by this firm to an order from Lord Baden-Powell in 1939.

From the end of the nineteenth century the pocket-watch lost favour to be replaced by the wrist-watch, an English development. The First World War gave impetus to the fashion since wrist-watches were very handy for those on active service. In 1923 John Harwood of Leeds invented a self-winding wrist-watch – but it was ignored in England. However, after the Second World War the Swiss used the system and saturated the world markets with automatically wound watches. One result of this was to destroy the newly founded English watch industry making pin-pallet escapement watches on the Swiss pattern for the mass market. Had it not been for the development of the quartz crystal watch in the 1960s, the self-winding wrist-watch based on Harwood's invention would have been the standard watch throughout the world.

Just a few English craftsmen remain today who are capable of making a complete watch from start to finish, the most outstanding being George Daniels who makes mechanical watches of the highest quality – alas, not for the common man! One watch-case maker remains making cases to the traditional pattern – Martin Matthews – the sole repository of generations of knowledge of craft practice.

Had English craftsmen continued in the same inventive genius that they displayed from 1670 to 1820, other countries would have found it just as futile to compete as they did in making marine chronometers. Now the supreme mechanical ingenuity, the elegance of execution, the perfection of hand-crafted parts too small to be seen with the naked eye, are no longer required; the only need for these skills today is in the maintenance of all the old treasures which will never again be made.

Musical Instruments

JEREMY MONTAGU

Iɴ the early Middle Ages the British Isles, and particularly Ireland, were already famous for harps and harpers. The harp was known as the favourite instrument of the minstrels, but so vague are the descriptions of it that we cannot be sure whether the instrument in question at this early date was in fact a harp or whether it was a lyre. A harp has a triangular frame with one side a soundbox, the second a curved neck with tuning pegs set in it, arching away from the top of the soundbox, and the third the forepillar, with strings running across the space from the neck to the soundbox. A lyre has a wooden body with two arms reaching up from it, joined at the top by a yoke with the tuning pegs set in it, and strings running from the yoke, across the gap between yoke and body, down to the bottom of the body: the instrument is akin to those of ancient Greece which were used by Homer and Orpheus to accompany their lays, and to that played by King David, the psalmist. By the eleventh and twelfth centuries, the medieval encyclopedias were referring to the lyre as the *cithara teutonica* and to the true harp as the *cithara anglica*, but prior to this the word *hearp* was used for both instruments.

There is a good deal of evidence to suggest, though insufficient to prove, that it was in Britain that the forepillar, which had been adopted and then abandoned at least twice in antiquity, was finally established as a permanent and essential element of the harp. When this happened is uncertain, but it may have been as late as the tenth century. Precisely where it happened is also uncertain. The Irish have claimed the instrument as theirs, but the early Irish descriptions of the harp are sufficiently vague that they could equally well refer to the lyre. If one were to follow iconographic evidence alone, the instrument which was later regarded as the Irish harp, with a massive soundbox, strongly arched neck, and heavy forepillar, appears in East Anglia, for example in the Choir of Lincoln Cathedral (Fig. 215), in the mid-thirteenth century, considerably earlier than it does in

215. King David with an Irish-type harp. Stone carving. *c.* 1270. Lincoln Cathedral, Angel Choir, South 14

Ireland. However, the lack of iconographic evidence is not in itself conclusive and while we may be certain that such a harp was well known and well developed in East Anglia by that date, we cannot say that it was not also known in Ireland.

As yet comparatively few musicologists have searched rolls and other records for references to instrument makers. Certainly we know from many written references and from carvings and paintings that throughout the Middle Ages and the early Renaissance there were a great many musicians playing in Britain, and a number of them are named in the records. Similarly, we have names for some instrument makers, but we have as yet little of the sort of information that would tell us whether any particular part of the country, or Britain as a whole, continued to bear an international reputation for any

216. Trumpet, by Simon Beale, London. Copper and silver. 1667. University of Oxford, Bate Collection (on loan)

one type of instrument. To take an example at random, Dr Page has shown, in the *Galpin Society Journal*, no. XXXI, that Oxford had more makers of harps around the year 1400 than of any other instrument, but he has shown also that their reputations were likely to have been purely local, and this is probably true of most instruments until the seventeenth century. From this period onwards we have a number of surviving instruments, and a greater number of named makers whose skill we may judge from their instruments as well as from contemporary references; Britain once again became an important centre for instrument manufacture.

There seem to be no references praising the qualities of British brass instruments, such as there are from a number of European countries for the great masters of Nuremburg, and yet the surviving seventeenth-century British trumpets are magnificent instruments, both in appearance and in sound, as Eric Halfpenny has shown in numerous articles and as may be determined by inspection (Fig. 216) and by trial of the instruments. They differ in a number of respects from the Bavarian trumpets, unquestionably surpassing them in appearance and producing a solidity of sound more impressive in fanfare than those of Nuremburg, if perhaps less easily capable of the subtleties required by the Italian trumpet sonatas and concertos of the period.

At much the same time or somewhat earlier, the English makers of bowed string instruments were building an international reputation. As far as violins

LEFT 217. Recorders, by Peter I. Bressan, London. (Left to right) bass, strut, tenor, voice-flute treble. Stained boxwood and ivory. *c.* 1700. Chester, Grosvenor Museum

RIGHT 218. Oboes. (Left) anonymous English, known as the 'Galpin Oboe'. Boxwood and ivory. *c.* 1690. (Right) Thomas Stanesby jun., London. Maple and silver. Pre-1754. University of Oxford, Bate Collection.

219. Pair of orchestral horns with master-crooks and couplers and a mute. By John Christopher Hofmaster, London. Brass. *c.* 1735. Warwickshire Museum, Shaw-Hellier Collection

were concerned, English makers such as Barak Norman, while fully comparable with other makers in Northern Europe, were not held in the same regard as the Italians nor as the Austrian Jacob Stainer. Viols, on the other hand, were quite another matter and the best English viols were eagerly sought after both in Britain and abroad. Sixteenth- and seventeenth-century makers such as Barak Norman, Richard Meares, John Rose, and Henry Jaye produced superb instruments, with a quality of sound and response which was unrivalled by the products of their contemporaries.

It is interesting that there seem to be national characteristics which can be transferred to instruments. For example, most of the best violin makers were Italians, the best lute makers were Austrians and Germans, often living in Italy, and many of the best viol makers were English. Similarly, the best flute and recorder makers in the Renaissance were Italians, and the Italian–Jewish family of the Bassanos were

musicians and instrument makers resident in Britain from the time of Henry VIII; it has been suggested by A. L. Rowse that Shakespeare's Dark Lady of the Sonnets was a member of that family. It is thought probable that many of the flutes and recorders, and perhaps other instruments, listed in the huge inventory of Henry VIII's instruments (published in extenso by Canon Galpin), were made either by the Bassanos or by English makers under their tutelage.

This immigrant inspiration of the instrument-making trade seems to have been common from the sixteenth to the eighteenth centuries. For example, Peter Bressan, one of the first great London flute and recorder makers (Fig. 217), who flourished from about 1690 to about 1730, came from France. He was followed by a number of famous English makers such as the Stanesbys, father (1690–1734) and son (died 1754), as well as by other foreigners such as Schuchart (1726–59) and Cahusac (1755–98). John Christopher Hofmaster, whose name must once have been Johann Christoph Hofmeister, introduced the new orchestral horns with separate crooks (Fig. 219) to London from Germany in the middle of the eighteenth century, and again was followed by a number of English makers; British horn players retained the German practice of using one or two master crooks and a set of couplers long after the French had adopted the use of a different crook for each key. Hermann Tabel, the Flemish harpsichord maker, settled in London around 1716 and was joined by the Alsatian Jakob Kirkmann and the Swiss Burkat Tschudi, both of whom were employed in his workshop. Tschudi changed his name to Shudi and his apprentice, son-in-law and successor, John Broadwood, was the last great harpsichord maker in Britain as well as the first great piano maker.

As far as other instruments are concerned, makers of the clarinet in Britain seem all to have been native, and there is some evidence to suggest that the new oboe owed something to this country: Richard Haka of Amsterdam, one of the more important early oboe makers, is known to have come from London. As yet we do not know whether he was an Englishman called Harker who changed the spelling of his name in Holland or whether he was perhaps of a Bohemian family who emigrated again. Certainly the oboes made in England by Bradbury, the Stanesbys, and others (Fig. 218) had a tone quality very different from that of the French instruments that superseded them in the second half of the eighteenth century.

John Broadwood has been mentioned as the first great piano maker in London, but the piano had been introduced into Britain in the middle of the eight-

220. Grand pianoforte, by John Broadwood, London. Presented to Beethoven in 1818. Bonn, Beethoven Haus

eenth century by refugees from the wars in Germany such as Zumpe, Beyer and others, and it was popularized by Johann Christian Bach (the youngest son of the great Bach), who, when he settled in London, gave the first solo recital on the instrument. Broadwood produced instruments so superior to the continental pianos of the end of the eighteenth and early nineteenth centuries that Haydn took one back to Vienna after his visit to London in the 1790s for the performances of his *London Symphonies*, and a later model was presented to Beethoven after he was no longer able to hear the more delicate Viennese instruments due to his increasing deafness (Fig. 220). Broadwood's career seems to have coincided with the final climax of British instrument making. Through the middle and latter part of the nineteenth century, though there were of course many instrument makers in Britain, the tendency on the whole was to import instruments, or at least instrumental models, from abroad. Distin was importing or copying Sax's instruments; Mahillon, Besson, and other European firms opened offices in London, and many British firms became agents for continental makers. Only minor instruments such as the double flageolet were

exported from this country or copied abroad. Even important inventions such as the key bugle, invented by the Irishman Joseph Halliday in 1810, were better exploited abroad. The French maker Halari, for example, produced a complete family of key bugles, the lowest of which, the *ophicléide*, was then widely copied in Britain. A number of important developments to the organ were invented in Britain but only became commonly used on British organs after they had become established through the work of makers such as the great French organ builder, Aristide Cavaillé-Coll.

Not until this century did British instrument making once again become internationally important, and it was then mainly as a result of the skills of individual craftsmen and small firms. In a few cases, for example Howarth, Cooper and Paxman, these have been makers of modern orchestral instruments, but the most exciting progress has been in the field of early music. Through the work of scholars and musicians of the late nineteenth and early twentieth centuries such as Alfred Hipkins, Arnold Dolmetsch, and Canon Francis Galpin, the Early Music Movement had its beginnings in this country. All three believed, as many musicians the world over believe today, that it is only by playing music on the instruments for which the composers conceived it and in the styles which they employed in their own day that the composers' intentions can be fully realized. Performance on modern instruments may reproduce the notes, but it will not reproduce the music, for a composer imagines his music in terms of sound, and modern instruments sound different from those of earlier times.

So long as the Early Music Movement was confined to a small number of devotees and to the music of the baroque period, there was an adequate surviving corpus of original instruments – though, as has often been pointed out, instruments and their sound alter with age and no musicians of Bach's or Handel's time were playing on instruments two hundred years old. Once the Movement gathered pace and adherents, and once attention moved back in time to the instrumental music of the Renaissance and Middle Ages (much of the renaissance vocal music was already well known), there arose a need for the manufacture of copies and reconstructions of earlier instruments which, because they were new, might sound as the original ones had done in their own day. The leader in this was Arnold Dolmetsch, a Frenchman of Swiss descent who settled in London in the last quarter of the nineteenth century and who built copies and reconstructions of recorders, viols,

harpsichords, clavichords, and other instruments. Many of the present older generation of makers were trained in his workshop or drew their inspiration from him.

It was, perhaps, an inevitable reflection of the spirit of the times that most late nineteenth- and early twentieth-century makers believed that while the original instruments were the ideal, they were capable of improvement through modern technology and techniques. Only since the 1950s has the realization dawned that the original makers really did know what they were doing and that copies, as exact as we can make them, will always sound better than reconstructions and 'improved' models. While that realization stemmed from the so-called Boston Revolution, led by the harpsichord makers Frank Hubbard and William Dowd, and while there are now makers of copies of early instruments in many parts of the world, Britain is still in a central position in this Movement. This is due not only to the qualities of British instrument makers but also to the influence of a number of authors who, in the old English amateur tradition, were deeply concerned with the history of and performance on the instruments of earlier times. Canon Galpin was the first of these and he was followed by younger colleagues and friends such as Anthony Baines, Philip Bate, Robert Donington, Eric Halfpenny, Edgar Hunt, Lyndesay Langwill, Reginald Morley Pegge, Geoffrey Rendall, and others. Not only were these authors enormously influential through their own writings, but they founded the Galpin Society in 1946, which has published in its *Journal* much of the most important original research into early instruments since that date. A more recent periodical, *Early Music*, has also been widely influential. There are as well a number of smaller and more specialized journals such as those of the Lute Society, the Viola da Gamba Society, the Dolmetsch Foundation, the Fellowship of Makers and Researchers of Historical Instruments (FoMRHI), and many others, all publishing original research addressed to players and makers of early instruments.

Britain is fertile ground for such authors, such societies and their journals, and while it would be excessive to claim that Britain stood alone in the Early Music Movement, for its creation has been the work of scholars, musicians and instrument makers in many countries, it is certain that had it not been for the developments here and the work of those mentioned and of many others whom there is not space to name, the movement would still today be where it was a century ago, confined to a small coterie of groups and individuals.

19

Modern Studio Crafts

MARIGOLD COLEMAN

At the beginning of the twentieth century the principles of the Arts and Crafts Movement were still an inspiration. At the heart of the movement had been William Morris, whose energetic genius had made him leader of a group of creative designers, architects, and artists who had begun to emerge in the 1860s. Like John Ruskin before them, they had reacted violently against the brutalizing effects of industrialization. Their criticisms of the grinding, inhuman life imposed on the factory worker in the name of profit, and of the squalid towns that grew round the factories, were inseparable from their criticism of the products of those factories, which they saw as aesthetically and structurally debased. They thought it inevitable that the one should lead to the other, and Morris's socialist vision was of a world where justice and humanity for all led naturally to beauty in the objects used in such a world.

To find the inspiration for such objects, Morris and his followers turned to the work of anonymous rural craftsmen, whose country life they romanticized, conveniently forgetting that there, too, misery and poverty ruled. Instead they emphasized the beauty of the countryside and the dignified simplicity of vernacular architecture and traditional cottage furnishings. For a more decorative tradition they looked back to the Middle Ages. Morris was poet, polemicist, printer, designer, weaver – a polymath who dominated the crafts world until he died in 1896.

After Morris's death, the influence of his total, radical vision diminished; nevertheless, various individuals have, throughout the twentieth century, continued to try to make his heady mixture of aesthetics and morality work. Morris's dream, 'art made by the people and for the people, a joy to the maker and the user', was a potent message even as late as the 1970s, when a strong drive to individualism and personal style was in operation. In a major respect, this dream of William Morris has not been realized. The studio crafts have become more and more a middle-class preserve; their roots in traditional, anonymous workmanship have been weakened; training is now through art colleges rather than apprenticeships. These changes have influenced the crafts as much as any personal aesthetic endeavour.

But at the turn of the century, the power of the crafts movement to change the fabric of society still seemed real. In 1902 C. R. Ashbee, the remarkable designer and craftsman who had founded the Guild of Handicraft in the East End of London, transported his entire cockney workforce to Chipping Camden, in the Cotswolds, where both their souls and their workmanship were supposed to benefit from 'the elemental things of life' and from physical jerks and maypole dancing. Though the experiment failed, it shows that Morris's followers still had the rather foolhardy courage of their convictions.

Also working in the Cotswolds were Ernest Gimson and Ernest and Sidney Barnsley, producing furniture which paid homage to traditional cottage furniture whilst enlarging that tradition, achieving simple elegance and occasionally an austere modernity which foretold the Bauhaus interpretation in Germany of the same principles. Sincere but rather safe, this school of furniture came nearer than any other craft to fulfilling Morris's dream when it became the source of the Utility range, the standard format for British furniture introduced during the Second World War and masterminded by another Cotswold maker, Gordon Russell.

Concern for workmanship and respect for materials was paramount, producing a notable quality found also in the work of the next generation – Peter Waals, Stanley Davies, and Romney Green – and later of Edward Barnsley. For seventy years, craft furniture was confirmed in the same quiet and understated vein, carefully adapting current design trends to suit the small workshop. It was John Makepeace in the late 1960s who really set out to combine excellence in making with a more flamboyant, romantic style, and a similar strain emerged in

the art colleges in the 1970s. But no English craft furniture ever had the daring of that designed by Charles Rennie Mackintosh for his Glasgow buildings, or the simple brilliance of the Isokon chair – 'truth to materials' applied to plywood, a product of Bauhaus logic.

High seriousness was very much a strain in the English craft tradition. Accordingly, there was little chance that the brief but colourful existence of the Omega Workshops would have much to contribute to that stream. The workshops were set up in 1913 and closely linked to the Bloomsbury set. Roger Fry and painters Duncan Grant and Vanessa Bell (Virginia Woolf's sister) were little concerned with truth to materials, but they were great decorators, free and exuberant, and they used decoration to integrate everything within a space – pots, tables, chairs, screens, carpets, and curtains. Both Grant and Bell went on to design fabrics for industry. The results – as seen in their former home, Charleston, in Sussex – possess great charm and vitality. Overall effect was paramount and details do not always stand up to close inspection, while the pots they commissioned for their purposes make potters catch their breath in horror; still, for them this was a passing phase, they had other fish to fry and closed the workshops in 1918. They were not committed to the crafts. For commitment we can look to two figures who began to attract public attention in the 1920s: Eric Gill and Bernard Leach.

In many ways Eric Gill was a man after Morris's own heart, though his fervent Catholicism drove him into narrower channels. Gill believed passionately in the need for a socialist society in which craftspeople worked to interpret the spirit of the whole community. He tried to live out his principles by forming a working group with a religious basis at Ditchling in Sussex, where he went in 1907. He worked there as a letter cutter, engraver and printer, but the group was shattered by quarrels about money and Gill and his family moved to Wales in 1924 and thence to Buckinghamshire.

Gill was for 'craft' and against 'art', by which he meant that he did not believe in the value of egotistical originality, but rather in an anonymous creativity that was governed by skill and by the needs of society. Yet he was no mean artist, not only in such forms as sculpture and wood engraving, but in the creation of the great typefaces, still in use today. Gill's deep understanding of letterforms stemmed from his training under Edward Johnston and his typefaces are classics – clear, elegant, flexible, yet with a strong personal identity (Fig. 221).

221. Eric Gill, *The Four Gospels*. 1931. Golden Cockerell Press

222. Bottle by Bernard Leach. Slab built in reduced stoneware with tenmoku glaze and combed decoration. *c.* 1960. London, Crafts Council Collection

Gill died in 1940. In that year was published *A Potter's Book*, Bernard Leach's credo, which summed up twenty years' experience as a working potter. In his own sphere – a smaller and less outward-looking one than that of Gill – Leach was just as potent a force, and since he lived till 1979 it was a longer-lasting one. As a young man in Japan Leach absorbed an attitude to ceramics shaped by Zen Buddhism. He came to value spontaneity and anonymity in execution, brought about by the rhythms of the work and respect for tradition as a living force to which the maker surrendered himself. When he returned to England in 1920, Leach set out to graft this view on to the English domestic tradition, then preserved in a dwindling number of country potteries.

Leach lived most of his life in St Ives, Cornwall, where he ran a working pottery producing mainly domestic ware. But for long periods, once his son David was able to help him, he travelled, lectured and wrote, and the force of his personality made him a hugely influential figure in the crafts world. Like anyone producing work in quantity and with assistants, his own output was variable, but his best pieces more than fulfilled his own tenets and have great presence (Fig. 222).

Among his notable pupils was Michael Cardew, who went on to run the Winchcombe Pottery (later taken over by Ray Finch) and to carry the Leach influence to Africa; also Katharine Pleydell-Bouverie and Nora Braden, whose experiments with glazes produced useful and interesting results and who clearly kept their own identities.

Another Eastern influence, Chinese rather than Japanese, was to be found in the pots of William Staite Murray, a largely self-taught potter who saw pots as fine art objects, foreshadowing an argument which was to become central later. He sold his majestic vases, with titles like 'Wheel of Life' and 'Persian Garden', through art galleries, and had considerable influence as a teacher. His decoration was freer than that derived from Japan, and one of his star pupils, Sam Haile, also went on to decorate in a lively style. But this was not a strain which stood up very powerfully to Leach's more dogmatic line.

Living at Ditchling when Gill was there was Ethel Mairet, who dominated the development of weaving in much the same way as Leach did that of pottery. It is difficult now to identify her work among that of her pupils, but her inspiration showed itself in the consistently high standard produced from that workshop, Gospels, and its willingness to experiment with dyes and weave structures. Her distinguished helpers

223. Detail of macrogauze weaving by Peter Collingwood. Linen, dyed black and bleached, with steel rods. 1973. London, Crafts Council Collection

included Margaret Leischner and Marianne Straub, both of whom went on to design for industry (Straub was an important teacher well into the 1970s), and Theo Moorman. Peter Collingwood, the most outstanding weaver of recent years, was one of her last pupils (Fig. 223).

Ethel Mairet's emphasis was on cloth for use, but some of the most remarkable products of the period were unashamed art objects – the group of hangings which another of her one-time assistants, Elizabeth Peacock, produced between 1933 and 1938 for Dartington Hall, and which were inspired by the surrounding landscape.

Outstanding printed fabrics were produced by Phyllis Barron and Dorothy Larcher, whose interest in hand-blocked designs was originally stimulated by designs found in France. Enid Marx was for a time their assistant, but she went on to cast her net wider, designing for industry, doing engraving and book illustration, and researching the folk art which was still an inspiration to the craft world.

Many Arts and Crafts ideals were introduced on the Continent by the Bauhaus, but in Britain that influence was felt chiefly through industrial design. Two outstanding craftspeople who arrived in Britain as refugees from Hitler did however acknowledge a debt to that school. Both Lucie Rie and Hans Coper were influenced by the Modern Movement (Figs. 224 and 225).

In Lucie Rie's work forms of great refined strength were (and still are) combined with decoration inspired by ancient sources. In recent years she has combined that purity of shape with daring and sensuous colouring, sometimes fringed with gold, producing an unexpected effect – like a Hawaiian sunset on the Acropolis. Coper at first assisted Rie but later set up alone and also taught at the Royal College of Art, where he had a lasting influence. Coper's pots are strongly reminiscent of Modernist architecture – stark and uncompromising, even an eight-inch high vessel can feel monumental. Both Rie and Coper provided a counterpoint to Leach, producing work which clearly had fine art intentions. Coper was one of the first living craftspeople to be given an exhibition at the Victoria and Albert Museum, along with Peter Collingwood.

During the 1940s and 1950s the emphasis on industrial design meant that crafts were somewhat overshadowed. But throughout the fifties Britain grew more and more prosperous, and at the beginning of the sixties the changes made in art colleges resulting from the Coldstream Report created opportunities quite new to British society. A wider range of courses and an increased student intake gave design a new importance. It was suddenly *the thing* for the 'Swinging Sixties' and there were to be notable spin-offs for the crafts as well.

The sixties were the decade of the designer-craftsmen – metalworkers like David Mellor, Robert Welch and Gerald Benney showed that they could combine individual pieces with production work. Like Durbin, Gleadhowe, and Goodden before them, in the main they designed for others to make. They received enlightened patronage from the Goldsmiths Company, as did jewellers like John Donald, Gerda Flöckinger, and Wendy Ramshaw. Potters also multiplied, and the Craftsmen Potters Association was formed to look after their interests and sell their work. Most were in the Leach tradition, though

ABOVE
224. Selection of pottery by Lucie Rie. 1970–80. Formerly London, Christie's

BELOW
225. Group of stoneware vases by Hans Coper. Formerly London, Christie's

226. Wearables, by Susanna Heron. Cotton on wire frame. 1982. Amsterdam, Collection Stedelijk Museum

227. Neckpiece, by Wendy Ramshaw. Gold with white, pink and blue Jasper beads. Made in collaboration with Wedgwood. 1982

really outstanding domestic potters like Jon Leach, Richard Batterham and Ray Finch set standards within that tradition which few could match.

Gradually the new intake of art students produced by Coldstream grew more radical, less willing to work for large, obviously capitalist industries. Setting up alone appealed to such people and help in doing so was to be forthcoming from the Crafts Advisory Committee, later the Crafts Council, set up in 1971 to direct funds on a national scale to the crafts in England and Wales. Similar work was carried out by the Scottish Development Agency and the Crafts

Chairs

MARIGOLD COLEMAN

Twentieth-century craft furniture had a strong beginning, a rather thin time from the thirties to the sixties, and a sudden burst of energy and variety in the seventies and eighties. The strength of the beginning lies in the considerable talent of the Cotswold furniture makers, Ernest Gimson and Sidney and Ernest Barnsley, all of whom trained as architects. Their furniture has strong lines without being stark, and there is a direct enjoyment expressed in the treatment of the wood. They sometimes used rural motifs: the chamfering detail employed to make wagons lighter by paring away the wood turns up on a dresser; the stretchers of a table are inspired by a hayrake. Other features and forms derive from the long admiring hours the makers spent in the South Kensington museums: English furniture of the seventeenth and eighteenth centuries was the great source of inspiration, and they made great use of native English woods.

OPPOSITE LEFT 1. Child's chair, by Richard La Trobe-Bateman. Unseasoned cleft oak. 1982. Collection of HRH the Prince of Wales

OPPOSITE RIGHT 2. Rush-seated ladderback chair, by Ernest Gimson. Private Collection

LEFT 3. Upright chair, by Fred Baier. Sycamore, stained yellow and grey with grey leather upholstery. 1978. London, Crafts Council Collection

BELOW 4. Chair designed by John Makepeace and made by Andrew Whateley. Solid and part laminated ebony and nickel silver wire. 1978. Private Collection

RIGHT 5. Split plank back chair in ash by Robert Williams. 1981. Private Collection

Ernest Gimson died in 1919, the Barnsleys in 1926; their tradition was continued chiefly by Peter Waals, who died in 1938, and by Edward Barnsley, whose workshop is still operating. But, apart from a few loyal students trained by Edward Barnsley, craft furniture makers were thin on the ground until the craft revival of the 1970s. Then there appeared a sudden proliferation. It was still possible to find 'reproduction Cotswold' by the end of the seventies – for instance, the rush-seated, ladder-backed chairs which are a symbol of that style (Fig. 2). But Richard La Trobe-Bateman brought the rustic tradition up to date, leaving the marks of his tools on the wood in a way reminiscent of the gouging technique so beloved at the beginning of the century (Fig. 1); and it was possible to go from that strain to the joking, brightly coloured eccentricities of Fred Baier (Fig. 3).

John Makepeace was the first to step outside the tradition of understatement at the end of the sixties and his workshop produced rather lush, gothic pieces which related more to American themes than to British ones (Fig. 4). But the confident atmosphere of the seventies led a whole new generation of young makers to experiment, to extend the boundaries of what had previously been acceptable, and to respond to references outside the craft tradition, using new materials and methods – for example, decorating with plastics, lacquering in brilliant colours, and returning to veneering (for long a skill of the trade but rather suspected by craftspeople as lacking 'truth to materials').

Council of Ireland. The artist-craftsman was to be the object of this government patronage.

As ever among the new talents emerging, the ceramicists (a word more embracing that 'potters') stood out in number and quality. The notable achievements were in non-functional work, and the best of the new wave were women: Jill Crowley moved quickly to sculpture, Jacqui Poncelet, Alison Britton, and Liz Fritsch made work which retained reference to vessels. Fritsch's *trompe l'œil* pots stand out, particularly in the way she employs coloured surfaces deliberately to distort perspective.

In textiles, tapestry weavers worked to their own designs rather than interpreting those of painters. Archie Brennan, director of the Dovecot Studio, Edinburgh, showed that wit could exist in tapestry, and two of his ex-pupils, Maureen Hodge and Fiona MacAlister, demonstrated that lyricism was compatible with a strong technique. Peter Collingwood went three-dimensional with his thread structures ('macrogauzes'), and continued to lead the rug-makers, though he had strong competition in Roger Oates. John Hinchcliffe wove with rags in a way which went way beyond the cheap doormats, derived from hookie mats, which had been products of the war.

The seventies was a time of confident experiment. Young jewellers moved away from precious – and expensive – metals, to work in plastic or steel, or they found materials which made it possible for them to move at speed through a succession of amusing and ingenious ideas that occasionally were genuinely original. Susanna Heron's progress sums up the mood: from the heavy silver and resin necklaces of 1973, with their naturalistic imagery, she came in 1980 to a clear acetate circle edged with a painted black line, and in 1982 to a form of jewellery which she describes simply as 'wearables' (Fig. 226).

The Crafts Council deliberately stimulated experiment – its Hot Glass Conference in 1976 was planned to widen the horizons of British glass-makers and to encourage colleges to provide courses. And a courageous private initiative was taken by John Makepeace who set up a school for craftsmen in wood in Dorset, where the views of veteran traditionalists like woodcarver David Pye, and minimalist furniture makers like Erik de Graaf (whose chairs were two interlocking planks of wood), could both get a hearing.

A craft which has actually gained from contrast with modern technology is book production. It held a strong attraction for William Morris, and he learned the numerous skills involved in order to set up the Kelmscott Press. The challenge of uniting the elements of print, paper, illustration and binding to make a truly superb book, and the combination of judgement and skills, continues to make the craft of the book one which has passionate adherents. Thus, at a time when print technology is becoming increasingly fast-moving and complex, letterpress printing, bookbinding and wood engraving still flourish. Before the Second World War, the Golden Cockerel Press run by Gill and his son-in-law set standards few could match; later the Rampant Lion Press, run by Will and Sebastian Carter, was highly respected.

On the whole, the craft revival was welcomed. Even those objects at the fine art end of the crafts spectrum were more approachable than the difficult and inward-looking work of many painters and sculptors, though people still automatically expected craft work to be cheap. Industry was quick to imitate the superficial qualities of craft – the random effects of craft glazes were carefully interpreted for mass production, moulded casseroles were given the ridged sides of hand-thrown ware. This superficiality showed elsewhere in the tendency to try to reduce the crafts to an adman's nostalgic dream of a rural past, all stripped pine and weakly floral fabrics.

Partly because of this earlier misinterpretation, the word 'craft' has continued to pose problems for those who use it. In a period when many craftspeople have been moving away from their roots in function and tradition, the separation of the crafts and the arts has seemed increasingly a bureaucratic convenience, and the essence of the word has been usefully reduced to denote high standards which can only be achieved where there is a strong personal control over the process of making, whatever the method of manufacture.

20

Industrial Design

STEPHEN BAYLEY

BRITISH DESIGN has been influenced by two independent forces: mercantile enterprise first, and moral purpose second. Josiah Wedgwood was, perhaps, influenced more by mercantile than by moral considerations when he employed the first industrial designers. He was among the first manufacturers to realize that the division of labour, from which he benefited so prodigiously, called into existence a new breed of being: one who would fill the gap created when inventing became separate from making, and making from selling. Describing the opportunities at about the time he opened his London shop, Wedgwood said: 'I saw the field was spacious, and the soil so good as to promise ample recompense to anyone who should labour diligently in its cultivation ...' It was Wedgwood who brought practising artists, like George Stubbs and John Flaxman, actually into his factories to breathe the perfumed breath of art on to the sulphurous, volcanic stuff of industry.

At the same time, the commercial opportunities which the integration of art into industry promised were sensed at an official level. Launching the Society of Arts in 1753, William Shipley said: '... [it] may prove an effectual means to embolden enterprise, to enlarge Science, to refine Art, to improve Manufactures and extend Commerce: in a word, to render Great Britain the school of instruction, as it is already the centre of traffic to the greatest part of the known world.' He thus synthesized in one sentence the material and metaphysical aims of the age.

Nearly a century later, in December 1836, the President of the Board of Trade opened a discussion about setting up government-sponsored Schools of Design in Ornamental Art. The idea was to inspire young practitioners by educating them in close proximity to works of art from across the ages and the continents that were acknowledged to be of high quality.

By 1837 the old premises of the Royal Academy in Somerset House had been made available to the new practical educators, a substantial symbol of fine art moving over to make way for design. Soon a surge of practical, artistic righteousness swept the provinces and seventeen other similar establishments were created in the major manufacturing cities. All the time the Schools of Design resisted fine art: even the painter, William Dyce, the first permanent professor, attempted to introduce a Jacquard loom into the school. This machine, he thought, was a better medium for the new generation than paint and canvas or clay and marble. Dyce's successor abolished life drawing, replacing it by lessons in painting on glass and china.

This was the beginning of the British art school system. The forces which created it were also responsible for the most magnificent (perhaps because most temporary) school of Victorian entrepreneurialism and optimism: the Great Exhibition of the Industry of All Nations, held in Hyde Park in 1851.

The most remarkable generalization about principles of design resulting from the Great Exhibition was Owen Jones's book, *The Grammar of Ornament*, which appeared, a triumph of early colour lithography, in 1856. Jones, who was one of the spirits involved in the Exhibition, compiled his *Grammar* as a corrective to what must have seemed an unstoppable wave of vulgarity (now that machines had been made to copy decorative details). It was in the questioning, analytical period after the shock of the Exhibition, when 'meaningless' and 'absurd' decoration and ornament were noted, condemned and discussed, that the germ of the idea was born that there is an appropriate form for every machine and an appropriate finish for every material.

Jones's preface included thirty-seven propositions, distilled, like La Rochefoucauld's maxims, after years of meditative study:

No. 36: '*The principles discoverable in the works of the past belong to us; not so the results. It is taking the end for the means.*'

No. 37: 'No improvement can take place in the Art of the present generation until all classes, Artists, Manufacturers and the Public are better educated in Art, and the existence of general principles more fully recognized.'

It was the search for these very general principles that had motivated the creation of the Great Exhibition, the first world's fair. It had been so successful (six million visitors in five and a half months) that it was decided to maintain the idea: so the building was moved to Sydenham and the bulk of the exhibits found their way into what was to become the Victoria and Albert Museum.

This process was entirely figurative of the Victorian reverence for education and the commitment to social progress. The School of Design was combined by Henry Cole into the new Museum of Practical Art. It was intended, in the spirit of the age, to be both popular and instructive, quite unlike the British Museum. Cole disliked architects and specified a corrugated iron building, which was designed by Charles Young and Company of Great George Street. Amply suggestive of the practical concerns of this most modern and utilitarian of museums – the first anywhere to have refreshment rooms – the metal building outraged establishment taste.

The museum was also remarkable in that instead of displaying only precious art objects and collectables, it showed badly designed objects, like a kind of inverse academy. The hope was that, for example, a gas bracket 'inappropriately' hidden in a cast convolvulus petal would excite a higher principle. It was to be a useful museum and as it expanded the idea spread: museums serving as laboratories for industry started up in Vienna, Hamburg, and Oslo. The urge to reform the practical arts excited in the 1850s is at the beginning of the direct line which leads to the other movement towards reform, that of the arts.

The reforming ideas which had created the original Museum of Practical Art were similar to those which influenced William Morris and the other rustic luminaries of the Arts and Crafts Movement. Seeking a solution to the problem of what mass-produced products should look like in the first industrial age, Morris and his followers suggested in their pamphlets, books, tracts, poems, and ways of life that elements of an answer might lie in redefining the attitudes to material and to work. John Ruskin, the celebrated art critic, whose social theories were an influence on the Arts and Crafts Movement, had mused wistfully about the days when every artist was a craftsman and every craftsman was an artist. This attachment to quality in manufactures had been lost in the process of industrialization and William Morris went in search of it, producing on the way many fine, dramatically graphic and novel textiles and wallpapers, many mawkish illustrations, and thousands of unreadable words of neurotic-romantic prose.

Nonetheless, the ideas of the Arts and Crafts Movement, embodied by Morris in visionary works such as his *News from Nowhere*, proved to be vastly influential on the Continent, particularly in Germany. It was in this respect that British design exerted its first great influence abroad. Through architectural competitions in Austria and via the books published by a Prussian diplomat, Herman Muthesius, the new English ideas about architecture and its relation to artefacts, to design, and to society became more widely known. When the Deutscher Werkbund was established in 1906 to promote the influence of art in German industry its ideas, although never overtly stated as such, had been drawn very much from those of the English avant-garde artists and designers of a generation before. Indeed, the transference was so complete that it was not until 1916 that England's version of the Deutscher Werkbund, the lacklustre Design and Industries Association, was formed to carry on ideas which, while invented at home, had found more fertile ground abroad.

The laggardliness and general lack of interest which attended the formation of the DIA reflected a malaise in British industry and culture which Prince Albert had tried to improve and is still today a significant influence on economic performance. While at an institutional level the Germans did everything possible to make mass production an economic reality by imposing through the Reichs Kuratorium für Wirtschaftslichkeit a degree of standardization fifty years ahead of its time, in Britain a too-literal interpretation of the ideals and ideas of the Arts and Crafts Movement (which found expression in a slavish and naïve devotion to what were assumed to be craft values) bedevilled the creation of a successful industrial culture. In architecture this same fear of innovation could be seen in, for instance, the British pavilion at the Paris Exposition of 1900 (Fig. 229). Here, when other cultures and countries were imaginatively engaged in finding a means of expression appropriate to the new age, the architect Edwin Lutyens built an imitation of the Jacobean Hall at Bradford-on-Avon.

Because the ruling class in England has consistently looked to the countryside, where, it was believed,

229. The British pavilion at the Paris Exposition of 1900, designed by Edwin Lutyens. An authentic copy of the Jacobean Hall at Bradford-on-Avon and evidence of a consistent taste for the picturesque in Britain

craft values might best be retained and promoted, design for mass production was not easily promoted at the influential levels of society. Indeed, while patronage was enjoyed by art-workers like Charles Robert Ashbee (see p. 233), or manufacturers of sophisticated reproduction furniture like the Barnsley brothers (see p. 233), England had no voice whatsoever during the period when the continental European nations were attempting to formulate a means for accommodating industry into culture. The mood is exemplified by the views and work of the architect and historian Reginald Blomfield, who rebuilt the lower end of Nash's Regent Street in a style that owed its inspiration to the French châteaux of the Renaissance. Blomfield was an establishment figure who became engaged in the vilification of any form of modernism, which he usually damned as being either Bolshevik or Jewish, and sometimes as both. Of the highest exemplars of modern architecture, he could only say that the buildings reminded him of housing prepared for vegetarian bacteriologists.

It was against this background of prejudice that the first exponents of industrial design as a serious profession and a worthy cause had to fight. One such

228. The Skylon, erected on London's South Bank for the *Festival of Britain* in 1951: an attempt to recapture the spirit of 1851 and a dynamic symbol of Britain's hoped-for emergence from economic decline and total war

was Milner Gray, the pioneer British industrial designer, and founder of the Society of Industrial Artists and Designers. This Society was formed in 1930 after more than a year of planning by a self-appointed committee, none of whose members considered himself to be an 'industrial designer'. However, the 1930s was a significant period for the development in Britain of the theoretical (if not practical) basis of the new culture. Magazines like the *Architectural Review* promoted European modernism by employing *émigré* designers like Laszlo Moholy-Nagy, while patrician writers like Philip Morton Shand patiently interpreted modern architecture and design to a native audience which suspected (both at a superficial and at a fundamental level) that modernism was the work of cranky foreign eccentrics. During the thirties the first wave of modern buildings was created in the smarter suburbs of London and on the south coast, and firms like Venesta – where the employees included the young Paul Reilly, later to become the chief influence in the formation of the Design Council – encouraged the architects whom the Nazis had forced out of Germany.

Britain's equivocation in its attitude to modern industrial design can be seen most clearly in the attitudes of the patrons. In Britain there is a huge housing stock of distinguished ancient buildings and successful manufacturers, and businessmen have always been socially encouraged to move into such premises when funds allowed. There was no private market for modern architecture, or for modern artefacts (except among an exclusive group of left-wing intellectuals). It was the institutions, the new BBC and London Transport, who were searching for

an image in the age of the mixed economy and became the patrons of the new designers. London Transport used the distinguished typography of Edward Johnston (Fig. 230) and the refined modern architecture of Charles Holden to give itself one of the most civilized and thorough-going of all corporate identity programmes; and the BBC hired almost every up-and-coming young architect and designer to create the interiors of its new London headquarters at Broadcasting House.

Although the government had responded to the inevitable and created a Council for Art and Industry in 1934, this organization was dissolved during the Second World War, only to emerge again under the Board of Trade as the Council of Industrial Design. This body, the forerunner of today's Design Council, was led from the first by Gordon Russell, the furniture maker from rural Broadway. Although Russell's probity and quality of character and eloquence did much for the cause of modern design, his own immersion in the craft tradition was a hindrance when it came to formulating and anticipating the exact needs of modern manufacturing industry in the modern age. If design means the culture of mass-produced artefacts, British design was not much encouraged by the creation of the CoID. In massive morale-boosting exhibitions such as *Britain Can Make It* (1946) and the *Festival of Britain* (1951), the extravagant optimism of each show served only to emphasize the poverty of ideas and initiative the government was prepared to invest in manufacturing (Fig. 228).

It was in the mid-fifties that the age of 'Pop' began, and the most far-sighted observers and designers realized that the Victorian age had past. Although Britain produced many highly distinguished capital and consumer products – the Vickers Viscount airliner (Fig. 231) and Robin Day's furniture are two familiar examples – the immediacy of mass communications emphasized that Britain's expertise lay more in ideas and information that in manufacturing. For instance, the *This is Tomorrow* exhibition held at the Institute of Contemporary Arts in 1956 showed to an interested public still starved of consumer goods the seductive vulgarity of American consumerism and, thereby, did much to lay the basis for the popular iconography of the later twentieth century. By the 1960s Britain's economic ills had been thoroughly disguised by a miasma, perceived from all positions, of bright mercantile optimism, pop music, fashion, and instantaneous journalism. The Ford Cortina car, named after a ski resort, reflected the opportunities of the first age of jet package tourism

230. The clear, distinguished typeface designed by Edward Johnston for London Transport. 1916

231. The Vickers Viscount airliner, 1954, bridged the gap between the piston-engined DC-3 and the pure jet 707, and defined for a while the shape of modern air transport

just as certainly as its appearance reflected the continuing seductiveness of Detroit (Fig. 232). Meanwhile the boutiques of London's King's Road offered a tinsel celebration of commercial change and immediacy. At the same time manufacturing industry floundered, frustrated at one end by a government concerned only with short-term accounting and at the other by a management educated to be prejudiced against mass-produced artefacts.

During the 1960s the circumstances of manufacturing in Britain were much as they had been during crucial periods in the two preceding centuries. In the eighteenth century the response to the perceived malaise had been to create the Society for the Encouragement of Arts, Industries and Manufacturers. In the nineteenth century it had been to organize the Great Exhibition, and all the contingent institutions and traditions which followed that. In the twentieth century the British response has been to organize, on the basis of the human riches provided

232. Ford Cortina. 1962. The first car to be professionally planned as a marketing concept, combining European efficiency with American style

by the nineteenth-century art school system, the most professional and commercially successful accumulation of independent design consultancies. The first was Milner Gray's Design Research Unit (set up in the thirties), which was followed by Allied International Designers, Conran Associates, Pentagram, Wolff Ollins, Michael Peters, and many others who include among their clients some of the largest international manufacturing and commercial organizations in the world.

233. Moulton bicycle. 1962. An exemplar of popular chic during Britain's pop explosion, it in fact employed radical engineering

It is in some senses a paradox that design, which was assumed by its institutional inventors in the eighteenth century to be a support and a stimulus to industry, flourishes most in a country where industry is atrophied. Yet with the benefits of historical perspective it seems clearer that Britain's real skills as a nation have never really been in manufacturing, but in the origination of ideas and in the innovation of institutions. This applies from the days of the Society of Arts to the flourishing consultancies and prosperous retailers of the 1980s. If at first it seems depressing that design is too much separated from manufacturing, it may be a palliative to consider that success in design is just a matter of thinking. In any new age which involves processing and applying information, thinking and ideas are going to have a greater economic influence than ever before.

Early Britain

BARRY CUNLIFFE

MORE than a quarter of a million years ago, man penetrated that part of the European land mass that was later to become the British Isles. In the beginning he was a hunter, dependent for a livelihood entirely upon his skills in trapping or shooting wild animals and foraging for plant and insect food. Hunting in bands would have left little time for indulging in purely creative activities simply for the joy of the act or product, but there can be little doubt that the simple flint hand-axes, made in tens of thousands by the earliest hunters, were chipped from flint nodules with a skill and a love of regular form that went well beyond the needs of simple utility. Already, then, at this remote time man had begun to show signs of an aesthetic sensitivity that was to develop with a dramatically quickening pace as the centuries passed.

The early stages were slow. It was not until about 40,000 years ago that a species of man indistinguishable from ourselves appeared in Europe at the beginning of the upper palaeolithic period (the later phase of the Old Stone Age). Implement manufacture began to change noticeably as finer chipping techniques were introduced to produce blades, struck from cores, which were then fashioned into tools and weapons. It was in this period, from 40,000 to about 8000 BC, that the first true 'art' appeared on mainland Europe: simple outlines of animals scratched on bones, ivory figurines of fat fulsome mother goddesses, and the staggeringly vivid painted caves of northern Spain and France with their friezes of bison, deer, and horses. The early artists knew their animal prey well and depicted them with an economy of line that never failed to catch the essence of the moving beast. Though these creations were realistic, it is the spirit of the creature that emerges.

Hunters of this period roamed Britain, settling briefly in cave mouths and at open summer camps. Little is yet known of their artistic achievements save for the occasional scratched animal bone, but who knows what future excavation will unearth?

The Ice Ages had passed and from about 8000 BC the climate of Britain began to settle down. The country became clothed with forest, colonizing the bare wastes left by the retreating ice, and man began to adapt to the new environment, using antler harpoons and finely made spears and arrows tipped with tiny chips of flint. This mesolithic period was to last until about 4000 BC. Of its artistic achievement we know very little – there was no metal, no pottery, no woollen fabric; but coloured stones, like amber, were picked up and perforated to be worn, and a variety of animal skins could be sewn together to make attractive clothing; nor should we forget the skills of more modern hunters in wood carving and bark-work. There is no need to suppose that these mesolithic hunters spent their lives in visually impoverished surroundings simply because vicissitudes of preservation have left us little of their material culture.

Late in the fifth millennium BC a process began which was to change Britain out of all recognition. Men who knew the art of grain cultivation and animal herding crossed the Channel from the European mainland and set up home in these islands, clearing land for their fields and beasts and thus beginning the process of taming the countryside that is still with us. The food-producing economy of the neolithic period, as it is called, had two dramatic effects on human society: men, now rooted to the land, no longer required to spend all their energies in the quest for food; and moreover, they could now begin to live together in sizeable communities. The results were that the surplus energies realized were absorbed by the emergence of new crafts and the creation of communal works of architecture.

A stable food-producing economy soon led to a great increase in peasant crafts: sheep produced wool which could be spun, dyed and woven, while the increasingly static life of the community encouraged the manufacture of pottery which could be kept and used in the home. In addition leather work, wood

carving and basketry, crafts already well established, would no doubt have continued to develop. Very little organic material has survived in the archaeological record but pottery lasts well. It shows that these early farmers soon acquired mastery of the technological problems and went on to decorate their vessels in a variety of ways, usually by impressing the leather-hard clay with sticks, bone ends or cords to give a lively texture to the pot surface before firing it. At first the forms were simple, copying leather vessels or baskets, but later in the third to second millennium they became more sophisticated, with furrowed and moulded decoration incorporating lozenge and spiral motifs. A few very simple chalk carvings, usually phallic symbols but including one example of a grotesquely fat female from Grimes Graves, are a pale reflection of what was probably a lively wood-carving tradition about which we know nothing.

In the thousand years, roughly 3500–2500 BC, the first great communal monuments were built. There were ditched enclosures, called causewayed camps, which probably served a range of functions – religious, social, economic, and defensive; and communal tombs, the long barrows of southern England and the

234. Carving 'pecked' into one of the upright stones in the megalithic tomb of New Grange, Ireland. Early 2nd millennium BC

chambered tombs of the west and north. Together these remarkable monuments, and the ceremonial centres (or henge monuments) which developed slightly later in the third millennium, represent the communal efforts of a society beginning to coalesce in tribes. These monuments symbolized the strength of the social group – using stone, earth and wood they are the first true architecture in Britain (Fig. 236). To what extent they were decorated must remain a mystery. Upright timbers could well have been carved and painted but nothing yet survives,

235. Breast-plate for a horse (or, less likely, a human), in gold plate embossed from behind. From a barrow at Mold, Clwyd. Early 1st millennium BC. London, British Museum

though some hint of the possibilities is given by carvings found on the upright stones of Irish tombs: spirals, zigzags, chevrons, and even faces were pecked with great labour into the faces of the stones (Fig. 234). The magic symbolism which these simple designs represent is lost to us.

Just before 2000 BC society shows signs of a major readjustment. Many of the old communal monuments had already gone out of use (though some of the henge monuments continued) and burial rite changed from the use of communal tombs to single graves often under round barrows. It was also at this time that the working of copper and its alloys was introduced into the Islands. Traditional crafts continued but the technology of metalworking opened up an entirely new range of creative possibilities which flourished in the period 2000–1500 BC under the patronage of a group of powerful chieftains who emerged to control Wessex. Craftsmen working for their masters produced a quite remarkable variety of

236. Avebury, Wilts. The massive enclosing earthwork is built in chalk rubble quarried from the ditch; the standing stones are sarsens local to the area. *c.* 2000 BC

beautiful things. Gold cups finely corrugated, gold plaques to decorate dress (Fig. 235), bronze daggers with minute gold pins set into the hafts, complex lunate-shaped necklaces made up of beads and plates of amber or jet, amber cups and bright blue beads of faience. One can fairly say of this period that it saw a revolution in technology, in craft, and in creative skill. An array of new and exotic materials became available, often brought from hundreds of miles away, and man responded with an inventiveness and an excitement that led to the creation of some of the most elegant but restrained masterpieces ever to be made in Britain.

By the end of the second millennium man's mastery of his materials was complete. Copper could now be alloyed with tin to provide bronzes with different qualities suitable for casting in complex moulds, using the lost wax process, or for beating into items of sheet bronze. The skills of the bronzesmith reached their peak in the period *c.* 1000–600 BC by which time elaborate decorated shields, buckets, cauldrons, and even musical horns were being made in workshops throughout the country.

The introduction of ironworking into Britain in the seventh century BC and the gradual development of the technique in the following centuries did not adversely affect the skill of the bronze workers. Iron tools and weapons soon came to replace those of bronze but ornaments and vessels continued to be made in the traditional metal.

The period from about 2000–400 BC was, then, a time of discovery and development when new materials came generally into use and craftsmen developed techniques and skills to exploit them to the full. It was also a time when the demands of the aristocracy, and the patronage they could provide, led to the creation of items of exquisite quality. But reviewing the range of things that have survived in the archaeological record there is little to lift them from the level of high craft to that of art – no stark originality, no exuberance, simply refined technical skill.

All this was to change in the centuries following about 400 BC, but to understand British developments it is necessary, briefly, to extend our horizons to mainland Europe. The sixth and fifth centuries saw

248

the emergence of a vastly wealthy aristocracy in the heart of Barbarian Europe, centred in eastern France and southern Germany. The chieftains who ruled here were able to control the flow of commodities, such as amber, gold, and slaves, that the Mediterranean classical world so desperately needed. In doing so they not only accumulated wealth but acquired a taste for southern luxuries such as wine and all the accoutrements of the wine-drinking ceremonies: cups, strainers, jugs, and great mixing bowls. These items were trans-shipped from the Mediterranean to the Barbarian courts. To these Greek and Etruscan products was added another influence – that of the East. To understand how this came about is difficult but one explanation may lie in the fact that from 520 to 480 BC the Persian armies were roaming the western shores of the Black Sea in their attempt to penetrate and subdue Greece. A great mixture of motifs – Greek and Scythian to which Persian was now added – were practised by the craftsmen of these Black Sea regions in the service of their masters. In the turmoil of the time it is possible that some artisans, immersed in the animal art of the East, moved westwards into the courts of the central European chiefs. At any event, in the fifth century there emerged in southern Germany a highly original art style combining classical, native, and eastern elements. Originally aristocratic, it developed and spread widely throughout Barbarian Europe to become the first truly pan-European style. It is called Early Celtic Art after the ethnic name by which the Greeks knew the barbarians of these parts.

The Celtic art style began to appear in Britain soon after 400 BC and by the beginning of the second century had established itself in a truly British guise. Celtic art was an art of curves, of growing things. Sinuous lines blossomed and bifurcated, stretched themselves and recurved. It was an art of intense energy coiled ready to spring just like the Celt himself – a remarkable reflection of the people as we know them from the writings of contemporary classical observers.

During the first century BC southern Britain began to come under the influence of the Roman world which was now spreading its control throughout France. First of all traders arrived on our southern coasts. Later in 55 and 54 BC the Roman armies led by Caesar spent two summers campaigning in the south-east and, once Gaul had been conquered, trade across the Channel intensified until finally, in AD 43, the armies of Claudius arrived to stay. This century of Roman influence before the Roman occupation of Britain began had a significant effect on the later

237. Model boat bearing warriors made of pinewood. Possibly a votive offering. Found in Roos Carr, Holderness. Early 1st millennium BC (?) Hull, Archaeology Museum

stages of artistic development in the country. The old freedom was abandoned and, while much of the grammar of Celtic art remained, a new symmetry was introduced. Instead of flowing across a surface as they had done, motifs now reflected themselves across a central line. But the Celtic spirit was still in control and as if to compensate for the new formality enamelling became popular and on some objects blobs of bright red glass were squeezed into carefully-made compartments in the bronze to add to the flashing brilliance of the shield, helmet, or horse trappings. Decked in this war-gear the chieftains would have awaited the Roman armies in AD 43.

The Roman conquest of Britain and the four centuries of Roman control which followed upon it brought Celtic art virtually to an end, at least in what was to become the civilized south-east; but to the north in Scotland, and to the west in Ireland and to a lesser extent in Wales, the old Celtic spirit survived to flower into the Later Celtic Art style of which the Book of Kells may fairly be regarded as the culmination. But within the Roman province old skills lingered for a while. In Yorkshire and the north dragonesque brooches continued the spirit of abstract Celtic animal art; and even in the New Forest, where potters were producing pottery for the Roman urban market, one of them drew a fat female on an unfired pot lid he was making for his own use, with a few simple scrolls exactly as a free Celt might have

done several centuries earlier. Examples of this kind are a reminder of the hybrid nature of the Romano-British population.

At the time when Britain became part of the Roman Empire its buildings were of timber, wattle, and thatch, its fortifications of earth and rubble, and its roads winding muddy tracks. Yet within half a century of the invasion masonry buildings, some of colossal size, were already to be seen in many parts of the country, forts and fortresses with regular masonry walls and gates were beginning to appear, and the countryside was criss-crossed with arrow-straight metalled roads linking newly planned towns. Development at this rate must have been difficult for the older inhabitants to come to terms with, yet it had come to stay.

Many new craft and artistic skills had to be introduced into the new province to enable Romanization to take root. There were technicians and engineers within the army who could lay out roads or supervise the erection of new town centres, but other skills were provided by the host of artisans who flowed into Britain in the wake of the advancing army to satisfy new tastes and new demands. At Fishbourne, close to Chichester, a local landowner, quite possibly the native client-king Cogidubnus, began to erect a vast palatial building which was eventually completed in the seventies of the first century. To decorate it he required mosaicists, stucco workers, marble cutters, stone carvers, and wall-painters, all practising crafts totally alien to Celtic tradition and virtually unknown in the young province. We can only suppose that men drawn from Gaul or even Italy were brought in specially for the job. People like this, seeing that there was a wide open market for their skills, may well have stayed and set up specialist schools taking on native apprentices. In this way, by the end of the first century AD, a new generation of native craftsmen had been trained in Mediterranean tastes and techniques.

That there was a ready market for their skills is clear. Even as early as the late seventies the Roman historian Tacitus tells us how the governor Agricola went out of his way to encourage the natives to adopt Roman manners. They were quick to learn and ready to embrace smart new ways. Once educated, the sons of local chieftains, now no doubt serving as magistrates in the newly founded towns, provided the consumer demand necessary to keep the artisans in work.

Roman consumer durables flooded the British markets: silver and bronze tableware, bright red Samian pottery from Gaul, vari-coloured glass vessels from as far afield as Egypt, and Roman styles of clothing: 'The toga', says Tacitus, 'was everywhere to be seen.' Marble and bronze statues were also imported to adorn public buildings. The assault on native traditional taste must have been staggering.

The cosmopolitan nature of Britain and its art during the Roman era sometimes makes it difficult to distinguish imported works from local, and amongst local products it is impossible to be sure of the ethnic origins of the manufacturers since the number of immigrants must have been considerable, but a range of British products can be distinguished.

The consumption of pottery was on a large scale. To begin with the demand was met partly by importation and partly by local small-scale production: there were even attempts to establish kilns near Colchester to produce a British copy of the imported Samian ware, but quality could not be maintained and the enterprise failed. By the late third century many small producers had gone out of business, while the market began to concentrate in the hands of a few large combines. One of these, in the Nene Valley, turned out a wide range of quality products including some of the finest local pottery to be made in Britain, elegant beakers decorated in barbotine with hunting scenes of hounds chasing hares, chariot races, and a range of other subjects often incorporating plants with long tendril-like leaves. The quality of the drawing and sense of movement would have gladdened the heart of any Celt and it is tempting to suppose that here we may be seeing something of the native spirit reasserting itself.

Another local industry of a rather different kind developed on the Isle of Purbeck, in Dorset, where a fine black shale, named after the village of Kimmeridge, could be dug out of the cliffs. In the pre-Roman period the shale had been used to make bracelets and elegant vessels. Roman taste allowed the production range to be extended to include the carved legs of low tripod tables found widely throughout the country. Though carved with animal heads there is nothing native about them, they are purely Roman in style – an example of how a native industry could adapt its output to suit the market. Much the same can be said of the jet industry based in York where lumps of Whitby jet were carved into pins, amulets depicting deities, or portraits of individuals. While the style of carving is often primitive the concept is purely Roman.

It is in the work of the Romano-British bronze-smith that most native spirit can be seen. We have already mentioned the case of the very Celtic-looking

dragonesque brooches of northern Britain. To these can be added a group of West Country brooches decorated with bright enamels much as the horse trappings of the pre-Roman period. There are also many little bronze statuettes, mainly of gods, which are distinctly Celtic in appearance with hair brushed straight back, lentoid eyes and wedge-shaped noses. Here surely we have a mixing of Roman iconography with native concepts of the human form.

In contrast the pewter industry based in the countryside around Bath, which developed first during the third century, owes nothing to tradition. Pewter was virtually unknown in the pre-Roman period, and the range of vessels produced, plates, bowls and jugs, was suited to the Roman table rather than the native feast. It is tempting to see it as the result of entrepreneurial activity designed to provide those with Roman pretensions, but insufficient cash, with a table set in imitation of the more desirable silver.

Before the conquest there was little tradition of stone carving in Britain. A few crudely carved 'Celtic heads' may have come from this period but their dating is highly speculative. Once the army was established all this changed, for immediately there was a need for tombstones carved in the Roman manner. One can only suppose that competent sculptors arrived in the wake of the troops to supply the need. Suitable stone would have been sought out, quarries opened, and blocks hauled to the workshops. Gradually, as the taste for Roman manners gained sway, a civilian market developed which was further enhanced when public buildings began to be erected in the newly founded cities. The sculptors were evidently kept busy, as the rich haul of altars, tombstones and monumental sculptures in our museums vividly demonstrates (Fig. 238).

One source of stone much favoured then as now was the oolitic limestone of the Cotswolds, the best varieties of which were available in the region of Bath. It is hardly surprising therefore that one of the richest collections of sculpture in the country should come from Bath and its region. From inscriptions found in the city we know of two sculptors by name, Priscus, son of Toutius from Chartres, and Sulinus, son of Brucertius. Sulinus, who calls himself a sculptor, set up an altar to the Suleviae – probably local goddesses of the spring waters. By fortunate coincidence an altar dedicated by the same man to the same goddesses was found in Cirencester, twenty-eight miles north of Bath, together with other carved stones, all in fresh condition, two of which depicted triads of female deities. Here, presumably, was

238. Boy charioteer carved in high relief from local limestone. 2nd or 3rd century AD. Lincoln Museum

Sulinus's stonemason's yard where, among other products, he turned out the altars which he and his fellows chose to erect to solicit the goodwill of their favourite local gods.

There would have been a great deal of work for men like Sulinus and Priscus in Bath because the city possessed remarkable hot mineral springs, sacred to the goddess Sulis Minerva, which were renowned throughout the Roman world. The main spring, now the King's Bath, was contained within a reservoir around which there developed a large complex of monumental buildings: a vast bathing establishment to the south and a classical-style temple to the north facing another building, either a forum or, more likely, a theatre. Although the bathing establishment was a simple plain building built with a stern solidity typical of the late first century AD, the temple and its ancillary buildings were highly decorated and continued to be improved in similar vein throughout the Roman period. Stylistic considerations have suggested that the temple itself, with its famous Gorgon's head pediment (Fig. 239), was probably built by craftsmen from eastern Gaul in the late first century, but the later buildings, all elaborately carved, have a more provincial look about them. They could well have been erected by local men like Sulinus.

Roman Mosaics

BARRY CUNLIFFE

THE art of mosaic was unknown in Britain before the Roman conquest; but in the wake of the armies skilled craftsmen from Gaul, possibly even from Italy, began to arrive on British shores. One of the earliest projects to absorb them was the great palatial building being put up at Fishbourne, near Chichester, in the seventies of the first century AD. Here there were at least fifty rooms to floor. At this time cool black-and-white designs, suitable for a hot Mediterranean climate, were fashionable. Patterns were intricate, repetitive, and kaleidoscopic, and the workmanship quite as good as much of that found at Pompeii.

Fishbourne and other great late first-century buildings would have set the standards for all who aspired to Roman culture. Soon local schools of mosaicists set themselves up in the major cities and, using pattern books, were able to persuade clients to select more colourful classical compositions. The early second century saw the owners of Fishbourne choosing a small floor with a Medusa head in the centre and another more elaborate floor with a cupid riding a dolphin surrounded by sea beasts (Fig. 1) – suitable motifs for a seaside location. Meanwhile in Verulamium (St Albans) an elegant shell mosaic (Fig. 2) and another with a lion carrying the bloody carcass of a freshly killed stag reflected the varying tastes of two local residents.

The greatest period of Romano-British mosaic art came in the time of prosperity in the early fourth century. The demand was so great that schools of mosaicists based on towns like Cirencester in Gloucestershire and Dorchester in Dorset were kept busy serving the now affluent country landowners. One of the greatest products of the Cirencester masters was the magnificent Orpheus floor at

ABOVE 1. Mosaic with a cupid riding a dolphin. From the villa at Fishbourne, near Chichester. Late 1st century AD

BELOW 2. Scallop shell mosaic from a Roman town-house at Verulamium. 2nd century AD. St Albans, Verulamium Museum

OPPOSITE TOP LEFT 3. Part of the mosaic from Hinton St Mary, Dorset. The chi-rho monogram suggests that the figure is Christ. 4th century AD. London, British Museum

OPPOSITE BOTTOM LEFT 4. Dido and Aeneas. Detail of a mosaic from Low Ham, Somerset. 4th century AD. Taunton, Somerset County Museum

Woodchester with its friezes of brilliantly drawn animals (Fig. 6). The most famous product of the Dorchester school was the enigmatic mosaic at Hinton St Mary depicting the bust of a young man, presumably Christ, against a chi-rho – the Christian monogram (Fig. 3). Whether or not the villa owner appreciated the symbolism any more than he would have understood the intricacies of Roman mythology remains uncertain.

There were many highly accomplished works of art created by these mosaic masters but it is the naive primitives who laid the floor at Rudston (Yorks.), with its charming, manic, and ill-endowed Venus gracing the centre panel (Fig. 5), that remind us how in many parts of Britain sophisticated Roman ways were barely skin deep.

BELOW 5. Venus mosaic from Rudston, Yorkshire. 4th century AD. Hull, Archaeology Museum

FAR RIGHT 6. Tiger, stag and leopard from the mosaic at Woodchester, Glos. 4th century AD

239. Gorgon's head, from the pediment of the temple of Sulis Minerva in Bath, Avon. Carved from the local Bathstone at the end of the 1st century AD. Bath, Roman Baths Museum

The elaboration of town centres like Bath provide a vivid reminder of the peace and prosperity of the province. Before Roman government was imposed on Britain the surplus wealth of the country was dissipated by warfare and absorbed by an aristocracy in social practices which required conspicuous consumption such as elaborate feasting, wasteful burial rituals, and so on. The Roman presence altered all that. One important change was that the population increased with the influx of troops, administrators, craftsmen, and traders. These consumers had to be maintained, while the government, by requiring taxes to be paid, put an additional burden on the economy. Thus the land had to be made to yield an even larger surplus and the mineral wealth of the country had to be exploited to the full. The Roman peace encouraged this to be done and under efficient management Britain became prosperous. The system allowed individuals to accumulate wealth but it also provided new standards by which personal affluence should be displayed. On one level a man would wish to improve his house by adding bathrooms, having walls repainted, laying mosaics, and building on new wings — there was a desire to keep abreast of fashion — but on the other the responsible citizen was expected to contribute to the well-being of his city, to erect statues, improve water supplies and contribute to other civic building projects. In other words greater prosperity meant increased investments in the various arts and crafts. Schools of mosaicists grew up in several major towns and no doubt there were similar firms of wall painters available for hire; stonemasons were readily on hand and every city would have harboured hosts of craftsmen working in their back-room workshops and selling their wares from their front-room counters. More exotic commodities like Nene Valley pots or Kimmeridge shale tables would have been on sale in the larger shops and markets: under the Roman peace productivity burgeoned.

The second half of the second century saw the beginnings of the economic decline in the Roman world which lasted throughout much of the third century and was exacerbated by a general political instability. For Britain the fourth century seems to have been a time of recovery and prosperity. It was now that the country houses reached the peak of their development, many of them being fitted out afresh with elaborate polychrome mosaics depicting a range of mythological scenes suitable to grace the floors of an educated aristocrat. For those in the south and east, however, a foretaste of what was to come was felt when the activities of Germanic pirates, who had been a nuisance as early as the beginning of the third century, began to intensify as the century proceeded. A chain of forts was gradually constructed to protect coastal regions between the Wash and the Solent, but intermittent raids continued culminating in a devastating attack on the province in AD 367 when barbarians from the coastal regions north of the Rhine mouth combined with those north of Hadrian's Wall to wreak havoc in the land as far south as London. The situation was restored but things were never the same again.

Throughout this period of growing insecurity the Roman administration adopted the policy of buying off the Germanic hoards by offering some of them land within the provinces close to the frontiers, where they were expected to act as a militia repelling further inroads. Some were absorbed into the Roman army and used as garrison troops. These policies were operated in Britain with the result that the frontiers, including the south-east coasts, and even some inland cities, gradually took on a more and more Germanic appearance. There is good archaeological evidence that these northern troops wore uniforms decorated with buckles and other fittings that were distinctly Germanic in style. A new alien strain was thus being added both to the British population and to its art styles.

Germanization increased apace. More and more mercenaries were brought in to protect the province

as the threat of raids from across the North Sea built up. Added to this, intrigue and rebellion in the army led on several occasions to large detachments of the British field army being taken to the Continent to fight, never to return. In 410 central government in Rome washed its hands of Britain, and within thirty years the change was complete: large parts of south-east Britain were now in the hands of settlers who had migrated from their homelands between the Rhine and the Elbe.

The total breakdown of Roman government meant the collapse of the economic system and with it all types of centralized production and marketing. Within a few decades Britain had regressed to a social and economic situation reminiscent of 500 years earlier, the main difference being that whereas before the culture and art were more or less uniform and Celtic, now the country was divided between a Celtic North and West and a Germanic South and East.

The north and west, including Ireland, soon began to produce a wide range of highly distinctive works of art in styles reminiscent of the Celtic past. Pen-annular brooches, a type well known in the prehistoric period, continued in use particularly in Ireland where they were often elaborately ornamented with coloured enamel. These brilliant pieces would have been worn as dress pins on the shoulder to hold the cloak in position. The basic form continued to be made well into the ninth century and even later, and was subjected to the most complex display of decorative skills. One example, the famous Tara brooch, dating to about AD 700, was made of gilded bronze ornamented with gold filigree, amber, and amethyst as well as enamel. The gold filigree work involved an energetic interlacing of intertwining animals and spirals – a theme much loved by the immensely skilled Irish craftsmen. Another famous piece, the Ardagh chalice, was made of silver, again encrusted with gold filigree, enamels, and gilt bronze but in addition to this the surface of the vessel is enlivened with an inscription picked out in reverse by finely punching the spaces between the letters, while its stem is chip-carved – a technique which gives the flowing and rectilinear designs innumerable facets to reflect the light. These two early eighth-century pieces display the full range of the Irish metalworkers' craftsmanship at its elegant best.

This same love of intricate interwoven patterning is also to be found on a number of the Irish stone crosses: indeed so similar are the motifs that there can be little doubt that the stone carvers were deliberately copying decorative metalwork. Although no indisputable evidence survives, it is tempting to suggest that the crosses were once elaborately painted in imitation of the gold and enamel.

Interlace, often intertwined animals, and bright colour are again to be found in profusion in the margins of the illuminated manuscripts which began to be produced in the Irish monasteries of this time. The uniformity of style which pervades the early Christian art of Ireland must, in great measure, be due to the unifying effects of Christianity as a patron for the arts, but it owes much to the unbroken Celtic tradition going back into the last centuries of the pre-Christian era.

Wales and Scotland shared much of this Celtic fringe artistic revival partly because of their common Celtic heritage, surviving largely untouched by the Romans, and partly through the movements of people (Fig. 240). Large numbers of southern Irish settled in Wales, while the Scoti from northern Ireland moved into the west of what is now Scotland, eventually expanding eastwards until, under their king, Kenneth MacAlpine, they succeeded in conquering virtually the whole of the country in about AD 850. One of the tribes they overran in the east of Scotland were the Picts – the 'Picti' or 'painted ones' as the Romans called them – an indigenous people descended from prehistoric ancestors. The Picts produced a remarkable if enigmatic art, carved on boulders, pagan at first but in its later stages Christianized. The motifs ranged from geometric symbols to lively representations of fish, birds, and larger mammals. Remembering the name by which the Romans knew them, it is not impossible that some of these symbols were copies in stone of the motifs with which they painted or tattooed their own bodies.

Pictish art declined after the conquest by the Scoti as Christianity began to take a firmer hold. From great monastic centres, like that on the island of Iona, knowledge of Celtic Christianity was spread southwards by missionaries into northern Britain. New monastic establishments like Lindisfarne, off the Northumberland coast, were established to become the centres of patronage for the arts as well as the focuses for further missionary zeal. In this way the northern and western Celtic fringes of Britain became part of a single cultural province cemented by its own brand of Christianity and sharing the same artistic traditions.

In the south-east of Britain, that is the Saxon-dominated part of the Islands, artistic development took a different, if parallel, direction. Anglo-Saxon art of the pagan period was a complex mixture of styles but two distinct threads may be recognized: the classical influences of Rome contributed the tech-

ABOVE 240. Penannular brooch of copper alloy inset with red enamel. Found in the Roman sacred spring in the centre of Bath, Avon. 3rd–6th century AD. Bath, Roman Baths Museum

RIGHT 241. The Alfred Jewel, with the inscription 'Alfred had me made'. From Athelney, Somerset. 9th century. Oxford, Ashmolean Museum

BELOW 242. Brooch from Kingston Down, Kent. Cloisonné, inlaid with garnet, glass, white shell and gold filigree panels. Early 7th century. Liverpool, Merseyside County Museum

OPPOSITE 243. The Sutton Hoo helmet. One of the objects buried in the tomb of a 7th-century king at Sutton Hoo, near Woodbridge, Suffolk. Bronze. London, British Museum

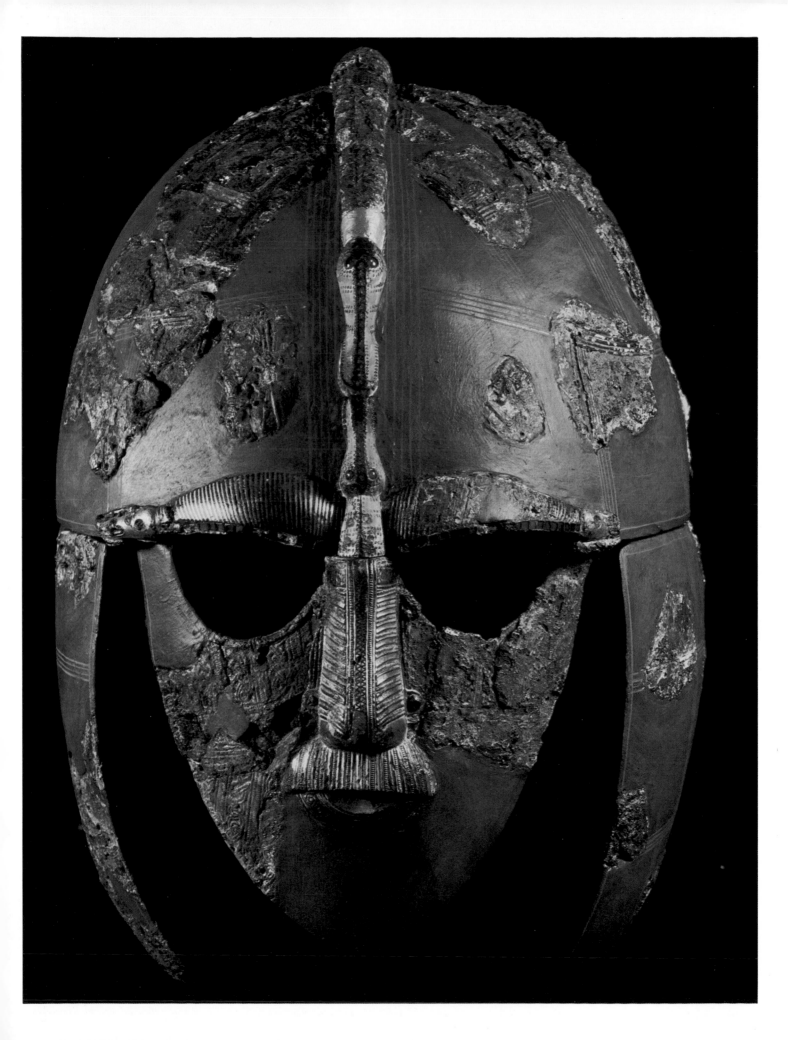

The Celts

BARRY CUNLIFFE

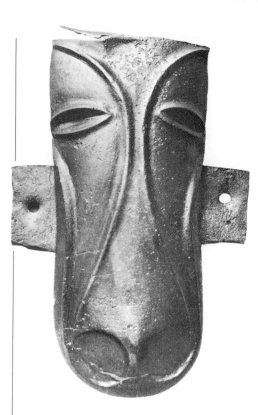

In the four centuries before the Romans there must have been many schools of craftsmen at work in Britain producing armour for the warrior aristocracy. One such school, based somewhere in the east of England, made a number of exquisite pieces – decorated shield bosses, sword sheaths, and parade helmets for the ponies who, yoked together, would have pulled the Celtic war chariots. These craftsmen were masters of *repoussé* decoration, beating up sinuous and bulging forms from the underside of a bronze sheet and enhancing them with carefully controlled incised motifs. It was art for the rich: such parade armour was hardly functional, but it would have suited the flashy arrogance of the boasting Celt.

While many of the finest items were made for this aristocratic market, Celtic art seems to have penetrated to all levels of society. Even simple home-made pottery from various parts of southern Britain was ornamented with curvilinear patterns drawn on the vessel side with a blunt point before firing. In the West Country, particularly vigorous styles developed, some of the best examples being found at a marsh-side site near Glastonbury. The waterlogged conditions of the archaeological layers here meant that much organic material was preserved, including several turned wooden bowls decorated in a manner similar to the pottery. Their survival is a reminder of how much we have lost on other sites.

By the first century BC iron had become plentiful and the smith had begun to break away from the monotony of producing simply tools and weapons. He experimented with more exciting forms suitable for the hearth of a chieftain – the cauldron chain by which the vessel was suspended over the fire, and the fire dogs to support the logs and roasting spits. Some of these fire dogs are masterpieces of blacksmith art with their simple recurved animal head-terminals.

Animals were evidently a much-loved element in Celtic art. Helmets often had model boars along their crests, the boar being a symbol of strength. Bucket handle attachments were frequently made in the form of ox heads, while many of the more abstract designs incorporate elements of birds or simply faces. This love of fleeting animal life, appearing and disappearing from more complex designs, led the great art historian Paul Jacobstahl to refer to it as the Cheshire cat style!

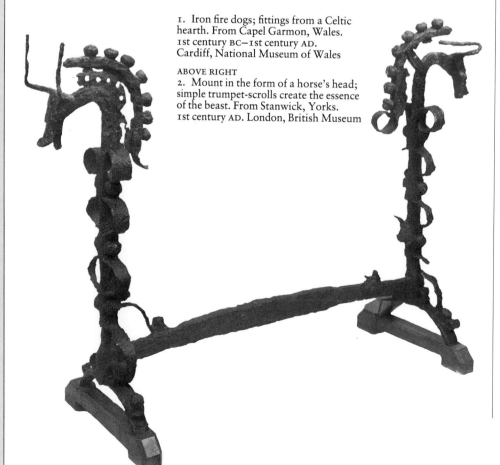

1. Iron fire dogs; fittings from a Celtic hearth. From Capel Garmon, Wales. 1st century BC–1st century AD. Cardiff, National Museum of Wales

ABOVE RIGHT
2. Mount in the form of a horse's head; simple trumpet-scrolls create the essence of the beast. From Stanwick, Yorks. 1st century AD. London, British Museum

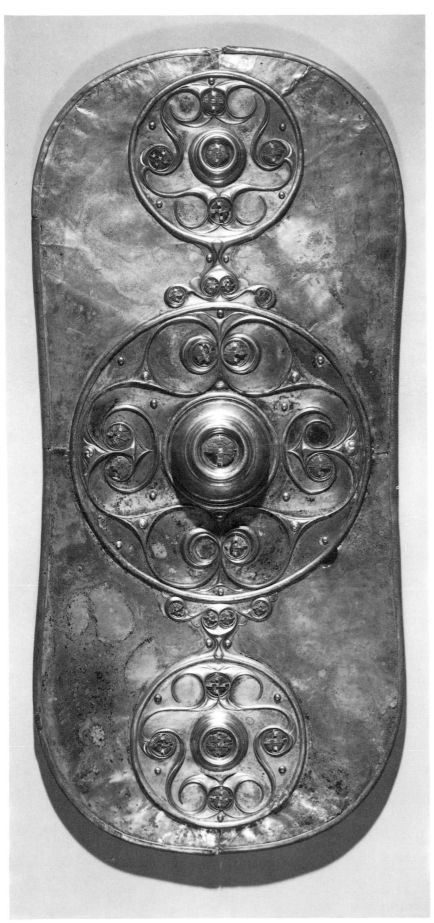

3. Display shield dredged from the River Thames at Battersea. Bronze, inset with red glass. Early 1st century AD. London, British Museum

4. Neck torque found at Ipswich, probably made in eastern Britain. Gold. 1st century BC. London, British Museum

5. Celtic coins depicting horses, a recurrent motif ultimately derived from a chariot team illustrated on coins of Philip of Macedon. Twice actual size. 1st century AD. London, British Museum

nique of chip-carving, popular along the Rhine frontier, and a love of animal ornament; while the Celtic and Germanic fringe of Britain and north-western Europe added techniques of polychrome jewelling and abstract linear motifs. The contributory elements were much the same as we found in the Celtic west in Ireland, but the mix was different and the resulting products unique. Much of the best pagan Saxon jewellery incorporated animal motifs integrated intimately with the overall patterning. As the archaeologist and art historian Sir Thomas Kendrick put it, 'The creature loses its zoological reality and is converted to a mere pattern. Heads and legs, tails and teeth are mixed together into an attractive pot-pourri of confusion which covers every square inch of the surface of the object.'

Brightly coloured jewellery was much prized. In the more luxurious pieces a base plate, usually of precious metal, was set with amethysts, garnets, blue or green glass, and white shell or coral, held in place in small compartments built up in the metal (Fig. 242). This cloisonné technique was further enlivened with filigree ornament using fine gold wires. The overall result was lively, sometimes garish, and deeply unclassical. The techniques of pagan Saxon jewellery, introduced in the fifth century, developed their own distinctive styles in a number of regional schools which flourished in the sixth and seventh centuries, but even after Christianity spread throughout the south and east and valuable objects were no longer buried with the dead (Fig. 243), the jewellers' skills continued to be employed, culminating in one of the finest of our Anglo-Saxon pieces, the Alfred Jewel, made in the ninth century and, as its inscription tells us, under the authority of King Alfred himself (Fig. 241).

Roman Christianity (as distinct from the indigenous Celtic Christianity of the north-west) was introduced to the pagan Anglo-Saxons by St Augustine, who landed in Kent in AD 596. As in Ireland the early Christian communities, once established, proved to be a considerable spur to artistic development. The art of illuminated manuscripts soon developed (the earliest Anglo-Saxon example is thought to be the Book of Durrow produced in Northumbria soon after AD 675), drawing upon inspirations from the Mediterranean and from the Celtic west, as well as from native Anglo-Saxon styles. In parallel the idea of the carved stone cross spread into Anglo-Saxon regions, probably from the Celtic fringes, and took root in many parts of the country, in particular in Northumbria where an especially vigorous and skilled school was established.

By the eighth century the whole of the British Isles, though still split into many small kingdoms, was now sharing in a broad artistic tradition. It was a mongrel art caused by an interbreeding of Mediterranean, Celtic and Germanic ideas and like the people themselves, it exuded a sturdy vigour that was to form the distinctive basis of the British nation.

North America: The British Legacy

JAMES AYRES

WHY single out North America? The answer has to be because in no other part of the English-speaking world has the British cultural inheritance been transformed into something quite independent. In North America the arts of Britain survived and developed by adapting to conditions that were new to them. They became American. How then did the first settlements evolve as their position was consolidated? How were ecclesiastic, civic and domestic buildings furnished? What of painting and sculpture? The whole process may be viewed as a 'controlled experiment' over a period of four hundred years.

In 1587 the first serious attempt to found an English settlement was begun at Roanoke in present-day North Carolina. By 1591 all 177 'planters' had vanished. In 1607 Jamestown in Virginia was successfully established and was followed in 1620 by Plymouth Plantation in Massachusetts. Of the contemporary descriptions of these events none is more illuminating or more magnificent for the splendour of its language than William Bradford's account *Of Plymouth Plantation*: 'And for the season it was winter, and they that know the winters of that cuntrie know them to be sharp & violent, & subject to cruell & feirce stormes, deangerous to travill to known places much more to serch an unknown coast. Besids, what could they see but a hidious & desolate wilderness, full of wild beasts & willd men? ...' The earliest shelters constructed at Plymouth plantation were the so-called 'English wigwams', surely one of the first products of this transatlantic marriage to resemble both parents. These 'wigwams' incorporated a chimney into an otherwise American-Indian structure. In Charlestown in 1630 a group of settlers 'were for some time glad to lodge in empty Casks to shelter them from the Weather, for want of Housing'. In Jamestown they sheltered themselves in 'cabbins and holes within the grounde'. These were, however, temporary expedients. In general the earliest settlements in the 'wilderness' may have been primitive but they still needed urban support. The English colonies in Virginia and New England were as dependent upon London as were the 'Planters' of Ulster, a relationship paralleled by the Patroons of the New Netherlands with their reliance on both old and New Amsterdam (founded in 1625). The exigencies of the moment may have resulted in extraordinarily basic conditions at first, but in the long run these communities were not particularly provincial, colonial though they undoubtedly were.

Most of the characteristics of the smaller English house had completed their evolution by the time that these settlements were being established. Consequently domestic architecture in British North America does not include examples of the earlier sequences in this development, such as the central open hearth which survived in remote parts of the mother country down to the early twentieth century. Even the 'luxury' of glass in window openings was known to the first colonists, although most window panes were imported well into the eighteenth century. (The attempt to found a glass-house in Jamestown as early as 1608 shows the importance attached to this commodity.) The sponsors of these first settlements, including those who in religious terms were non-conformists, were members of the mainstream of British life and their standards set the tone if not always the quality of the colonists' way of life. With the virgin forests of the New World before them, timber – both for framing houses and for cladding them – remained the material used by the house-wrights of Massachusetts; but in Jamestown, at least, bricks were in use by 1611 for the ground-floor walls of some houses. Bacon's Castle (*c.* 1655) could, in its use of brick and with its 'dutch gables', be mistaken for a small manor house in East Anglia of perhaps twenty years earlier. An even more striking example of stylistic time-lapse is Newport parish church at Smithfield (Fig. 261), a brick structure of 1632 with simple tracery windows and crow-stepped gables.

In eighteenth-century Williamsburg, the capital of

244. St Paul's Chapel, New York City. Designed by Thomas McBean and built 1764–6 (the spire and portico added 1794–6); the influence of James Gibb's design for St Martin-in-the-Fields, London, is obvious

Virginia from 1699 to 1779, a new variant of English Baroque appeared. It is there, in Bruton parish church, that an interior may be encountered which resembles one of the City of London's churches. Also at Williamsburg the College of William and Mary (built 1695–1702) has been associated with Christopher Wren, and while the bones of its interior arrangement of chapel and great hall bear some resemblance to the Royal Hospital, Chelsea, other features are rather awkward. The steep pediments that cap the dormer windows do occur in Britain but they are distinctly provincial and far removed from the sophistication of Wren. The Capitol (built 1701–5) and the Governor's 'Palace' (built 1706–20) at Williamsburg appear in their reconstructions (of the early 1930s) somewhat Germanic, despite their sash windows. All these buildings are constructed in brick, a material also used at Stratford Hall (c. 1725), Westmoreland County, Virginia. Here the monumental

external elevations resemble the theatrical but nonetheless architectural qualities of Vanbrugh. Despite the relative importance of brick in the South compared with the North, much of the brick used in Colonial times was imported. Field stone was extensively used for complete elevations in the Middle Colonies, especially in Pennsylvania, and in the North surface boulders provided timber buildings with a damp-proof plinth. In the Southern colonies in the seventeenth century, primitive 'earth-fast' or 'hole-set' buildings were constructed which closely resemble the underlying principles of stave construction of Saxon and Viking Europe.

Timber remained the most important single building material throughout North America, and outside the cities so it remains. The persistence of words now obsolete in Britain, relating to carpentry rather than to masonry and brickwork, shows the strength of that tradition there. Among these are the 'summer beam' and a number concerned with roof construction including the 'jerkin-head'. The 'salt-box' of Cape Cod apparently describes a new form of house but in fact alludes to the overall shape of the building resulting from that extension known in England as the outshot or outshut.

Classicism, in that most domestic form created in England by the Scottish-born architect James Gibbs (1682–1754), which is as much related to the Baroque of Wren as to the Palladianism of Burlington, became the basis for many of the more significant buildings in eighteenth-century America. The natural preference for this less thoroughbred architecture was assisted by Gibbs's publication of his *Book of Architecture* (1728) and his *Rules for Drawing the Several Parts of Architecture* (1732), both of which were enormously influential in America and did much to perpetuate his style there throughout the eighteenth century. Buildings demonstrating Gibbs's influence include the numerous white-painted timber churches of rural New England and, most important of all, St Paul's Chapel (built 1764–6 and 1794–6) (Fig. 244), designed by the Scottish-born Thomas McBean. This stone church survives in the alien setting of the high-rise offices of downtown Manhattan, and resembles Gibbs's St Martin-in-the-Fields in London.

Many domestic buildings in this manner are constructed of wood rather than stone or brick. Details such as rustication, a feature that evolved on the mason's 'banker', were translated by the carpenter into wood with a delightful failure to deceive. This 'carpenter's classicism' represents an unusual instance of a reversion from stone or marble idioms to

wood, from which in turn those idioms derived. The columns for a portico were no longer composed of a series of stone 'drums' but of long tree-trunks. In the process the importance of the ratio of column diameter to height, and details such as the point at which entasis should begin, were forgotten or adapted. Only rarely were these architectural rules ignored in Britain, an example being Dorset House on Clifton Down, Bristol (c. 1825), which has achieved notoriety among some architectural historians for 'its distressingly tall colonnade' in stone. Attenuated columns, structurally possible in wood but inappropriate in stone and rising over two storeys, became the characteristic American portico which in both the North and the South was fre-

quently a late eighteenth-century addition. Examples include the Roger Morris Mansion (c. 1765) in New York City and the south façade (c. 1791) of 'Hampton', in South Carolina. In general these Anglo-Venetian clothes were worn in an unconventional way in America. In Boston, Charles Bulfinch (1763–1844), building mainly in brick, skilfully composed the massing of the State House (c. 1800), but incorporated strange details such as the stucco key-'stones' which don't 'return' under the arches they purport to anchor. At the University of Virginia (founded 1819) Jefferson successfully combined architectural orthodoxy with originality and yet in his own house, Monticello (1770–5), the absence of a *piano nobile* is emphasized by the lack of a significant staircase.

245. The Shadows, New Iberia, Louisiana. Begun 1830. The evergreen oaks festooned with Spanish moss provide a typical setting

George Washington's house, Mount Vernon, has every appearance of having been designed by an amateur such as Washington himself; the pediment on the entrance front (1778) has no projecting bay to support it and at one end is visually undermined by a stray window. These unfortunate details result from the refacing of an earlier structure, a circumstance which has failed to produce the symmetry so essential to Classicism. On the other hand, the interiors are remarkably pure, being simplified adaptations of the plates in Abraham Swan's *British Architect* (1745). The chimney-piece in the dining-room (1775) closely follows plate 50 in Swan's book, and was in fact supplied by Samuel Vaughn of London. Reasonably orthodox Palladianism does occur in America, as in Thomas Jefferson's Edgemont, Virginia, but in general its fundamental tenets of raised principal floor, symbolized externally by the rustication of ground-floor walls, and internally or externally by an imposing staircase or steps, do not occur with sufficient regularity to be considered characteristic.

With the age of steam the Mississippi became a two-way thoroughfare and the 'New South' prospered. In these delta waters conditions were similar to those of Venice and it was there that the *piano nobile* assumed a significance and therefore an importance similar to that which had inspired it. However, by this time the Greek Revival had taken over. In the climatic conditions of the delta the staircase was often moved so that it connected the two levels of verandah that surrounded these houses, giving them both shade and an appearance of greater size than they possess. In towns like Natchez, and with the plantation 'mansions', a domestic architecture evolved that owed something to the French of Louisiana, to the Mediterranean and to Britain, but in its total orchestration was an empirical response to the surroundings. In this semi-tropical setting the impeccably white elevations of the plantation mansions stand as a foil to the dark avenues of evergreen oaks festooned with Spanish moss, a contrast that is paralleled by their classically patrician façades and their unexpectedly dark and bourgeois Victorian interiors (Fig. 245).

In the design of the republic's capital at Washington, DC, there was a self-conscious desire to emulate the first democracy in history, a desire which coincided with the Greek Revival in Europe. The principal architect of the great civic buildings in Washington was Benjamin Latrobe (1764–1820), who, despite his name, was born in Yorkshire. The federal capital may have aspired to the democratic spirit of Athens, but in their collective impact its buildings speak more of Imperial Rome. Although the ideological relevance of the Greek Revival was greater for America and Republican France, it found many exponents in Britain, initially James (Athenian) Stuart in the eighteenth century and later Thomas Hardwick, William Watkins, Henry Inwood and Decimus Burton. Other figures, less well known in Britain, include William Jay (1794–1837), who worked in Georgia from 1817 to 1824. Perhaps his finest design is the Owens-Thomas house in Savannah, the unpainted stucco of which so much resembles the stone of his native Bath.

There were of course influences on American design other than those from Britain: the numerous gables of the houses of the Dutch in New York (originally New Amsterdam), the log cabins of the Swedes in the Delaware valley, and the adobe buildings of the Spanish in New Mexico which incorporate certain Pueblo Indian details. Mention should also be made of Spanish colonial work in Florida, California and Texas, as well as the French traditions of New Orleans and the Cajun or Arcadian influences on Louisiana resulting from the presence of refugees from Canada following the Treaty of Paris (1763). Some Germanic influences occur in Pennsylvania and in areas under Moravian influence, with visible effect on ironwork and woodwork, the designs of which often merged with the building traditions of the surrounding English communities. It is possible that some of these hybrids returned to Britain. An eighteenth-century house refronted in *c.* 1800 at Hotwells, Bristol (Fig. 246), could equally well stand in New Orleans or in some other port in the Gulf of Mexico or the Caribbean.

The influence of climate upon American architecture has probably been underestimated. It affected more than details, like the early use of Venetian blinds or the massive punkahs or breeze fans suspended from the ceiling over dining-tables in the South (as can be seen in three houses at Natchez, Mississippi – Fair Oaks, Elmscourt and Linden). House plans were adapted to keep temperatures at a minimum in the heat of the summer – the 'dog-run' or 'possum-trot' was used in smaller houses, and in larger buildings rooms were given high ceilings in relation to their floor plan. In public buildings such as the Old Court-House in St Louis, tiers of domes and rotundas, each with unglazed windows and enclosing one space from the ground to its apex, provide ventilation for the core of the building. In New England the low temperatures of winter inspired housewrights to introduce various insulation features that were rarely used or unknown in England. By

246. Rock House, Hotwells, Bristol. The front, added *c.* 1800, has a strong affinity with the façades of domestic buildings in the Gulf of Mexico and the Caribbean

1700 houses were built as a matter of course with a cellar, a double-boarded ground floor, a roof boarded under the shingles, and walls clad both internally, with feather-edge boarding or panelling, and externally with clapboarding (weather-boarding). Thus, separated from the cold ground and cocooned in a double cladding, the New England house could effectively resist the extremes of temperature.

Some features were unquestionably English in origin such as the seventeenth-century sgraffito or painted fireplace linings of Devon and Somerset which also occur in Massachusetts, or the cloam ovens of Barnstaple which were early exported to Virginia. But these are details. The general features of American domestic building produced an architecture that, if recognizably English in origin, possessed a distinctive accent, a new vernacular that reached its climax with the late nineteenth-century 'gingerbread houses' made so famous by Edward Hopper.

The Arts and Crafts Movement may have had its genesis in Britain, but in the early work of Frank Lloyd Wright it found a collateral descendant via

247. Detail of the pendentive on the external jettied storey of the Parson Capen House, Topsfield, Mass (compare Fig. 249). 1683

248. American chimney-board. Oil on board. *c.* 1825. Boston, Mass., Society for the Preservation of New England Antiquities

Richardson and Sullivan which, unlike its English forerunners, was not backward-looking. In the first phase of Frank Lloyd Wright's work may be seen an 'American' architecture that celebrated 'the Art and Craft of the Machine'.

For large-scale exterior work, Portland stone and even completed masonry for door surrounds was imported, as at Westover, Charles City County, Virginia (built *c.* 1730–4). The marble figure of the Colonial Governor of Virginia, Lord Botetourt, which stands outside the College in Williamsburg, arrived in 1773 direct from the London studio of Richard Hayward (1728–1800). For the smaller-scale needs of the furnishing and plenishing of colonial interiors, a distinction should be drawn between large objects of no great value which were seldom imported, and smaller objects of greater value which were often imported. A good example of this trend would be the large carcase furniture which was made in the colonies but which bore imported

249. Welsh press cupboard with pendentive (compare Fig. 247). 17th century. Cardiff, National Museum of Wales

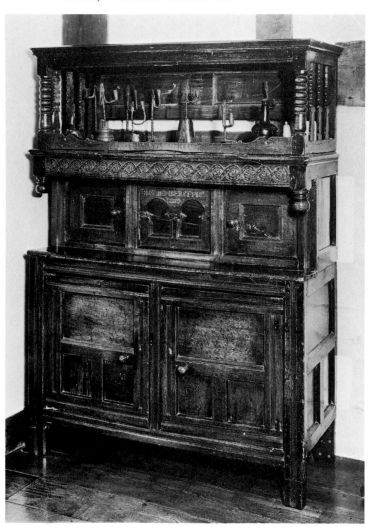

hardware. Of course, in the peculiar circumstance of Colonial America where skill was at a premium, the trade guilds lost their cohesion, their collective force. Having abandoned the standards that these guilds imposed in the principal towns in Britain, craftsmanship in America was more easily able to evolve, subject to the effects of materials native to America and to the influence of imported manufactured goods. The carpenters and housewrights were not prevented by the restrictive practices of the guilds from working as joiners and furniture makers. In short, in the words of a colonial craftsman recorded in 1806, they 'taught what they practised not what they knew'. This could result in a certain cross-fertilization of ideas, a possible early example of which is the pendentive that is found on many examples of the jettied storey in the timber-frame houses of Massachusetts. This feature is seldom used in this way on external elevations in England although the pendentive is commonly found on staircases, gables and press cupboards on both sides of the Atlantic (Figs. 247 and 249).

The considerable Dutch influence on design in Britain in the late seventeenth century was predictably re-exported to the colonies. The existing Dutch communities in the New Netherlands reinforced this tradition. As a result, the William and Mary style persisted longer in America than in Britain, as did details of furnishings such as the continued use of table carpets demonstrated in Robert Feke's portrait of *Isaac Royall and his Family* (1741). Much of the originality found in this seventeenth-century furniture must be due not only to the blurring of the distinctions between the various woodworking crafts and to a declining memory of Old World designs, but also to the greater reliance on native timber. This is not to say that cedar and Virginia walnut were not used in England; they were. However, these timbers were used in America more widely, together with less 'exotic' woods. Some, such as evergreen oak and pecan, were seldom if ever used in Britain. In contrast the timbers native to the Caribbean such as mahogany (especially Cuban and Honduras) and kingwood (known in the seventeenth century as prince's wood) assumed, by the eighteenth century, an international importance.

Two forms of furniture in eighteenth-century America, the stick-back chair and block-fronted carcase pieces, will serve to explain the way in which furniture there could evolve into something new. In eighteenth-century Britain the chairmaker was developing into a specialist craftsman. This was because the fluid lines necessary for comfort resulted in

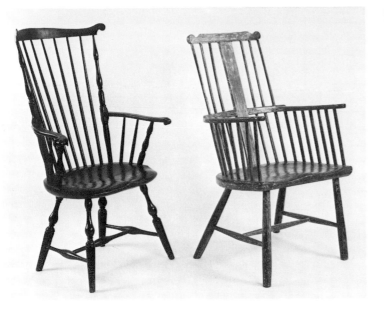

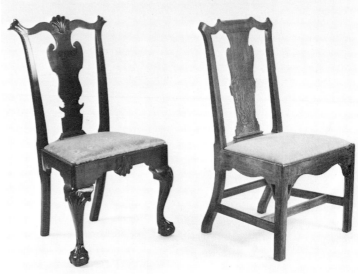

ABOVE FAR LEFT
250a. English comb-back chair. Elm and ash painted pale
blue. Late 18th century. Bath, Ayres Collection

ABOVE LEFT
250b. American comb-back chair, painted dark green.
18th century. Bath, American Museum in Britain

ABOVE
251a. English provincial chair, with dowled 'through-tenons',
a back-splat of early 18th-century type incorporated
in a mid-18th-century design. Bath, Ayres Collection

ABOVE RIGHT
251b. Colonial chair, by Samuel Mickle, Haddonfield, New Jersey.
Mahogany. c. 1776–80. A 'high style' version of an English
country design. Bath, American Museum in Britain

BELOW
252. American block-front bureau, attributed to George Bright
of Boston. Mahogany. c. 1770. As in most block-fronted
carcase pieces the 'blocking' is worked in solid scantlings,
not applied. Bath, American Museum in Britain

mortices and tenons with few right angles. Provincial
and colonial chairs of the eighteenth century share
the uncomfortable and more rectilinear lines of the
joiner-made chairs of the seventeenth century and
earlier (Fig. 251a, b). Windsor chairs, although made
by specialists, met the requirements of comfort and at
the same time dispensed with the need for the
expensive mortice and tenon (Fig. 250a, b). They
offered cheap comfort and after their initial appear-
ance in Philadelphia became popular throughout
America. Compared with their English and Welsh
cousins their lines were elongated, their seats elabor-
ately dished and chamfered. Although elm for the
seats and ash for the stick-backs of these chairs were
used in America as in England, the frequent use of
pine seats and hickory sticks may well account for the
distinctive appearance of the American stick-back
chair. In passing it may be noted that hickory was
imported into England where it was used in the
walking sticks advertised in the trade cards (c. 1787)
of Edward Beesly of Fleet Street, London.

In carcase furniture the 'block-front', which after
its early appearance in about 1738 became such a
feature of New England furniture for half a century,
has long provoked questions as to its origins (Fig.
252). Among the earliest examples of the use of
mahogany in eighteenth-century Britain is a small

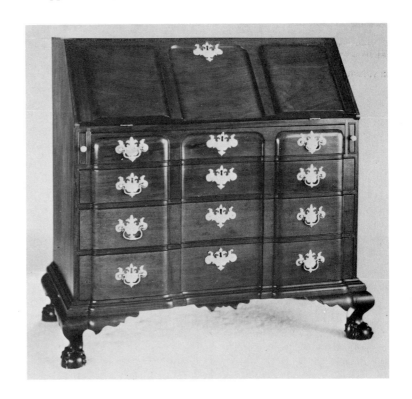

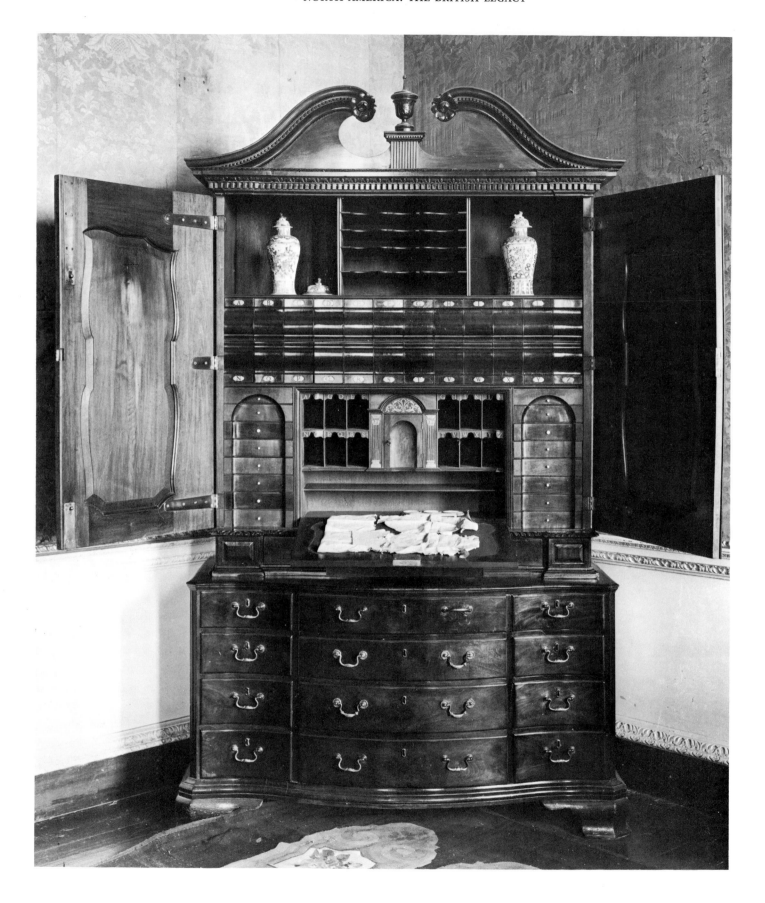

group of large bureau-bookcases (Fig. 253), all of which have a distinctly Dutch appearance and which accommodate within their very ample proportions some 'block-front' elements, elements that also occur on the interior drawers of eighteenth-century bureaux. It would therefore appear that the block-front as such is not original; rather its exaggeration and importance render it an American contribution to the history of furniture design. It was a feature not found outside New England and was quite unknown in Philadelphia where the finest highboys were made. Before leaving this question there is one matter of detail which is probably of some importance. In the block-front both the projecting and the recessed forms were worked in the solid timber. On most chests of drawers where a 'cock bead' surrounds the individual drawers, this bead is usually part of the drawer and not part of the carcase. In block-fronted furniture the bead is customarily part of the carcase and not part of the drawer. This suggests that in manufacturing furniture of this kind a series of drawer fronts would be cramped together so that the alternately convex, concave, convex vertical panels could be worked straight through, across the grain, without the obstruction of the cock bead.

American furniture historians, with a confidence not paralleled in Britain, ascribe their furniture not only to regions but also to particular towns. The great distance between the colonies produced regional variations often derived from cultural origins. An example of this, but one that has received little attention, is the settle-bed of Ulster (Fig. 254) which, though not found elsewhere in Britain, is found in the north-eastern states of the United States and the adjacent provinces of Canada (Fig. 255).

In American furniture, carved detail was kept to a minimum but where it occurs it is usually unsophisticated. An exception is found in Philadelphia where the Scottish-born Thomas Affleck (arrived Philadelphia 1763, died 1795) produced elaborately carved pieces of unusual sophistication not achieved by Samuel McIntire of Salem. In contrast to Affleck's is the furniture made by Major John Dunlap and his followers in New Hampshire. The splendour of this hybrid work has qualities not enjoyed by contemporary provincial cabinet work in Britain. Japanned furniture, well known in England, seems in America to have been an exclusively Bostonian delight. In general the more elaborate details of carving, 'cut-in-

ABOVE
254. Ulster settle-bed. 19th century. The seat folds forward to provide a box for a straw mattress. Ulster Folk and Transport Museum

BELOW
255. American settle-bed, from Connecticut. Pine. 19th century. Bath, American Museum in Britain

the-white' gesso, and water gilding found on eighteenth-century English pier glass frames and console tables, were beyond the range of colonial craftsmen until the nineteenth century. Some eighteenth-century examples bearing American makers' labels have proved on investigation to be imported.

Until recently it was widely assumed that the close links between the South and Britain discouraged the development of American furniture-making below the Mason-Dixon line. This hypothesis is now known to be false but little is known so far of the special characteristics of Southern furniture outside Louisi-

LEFT
253. Bureau. Mahogany. Second quarter of the 18th century. Although made in the British Isles, this bureau includes some block-front elements. Castletown, Co. Kildare

ana, where a colonial version of the French-Provincial armoire of chestnut or oak was made in pecan wood.

The Federal style adopted either an English 'Regency' or a French Empire appearance. For all this the banjo clock is singularly American, as are the andirons found in the wood-burning grates of elegant houses at a time when Britain has turned to the use of coal-burning grates. The lines of these fire-dogs may derive from the work of the Adam brothers but that is all, for Robert Adam was himself a director of a company that made coal grates and it is unlikely he would have designed for such an obsolete fuel as wood. Lambert Hitchcock (1795–1835) with his mass-produced chairs has sometimes been cited as an industrial innovator but he was simply continuing the long-realized possibilities for mass production and division of labour inherent in the Windsor chair. Far more original in construction, though not in design, were the steam-pressed laminated rosewood chairs made by the German-born John Henry Belter of New York (1804–63).

256. Chair patented by Samuel Gragg of Boston in 1808. Bath, Collection: The John Judkyn Memorial

Revolutionary innovation occurs in America at two levels: from the individual craftsman such as Samuel Gragg of Boston whose bentwood chairs anticipate Thornet by three or four decades (Fig. 256); or as a by-product of religious doctrine exemplified by the Shakers. Their ethos was summed up by Father Joseph Meacham (1742–96) in his book *Way Marks* (c. 1790) in which he argued that all things made by the United Society of Believers in Christ's Second Appearing should be created 'according to their order and use', and that 'all work done, or things made in the church, ought to be faithfully and well done, but plain and without superfluity – neither too high nor too low'. In following this philosophy a pared-down version of nineteenth-century country furniture was achieved which incorporated original details like the 'buttons' for 'tilting-chairs'. In the simplicity and functionalism of their furniture and furnishing, the Shakers anticipated the more doctrinaire products of the Bauhaus. Painted floors were simply a means of avoiding the cost of expensive woven carpets before industrialization made textiles generally available. The Shakers and their preference for painted floors were unusual in perpetuating this tradition. Similarly the continuous line of coat pegs (on which chairs were also hung), that forms a dominant feature in Shaker living-rooms, is original in location although the design of the pegs themselves was not.

Britain and more particularly London was the 'style capital' of America to the extent that many colonial craftsmen who had been born and even trained in Europe adopted an English style for their 'American' work. This was true of the German pewterer John Will (c. 1707–74) who worked in New York from 1752. It was of course a relatively simple matter to adopt English pewter forms; it was technically more difficult to achieve the hammered surface that gave to London pewter its lustrous burnish and international reputation. Remarkably, some American craftsmen like John Skinner (1733–1813) could reproduce this finish – a finish that many Europeans failed to achieve. In both metal and wood the adoption in the colonies of English fashion was usually subject to a time-lag, sometimes as much as thirty years or more. Paul Revere's work before the Revolution is comparable to the early eighteenth-century work that his silversmith father Apollos Rivoire would have known as a Huguenot refugee in Boston. Such father/son, master/apprentice relationships could account for the slow pace of stylistic change. In Copley's well-known portrait of Revere (1768–70), the pear-shaped teapot could well have

been made by a previous generation of silversmiths in England. For five years during the course of the War of Independence, Revere abandoned his craft, but when he re-emerged as a silversmith his work assumed the austere elegence of the Classical Revival. Had his post-Revolutionary work been produced in 1776 it would have been in the height of fashion in London. Paradoxically, political independence coincided with a greater dependence upon British design precedents. This may have been due to the increase in the publication of books on design, but probably owes much to the enthusiasm for the Classical Revival.

Silversmiths, pewterers, blacksmiths and cabinet-makers had access to imported models on which to base and develop their work. In contrast colonial architects and easel painters often possessed only a tenuous link with the Old World through pattern-books or mezzotints. The position was characterized by Copley in a letter to Benjamin West: 'In this country [America] there are no examples of Art

except what is to [be] met with in a few prints indifferently executed ... I think myself peculiarly unlucky in living in a place into which there has not been one portrait brought that is worthy to be called a Picture. ...' With the inscrutable confidence of eighteenth-century taste Copley was dismissing the tradition of formalized, hieratic portraiture. Not for him or his contemporaries the unreal reality of the seventeenth-century portrait of *Elizabeth Freake and Baby Mary* which may be read in the same spirit that Anne Bradstreet's poetry may be seen. Both speak to us in an English vernacular, neither are especially original, both possess the power of simplicity and both could have been created in England fifty years before their appearance in New England. In the watercolours of the limner or the oil paints or distempers of the journeyman painter on both sides of the Atlantic may be found a vision which is so direct, so little distorted by the mirror of fashion, that both reflect their common ancestry. They perpetuate an almost heraldic and certainly medieval concern

257. Edward Hicks, *The Peaceable Kingdom*. Oil. c. 1830–40. Williamsburg, Virginia, Rockefeller Folk Art Centre

ABOVE
258. *Adam Naming the Animals*, by an unknown British artist *c.* 1830–40. Farmington, Conn., Troiani Collection

BELOW
259. American whirligig, found in New Hampshire. Carved wood. Second half of 19th century. Bath, American Museum in Britain

RIGHT
260. Two English whirligigs photographed at Clovelly, Devon in the late 19th century. Carved wood. These are the only fully authenticated English whirligigs known to the author

with symbolism. The auxiliary details in Ezra Stiles's portrait of *Samuel King* (painted 1770–1) were described by the sitter as 'Emblems' which 'are more descriptive of my Mind, than the Effigies of my Face'.

These values remained common to the non-academic artists of both Britain and English-speaking North America throughout the eighteenth and nineteenth centuries. Their work differed, if it differed at all, in subject matter. Today's concept of originality was unknown to these painters. In America the Quaker Edward Hicks (1780–1840) was characteristic of this school of craftsmen artists. Hicks painted his favourite subject *The Peaceable Kingdom* perhaps as many as fifty times (Fig. 257). In general each painting was based on an engraving after a painting by the English artist Richard Westall R.A. Even though Hicks had seen the Niagara Falls for himself, his version derives, line for line, from a vignette in H. S. Tanner's map of North America published in Philadelphia in 1822. Despite such slavish copying, Hicks somehow emerges as an individual, an artist to be reckoned with. He was the history painter of post-colonial America and not for nothing did he 'quote' from the works of that other Quaker and fellow Pennsylvanian, the history painter Benjamin West. Unlike Hicks, some artists of this kind did of course paint from life. This is evident in the other-worldly silence that pervades the work of the deaf-mute John Brewster Jnr. (1766–1854) or the matter-of-fact statements of Captain Simon Fitch (1758–1835).

Sculpture, in so far as it existed at all, was dominated in America by the woodcarvers, those who adorned a ship or created a cigar-store Indian. The sculptor William Rush (1756–1833) may have been a founder of the Pennsylvania Academy but this son of a ship's carpenter, himself apprenticed as a ship's carver, made his reputation in that field and the vigour of his work in wood shows that in essence a ship's carver he remained. The second half of the nineteenth century was dominated by academic sculptors like Hiram Powers (1805–73) and the Irish-born Augustus Saint-Gaudens (1848–1907). In this century Alexander Calder (1898–1976), the son and grandson of American sculptors, returned to the playfulness of the whirligig with his mobiles, and demonstrated a fondness for an earlier, more egalitarian sculpture (Figs. 259 and 260).

Compared with the sculptors, painters aspired to the elegance of the élite of Europe much earlier. Benjamin West left Pennsylvania for Europe in 1760, and when he finally settled in London in 1763 he established a tradition, especially prevalent in the

arts, of the American as ex-patriot. As a consequence of this trend American painting tends to be international in character. West and Copley may have audaciously clothed the 'history painting' in modern dress but it is in Copley's 'American', rather than in his 'English', work that an originality of substance as well as form is discernible. His earlier portraits owe much to the clear hard light of Massachusetts, confirmed by the chiaroscuro of the mezzotint and the uninhibited colour of life. It was probably this dependence on engravings that led Copley to suppose that Titian's works were created 'with great precision, smooth Glossy and Delicate, something like Enamil wrought up with care and great attention to the smallest parts with a rich brilliancy that would astonish at first sight'. Here Copley is describing his own rather than the Venetian master's achievement. In reality he later found that 'Titiano is in no ways minute but sacrifices all the small parts to the general effect'. Benjamin West, writing from England to Copley on 20 June 1767, was disconcerted by the Bostonian's palette. He found the 'Colouring very Brilliant, though this Brilliancy is Somewhat misapplied, as for instance, the Gown too bright for the flesh, ... the dog and Carpet too Conspicuous for Accessory things'. Freed from the conventions of West's time, Copley may now be seen as the supreme American artist of the eighteenth century and the first to use the brilliance of American light to give what the Luminists saw and the Hudson River School failed to achieve. In the incidentals of his pictures Copley may be looked upon as the first realist in the manner of Harnett, and in the tonal truths of his Boston portraits he was the first 'Super-Realist'.

If portraiture dominated painting in America in the eighteenth century, landscape came to dominate the nineteenth. A thesis was developed, first by the painter Washington Alston and later by the poet William Cullen Bryant, that a new art would evolve through painting the 'New World'. Bryant, who was a close friend of the painter Thomas Cole, observed that in America 'our country abounds with scenery new to the artist's pencil ... in the Old World every spot has been visited by the artist, studied and sketched again'. Although American artists as diverse as Whistler, Abbey, Sargent, and Epstein would continue to settle or base themselves in Britain, the notion that Europe was somehow culturally superior was losing its force. American fine art was consciously moving towards its emancipation.

In many ways the familiar patchwork coverlet may be viewed as an emblem that demonstrates the similarities and differences between Britain and

America. In Britain the labour intensive, geometric, pieced or mosaic technique was common, whereas in America the more spontaneous and free-flowing forms of appliqué work were more usual. Each method was certainly used in both countries and some designs are found on both sides of the Atlantic. However, it was the American preference for appliqué work that left these 'artists in aprons' open to new influences, most dramatically illustrated by the coverlets of Hawaii.

In general the American decorative arts developed recognizably American characteristics earlier than the fine arts. This transformation was not so much because of any consciously held aesthetic beliefs; it was rather, as we have seen, due to the combined effect of new materials and a new climate.

261. Newport Parish Church, Smithfield, Virginia. 1632.
Built by Charles and Thomas Driver under the direction of Joseph Bridger

Public Collections

Great Britain and Ireland are treasure-chests: in every town or village there is likely to be something relevant to one or more sections of this book. Any comprehensive list of where to find such diverse subject matter would be unmanageably long and still remain incomplete. Here is simply a short-list of places, recommended by the respective authors. For details of what each place offers the reader must be referred to specific publications.

1. Painting and Drawing

Barnard Castle (Co. Durham), Bowes Museum
Bath, Holburne of Menstrie Museum
Bedford, Cecil Higgins Art Gallery
Belfast, Ulster Museum
Birkenhead, Lady Lever Art Gallery, Port Sunlight
Birmingham, Museums and Art Gallery
 Barber Institute of Fine Arts
Bradford, Art Gallery
Brighton, Museum and Art Gallery
Bristol, City Museum and Art Gallery
Cambridge, Fitzwilliam Museum
 Kettles Yard Gallery
Cardiff, National Museum of Wales
Chichester, Pallant House Gallery
Cookham-on-Thames (Berks.), Stanley Spencer Gallery
Derby, Art Gallery
Dublin, National Gallery of Ireland
 Hugh Lane Municipal Gallery of Modern Art
Eastbourne (E. Sussex), Towner Art Gallery
Edinburgh, National Gallery of Scotland
 Scottish National Gallery of Modern Art
 Scottish National Portrait Gallery
Glasgow, Art Gallery
 Burrell Collection Gallery
 Hunterian Art Gallery
 Pollok House
Haverfordwest (Dyfed), Picton Castle, Graham Sutherland Gallery
Hull, Ferens Art Gallery
Leeds, City Art Gallery
 Temple Newsam House
Leicester, Leicestershire Museum and Art Gallery
Liverpool, Walker Art Gallery
London, Apsley House
 British Museum
 Buckingham Palace, Queen's Gallery
 Courtauld Institute Galleries
 Dulwich Picture Gallery
 Hampton Court Palace
 Kenwood, Iveagh Bequest
 Leighton House Art Gallery
 National Gallery
 National Maritime Museum, Greenwich
 National Portrait Gallery
 Royal Academy of Arts
 Tate Gallery
 Victoria and Albert Museum
 Wallace Collection
 William Morris Gallery, Walthamstow
Manchester, City Art Gallery
 Gallery of Modern Art
 Queen's Park Art Gallery
 Whitworth Art Gallery
Newcastle upon Tyne, Laing Art Gallery
 Hatton Gallery
Norwich, Castle Museum
Nottingham, Castle Museum
Oldham, Art Gallery
Oxford, Ashmolean Museum
Plymouth, City Art Gallery
Rochdale, Art Gallery
St Ives (Cornwall), Penwith Gallery
Salford, Museum and Art Gallery
Sheffield, Graves Art Gallery
 Mappin Art Gallery
Southampton, Art Gallery
Stoke-on-Trent, City Museum and Art Gallery
Sudbury (Suffolk), Gainsborough's House
Swansea, Glynn Vivian Art Gallery
Wakefield, Art Gallery
Walsall, Museum and Art Gallery
Whitby, Pannett Art Gallery
Wolverhampton, Central Art Gallery
York, City Art Gallery

2. Photography

Bath, Royal Photographic Society
Lacock (Wilts.), Fox Talbot Museum
London, Arts Council of Great Britain
 Kodak Museum
 National Portrait Gallery
 Science Museum
 Victoria and Albert Museum

3. Prints and Book Illustration

Cambridge, Fitzwilliam Museum
Edinburgh, National Library of Scotland
London, British Library
 British Museum
 Victoria and Albert Museum, National Art Library
Oxford, Ashmolean Museum
 Bodleian Library

4. Folk Art

There are no public galleries of British folk art in the British Isles, though the following include such work as part of social history.

Birmingham, Museums and Art Gallery (Pinto Collection of Treen)
Bristol, Blaise Castle Museum
Cambridge, Folk Museum
 Kettle's Yard (for its collection of paintings by Alfred Wallis)
Cardiff, Welsh Folk Museum, St Fagans Castle
Edinburgh, Huntly House Museum
Holywood (Co. Down), Ulster Folk and Transport Museum
Hull, Town Docks Museum
London, Museum of London
 National Maritime Museum
 Horniman Museum
Norwich, Castle Museum
Reading, Museum of English Rural Life
Stoke Bruerne (Northants.), Waterways Museum
Taunton, Castle Museum
Tresco (Isles of Scilly), Valhalla Maritime Museum
Tunbridge Wells, Museum
Wookey Hole (Som.), Lady Bangor's Collection of Fairground Art
York, Castle Museum

5. Architecture

Britain is an open museum, and the exhibits of architectural interest are the buildings themselves, found in almost all her towns and villages. However, some museums do contain exhibits relating to architecture, notably the British Museum and the Victoria and Albert Museum in London.

6. Building in the Vernacular

Bromsgrove (Hereford & Worcester), Avoncroft Museum of Buildings, Stoke Heath
Cardiff, Welsh Folk Museum, St Fagans Castle
Chichester, Weald and Downland Museum, Singleton
Coggeshall (Essex), Paycock's
Cregneash (Isle of Man), Manx Open-Air Folk Museum
Holywood (Co. Down), Ulster Folk and Transport Museum
Kingussie (Highland), Highland Folk Museum
St Helier (Jersey), Société Jersiaise, Museum

7. Stained Glass

Birmingham, Anglican Cathedral
 Roman Catholic Cathedral
Cambridge, especially Christ's College, Jesus College, and King's College
Canterbury Cathedral
Coventry Cathedral
East Harling (Norfolk)
Ely Cathedral, in the North Triforium the Stained Glass Museum
Exeter Cathedral
Fairford (Glos.)
Glasgow, Burrell Collection Gallery
Gloucester Cathedral
Great Malvern Priory (Hereford & Worcester)
Lincoln Cathedral

Liverpool, Roman Catholic Cathedral
London, Victoria and Albert Museum
 Westminster Abbey
Long Melford (Suffolk)
Ludlow (Shropshire)
Norwich, especially Cathedral, St Andrew,
 and St Peter Mancroft
Oxford, especially Christ Church College
 (Cathedral), All Souls College, Balliol
 College, Merton College, New College
Shrewsbury, St Mary
Tewkesbury Abbey (Glos.)
Twycross (Leics.)
Warwick, St Mary
Wells Cathedral
Wilton (Wilts.)
Winchester Cathedral
 Winchester College
York, especially York Minster, All Saints
 (North Street), Holy Trinity
 (Goodramgate), St Denys (Walmgate),
 and St Michael-le-Belfrey

8. Garden Design

*Gardens of particular historical
significance:*
Alton (Staffs.), Alton Towers
Ardingly (W. Sussex), Wakehurst Place
Bakewell (Derbys.), Chatsworth
Buckingham (Bucks.), Stowe
Castle Douglas (Dumfries & Galloway),
 Threave School of Practical Gardening
Cheddon Fitzpaine (Som.), Hestercombe
Coneythorpe (N. Yorks.), Castle Howard
Crieff (Tayside), Drummond Castle
Edzell (Tayside), Edzell Castle
Handcross (W. Sussex), Nymans
Hidcote Bartrim (Glos.), Hidcote Manor
Kendall (Cumbria), Levens Hall
Lamberhurst (Kent), Scotney Castle
London, Hampton Court Palace
 Royal Botanic Gardens, Kew
Lower Beeding (W. Sussex), Leonardslee
Melbourne (Derbys.), Melbourne Hall
Northiam (E. Sussex), Great Dixter
Pitmedden (Grampian), Pitmedden House
Poolewe (Highland), Inverewe
Sissinghurst (Kent), Sissinghurst Castle
Stourton (Wilts.), Stourhead
Studley (Wilts.), Bowood
Studley Roger (N. Yorks.),
 Studley Royal and Fountains Abbey
Tal-y-Cafn (Gwynedd), Bodnant
Tresco (Isles of Scilly), Tresco Abbey
Uckfield (E. Sussex), Sheffield Park
Welshpool (Powys), Powis Castle
Windsor (Berks.), Savill Garden, Windsor
 Great Park
Wisley (Surrey), Royal Horticultural
 Society's Garden
Woodstock (Oxon.), Blenheim Palace

9. Sculpture

Before 1500
*The major ensembles of monumental
sculpture are still on or in the buildings they
originally adorned; the most outstanding
sites are:*

Barfreston (Kent)
Beverley Minster (Yorks.)
Bewcastle (Cumbria)
Bradford-on-Avon (Wilts.)
Breedon-on-the Hill (Leics.)
Canterbury Cathedral (Kent)
Castle Frome (Hereford & Worcester)
Chichester Cathedral (W. Sussex)
Eardisley (Hereford & Worcester)
Ely Cathedral (Cambs.)
Exeter Cathedral (Devon)
Fownhope (Hereford & Worcester)
Gosforth (Cumbria)
Hawton (Notts.)
Kilpeck (Hereford & Worcester)
Lenton (Notts.)
Leominster (Hereford & Worcester)
Lincoln Cathedral
London, Westminster Abbey
Malmesbury Abbey (Wilts.)
Much Wenlock Priory (Shropshire)
Norwich Cathedral (Norfolk)
Rochester Cathedral (Kent)
Romsey (Hants.)
Rowlstone (Hereford & Worcester)
Ruthwell (Dumfries & Galloway)
Salisbury Cathedral (Wilts.)
Shobdon (Hereford & Worcester)
Southwell (Notts.)
Stretton Sugwas (Hereford & Worcester)
Warwick, Beauchamp Chapel
Wells Cathedral (Som.)
Winchester Cathedral (Hants.)
Wirksworth (Derbys.)

Museums
Durham, Cathedral Treasury
London, British Museum
 Victoria and Albert Museum
Reading (Berks.), Museum
Winchester (Hants.), Museum
York, Yorkshire Museum

After 1500

Bath Abbey
Cambridge, Fitzwilliam Museum
 Trinity College Library and Antechapel
Chenies parish church (Beds.)
Ilam parish church (Staffs.)
Liverpool, Walker Art Gallery
London, National Portrait Gallery
 St Paul's Cathedral
 Tate Gallery
 Victoria and Albert Museum
 Westminster Abbey
Manchester, Whitworth Art Gallery
Melbourne Hall (Derbys.)
Osborne House (I.o.W.)
Petworth House (W. Sussex)
Sherborne parish church (Dorset.)
Warkton parish church (Northants.)
Wetherall parish church (Cumbria)
Windsor Castle, Albert Memorial Chapel
 (Berks.)

10. Arms and Armour

Abbottsford House (Borders)
Arundel Castle (W. Sussex)
Blair Castle (Tayside)

Boughton House (Northants.)
Dublin, National Museum of Ireland
Edinburgh, National Museum of
 Antiquities of Scotland
 Royal Scottish Museum
 Scottish United Services Museum
Glasgow, Art Gallery and Museum
Hever Castle (Kent)
London, The Armouries, H. M. Tower of
 London
 Imperial War Museum
 Museum of Artillery, The Rotunda,
 Woolwich
 National Army Museum
 National Maritime Museum
 Victoria and Albert Museum
 Wallace Collection
Penshurst Place (Kent)
Waddesdon Manor (Bucks.)
Warwick Castle
York, Castle Museum

11. Ceramics

Bedford, Cecil Higgins Art Gallery
Birkenhead, Lady Lever Art Gallery, Port
 Sunlight
Birmingham, Museums and Art Gallery
Brighton, Museum and Art Gallery
 (including Willet Collection)
Bristol, Museum and Art Gallery
Cambridge, Fitzwilliam Museum
Derby, Museum and Art Gallery
 Royal Crown Derby Works Museum
Leeds, Temple Newsam House
Leicester, Leicestershire Museum and Art
 Gallery
Liverpool, Merseyside County Museum
London, British Museum
 Museum of London
 Victoria and Albert Museum
Manchester, City Art Gallery
Norwich, Castle Museum
Nottingham, Castle Museum
Oxford, Ashmolean Museum
Stoke-on-Trent, City Museum and Art
 Gallery
 Wedgwood Museum
Swansea, Glyn Vivian Art Gallery and
 Museum
Telford (Shropshire), Ironbridge Gorge
 Museum
Worcester, Dyson Perrins Museum

12. Glass

Barnsley, Cannon Hall Art Gallery
Bedford, Cecil Higgins Art Gallery
Bristol, City Museum and Art Gallery
Cambridge, Fitzwilliam Museum
Edinburgh, Huntly House Museum
Kingswinford (W. Midlands), Broadfield
 House Glass Museum
London, British Museum
 Victoria and Albert Museum
Manchester, City Art Gallery
Newcastle upon Tyne, Laing Art Gallery
Oxford, Ashmolean Museum
Sunderland, Museum and Art Gallery

13. Textiles

Birkenhead, Lady Lever Art Gallery, Port Sunlight
Blackburn (Lancs.), Lewis Textile Museum
Burnley (Lancs.), Gawthorpe Hall
Calstock (Cornwall), Cotehele House
Cardiff, Welsh Folk Museum, St Fagans Castle
Chesterfield (Derbys.), Hardwick Hall
Durham Cathedral
Edinburgh, National Museum of Antiquities of Scotland
 Royal Scottish Museum
Holywood (Co. Down), Ulster Folk and Transport Museum
Kilbarchan, nr. Paisley (Strath.), Hand-Weaver's Cottage
London, Hampton Court Palace
 Museum of London
 Victoria and Albert Museum
Manchester, Gallery of English Costume
 North-West Museum of Science and Industry
 Whitworth Art Gallery
Norwich, Strangers' Hall
Nottingham, Castle Museum
Paisley (Strath.), Museum and Art Galleries
Petersfield (Hants.), Butser Ancient Farm
Stonyhurst College (Lancs.)
Styal (Ches.), Quarry Bank Mill
Walthamstow (Essex), William Morris Gallery

14. Jewellery

Birmingham, Museums and Art Gallery
Edinburgh, National Museum of Antiquities of Scotland
London, British Museum
 Museum of London
 Victoria and Albert Museum

15. Silver

Bath, Holburne of Menstrie Museum
Birmingham, Museums and Art Gallery
Bristol, City Museum and Art Gallery
Cambridge, Fitzwilliam Museum
Chester, Grosvenor Museum
Exeter, Royal Albert Memorial Museum
London, British Museum
 Goldsmiths' Hall
 Museum of London
 Victoria and Albert Museum
 Wellington Museum, Apsley House
Manchester, City Art Gallery
Norwich, Castle Museum
Oxford, Ashmolean Museum
York, Castle Museum

There are treasuries of plate from local churches, often containing splendid domestic as well as liturgical silver, in fifteen English cathedrals, of which the largest is St Paul's, London.

16. Furniture

Barnard Castle (Co. Durham), Bowes Museum
Brighton, Museum and Art Gallery
Cambridge, Fitzwilliam Museum
Glasgow, University Collections
Harewood House (W. Yorks.)
Leeds, Temple Newsam House
Leicester, Newarke Houses
London, Bethnal Green Museum
 Victoria and Albert Museum
 William Morris Gallery, Walthamstow
Nostell Priory (Yorks.)
Oxford, Ashmolean Museum
Petersham (Surrey), Ham House

17. Clocks and Watches

Basingstoke (Hants.), Willis Museum
Birkenhead, Lady Lever Art Gallery, Port Sunlight
Birmingham, Museums and Art Gallery
Bury St Edmunds (Suffolk), Gershom-Parkington Memorial Collection
Cambridge, Fitzwilliam Museum
Edinburgh, Royal Scottish Museum
Keighley, Art Gallery and Museum
Leeds, Abbey House Museum
Leicester, Newarke Houses
 Belgrave Hall
Lincoln, Usher Art Gallery
Liverpool, City Museum
London, British Museum
 Clockmakers' Company Museum
 Museum of London
 National Maritime Museum, Greenwich
 Old Royal Observatory, Greenwich
 Science Museum
 Victoria and Albert Museum
 Wallace Collection
Newark, British Horological Institute
Oxford, Museum of the History of Science
Waddesdon Manor (Bucks.)
Warrington, Municipal Museum
York, Castle Museum

18. Musical Instruments

Brighton, Museum and Art Gallery
Cardiff, Welsh Folk Museum
Dublin, National Museum of Ireland
Edinburgh, Reid School of Music
 St Cecilia Hall
Glasgow, Kelvingrove Museum
Liverpool, City Museum
London, Fenton House
 Horniman Museum
 Museum of London
 Royal College of Music
 Royal Military School of Music, Twickenham
 Victoria and Albert Museum
Manchester, Royal Northern College of Music
Oxford, Ashmolean Museum
 Bate Collection, Faculty of Music
Snowshill Manor (Glos.)
Warwick, County Museum

19. Modern Studio Crafts

Bath, Holburne of Menstrie Museum
Cheltenham, Art Gallery and Museum
London, Crafts Council
 Goldsmiths' Hall
 Victoria and Albert Museum
York, City Art Gallery

20. Industrial Design

London, Design Council
 Victoria and Albert Museum (including Boilerhouse)
 Science Museum

21. Early Britain

Bath, Roman Baths Museum
Bignor (Sussex), Roman Villa
Birmingham, Museums and Art Gallery
Cardiff, National Museum of Wales
Chester, Grosvenor Museum
Chesterholm (Cumbria) = Roman *Vindolanda*
Colchester, Castle Museum
Devizes, Museum
Dublin, National Museum of Ireland
Edinburgh, National Museum of Scotland
Fishbourne (W. Sussex), Roman Palace Museum
London, British Museum
 Museum of London
Lullingstone (Kent), Roman Villa
Newcastle upon Tyne, Museum of Antiquities
Norwich, Castle Museum
Oxford, Ashmolean Museum
Worthing, Museum
York, Castle Museum

22. North America: The British Legacy

Major works by British artists will be found in many American museums and art galleries – and vice versa. The following collections are particularly concerned with the relationship between British provincial work and the colonial work of British North America:

America
Boston (Mass.), Museum of Fine Arts
New Haven (Conn.), Yale University Art Gallery
New York, Metropolitan Museum (American Wing)
Winterthur (Del.), Henry Francis Du Pont Museum

Great Britain
Bath, American Museum in Britain
Omagh (Tyr.), Ulster American Folk Park

Bibliography

1. Painting and Drawing

Alley, R.,
British Painting since 1945,
London, 1966.
Boase, T. S. R. (ed.),
The Oxford History of English Art
(planned in eleven volumes, to 1940),
Oxford.
Bowness, A.,
Recent British Painting,
London, 1968.
Burke, J.,
English Art, 1714–1800,
Oxford, 1976.
Gaunt, W.,
A Concise History of English Painting,
London, 1964.
Gaunt, W.,
*The Restless Century: Painting in Britain,
1800–1900,*
London, 1972.
Klingender, F.,
Art and the Industrial Revolution,
London, 1968.
Morphet, R.,
British Painting, 1910–1945,
London, 1967.
Pevsner, N.,
The Englishness of English Art,
Harmondsworth, 1964.
Piper, D.,
Painting in England, 1500–1870,
London, 1960.
Piper, D.,
The Genius of British Painting,
London, 1975.
Rawley, T.,
British Painting,
Oxford, 1976.
Roskill, M.,
English Painting from 1500 to 1865,
London, 1959.
Rothenstein, J.,
Modern British Painters (3 vols),
London, 1976.
Shone, R.,
*The Century of Change: British Painting
since 1900,*
Oxford, 1977.
Strong, R.,
The English Icon,
London, 1969.
Sunderland, J.,
Painting in Britain, 1525 to 1975,
Oxford, 1976.
Waterhouse, E.,
Painting in Britain, 1530–1790,
Harmondsworth, 1953.
Wilson, S.,
*British Art from Holbein to the Present
Day,*
London, 1970

2. Photography

Beaton, C., and Buckland, G.,
*The Magic Image: The Genius of
Photography from 1839 to the Present
Day,*
London, 1975.
Gernsheim, H. and A.,
*The History of Photography 1685–1914:
From the Camera Obscura to the
Beginning of the Modern Era,*
London, revised edn. 1969.
Jeffrey, Ian,
Photography: A Concise History,
London, 1981.
Lloyd, Valerie,
Photography: The First Eighty Years,
London, 1976.
Scharf, Aaron,
Pioneers of Photography,
London, 1975.

Taylor, J., 'Pictorial Photography in the
First World War',
The History of Photography Journal,
April 1982.

Modern British Photography 1919–1939
(Arts Council of Great Britain),
London, 1980.
*Pictorial Photography in Britain 1900–
1920*
(Arts Council of Great Britain),
London, 1978.
Three Perspectives on Photography
(Arts Council of Great Britain),
London, 1979.

3. Prints and Book Illustration

Bland, D.,
*A History of Book Illustration: the
Illuminated Manuscript and the Printed
Book,* 2nd edn.,
London, 1969.
Calloway, S.,
English Prints for the Collector,
Guildford, 1980.
Feaver, W.,
*When We Were Young: Two Centuries of
Children's Book Illustration,*
London, 1977.
Godfrey, R. T.,
Print Making in Britain,
Oxford, 1978.
Harthan, J.,
*The History of the Illustrated Book: the
Western Tradition,*
London, 1980.
McLean, R.,
*Victorian Book Design and Colour
Printing,* 2nd edn.,
London, 1972.
Marks, R., and Morgan, N.,
*The Golden Age of English Manuscript
Painting, 1200–1500,*
London, 1981.
Muir, P.,
English Children's Books, 1600–1900,
London, 1969 (reprint).

Whalley, J. I.,
*'Cobwebs to Catch Flies' : Illustrated
Books for the Nursery and Schoolroom,
1700–1900,* London, 1974.

Pierpont Morgan exhibition catalogues:
William Morris and the art of the book, 1976.
*Early children's books and their
illustration,* 1975.

4. Folk Art

Ayres, James,
British Folk Art,
London, 1976; New York 1977.
Ayres, James,
English Naive Painting 1750–1900,
London & New York, 1980.
Banks, Steven,
The Handicrafts of the Sailor,
Newton Abbot, 1974.
Braithwaite, David,
Fairground Architecture,
London, 1968.
Jones, Barbara,
The Unsophisticated Arts,
London, 1951.
Lambert, Margaret, and Marx, Enid,
English Popular Art,
London, 1951.
Lambert, Margaret, and Marx, Enid,
English Popular and Traditional Art,
London, 1946.
Lewery, A. J.,
Narrow Boat Painting,
Newton Abbot, 1974.
Mullins, Edwin,
Alfred Wallis, Cornish Primitive Painter,
London, 1967.

5. Architecture

Betjeman, John (ed.),
Pocket Guide to English Parish Churches,
London, 1968.
Binney, Marcus, and Pearce, David (eds.),
Railway Architecture,
London, 1979.
Clark, Kenneth,
The Gothic Revival,
London, 1928 (revised 1962).
Clifton-Taylor, A.,
The Pattern of English Building,
London, 1972.
Cook, G. H.,
The English Medieval Parish Church,
London, 1954.
Davey, Peter,
Arts and Crafts Architecture,
London, 1980.
Dixon, R., and Muthesius, S.,
Victorian Architecture,
London, 1978.
Dunbar, J. G.,
The Architecture of Scotland,
London, 1966.
Girouard, Mark,
*Sweetness and Light: the 'Queen Anne'
Movement, 1860–1900,*
London, 1977.

Harvey, John,
The Perpendicular Style,
London, 1978.
Hilling, John B.,
The Historic Architecture of Wales,
Cardiff, 1975.
Lloyd, Nathaniel,
A History of the English House,
London, 1931 (reissued 1975).
Morris, Richard,
Cathedrals and Abbeys of England and Wales,
London, 1979.
Nicolson, Nigel,
Great Houses of Britain,
London, 1981.
Pevsner, Nikolaus,
The Englishness of English Art,
London, 1956.
Richards, J. M.,
The Functional Tradition in Early Industrial Buildings,
London, 1958.
Richards, J. M.,
The National Trust Book of English Architecture,
London, 1981.
Riseboro, Bill,
The Story of Western Architecture,
London, 1979.

Also the individual county volumes of Nikolaus Pevsner's *The Buildings of England*, and their successors covering some counties of Wales and Scotland (published by Penguin Books from 1951 onwards).

6. Building in the Vernacular

Ayres, James,
The Shell Book of the Home in Britain,
London, 1981.
Barley, M. W.,
The English Farmhouse and Cottage,
London, 1961.
Brunskill, R. W.,
Illustrated Handbook of Vernacular Architecture,
London, 1971.
Harris, Richard,
Discovering Timber Frame Houses,
Princes Risborough, 1978.
Hewett, Cecil A.,
English Historic Carpentry,
London and Chichester, 1980.
Innocent, C. F.,
The Development of English Building Construction,
Cambridge, 1916; Newton Abbot, 1971.
Mercer, Eric,
English Vernacular Houses,
London, 1975.
Peate, Iorwerth C.,
The Welsh House,
Liverpool, 1940.
Salzman, L. F.,
Building in England down to 1540,
Oxford, 1952.

7. Stained Glass

Baker, J.,
English Stained Glass,
London, 1960.
Caviness, M. H.,
The Windows of Christ Church Cathedral, Canterbury (Corpus Vitrearum Medii Aevi. Great Britain II),
London, 1981.
Clarke, B. (ed.),
Architectural Stained Glass,
London, 1979.
Cormack, P.,
Christopher Whall 1849–1924: Arts and Crafts Stained Glass Worker,
William Morris Gallery, Walthamstow, 1979.
Donnelly, M.,
Glasgow Stained Glass,
Glasgow, 1981.
Harrison, M.,
Victorian Stained Glass,
London, 1980.
Harrison, M.,
Glass/Light,
Festival of the City of London (exhibition catalogue), London, 1978.
Le Couteur, J.D.,
English Mediaeval Painted Glass,
London, 1926, reissued 1978.
Lee, L.,
The Appreciation of Stained Glass,
London, 1977.
Lewis, M.,
Stained Glass in North Wales up to 1850,
Altrincham, 1970.
Newton, P. A.,
The County of Oxford. A Catalogue of Medieval Stained Glass (C.V.M.A. Great Britain I), London, 1979.
Perrot, F. (ed.),
New British Glass and Vitrail Français Contemporain,
Centre International du Vitrail, Chartres, 1982.
Reyntiens, P.,
The Technique of Stained Glass,
London, 1967.
Wayment, H. G.,
The Windows of King's College Chapel, Cambridge (C.V.M.A. Great Britain, supplementary vol. I), London, 1972.
Wynne, M.,
Irish Stained Glass,
Dublin, 1977.
Journal of the British Society of Master Glass-Painters,
London, 1924 onwards.

8. Garden Design

Clifford, Derek,
A History of Garden Design,
London, 1975.
Hadfield, Miles,
A History of British Gardening,
London, 1979.
Hellyer, Arthur,
Gardens of Genius,
Feltham, 1980.
Hellyer, Arthur,
The Shell Guide to Gardens,
London, 1977.
Huxley, Anthony,
An Illustrated History of Gardening,
London, 1978.
Thacker, Christopher,
The History of Gardens,
London, 1979.
Thomas, Graham Stuart,
Gardens of the National Trust,
London, 1979.

9. Sculpture

Before 1500

Beckwith, John,
Ivory Carvings in Early Medieval England,
London, 1972.
Boase, T. S. R.,
English Art 1100–1216,
Oxford, 1953.
Brieger, Peter,
English Art 1216–1307,
Oxford, 1957.
Crossley, F. H.,
English Church Monuments AD 1150–1550,
London, 1921.
Evans, Joan,
English Art 1307–1461,
Oxford, 1949.
Gardner, Arthur,
English Medieval Sculpture,
Cambridge, 1951.
Longhurst, M. H.,
English Ivories,
London, 1926.
Prior, E. S., and Gardner, A.,
An Account of Medieval Figure-Sculpture in England,
Cambridge, 1912.
Stone, Lawrence,
Sculpture in Britain: the Middle Ages,
Harmondsworth, 1955.
Talbot Rice, D.,
English Art 871–1100,
Oxford, 1952.
Zarnecki, George,
English Romanesque Sculpture 1066–1140,
London, 1951.
Zarnecki, George,
Later English Romanesque Sculpture 1140–1210,
London, 1953.

After 1500

Esdaile, K. A.,
English Monumental Sculpture since the Renaissance,
London, 1927.
Eustace, Katharine,
Michael Rysbrack,
Bristol, 1982.
Gunnis, Rupert,
A Dictionary of British Sculptors, 1660–1851,
London, 1953.

Irwin, David,
John Flaxman,
London, 1979.
Penny, Nicholas,
*Church Monuments in Romantic
England,*
New Haven and London, 1977.
Potterton, Homan,
Irish Church Monuments 1570–1880,
Belfast, 1975.
Potts, Alex,
Sir Francis Chantrey,
London, 1981.
Read, Benedict,
Victorian Sculpture,
New Haven and London, 1982.
Read, Herbert,
A Concise History of Modern Sculpture,
New York, 1971.
Read, Herbert,
Henry Moore,
London, 1965.
Whinney, Margaret,
Sculpture in Britain 1530–1830,
Harmondsworth, 1964.
Whinney, Margaret,
English Sculpture 1720–1830,
London, 1971.

10. Arms and Armour

Blackmore, H. L.,
Guns and Rifles of the World,
London, 1965.
Blackmore, H. L.,
Hunting Weapons,
London, 1971.
Blair, C.,
European and American Arms,
London, 1962.
Blair, C.,
European Armour,
London, 1958.
Blair, C.,
Pistols of the World,
London, 1968.
Borg, A.,
Arms and Armour in Britain,
London, 1979.
Dufty, A. R.,
*European Armour in the Tower of
London,*
London, 1968.
Dufty, A. R.,
*European Swords and Daggers in the
Tower of London,*
London, 1974.
Hayward, J. F.,
The Art of the Gunmaker,
London, 1962.
Norman, A. V. B.,
The Rapier and Small-Sword 1460–1820,
London, 1980.
Oakeshott, R. E.,
The Sword in the Age of Chivalry,
London, 1964 (reprinted 1981).
Reid, W.,
The Lore of Arms,
London, 1976.

Stone, G. C.,
*A Glossary of the Construction,
Decoration and Use of Arms and
Armour,*
New York, 1934 and later reprints.

11. Ceramics

Charleston, R. J.,
World Ceramics,
Feltham, 1968.
Charleston, R. J., and Towner, D. (eds.),
English Ceramics 1580–1830,
London, 1977.
Cushion, J. P.,
*The Connoisseur Illustrated Guides:
Pottery and Porcelain,*
London, 1972.
Cushion, J. P.,
Pocket Book of British Ceramic Marks,
London, 1959.
Cushion, J. P.,
Pottery and Porcelain Tablewares,
London, 1977.
Godden, G. A.,
*Encyclopedia of British Pottery and
Porcelain Marks,*
London, 1964.
Godden, G. A.,
Godden's Guide to English Porcelain,
St Albans, 1978.
Godden, G. A.,
*An Illustrated Encyclopedia of British
Pottery and Porcelain,*
London, 1966.
Honey, W. B., revised by Barrett, F. A.,
*Old English Porcelain: A Handbook for
Collectors,*
London, 1977.

12. Glass

Brooks, John,
The Arthur Negus Guide to British Glass,
Feltham, 1981.
Charleston, R. J.,
Gilding The Lily (exhibition catalogue),
Delemosne & Son, July 1978.
Elville, E. M.,
English Table Glass,
Feltham, 1951.
Elville, E. M.,
English and Irish Cut Glass,
Feltham, 1953.
Elville, E. M.,
The Collector's Dictionary of Glass,
Feltham, 1961.
Grover, Ray and Lee,
English Cameo Glass,
New York, 1980.
Guttery, D. R.,
From Broad Glass to Cut Crystal,
London, 1956.
Morris, Barbara,
Victorian Table Glass and Ornaments,
London, 1978.
Northwood, John, II,
John Northwood,
Stourbridge, 1958.

Thorpe, W.,
English Glass,
London, 1935.
Wakefield, H.,
Nineteenth Century British Glass,
London, 1961, 2nd edn. 1982.

13. Textiles

Butler, A.,
Embroidery Stitches,
London, 1979.
Christie, G. (Mrs A.),
English Mediaeval Embroidery,
Oxford, 1938.
Clabburn, P.,
The Needleworker's Dictionary,
London, 1976.
Fairclough, O., and Leary, E.,
*Textiles by William Morris and Morris &
Co., 1861–1940,*
London, 1981.
Flanagan, J. F.,
*Spitalfields Silks of the 18th and 19th
Centuries,*
Leigh-on-Sea, 1954.
Forbes, R. J.,
Studies in Ancient Technology,
vol. iv, Leiden, 1956.
Irwin, J., and Brett, K.,
The Origins of Chintz,
London, 1970.
Jenkins, J. G. (ed.),
*The Wool Textile Industry in Great
Britain,*
London, 1972.
Jones, J. Brandon-, and others,
C. F. A. Voysey, Architect and Designer,
London, 1978.
Kendrick, A. F.,
English Needlework, 2nd ed.,
London, 1967.
Lubell, E.,
Textile Collections of the World, vol. 2:
United Kingdom and Ireland,
London, 1976.
Morris, B.,
Victorian Embroidery,
London, 1962.
Power, E.,
The Wool Trade in Medieval History,
London, 1949.
Robinson, S.,
A History of Printed Textiles,
London, 1969.
Stenton, F. (ed.),
The Bayeux Tapestry,
London, 1965.
Storey, J.,
*The Thames & Hudson Manual of Textile
Printing,*
London, 1974.
Swain, M. H.,
*Historical Needlework. A Study of
Influences in Scotland and Northern
England,*
London, 1970.
Thomson, W. G.,
A History of Tapestry,
new edn., London, 1973.

Victoria and Albert Museum,
The Raphael Cartoons,
London, 1966.
Wardle, P.,
Guide to English Embroidery,
London, 1970.
Warner, F.,
The Silk Industry,
London, 1921.
Wild, J. P.,
*Textile Manufacture in the Northern
 Roman Provinces,*
Cambridge, 1970.
Yorkshire Museum, York,
The Vikings in England,
York, 1982.

C.I.B.A. Review,
Basle, 1936–(discontinued).
Embroidery,
Journal of the Embroiderers' Guild,
London.
Textile History,
Pasold Research Fund, London.

Scottish Arts Council, Edinburgh,
*Master Weavers. Tapestry from the
 Dovecot Studios, 1912–1980*
(exhibition catalogue), Edinburgh, 1980.

14. Jewellery

Cooper, D., and Battershill, N.,
Victorian Sentimental Jewellery,
London, 1972.
Evans, J.,
*English Jewellery from the Fifth Century
 AD to 1800,*
London, 1921.
Evans, J.,
A History of Jewellery, 1100–1870,
London, 1st edn. 1953; 2nd edn. 1970.
Flower, M.,
Victorian Jewellery,
London, 1951.
Gere, C.,
*European and American Jewellery 1830–
 1914,*
London, 1975.
Oman, C. C.,
British Rings 800–1914,
London, 1914.

*The Cheapside Hoard of Elizabethan and
 Jacobean Jewellery,*
London Museum Catalogue, no. 2, 1928.
*Princely Magnificence, Court Jewels of the
 Renaissance 1500–1630,*
Victoria and Albert Museum catalogue,
1980.

15. Silver

Barr, E.,
George Wickes, Royal Goldsmith,
London, 1980.
Bradbury, F.,
Bradbury's Book of Hallmarks,
Sheffield, 1975, revised annually.

Clayton, M.,
Collector's Dictionary of Silver and Gold,
Feltham, 1971.
Culme, J.,
Nineteenth-Century Silver,
Feltham, 1977.
Grimwade, A.,
London Goldsmiths 1697–1976,
revised edn. London, 1982.
Grimwade, A.,
Rococo Silver,
London, 1974.
Hayward, J.,
Huguenot Silver,
London, 1959.
Jackson, C. J.,
English Goldsmiths and Their Marks,
2nd edn., revised 1921, reprinted New
 York, 1964.
Jackson, C. J.,
An Illustrated History of English Plate,
2 vols. 1st edn. 1911, reprinted New
 York, 1969.
Jones, K. C. (ed.),
*Silversmiths of Birmingham and Their
 Marks 1750–1980,*
London, 1981.
Oman, C. C.,
Caroline Silver,
London, 1970.
Oman, C. C.,
English Domestic Silver,
London, 6th edn. revised 1964.
Rowe, R.,
Adam Silver,
London, 1965.
Taylor, G.,
Silver,
Harmondsworth, revised edn., 1964.
Wardle, P.,
Victorian Silver and Silver Plate,
London, 1963.

Goldsmiths' Hall,
*Touching Gold and Silver: 500 Years of
 Hallmarks* (exhibition catalogue),
London 1978.

16. Furniture

Edwards, Ralph,
*The Shorter Dictionary of English
 Furniture,*
Feltham, 1964.
Fastnedge, Ralph,
English Furniture Styles 1500–1830,
Harmondsworth, 1955.
Gilbert, Christopher,
Thomas Chippendale,
2 vols., London, 1978.
Harris, Eileen,
The Furniture of Robert Adam,
London, 1963.
Joy, Edward,
English Furniture 1800–51,
London, 1977.
Moody, Ella,
Modern Furniture,
London, 1968.

17. Clocks and Watches

Baillie, G. H.,
*Watchmakers and Clockmakers of the
 World,*
London 1929 and 1951 (the standard
 work for information on the makers of
 clocks and watches).
Baillie, G. H.,
*Watches, Their History, Decoration and
 Mechanism,*
London, 1929.
Bruton, E.,
Antique Clocks and Clock Collecting,
Feltham, 1974.
Bruton, E.,
The History of Clocks and Watches,
London, 1979.
Carle, Donald de,
Watches and Their Value,
London, 1978.
Clutton, Cecil,
Collector's Collection,
London, 1974.
Clutton, Cecil, and Daniels, George,
Watches,
London, 1965.
Jagger, Cedric,
Clocks,
London, 1973.
Pearson, Michael,
The Beauty of Clocks,
Guildford, 1979.
Smith, Alan (ed.),
*The Country Life International
 Dictionary of Clocks,*
Feltham, 1979.
Ullyett, Kenneth,
Watch Collecting,
London, 1970.

18. Musical Instruments

Baines, A. C.,
Brass Instruments,
London, 1976.
Baines, A. C.
*European and American Musical
 Instruments,*
London, 1966.
Baines, A. C.,
Woodwind Instruments and Their History,
London, 1957 (1st edn.).
Baines, A. C. (ed.),
Musical Instruments Through the Ages,
Harmondsworth and London, 1961 (1st
 edn.).
Bate, Philip,
The Flute,
London, 1969 (1st edn.).
Bate, Philip,
The Oboe,
London, 1956 (1st edn.).
Bate, Philip,
The Trumpet and Trombone,
London, 1966.
Dolmetsch, Arnold,
*The Interpretation of the Music of the XVII
 and XVIII Centuries,*
London, 1916 and 1946.

Donington, R.,
Baroque Music; Style and Performance,
London, 1982.
Donington, R.,
The Instruments of Music,
London, 1949 (1st edn.).
Donington, R.,
The Interpretation of Early Music,
London, 1963 (1st edn.).
Donington, R.,
String Playing in Baroque Music,
London, 1977.
Galpin, F. W.,
Old English Instruments of Music,
London, 1910 (1st edn.).
Galpin, F. W.,
*A Textbook of European Musical
Instruments,*
London, 1937.
Halfpenny, Eric,
numerous articles throughout the *Galpin
Society Journal* and elsewhere.
Hunt, Edgar,
The Recorder and Its Music,
London, 1962 (1st edn.).
Langwill, L. G.,
The Bassoon and Contrabassoon,
London, 1965.
Langwill, L. G.,
*An Index of Musical Wind Instrument
Makers,*
Edinburgh, 1960 (1st edn.).
Morley Pegge, R.,
The French Horn,
London, 1960 (1st edn.).
Rendall, F. Geoffrey,
The Clarinet,
London, 1954 (1st edn.).

19. Modern Studio Crafts

Cheltenham Museum,
C. R. Ashbee and the Guild of Handicraft,
Cheltenham, 1981.
Comino, Mary,
Gimson and the Barnsleys,
London, 1980.
Digby, George Wingfield,
The Work of the Modern Potter,
London, 1952.
Gill, Eric,
Autobiography,
London, 1940.
Henderson, Philip,
William Morris,
London, 1967.
Houston, John (ed.),
Michael Cardew,
London, 1976.
Leach, Bernard,
A Potter's Book,
London, 1967.

MacCarthy, Fiona,
British Design Since 1880,
London, 1982.
Yorke, Malcolm,
Eric Gill,
London, 1981.

Enid Marx: Retrospective Exhibition,
London, Camden Arts Centre, 1979.
The Craftsman's Art,
London, Crafts Advisory Committee,
1973.
The Maker's Eye,
London, Crafts Council, 1981.

20. Industrial Design

Bayley, Stephen,
*In Good Shape. Style in Industrial
Products 1900–1960,*
London, 1979.
Bell, Quentin,
The Schools of Design,
London, 1963.
Blake, John and Avril,
*The Practical Idealists: 25 Years of
Designing for Industry,*
London, 1969.
MacCarthy, Fiona,
*All Things Bright and Beautiful: Design in
Britain, 1830 to Today,*
Hemel Hempstead, 1972.
Russell, Gordon,
*Designer's Trade: Autobiography of
Gordon Russell,*
Hemel Hempstead, 1968.

21. Early Britain

Brailsford, John,
*Early Celtic Masterpieces from Britain in
the British Museum,*
London, 1975.
Burl, H., and Piper, E.,
Rings of Stone,
London, 1979.
Henderson, Isabel,
The Picts,
London, 1967.
Neal, D. S.,
Roman Mosaics in Britain,
London, 1981.
Paor, M. and L. de,
Early Christian Ireland,
London, 1958.
Piggott, S., and Daniel, G. E.,
A Picture Book of Ancient British Art,
Cambridge, 1951.
Rees, Alwyn and Brinley,
The Celtic Heritage,
London, 1961.

Toynbee, J. M. C.,
Art in Roman Britain,
London, 1962.
Toynbee, J. M. C.,
Art in Britain Under the Romans,
Oxford, 1964.
Wilson, D. M.,
The Anglo-Saxons,
London, 1960.

22. North America: The British Legacy

Cummings, A. L.,
*The Framed Houses of Massachusetts Bay
1625–1725,*
Cambridge, Mass., and London, 1979.
Gidley, M.,
*A Catalogue of American Paintings in
British Public Collections,*
American Arts Documentation Centre,
University of Exeter, 1974.
Gowans, Alan,
*Images of American Living – Four
Centuries of Architecture and Furniture
as Cultural Expression,*
Philadelphia and New York, 1964.
Guinness, D., and Sadler, J. T.,
*Palladian Style in England, Ireland and
America,*
London, 1976.
McCallum, Ian, and Ayres, James,
American and British Folk Art,
catalogue of exhibition shown at Embassy
of United States of America, London,
1976.
Montgomery, Charles, and Kane, Patricia
(eds.),
*American Art 1750–1800 Towards
Independence,*
exhibition catalogue, published by Yale
University Art Gallery, New Haven,
Victoria and Albert Museum, London,
New York Graphic Society, Boston,
1976.
Morrison, Hugh,
Early American Architecture,
New York, 1952.
Novak, Barbara,
*American Painting of the Nineteenth
Century,*
New York, 1969.
Poesch, Jessie J.,
Early Furniture of Louisiana,
New Orleans, 1972.
Quennell, Peter, and Hodge, Alan,
The Past We Share,
London, 1960.
Quimby, Ian M. G. (ed.),
*Arts of the Anglo-American Community
in the Seventeenth Century*
(for the Henry Francis du Pont Museum),
Charlottesville, 1975.

Index

Acknowledgements

The Publishers are grateful to all individuals, museums and institutions who have given permission for the works in their possession to be reproduced. They have endeavoured to credit all known persons holding copyright or reproduction rights to the illustrations in this book. (References are to illustration numbers.)

By Gracious Permission of Her Majesty the Queen, 9, 201
H. R. H. The Prince of Wales, p. 238, 1

Abby Aldrich Rockefeller Art Centre, Williamsburg, Virginia, 257
The Amateur Photographer, London, p. 48, 1, p. 49, 4
American Museum in Britain, Bath, 250b, 251b, 252, 254, 259
The Armouries of the Tower of London, 131, 132, 134, 136
Ashmolean Museum, Oxford, 189, 194, 241
James Austin, 121
James Ayres, 260
Ayres Collection, Bath, 250a, 251a
Bate Collection of Historical Instruments, University of Oxford, 216, 218
B. J. Batsford Ltd, London, 246
Bayeux Tapestry Museum, Bayeux, 154
Bede Monastery Museum, Jarrow, 90
Beethoven House, Bonn, 220
Birmingham Museums and Art Gallery, 22
Border Regiment Museum, Carlisle Castle, Carlisle, 49
Bill Brandt, 39
Bridgeman Art Library, 203, 206
British Aerospace Ltd, Weybridge, 231
British Council, London, 26, 33
British Library, London, 40, 41
British Museum, London: Reproduced by courtesy of the Trustees, 2, 3, 127, 173, 177, 212, 235, 243, p. 12, 1, 2, 3, p. 13, 4, 5, p. 65, 4, p. 122, 1, p. 253, 3, p. 258, 2, p. 259, 3, 4, 5
British Rail, London, p. 80, 2, p. 81, 3, 4
Brunel Engineering Centre Trust, Bristol, p. 80, 1
A. B. Brunnschweiler – U. K., Manchester, p. 177, 5
Collection of Mr and Mrs William A. M. Burden, New York, 29
The Camera Club Permanent Collection, London, p. 48, 2, p. 49, 3
Cecil Higgins Art Gallery, Bedford, 151

The Centre for the Study of Cartoons and Caricature, University of Kent at Canterbury, p. 13, 7
Cheltenham Art Gallery and Museum, p. 65, 3
Christie's, London, 138, 197, 204, 211, 214, 224, 225, p. 209, 3
The Circle Press, Guildford, 45
City Art Gallery, Manchester, 124, p. 31, 5
City of Bristol Museum and Art Gallery, 126, p. 152, 2
City of Derby Museum and Art Gallery, 16
City Museums and Art Galleries, Kingston-upon-Hull, 46, 237, p. 253, 5
City of Salford Art Gallery, p. 31, 6
City of Stoke-on-Trent Museum and Art Gallery, 148
Peter Clayton, 127, p. 253, 6
Corning Museum of glass, Corning, N. Y., p. 163, 1
Courtauld Institute of Art, London, *frontispiece*, 102, 114, p. 30, 1, p.131, 5
Crafts Council, 221, 223, p. 239, 3
Derbyshire Countryside Ltd, 93
The Design Council, London, 233
Dyson Perrins Museum, the Royal Worcester Porcelain Company, Worcester, 145
Edinburgh Tapestry Company, 171
Ely Cathedral Stained Glass Museum, 92
The Fitzwilliam Museum, Cambridge, 139, 149, 150, 164
Ford Motor Company, 232
The Frick Collection, New York, copyright 7
Gallery of English Costume, Platt Hall, Manchester, p. 185, 4
Glasgow School of Art, 67, 206
Glass Museum, Dudley, p. 163, 3, 4
Goethe Museum, Frankfurt, 18
Golden Cockerell Press, 221
The Goldsmith's Company, 181, p. 199, 5
Joel Gordon, 244
The Greater London Council as Trustees of the Iveagh Bequest, Kenwood, 13
Grosvenor Museum, Chester, 217
Hille International Ltd, Watford, 207
The Houghton Library, Harvard University, Cambridge, Mass., 43
Hunterian Art Gallery, University of Glasgow, p. 185, 3, Mackintosh Collection, 206
The Ironbridge Gorge Museum, Ironbridge, Telford, 143, 147, p. 151, 3, 4
Juda Rowan Gallery, London, 26
A. F. Kersting, 56, 63, 64

The Kodak Museum, Harrow, 37
Lady Lever Art Gallery, Port Sunlight, 120, 199, p. 209, 4
Dean and Chapter, Lincoln Cathedral, 91
Lincoln City and County Museum, Lincoln, 238
London Transport Executive, 230
Lyons, Musée Historique des Tissus, 155
Manchester Public Library, p. 176, 1
Paul Mellon Collection, Upperville, Virginia, 1
Merseyside County Museum, Liverpool, 242
The Metropolitan Museum of Art, New York, p. 123, 4
The Minton Museum, Stoke-on-Trent, 148
Jeremy Montagu, 215
The Museum of London, 137, 175, p. 64, 1
The National Art Library, the Victoria and Albert Museum, London, 42, 44, 45, 159, p. 54, 1, 2, p. 55, 3
National Gallery, London, 15, p. 30, 4
National Maritime Museum, Greenwich, 12
National Monuments Record, 52, 53, 54, 55, 57, 59, 60, 61, 66, 68, 69, 70, 71, 72, 73, 74, 75, 77, 79, 80, 81, 82, 83, 85, 86, 100, 106, 108, 109, 115, 116, 119, 120, 121, 128, 129, 130, p. 72, 1, p. 73, 3, 4, 5, p. 81, 5, p. 130, 1, 2, 3, p. 131, 4, 5, 6, p. 253, 3
National Monuments Record for Wales, Aberystwyth, 62, 65
National Monuments Record, Scotland, 78, 84, 99
National Museum of Antiquities of Scotland, Edinburgh, 135
National Museum of Wales, Cardiff, 249, p. 258, 1
National Portrait Gallery, London, 117, 172
The National Trust, 193, 195
The National Trust for Historic Preservation in the United States, Washington, D.C., 245, 261
New College, Oxford, 178, 179
Peter Stuyvesant Foundation, Amsterdam, 32
Picton Castle Gallery, Haverfordwest, 4
Plymouth Museum and Art Gallery, 146
Powell and Moya Architects, 228
Quarry Bank Mill, Styal, p. 176, 1
Wendy Ramshaw, 227
Réunion des Musées Nationaux, Paris, 157
Canon M. H. Ridgway and F. H. Crossley, 110
Roman Baths Museum, Bath, 239, 240
The Royal Photographic Society, Bath, 35, 36, p. 49, 5
Royal Scottish Museum, Edinburgh, 163
Rutland Gallery, London, 47, 48

The Vicar, St Mary's Church, Fairford, 89
Science Museum, London, 209, 210
Walter Scott, Bradford, 51, p. 73, 2
Henry Smith Horticultural Photographic Collection, Chelmsford, 94, 95, 96
Society for the Preservation of New England Antiquities, Boston, Mass., 247, 248
Somerset County Museum, Taunton, p. 253, 4
Sotheby's, London, 165
Stedelijk Museum, Amsterdam (photograph David Ward), 226
Suffolk County Archives, Ipswich, p. 65, 5
Sunderland Central Museum and Art Gallery, 152
The Tate Gallery, London, 5, 6, 11, 20, 21, 23, 24, 25, 27, 28, 30, 123, 125
By kind permission of the Marquess of Tavistock and the Trustees of the Bedford Estates, 3
Temple Newsam, Leeds, 196, 198, 202, 205, p. 208, 2
Thomas Photos Ltd, 76, 88, 178
Troiani Collection, Farmington, Conn., 258
Ulster Folk and Transport Museum, Holywood, 87, 254
The Victoria and Albert Museum, London (Crown copyright), 8, 10, 17, 19, 140, 142, 144a, 144b, 156, 158, 159, 160, 162, 166, 167, 174, 176, 182, 183, 185, 186, 187, 188, 190, 191, 192, 200, p. 122, 2, p. 123, 3, 5, 6, p. 151, 5, p. 177, 2, 4, p. 198, 1, p. 199, 2, 3, 4, p. 209, 5, p. 208, 1
Verulamium Museum, St Albans, p. 252, 2
Walker Art Gallery, Liverpool, 14, 122, 199, p. 209, 4
The Trustees of the Wallace Collection, 133
Frederick Warne PLC, London, p. 55, 4
Warwickshire Museum, 219
The Wedgwood Museum, Barlaston, 141, p. 150, 1
Whitworth Art Gallery, University of Manchester, 161, 168, 169, 170, 171, p. 177, 3
The Dean and Chapter, York Minster, and the York Glaziers Trust, p. 104, 1, 2, p. 105, 4, 5

Particular thanks are also due to the following, who have helped in the preparation of this book: J. David Bohl, Robert Chapman, Ted Colman, the Hamlyn Picture Library, Christopher Hutchinson, Petersburg Press Ltd, Gordon Roberton, Tom Scott, the Weidenfeld and Nicolson Picture Library.